First published and distributed by
viction:workshop ltd

viction:ary™

viction:workshop ltd
Unit C, 7/F, Seabright Plaza,
9-23 Shell Street,
North Point, Hong Kong SAR
Url: www.victionary.com
Email: we@victionary.com

🅕 @victionworkshop
🅞 @victionworkshop
Bē @victionary
🅟 @victionary

Edited and produced by viction:workshop ltd
Creative Direction: Victor Cheung
Design: Pallas Lo, Scarlet Ng
Editorial: Ynes Filleul, YL Lim
Coordination: Jeanie Choy, Katherine Wong
Production: Bryan Leung
Typeface: Harber by Benoît Bodhuin

ISBN 978-988-76845-7-2
Printed and bound in China

GOOD DOGS

Canine Companions in Art and Illustration

INTRO

In the grand tapestry of human history, dogs have secured a rather privileged thread. From ancient civilisations that honoured them as guardians, to the cosy corners of our modern homes where they personify loyalty and love, dogs have been with us through thick and thin, shedding both hair and unconditional affection. Their unerring companionship has won them a special place in our hearts, and it's no surprise that they have also become perpetual muses for artists, who capture their essence in a myriad of creative ways.

GOOD DOGS is not just a book, but a tail-wagging celebration of our four-legged friends. Within these pages, you'll find a kaleidoscope of art styles and interpretations, from the stately Mastiff to the sprightly Maltese. Each illustration is a testament to the artist's love for their subject, imbued with a sense of whimsy, wonder, and warmth. The diversity in art styles mirrors the rich variety of dog breeds, each with its own unique charm and personality.

Ever since the dawn of the Internet, dogs, along with cats, have also carved out a niche in the

world of meme culture. From the iconic Doge (also known as Kabosu) with his Shiba Inu charm to the endless parade of goofy, heartwarming, and downright hilarious dog videos, our furry friends have taken over the digital realm. These memes have transcended mere entertainment, becoming a language of their own that conveys humour, joy, and sometimes even profound truths about life.

Imagine, if you will, a world without dogs. Dreary, isn't it? Now, flip through these pages and watch as that world transforms into one filled with joy, loyalty, and the occasional slobbery kiss. You'll find illustrations that make you chuckle, those that tug at your heartstrings, and others that simply make you appreciate the sheer artistry of capturing the essence of our paw-some pals.

But the charm of GOOD DOGS doesn't stop at the illustrations. You'll also be treated to plenty of dog-related fun facts, like the best places to give your doggo scratches, and even a body language chart to get to know your dog best friend more.

Let's be honest—there's something universally heartwarming about dogs. They're the comedic relief in our otherwise mundane lives, the heroes in our stories of companionship, and often the unsung protagonists in our daily adventures. This anthology captures that spirit perfectly, offering you, dear reader, not just a visual feast but a heartfelt homage to these remarkable pooches.

Had a ruff day? No worries—simply find a cosy spot, perhaps with your own pup by your side, and dive into this delightful anthology. Let the illustrations within these pages remind you of the joy, love, and laughter that dogs bring into our lives, and the incredible creativity they inspire. Welcome to GOOD DOGS—where every dog has more than just its day, but its own art too!

Although every pet owner wishes they could hold real conversations with their BFF (best fur-friend), they can derive certain cues from the latter's body language and facial expressions — particularly the eyes. Here's a little help from our guide, but remember, every pooch is different!

WHAT IS YOUR

"What are you up to?"

If your dog is tilting its head to the left/right with its eyes wide open, mouth closed, and ears upward, it is probably being inquisitive.

"Play with me!"

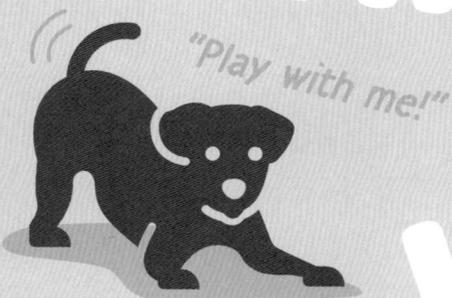

A dog with its ears upward, bent forepaws, and a wagging tongue and tail is likely in the mood to play with you or other furry friends!

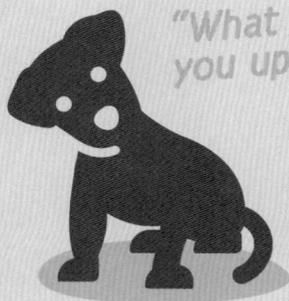

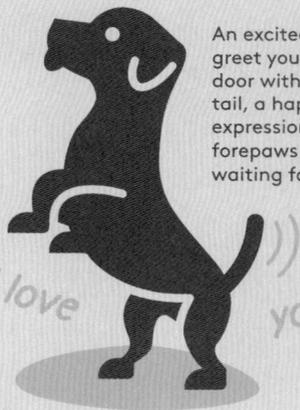

An excited dog may greet you at your door with a wagging tail, a happy facial expression, and forepaws lifted as if waiting for a hug.

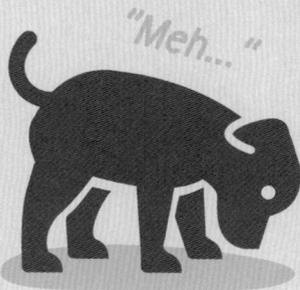

"Meh... "

An indifferent dog could indicate that it is no threat to others with its head down, a slightly moving tail as well as a smooth nose and forehead.

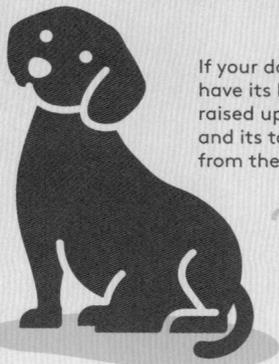

"I love you!"

If your dog is calm, it could have its head and ears raised up with bright eyes and its tongue hanging out from the side of its mouth.

"Life's good."

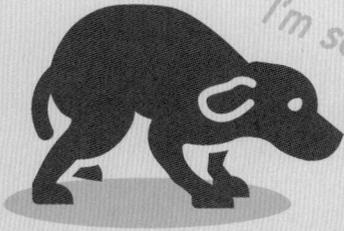

"I'm scared..."

DOG

A dog may show that it is scared by yawning, dry panting, and giving indirect eye contact with its tail hanging low.

"Hmmm..."

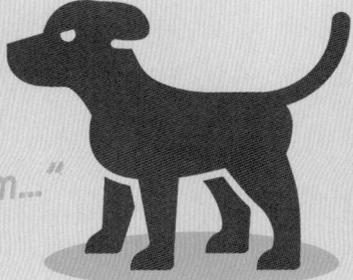

A suspicious dog is on high alert, as reflected in its sharp ears, stiff posture, raised tail, and flattened ears against its head.

REALLY

"This is stressful..."

"Back off!"

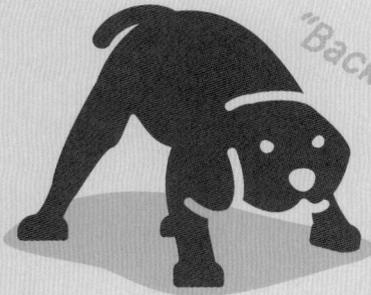

To tell if your dog is stressed, see if it reveals the whites of its eyes, yawns, licks its lips, and tucks its ears or tail while avoiding eye contact.

If a dog is growling and snapping at you with cold, staring eyes and its head hung low while slightly leaning forward, stay away!

"That was embarassing..."

An embarrassed dog typically has a submissive body posture with its body lowered and its tail tucked between its legs.

FEELING?

HOW TO GIVE SCRITCHES

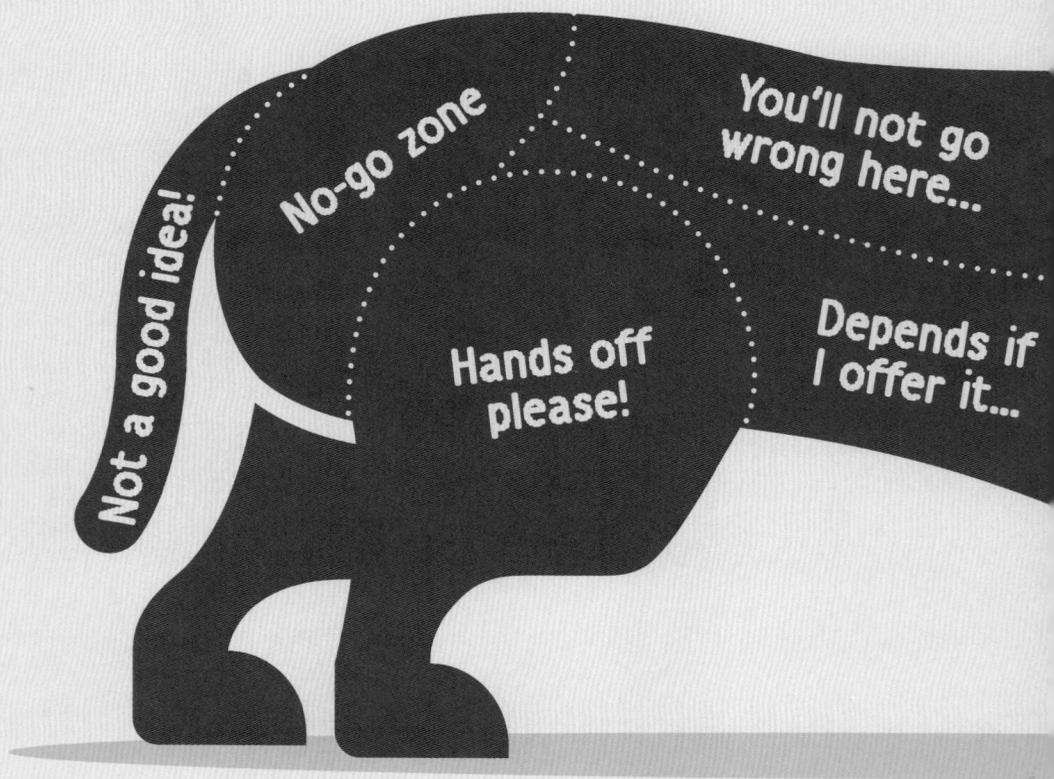

Not a good idea!

No-go zone

You'll not go wrong here...

Hands off please!

Depends if I offer it...

THE BEST

YES PLEASE!

OK zone

...or here!

LOVE IT!

Nope!

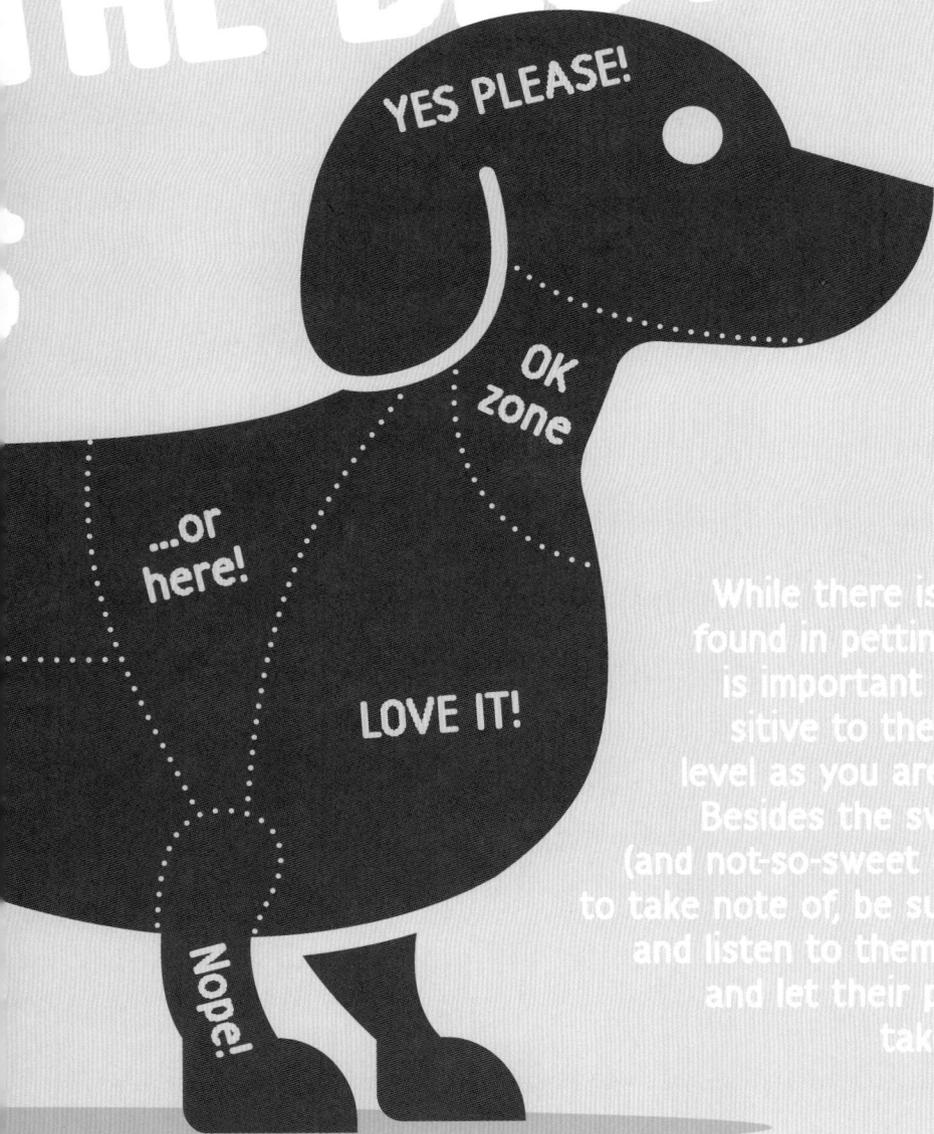

While there is joy to be found in petting a dog, it is important to be sensitive to their comfort level as you are doing so! Besides the sweet spots (and not-so-sweet ones) here to take note of, be sure to look and listen to them closely — and let their personality take the lead!

As (hu)man's best friend, dogs are a big part of our lives — as evidenced by their presence in our languages. Here are some English phrases that feature pups in them and what they mean!

Dog-eared
The folded corners of a book that resembles a dog's ear.

"The tail wagging the dog"
A situation where a small, unimportant part controls the larger, more important whole.

Puppy dog eyes
A pleading, innocent facial expression, often used by dogs.

Dog tags
Identification tags worn by military personnel.

"You can't teach an old dog new tricks"
It is difficult to make someone change, especially if they are set in their ways.

DOGGIE DICTIONARY

Dog days of summer
The hottest and most uncomfortable part of the summer season.

"It's a dog-eat-dog world"
The world is a competitive and ruthless place where people need to look out for themselves.

"Every dog has its day"
Everyone will have their moment of success or luck, even if it does not last forever.

"Let sleeping dogs lie"
It is best not to disturb a situation that is currently calm and stable, as it may cause trouble!

Underdog
The party or competitor that is expected to lose in a contest.

A dog's life
A life of hardship, misery, or servitude.

"Putting on the dog"
Behaving in an ostentatious or pretentious manner.

A dog and pony show
An over-the-top, flashy presentation or event intended to impress or mislead.

13

Kanae Sato

kanaes.com

Kanae Sato, a Tokyo-based freelance illustrator since 2010, uses a simple, colourful style to depict subtle interactions between people and animals. She creates illustrations for ads, publications, picture books, and goods, while participating in gallery exhibitions, events, and collaborative projects globally.

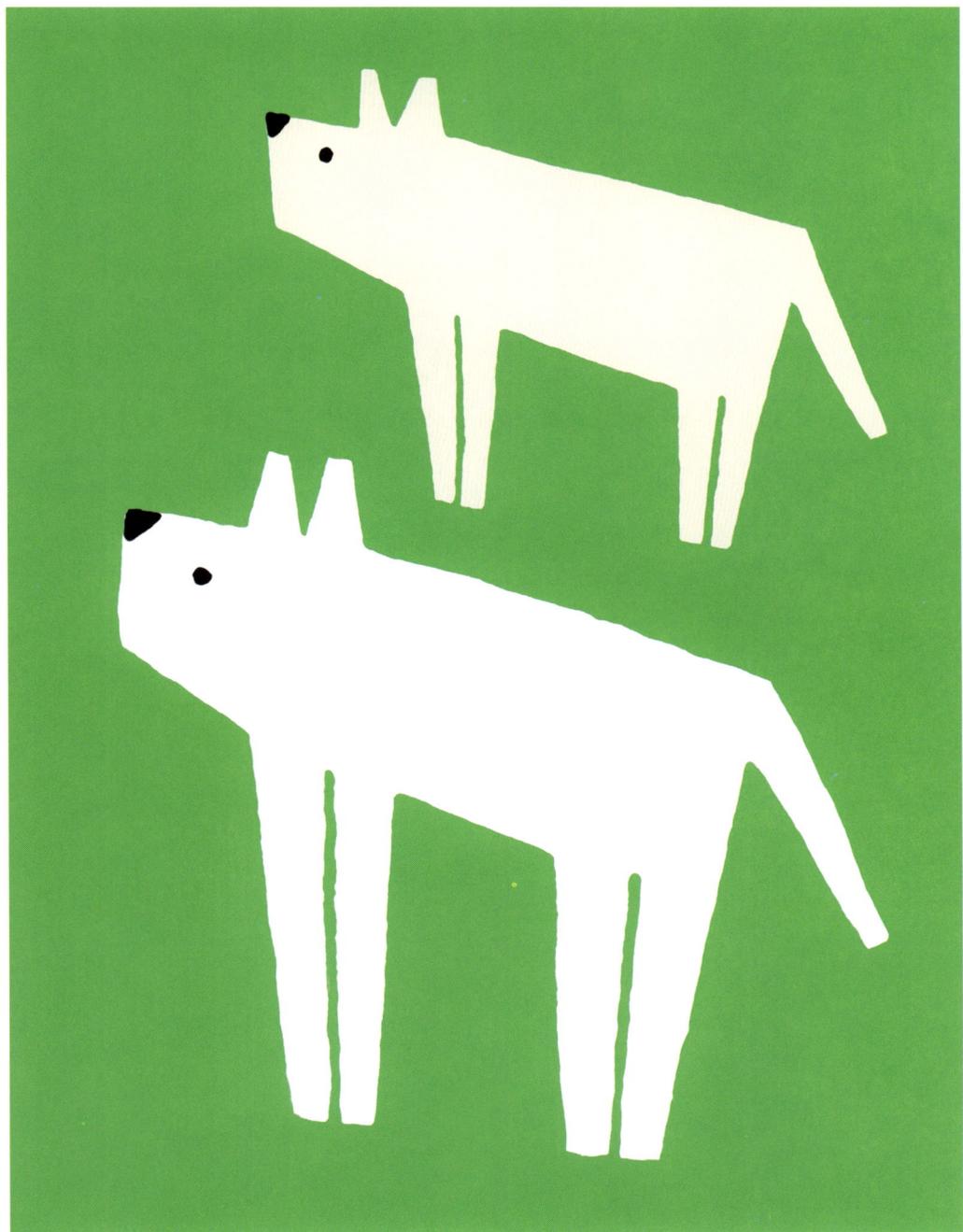

Wind
377 x 287 mm, Acrylic

15

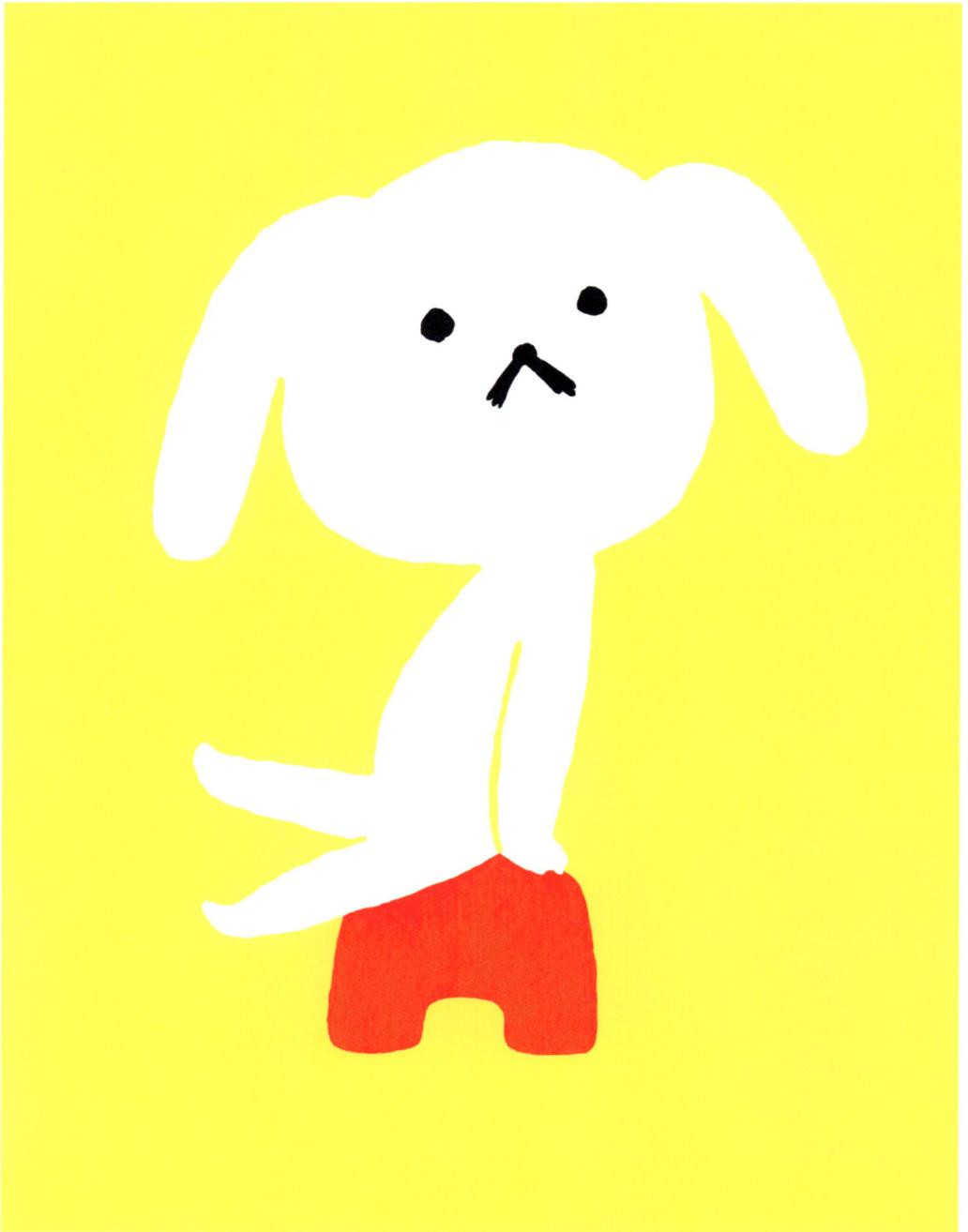

Pause
377 x 287 mm, Acrylic

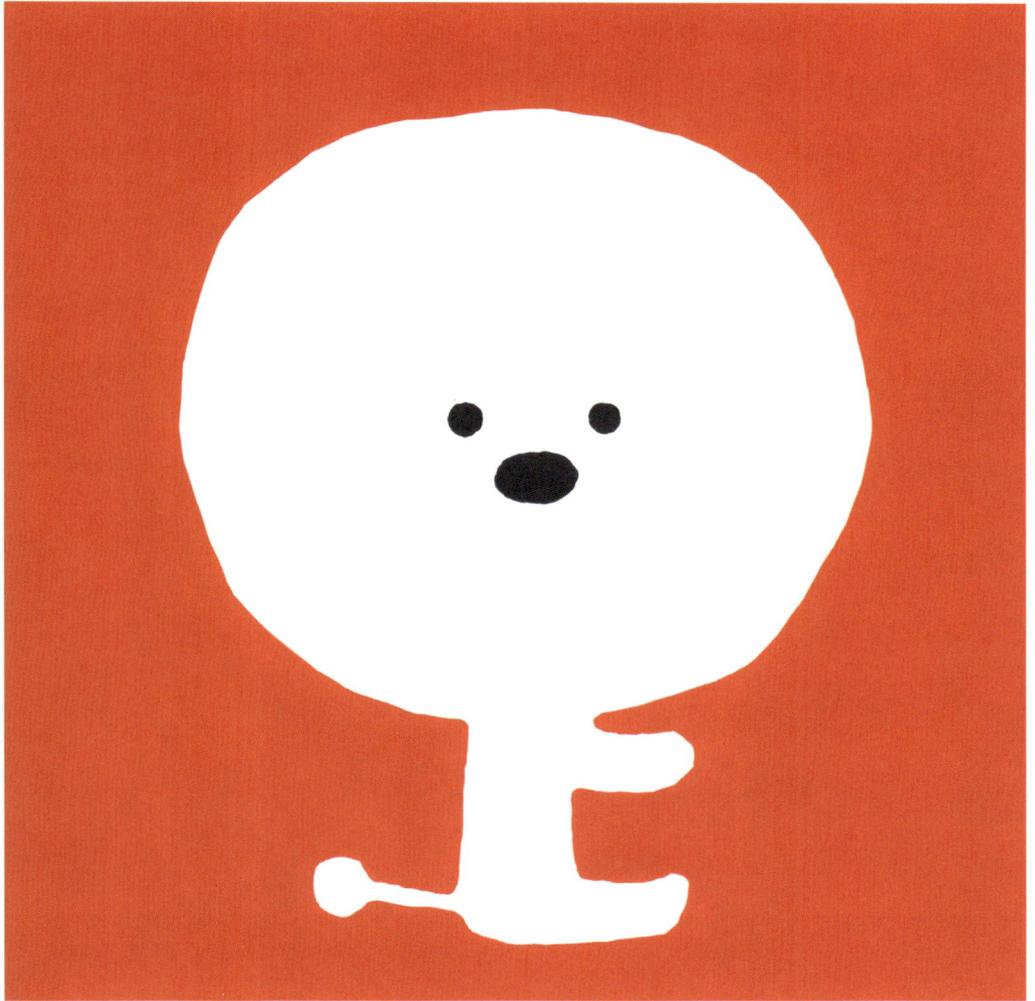

Circle
200 x 200 mm, Acrylic

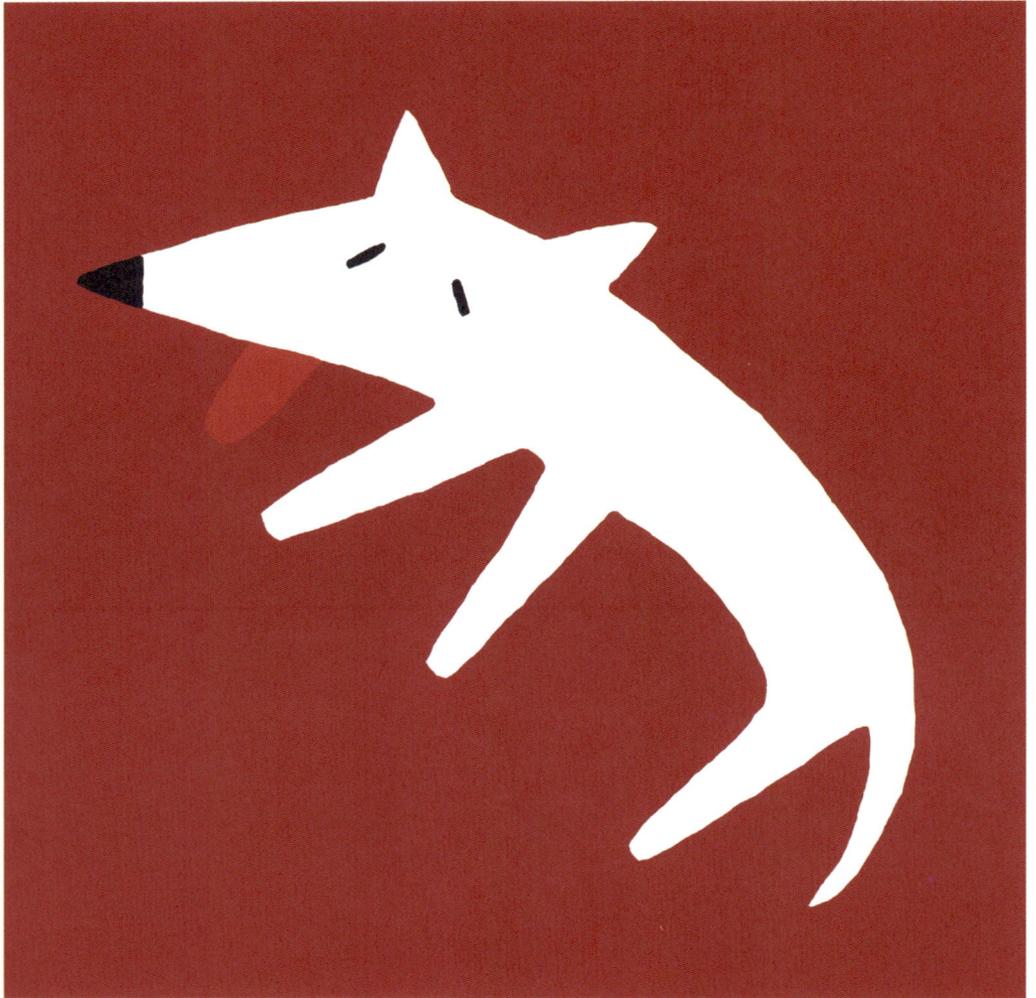

18

Hot
200 x 200 mm, Acrylic

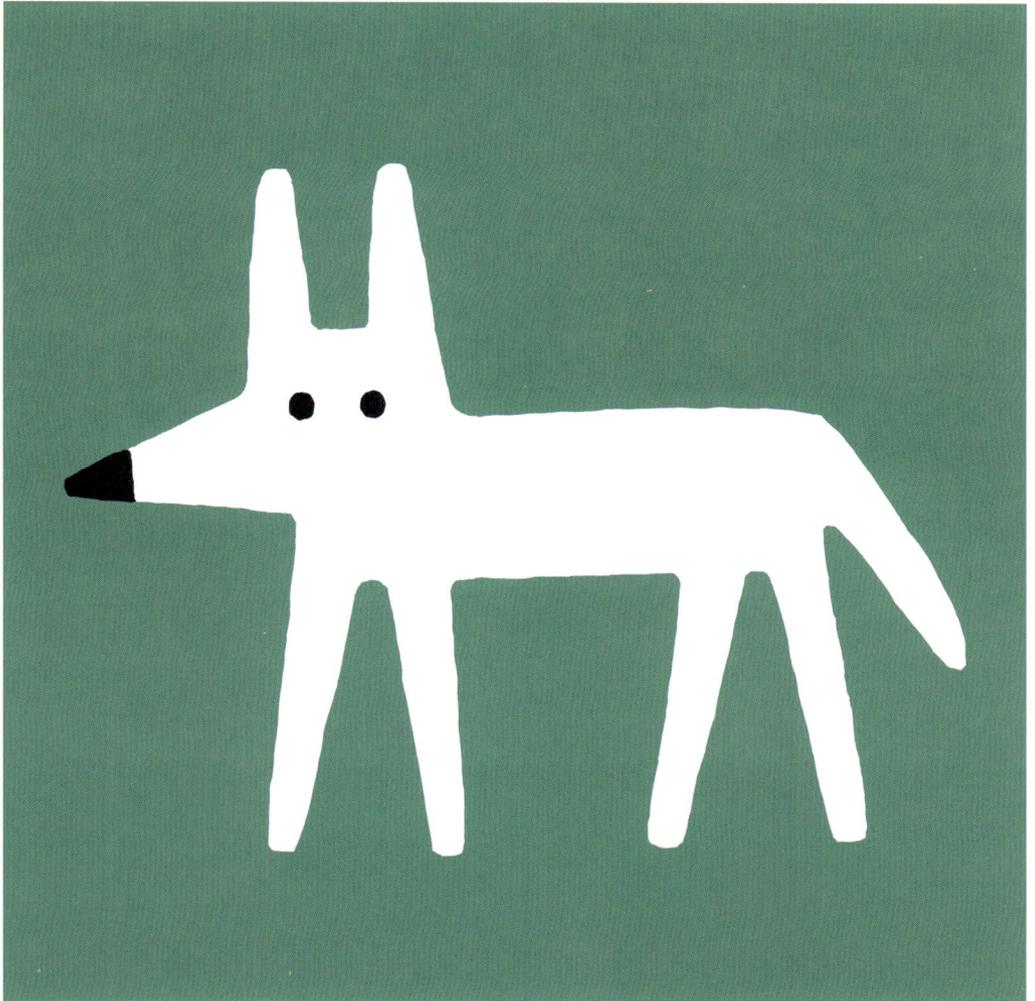

Calm
200 x 200 mm, Acrylic

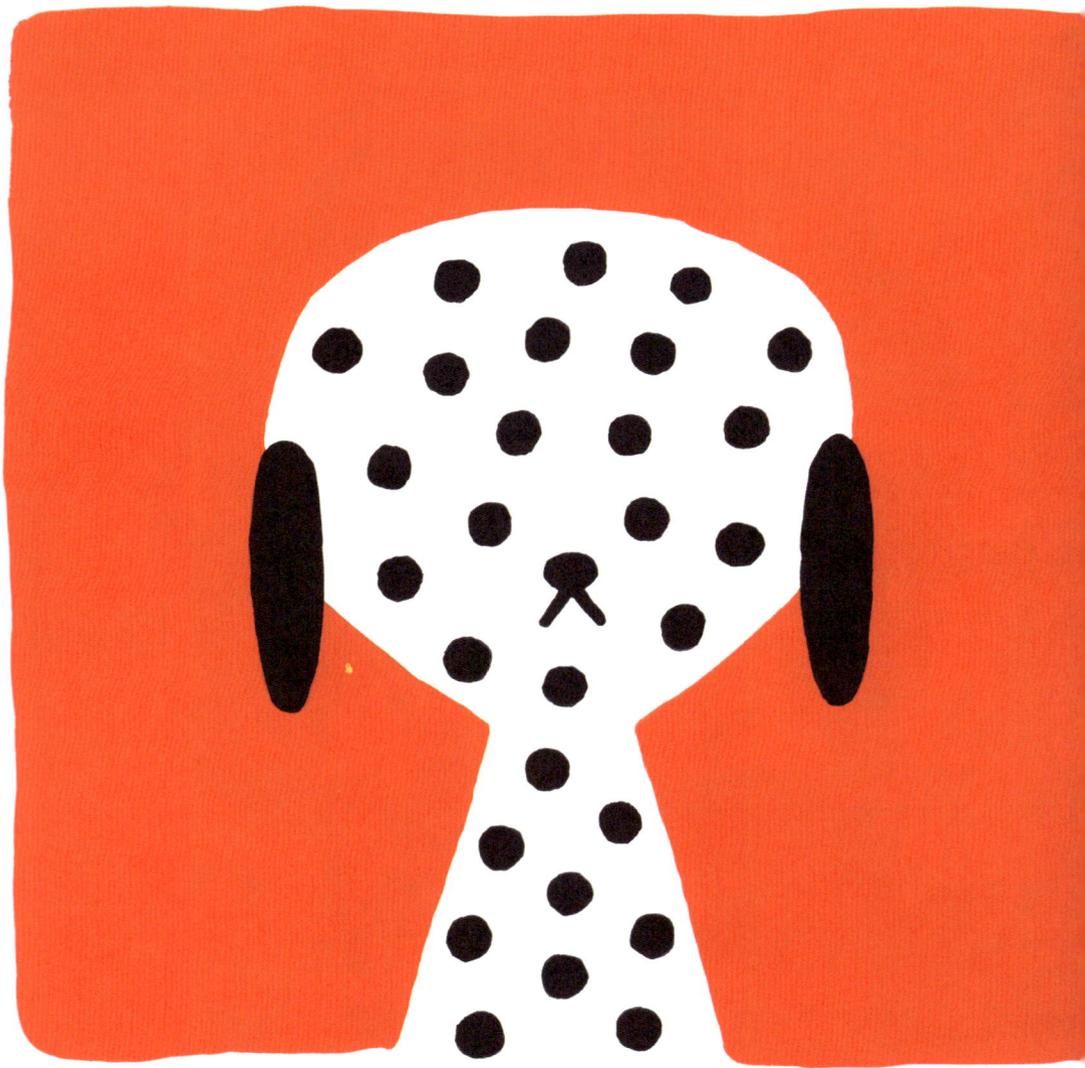

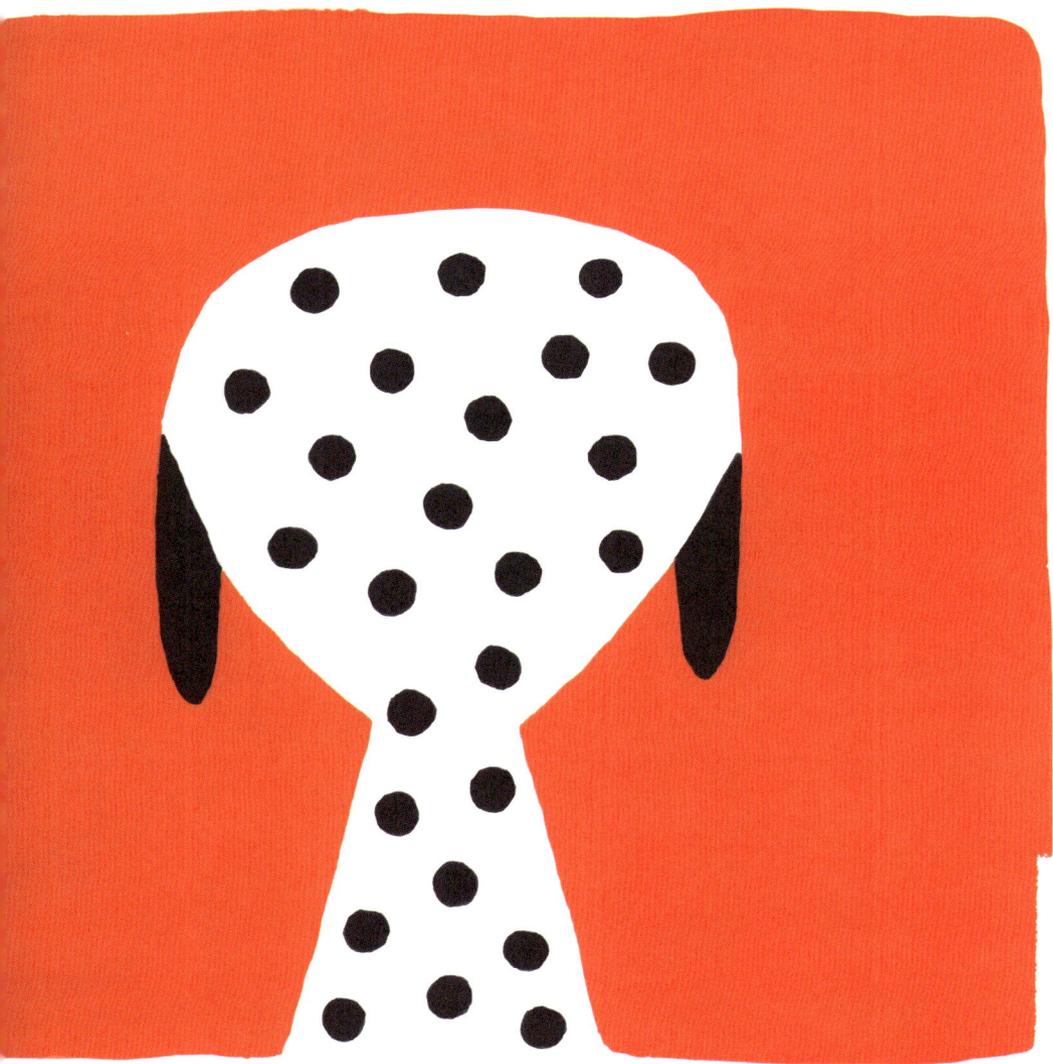

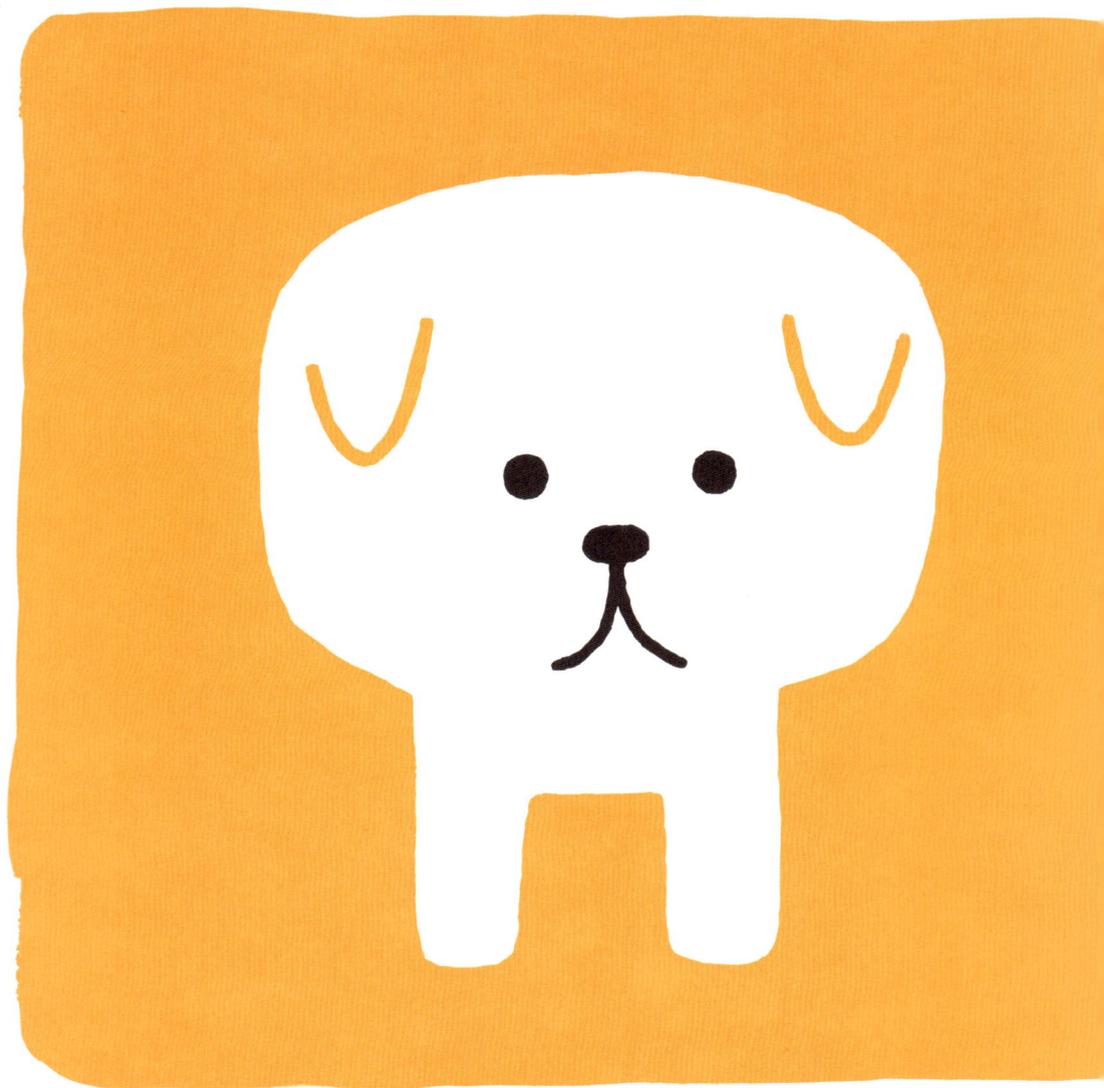

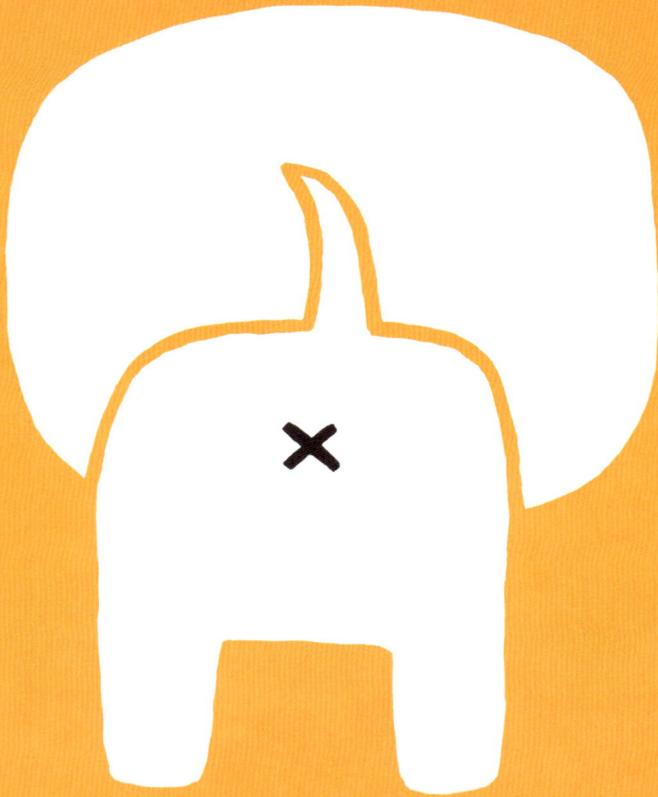

Donnie O'Donnell is an artist from Milton Keynes and based in Manchester. His work is based around animals and nature and is rendered in his colourful signature style. His works have been included in newspapers, on clothing, children's books, and record covers alongside his more personal pieces including his ongoing pet portraits commissioned by animal lovers worldwide.

@donnie_odonnell

Donnie O' Donnell

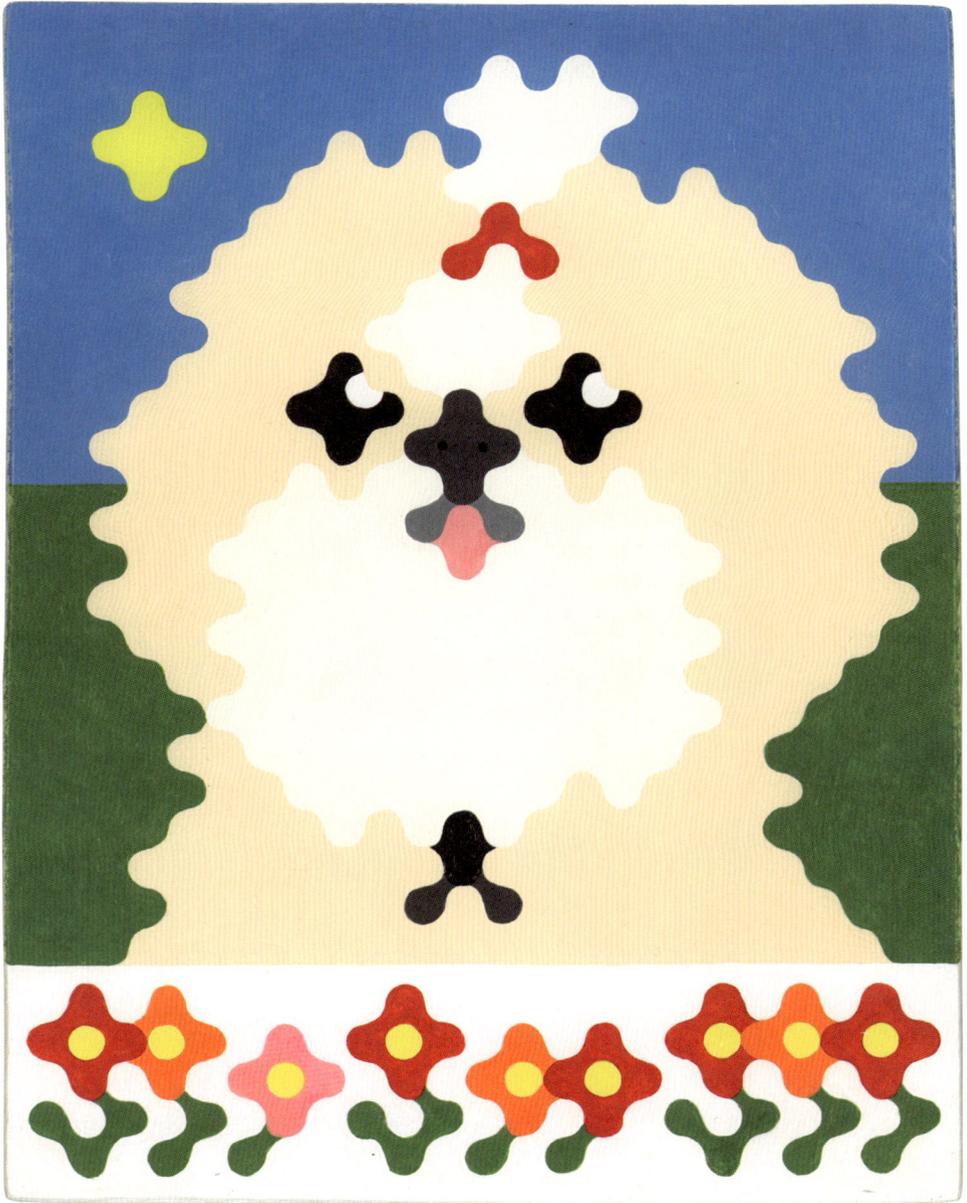

Udon from Tokyo, Japan
230 x 300 mm, Acrylic, Varnish, Wood

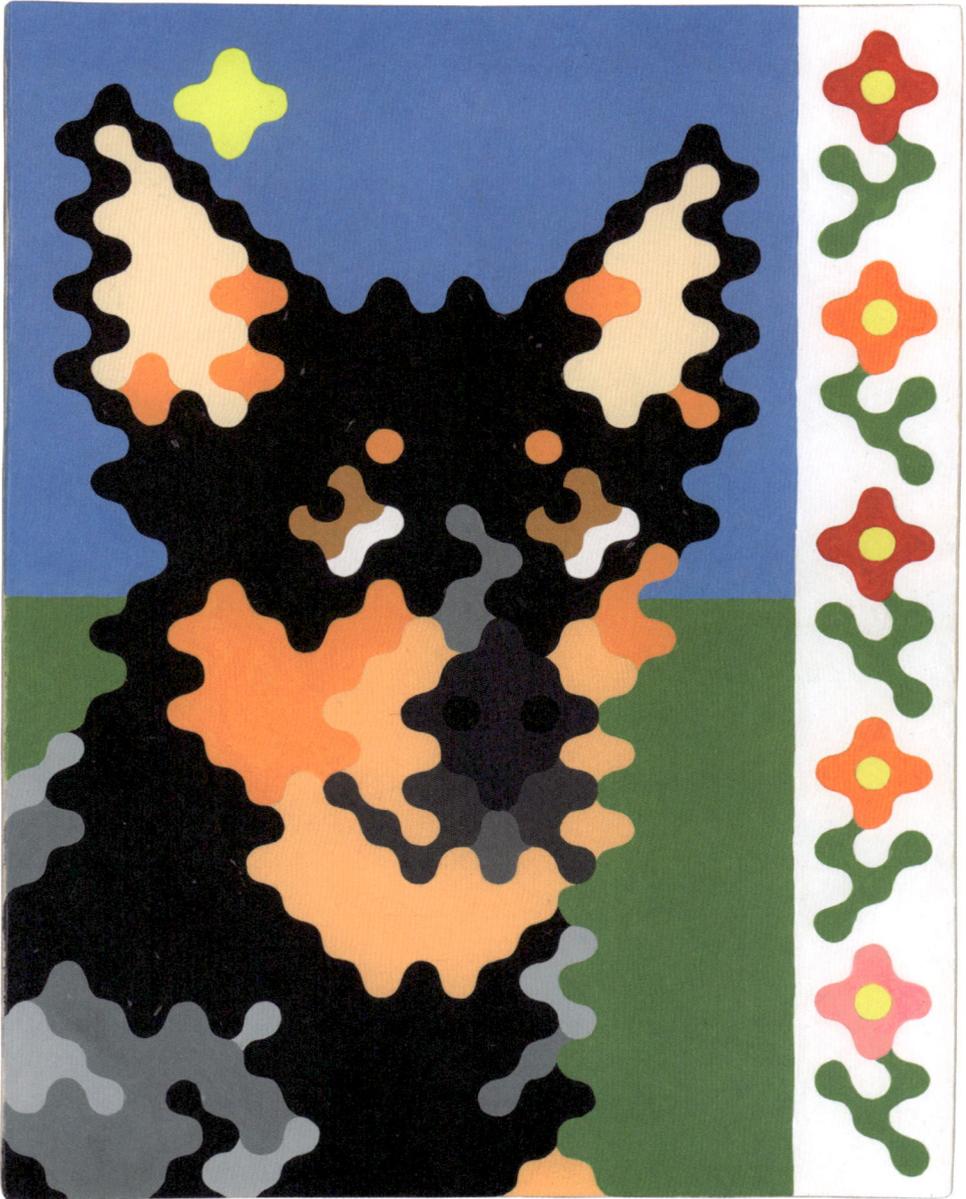

Harper from Minneapolis, Minnesota
230 x 300 mm, Acrylic, Varnish, Wood

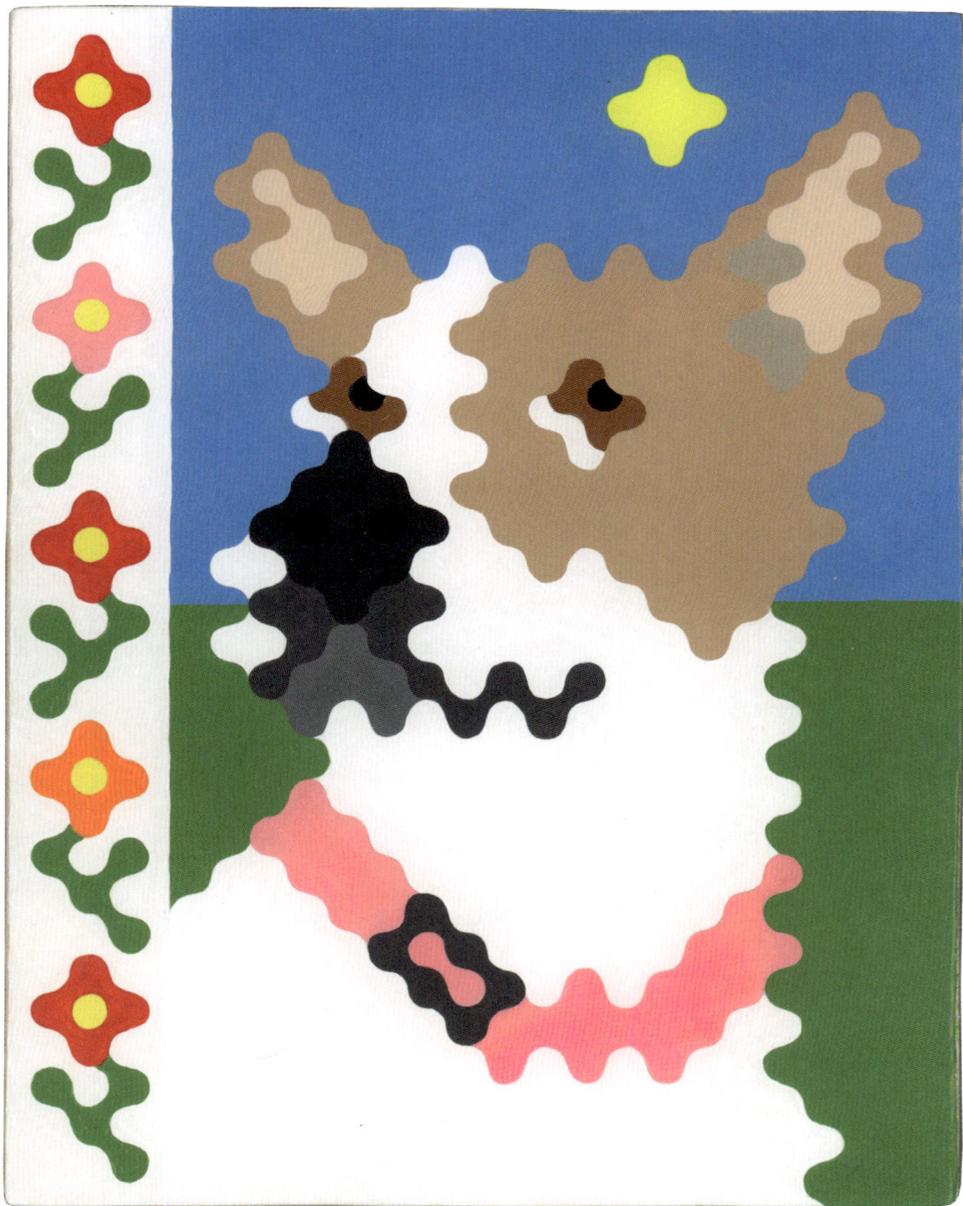

Olivia from Naperville, Illinois
230 x 300 mm, Acrylic, Varnish, Wood

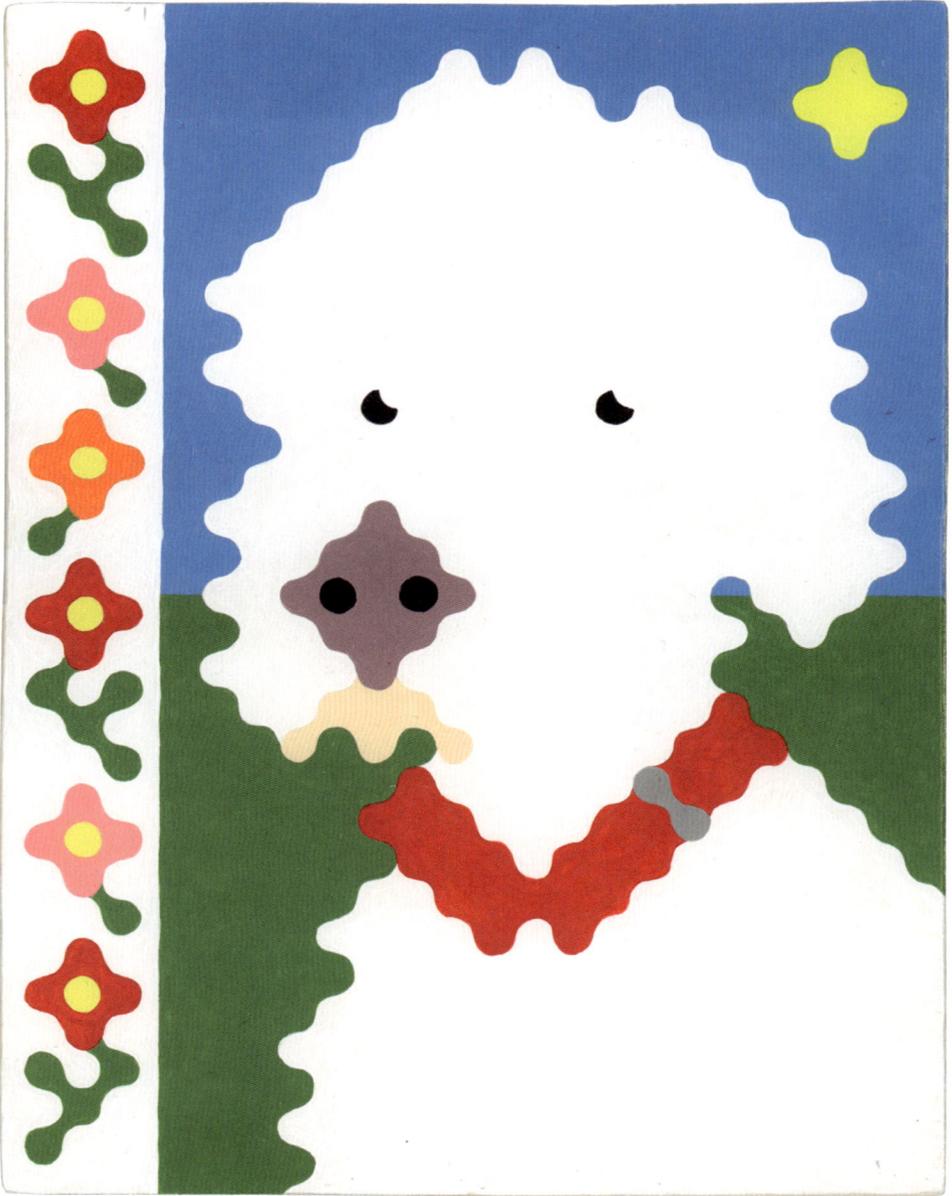

30

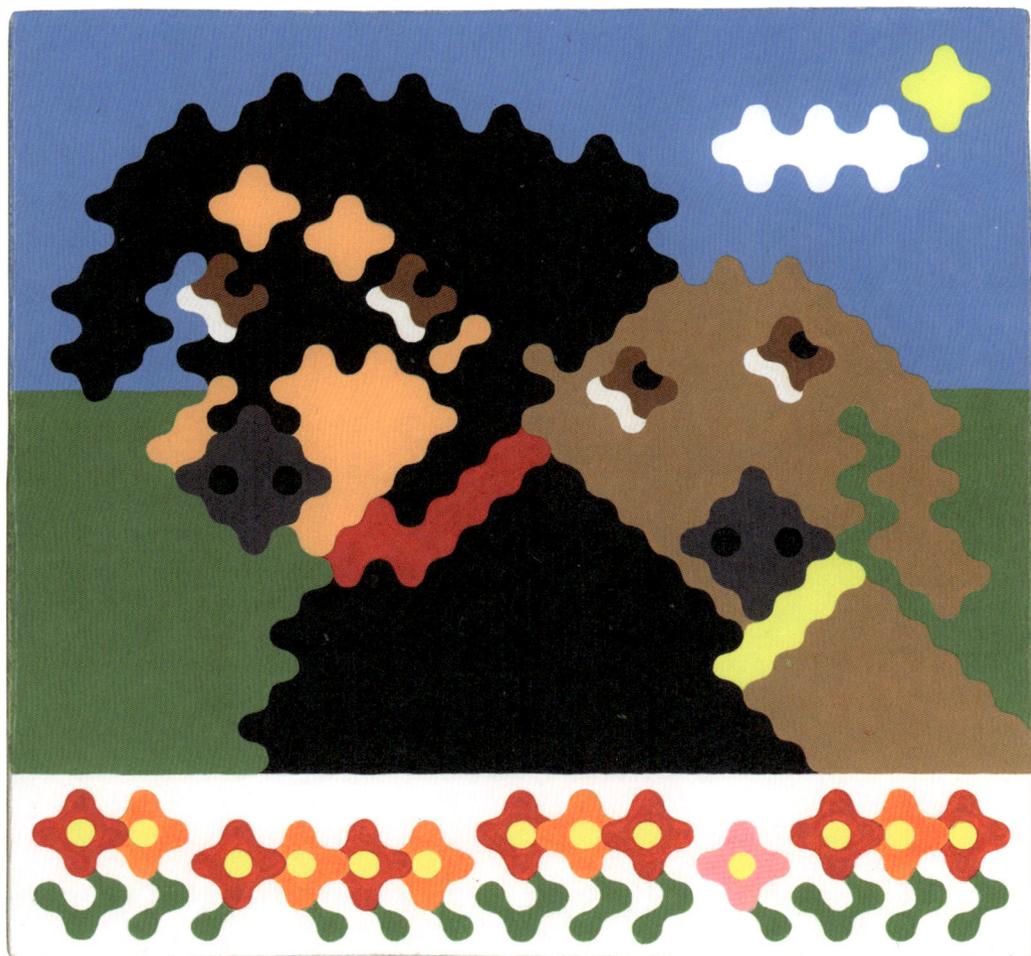

Charlie and Chico from Tucson, Arizona
270 x 260 mm, Acrylic, Varnish, Wood

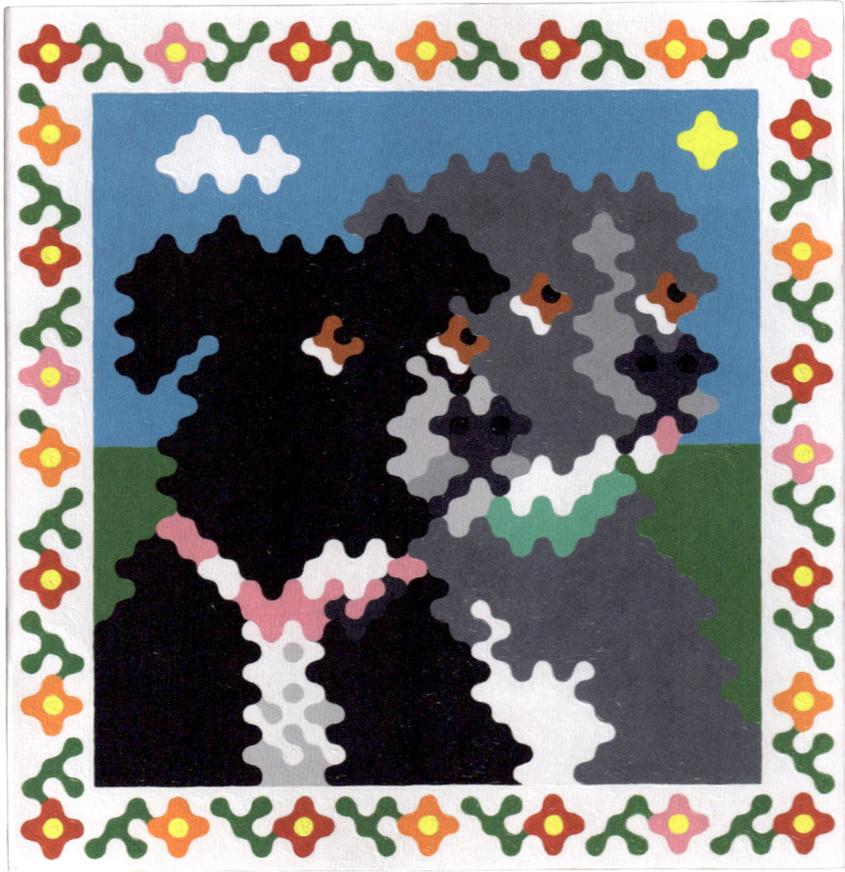

Nan and Goose from Glendale, California
350 x 370 mm, Acrylic, Varnish, Wood

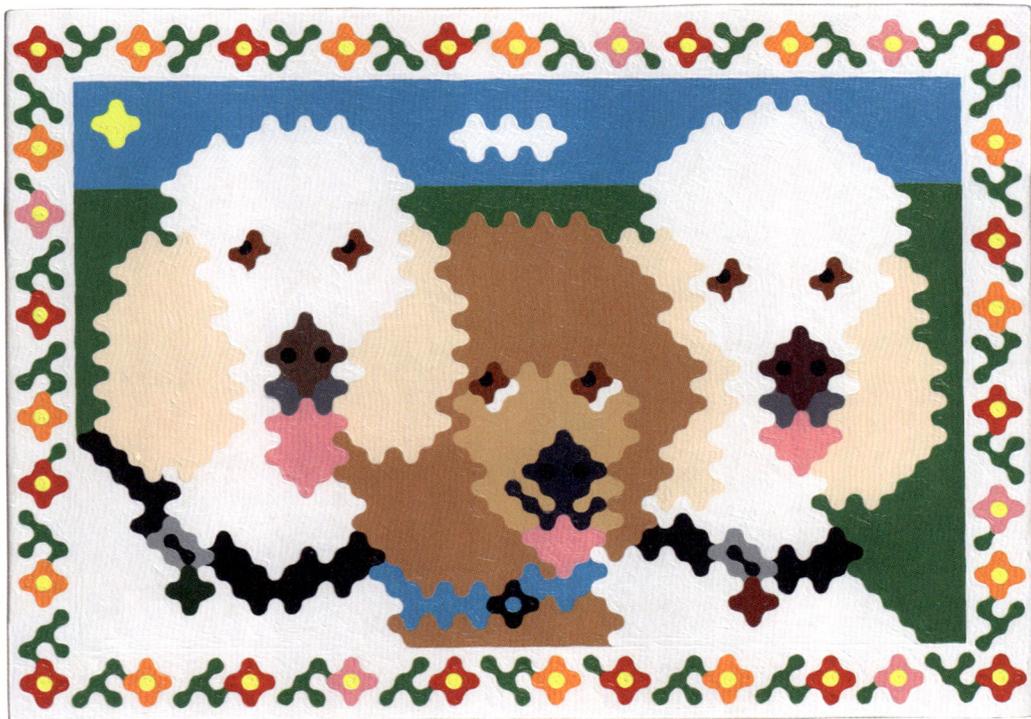

Lola Keeper and Maya from Brookline, Massachusetts
420 x 300 mm, Acrylic, Varnish, Wood

33

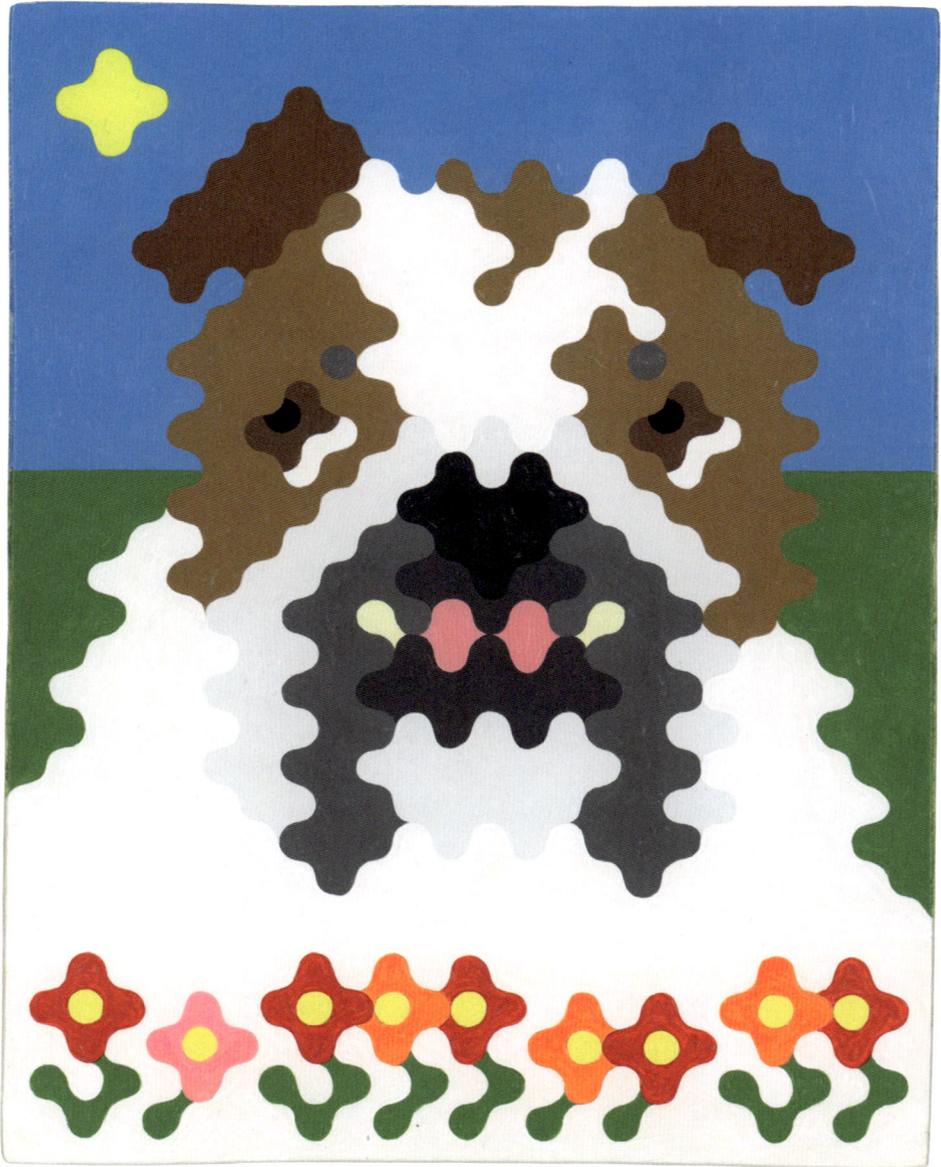

34

Bruno from Portland, Oregon
230 x 300 mm, Acrylic, Varnish, Wood

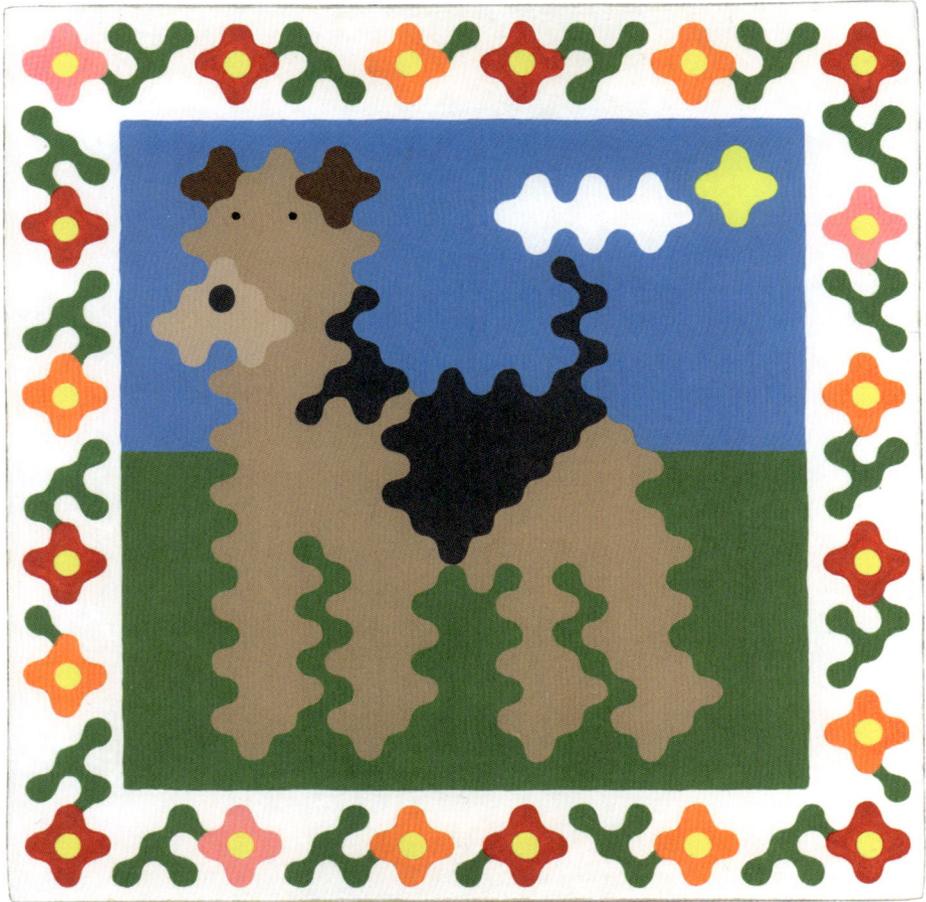

Hanks from Riverwoods, Illinois
270 x 270 mm, Acrylic, Varnish, Wood

Manon Cezaro

manoncezaro.com

Manon Cezaro, a 2016 graduate in illustration from Arts Décoratifs de Strasbourg, explores various mediums and formats beyond traditional publishing. Drawing inspiration from surrounding shapes, everyday details, and old decorating books, her work often features abstract and blurred drawings composed with a distinctive vocabulary of shapes.

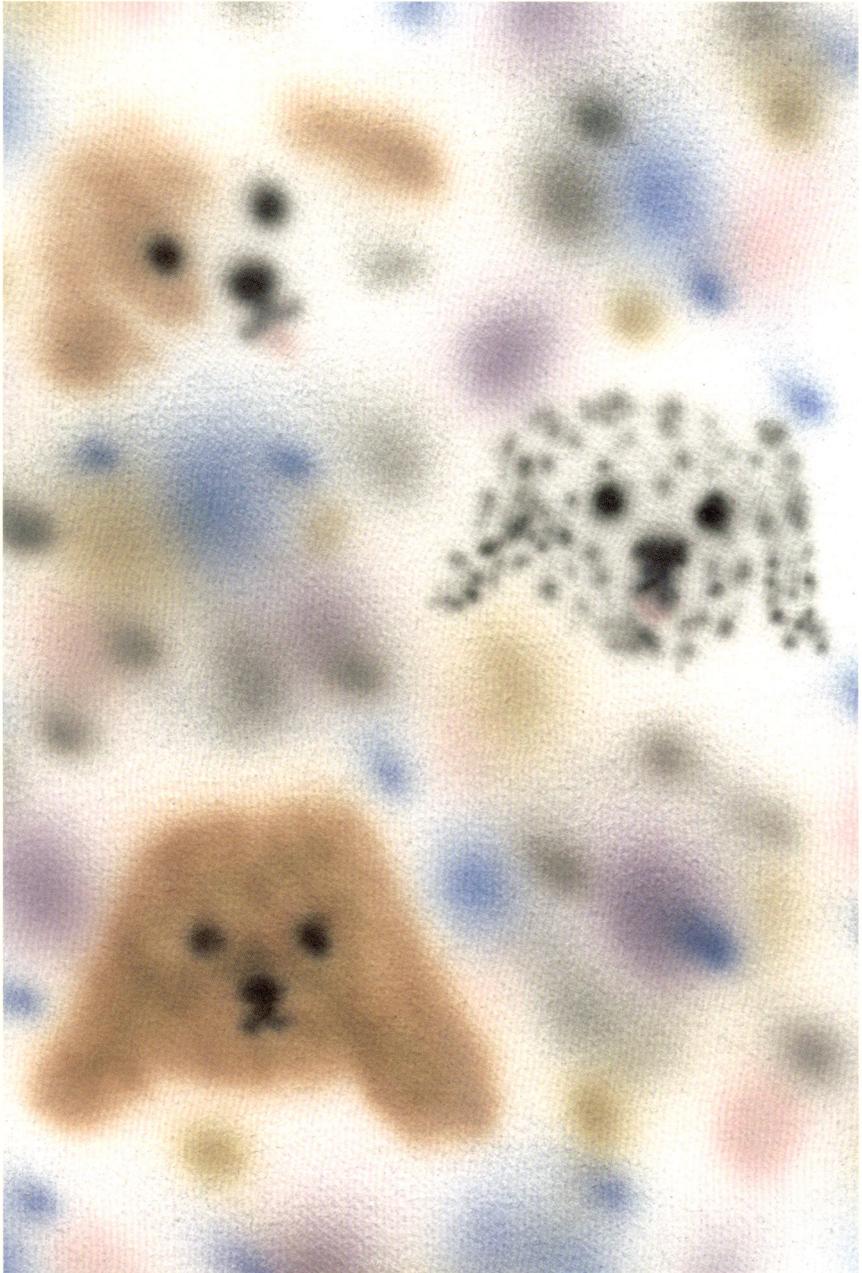

Portrait Of Dogs
148 x 210 mm, Airbrush

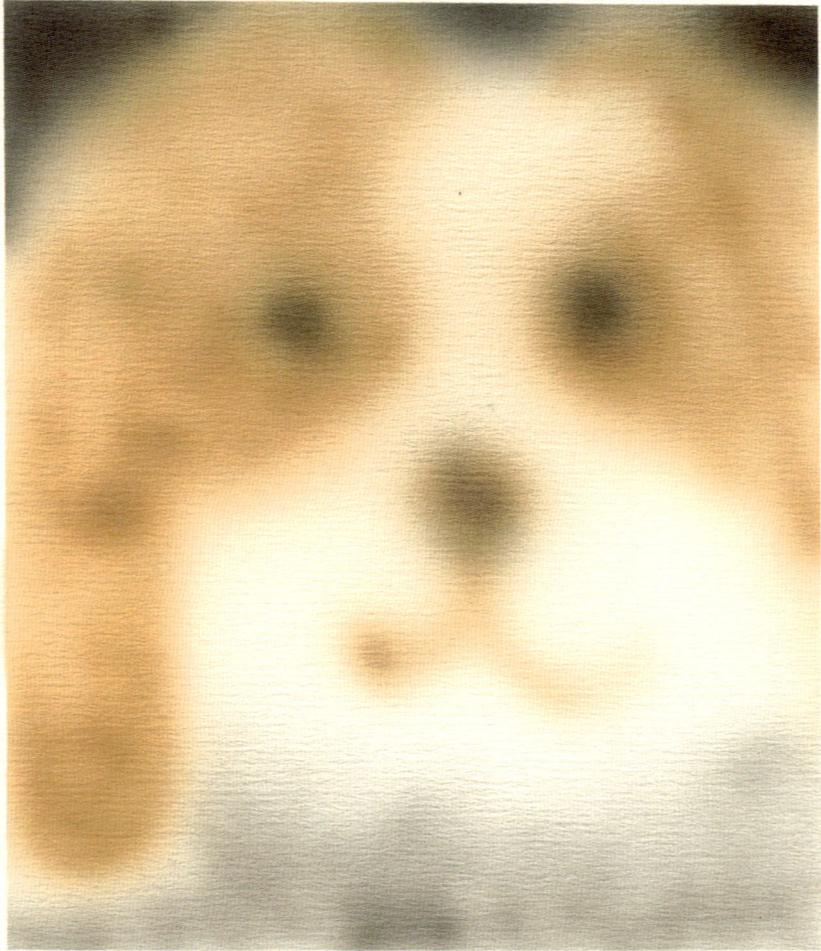

Portrait Of Dogs
148 x 210 mm, Airbrush

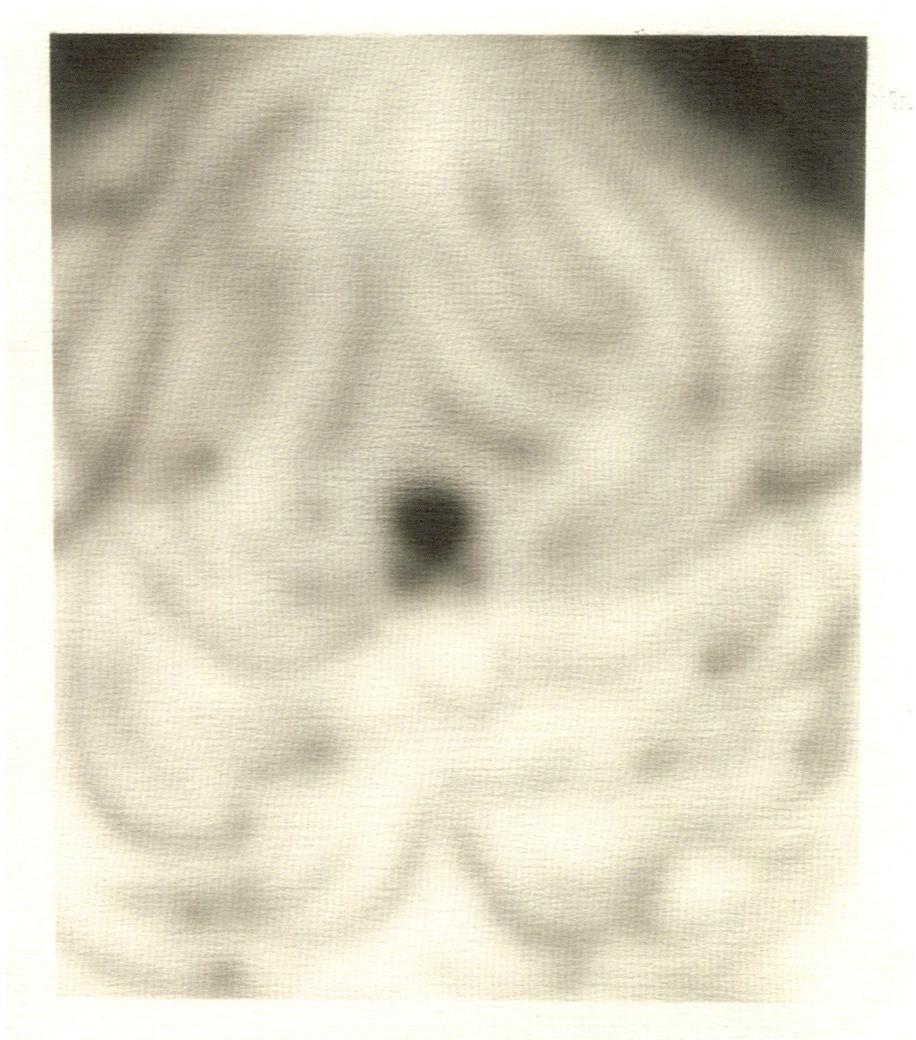

Portrait Of Dogs
148 x 210 mm, Airbrush

39

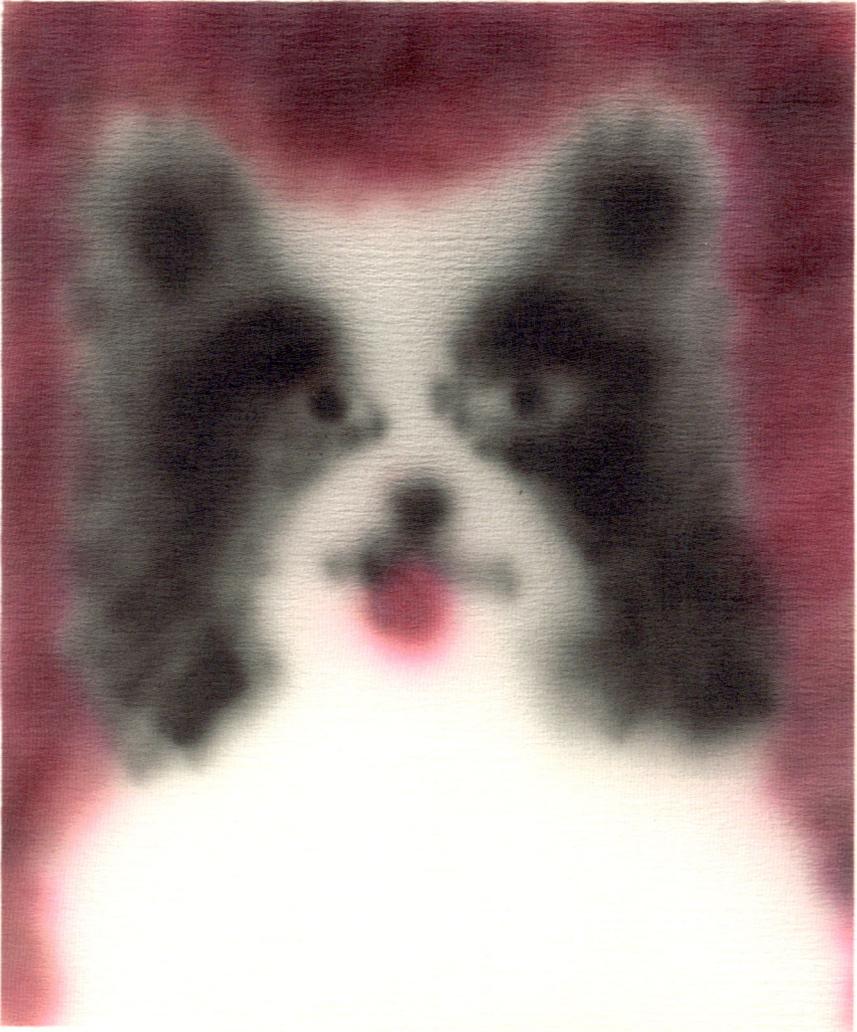

40

Portrait Of Dogs
148 x 210 mm, Airbrush

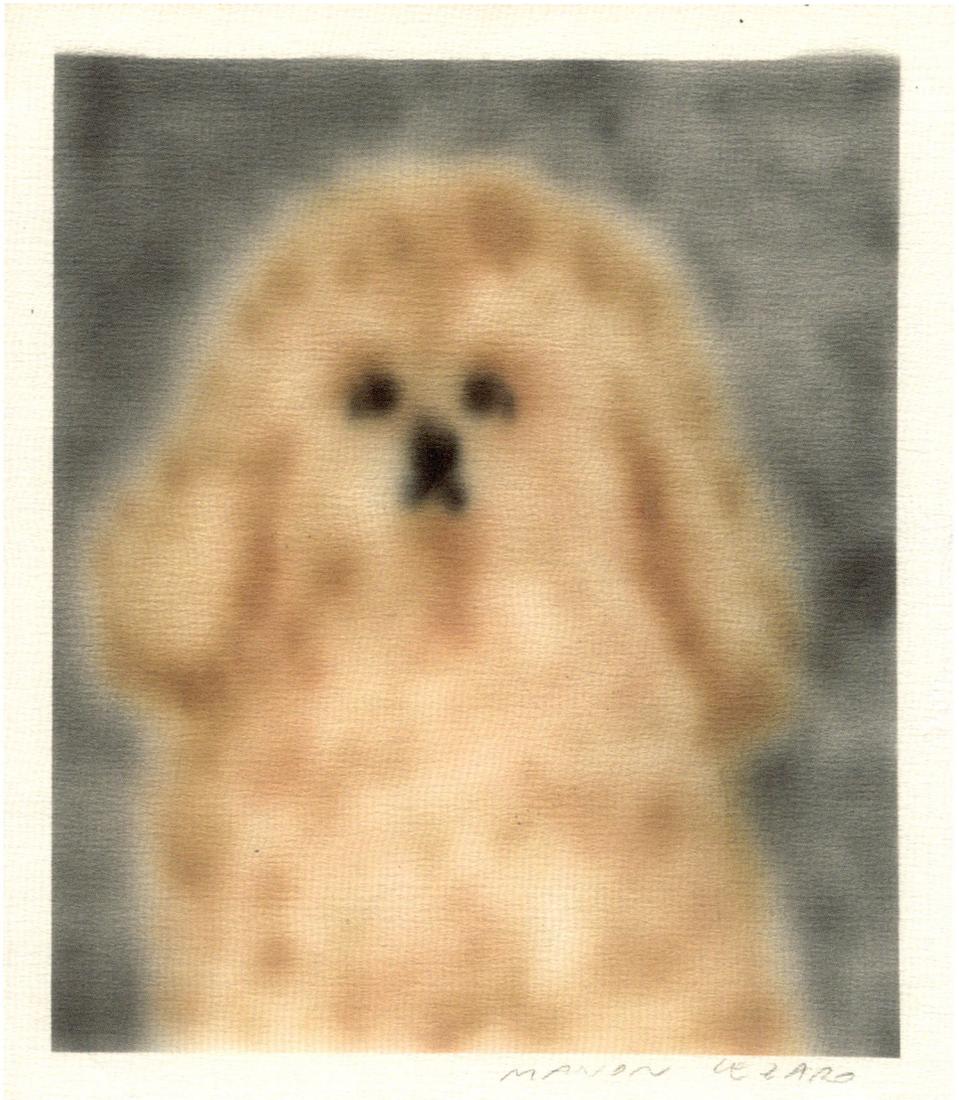

Portrait Of Dogs
148 x 210 mm, Airbrush

41

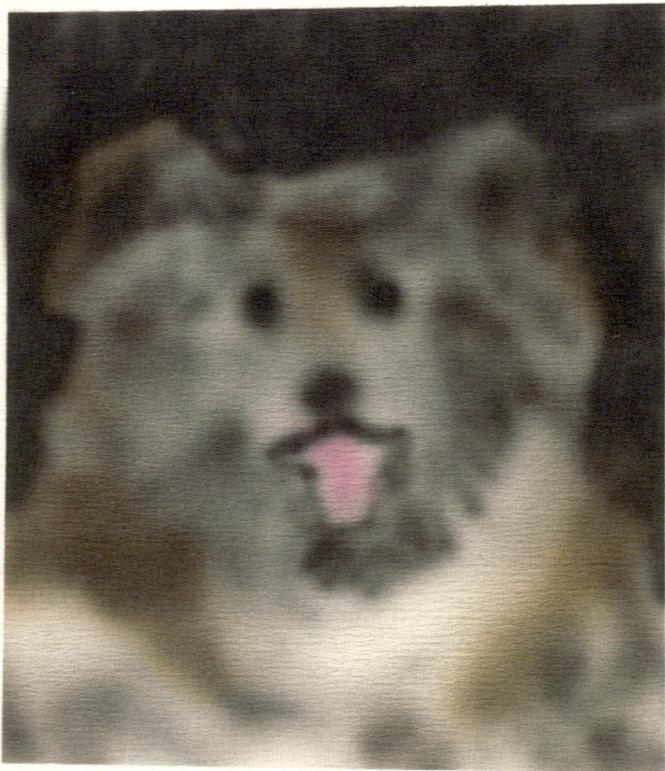

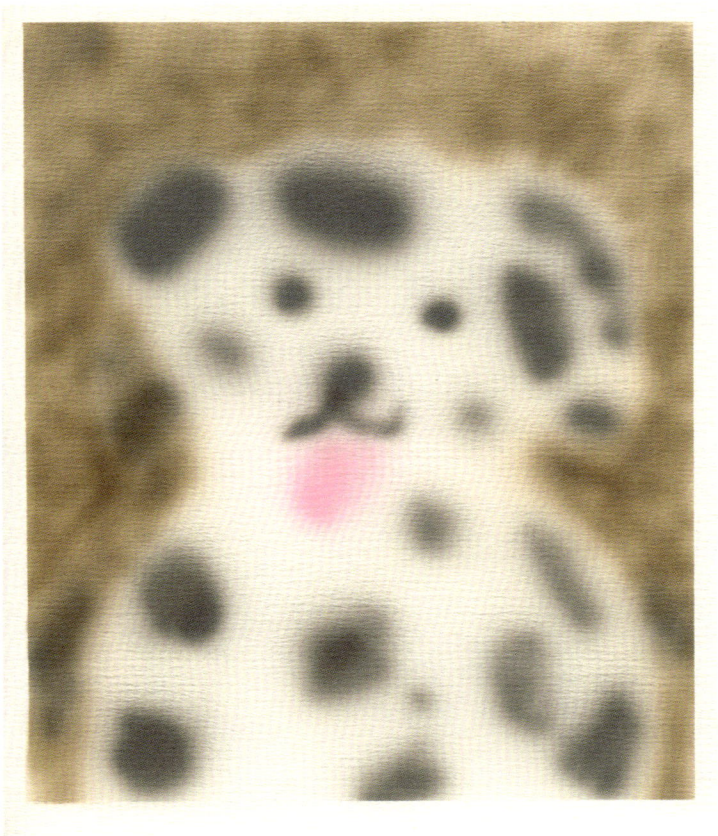

Portrait Of Dogs
148 x 210 mm, Airbrush

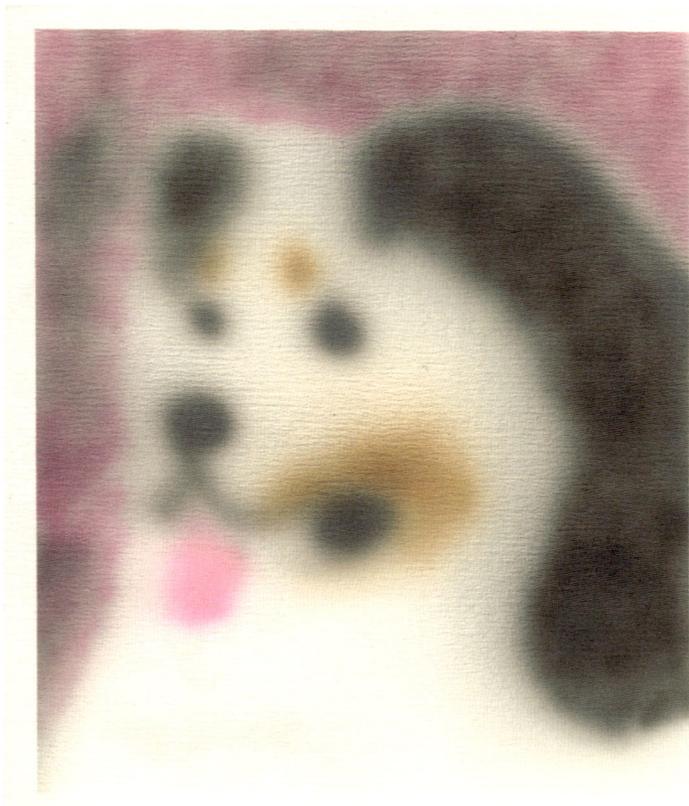

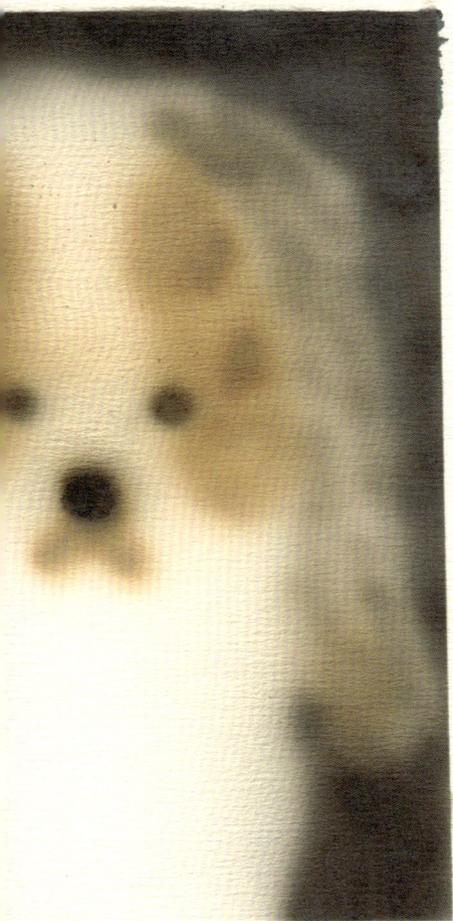

Catherine Rayner

catherinerayner.co.uk

Award-winning author and illustrator Catherine Rayner has had her children's books translated into 35 languages with over 1.6 million copies sold. Besides being adapted for TV, theatre, and musicals, her works have also been exhibited as large-scale paintings in UK galleries. She currently lives in Edinburgh with her family and pets, including a dachshund called Otto.

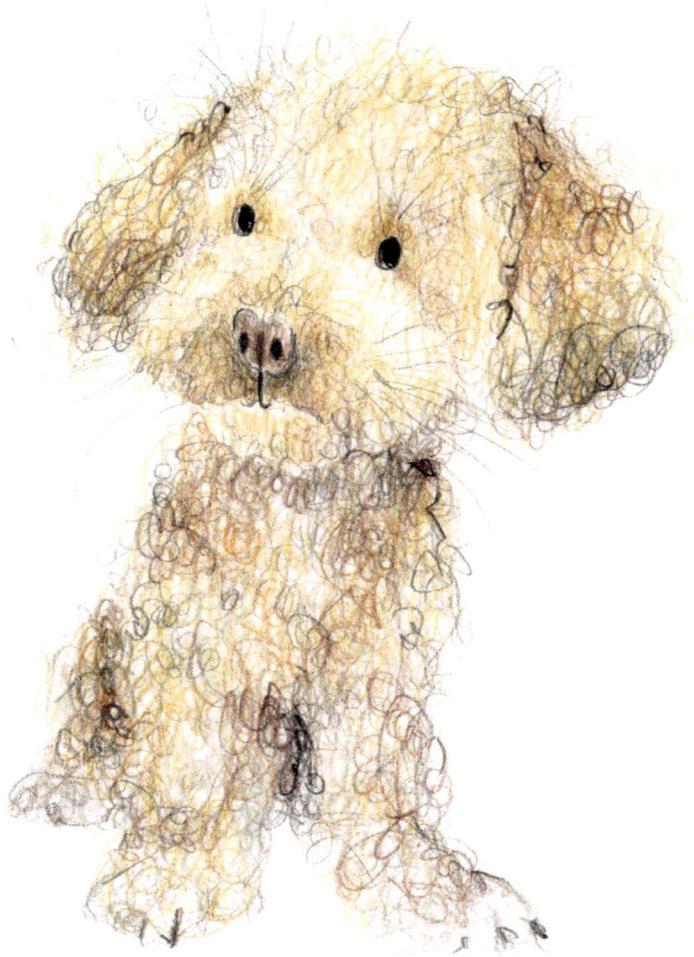

CocoBean
170 x 170 mm, Ink, Watercolour, Pencil

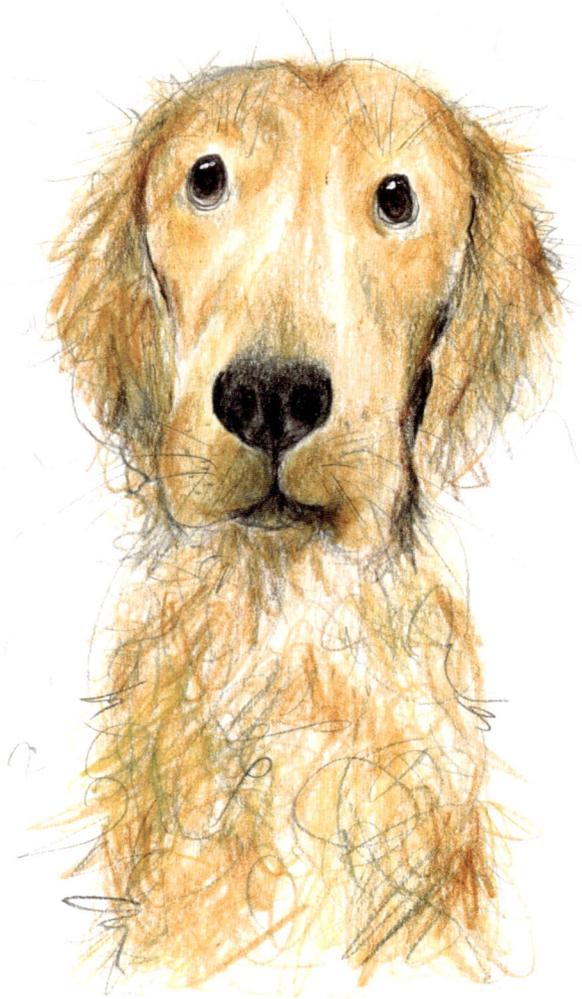

Gladys
170 x 180 mm, Ink, Watercolour, Pencil

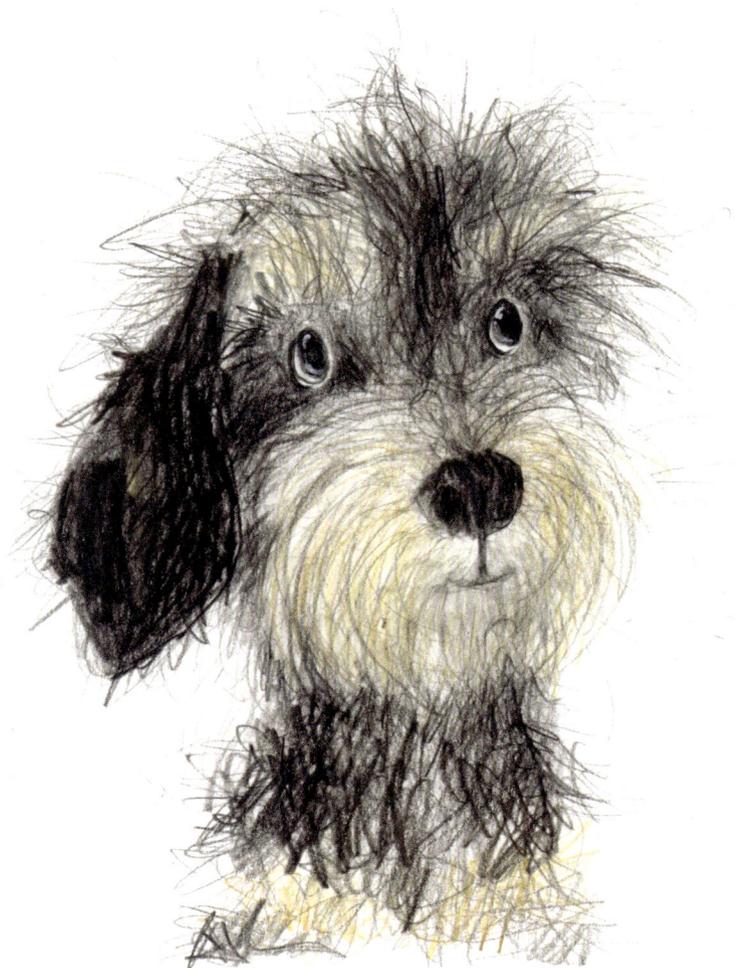

Lionel
190 x 190 mm, Ink, Watercolour, Pencil

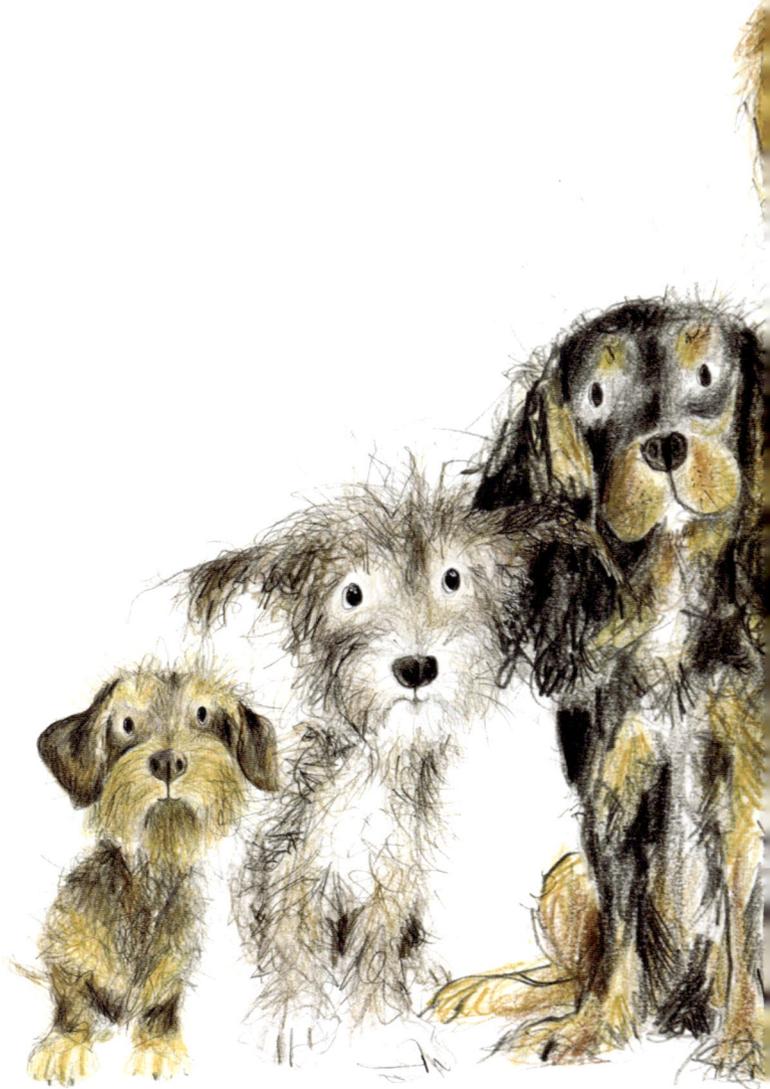

The Motley Crew
297 x 210 mm, Ink, Watercolour, Pencil

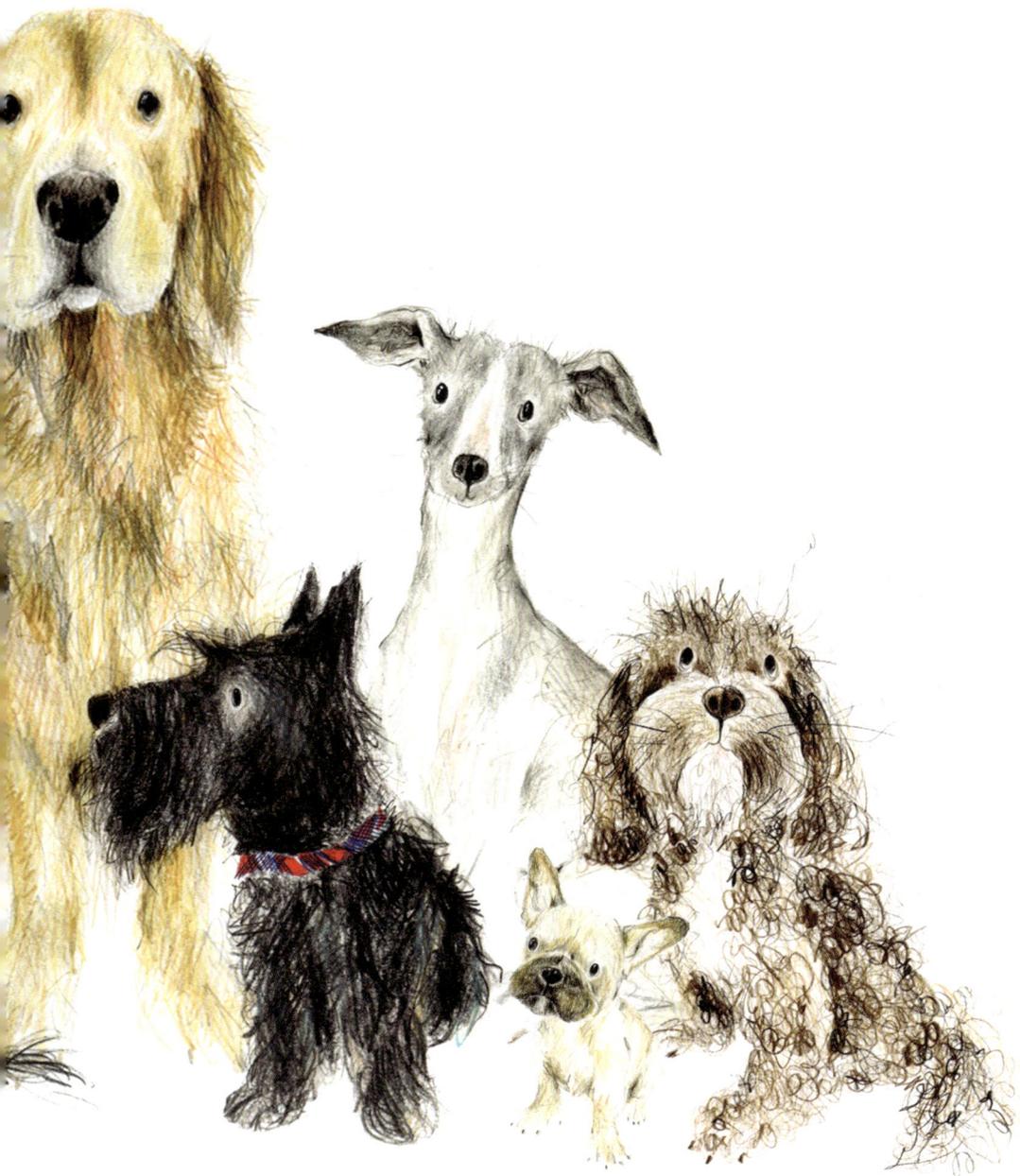

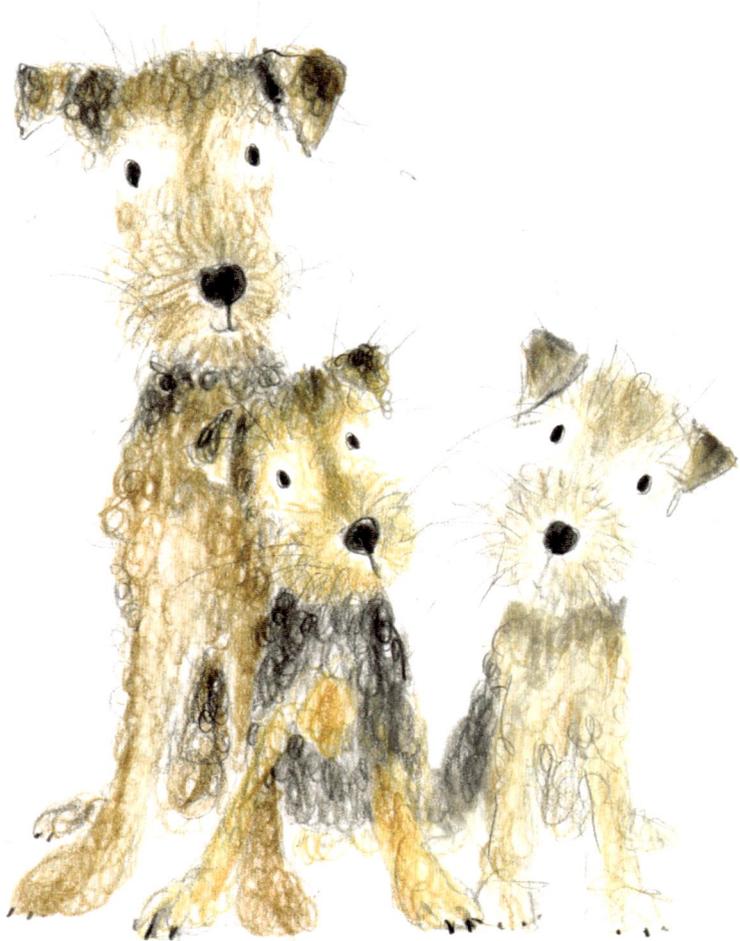

Charlie, Ted and Sybil
200 x 200 mm, Ink, Watercolour, Pencil

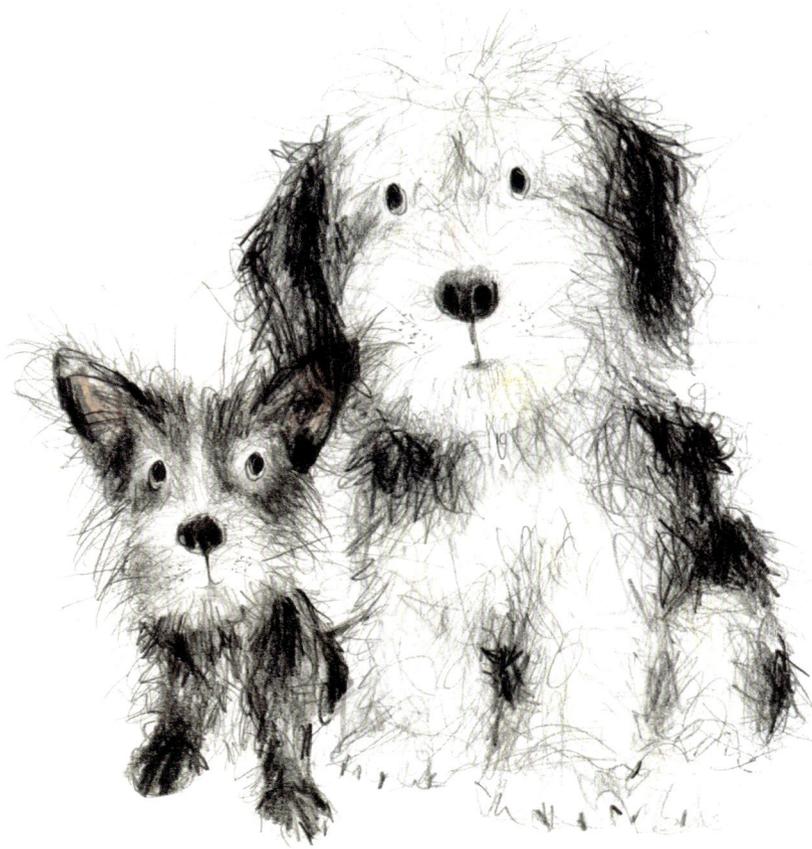

Rascal and Flo
200 x 180 mm, Ink, Watercolour, Pencil

Justin graduated in 2023 from the MA Children's Book Illustration course at Anglia Ruskin University, UK. His primary medium of choice is paint and he gets excited by the sometimes-unexpected results that fluid materials produce. He strives for simplicity in his image making, combining this with texture and energy through mark making. His playful style is influenced by his 30-year experience in toy design and a love of creating animal characters.

@justin.worsley

Justin Worsley

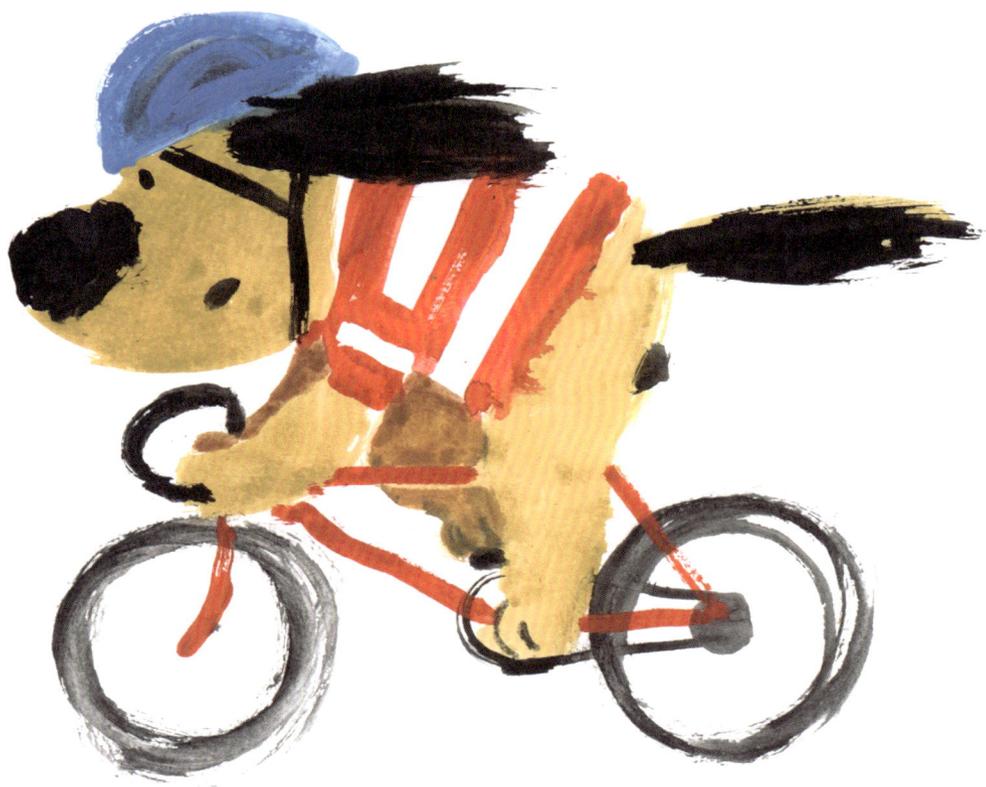

Speed
297 x 215 mm, Gouache

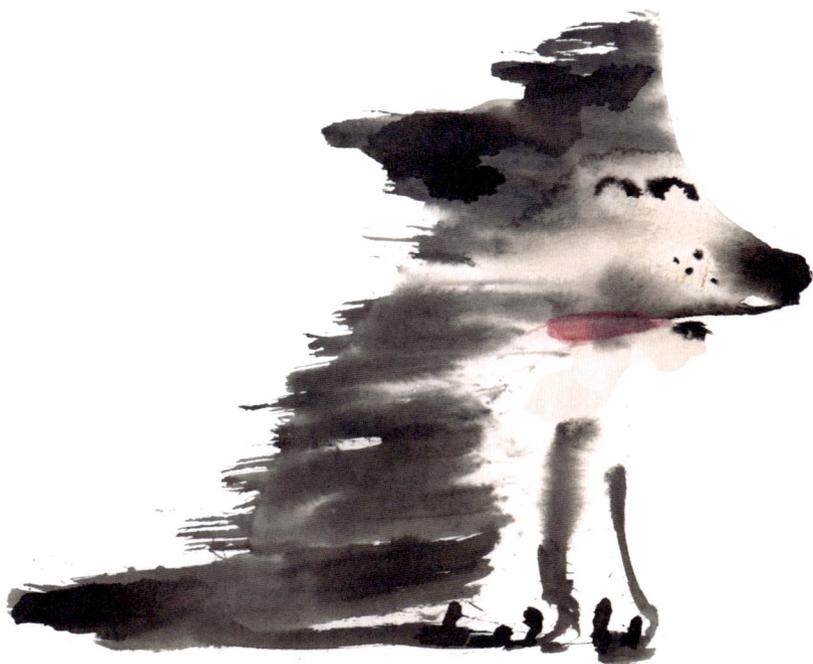

Dog in the Wind
411 x 287 mm, Gouache

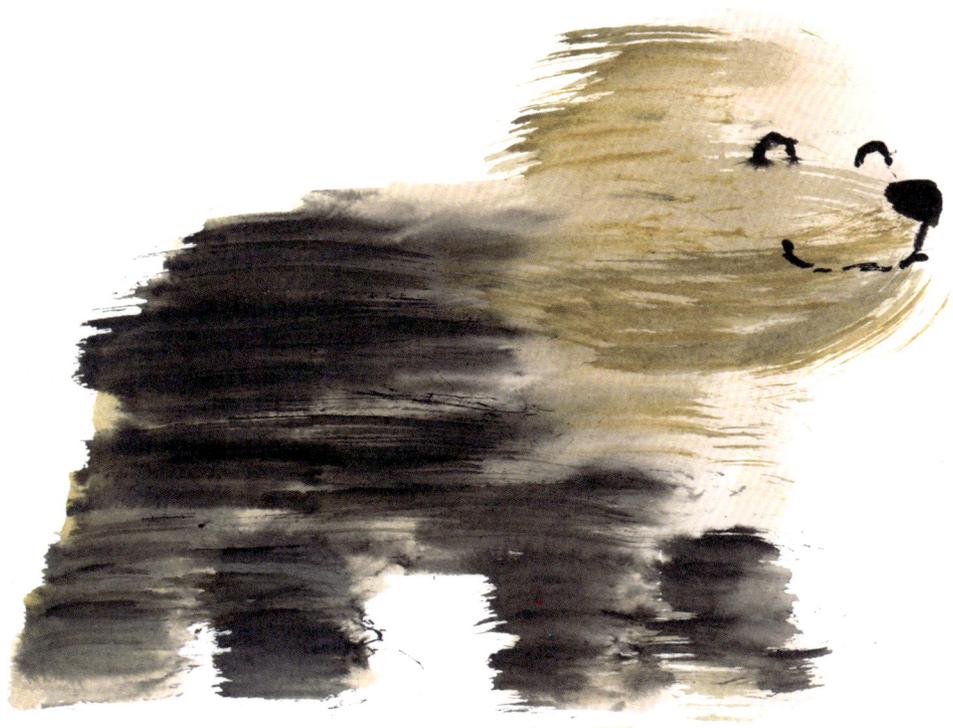

Dog in the Wind
354 x 506 mm, Gouache

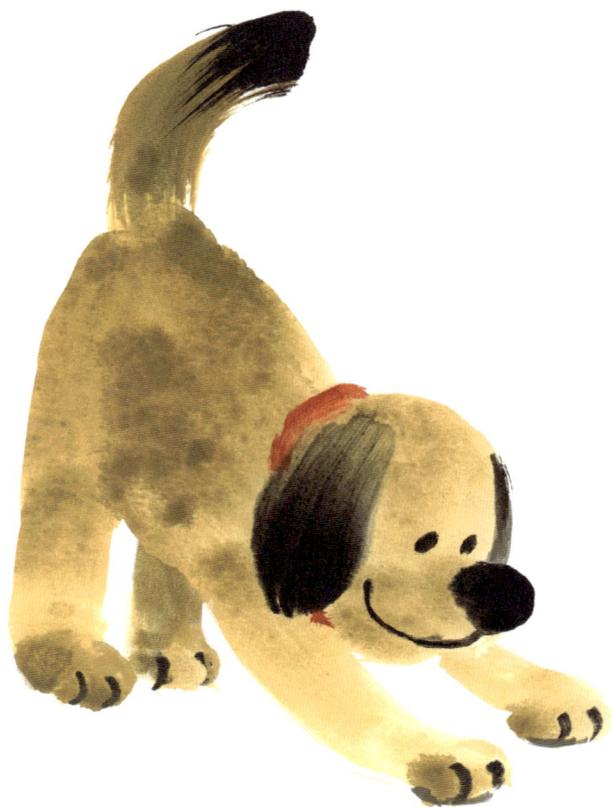

Henry and the Hedgehog
318 x 318 mm, Gouache

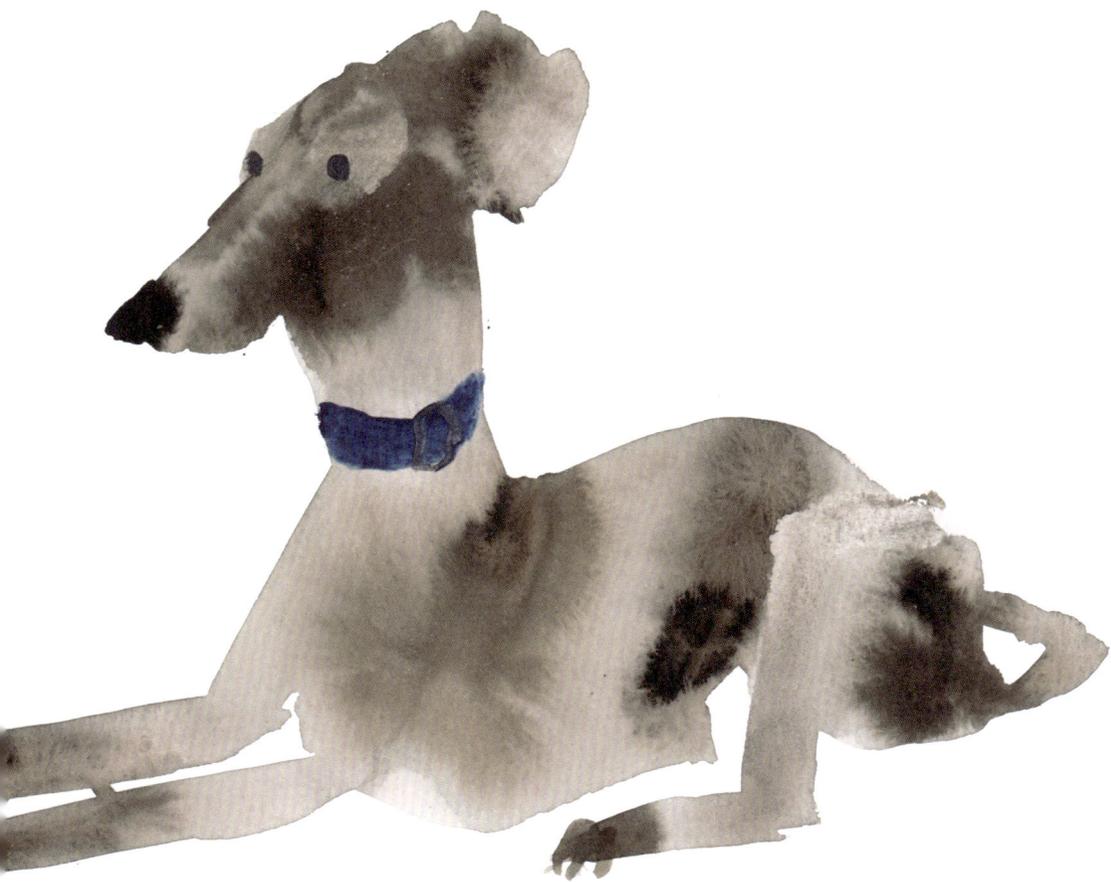

Greyhound Lying Down
236 x 340 mm, Watercolour

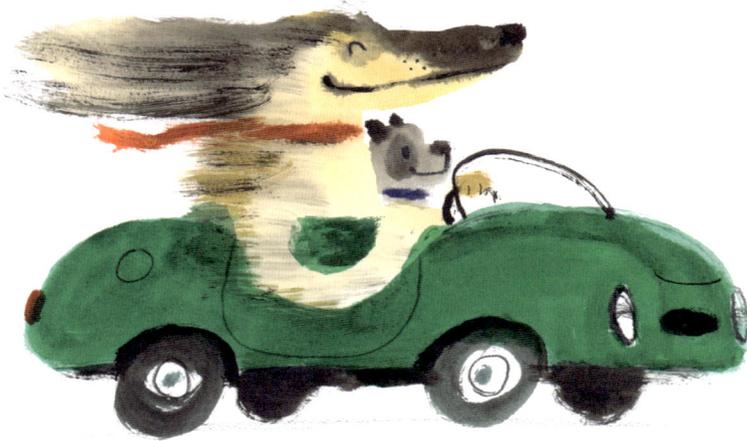

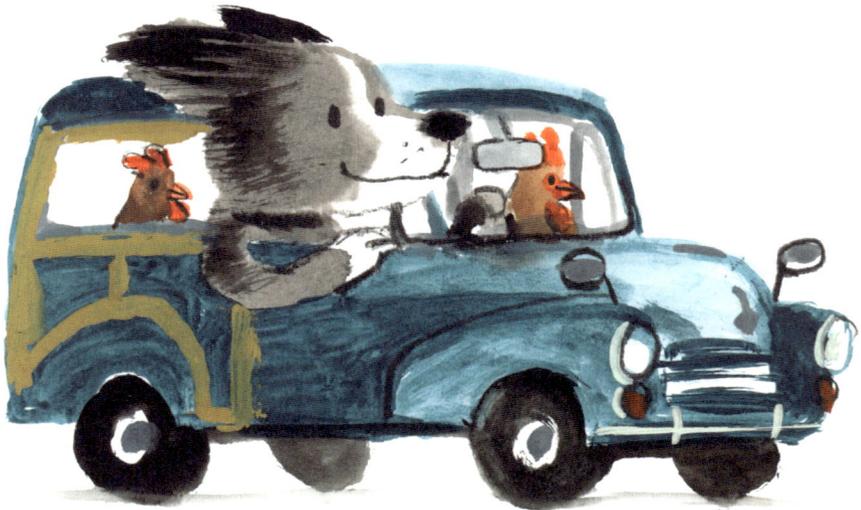

Morris and His Chicken Pals Go for a Drive (↑)
273 x 273 mm, Gouache, Pencil Crayons

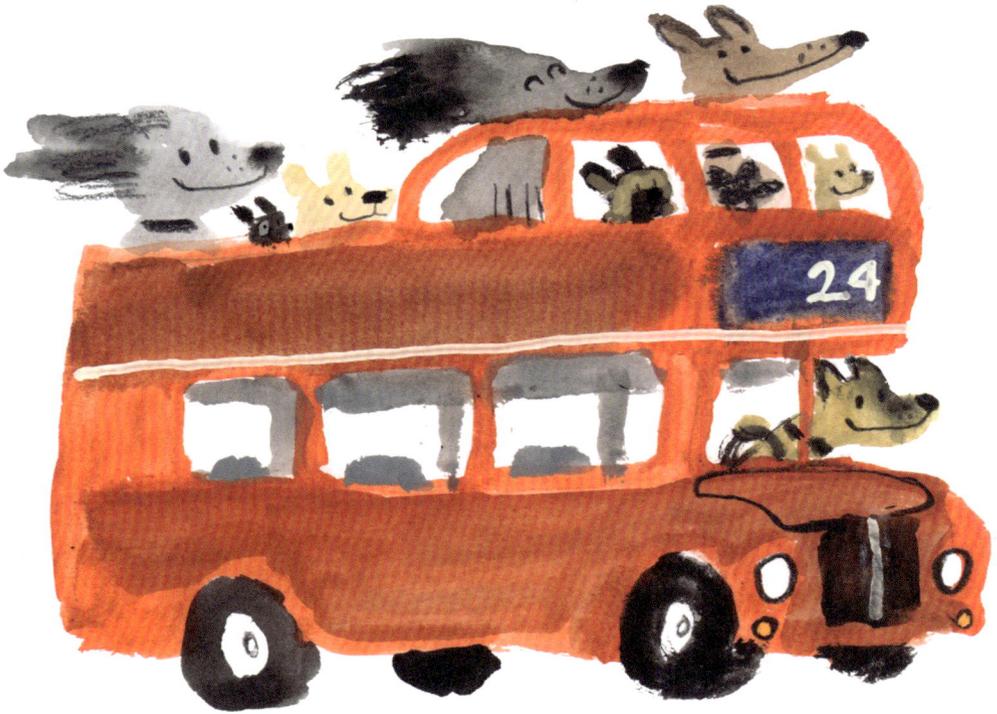

Doggy Bus Tour
230 x 230 mm, Gouache

Monika Forsberg is a freelance illustrator and designer based in London, known for her technicolour cut-out style. Her recent clients include Penguin Random House, Free Spirit Fabrics, Magic Cat Books, and Liberty London.

Monika Forsberg

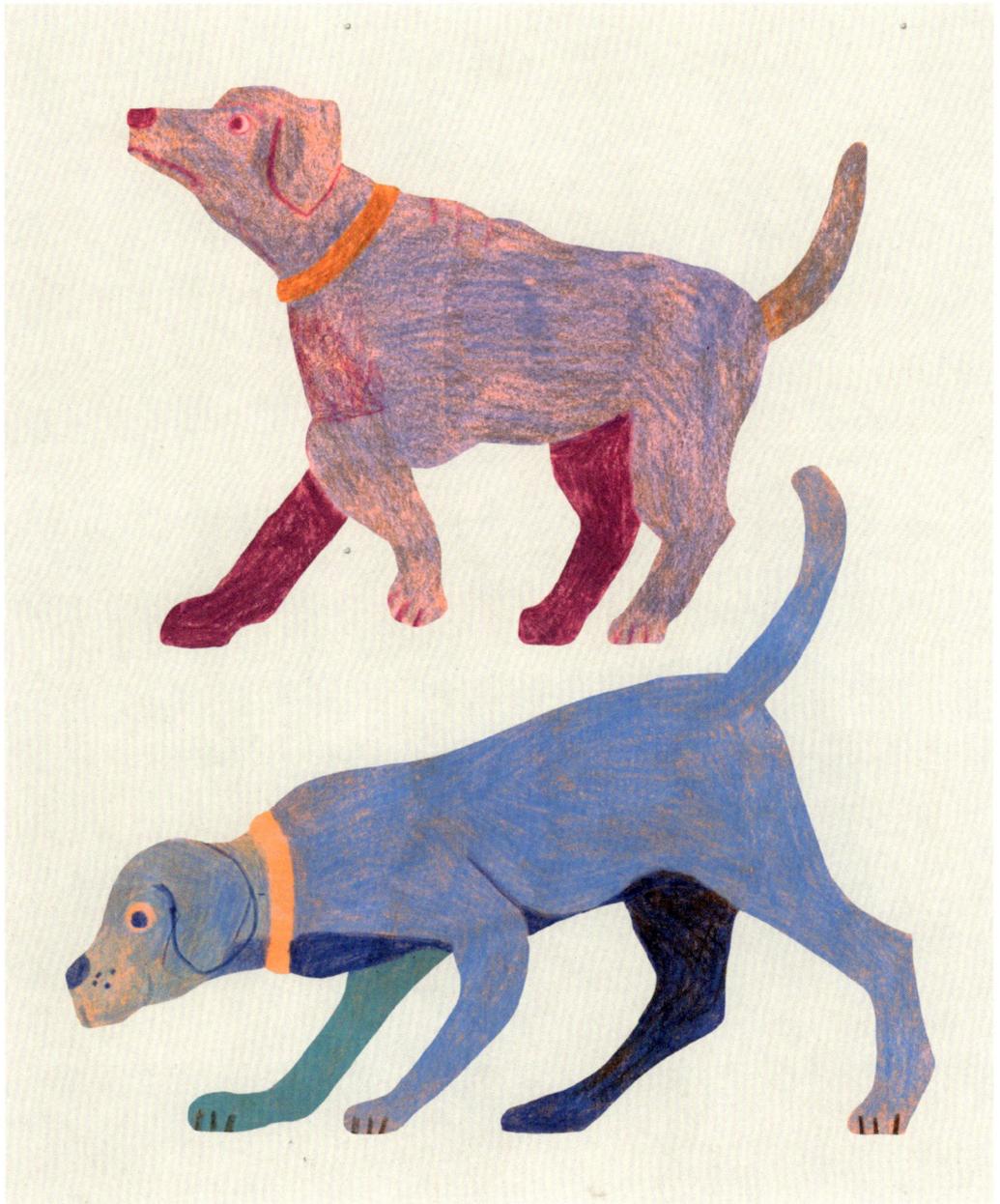

Dogs
210 x 297 mm, Gouache

63

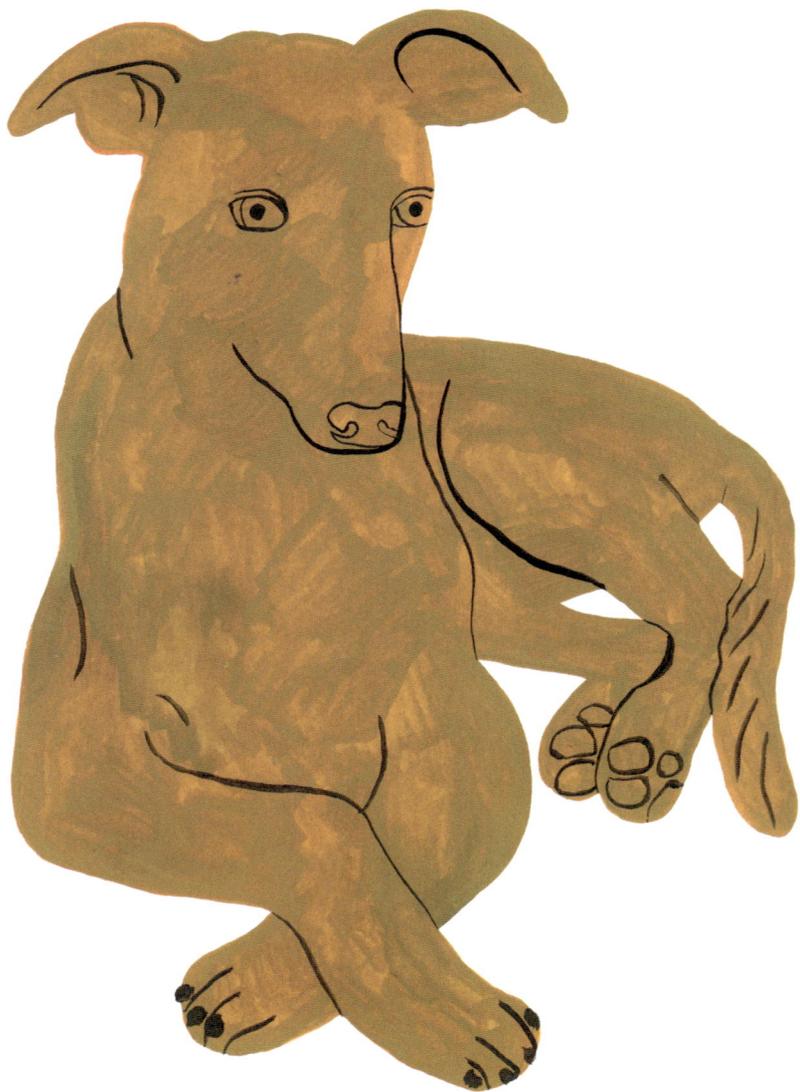

Dog 25
210 x 297 mm, Gouache

Dog 2 (→)
210 x 297 mm, Gouache, Paper

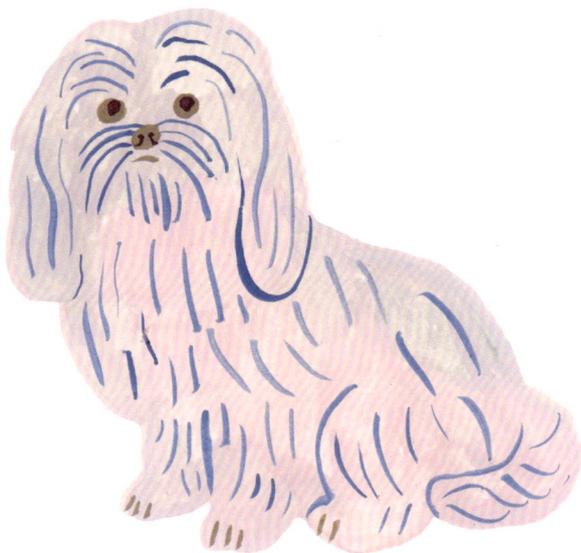

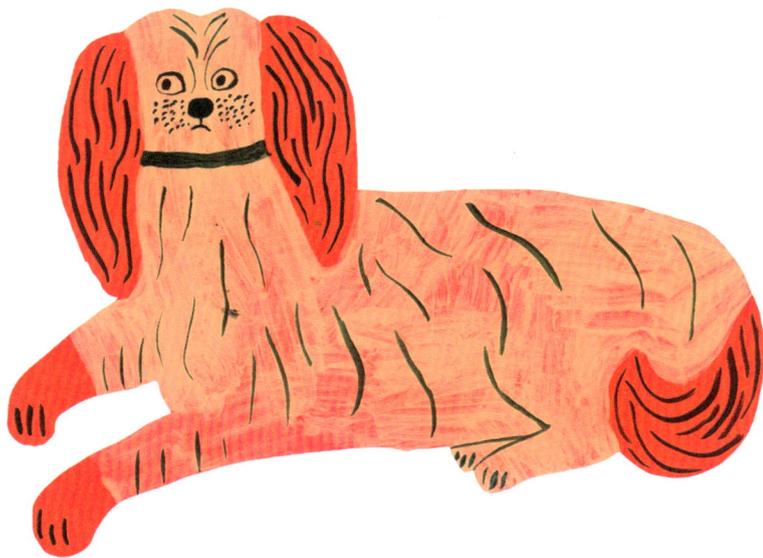

Dog 7 (↑)
210 x 297 mm, Gouache

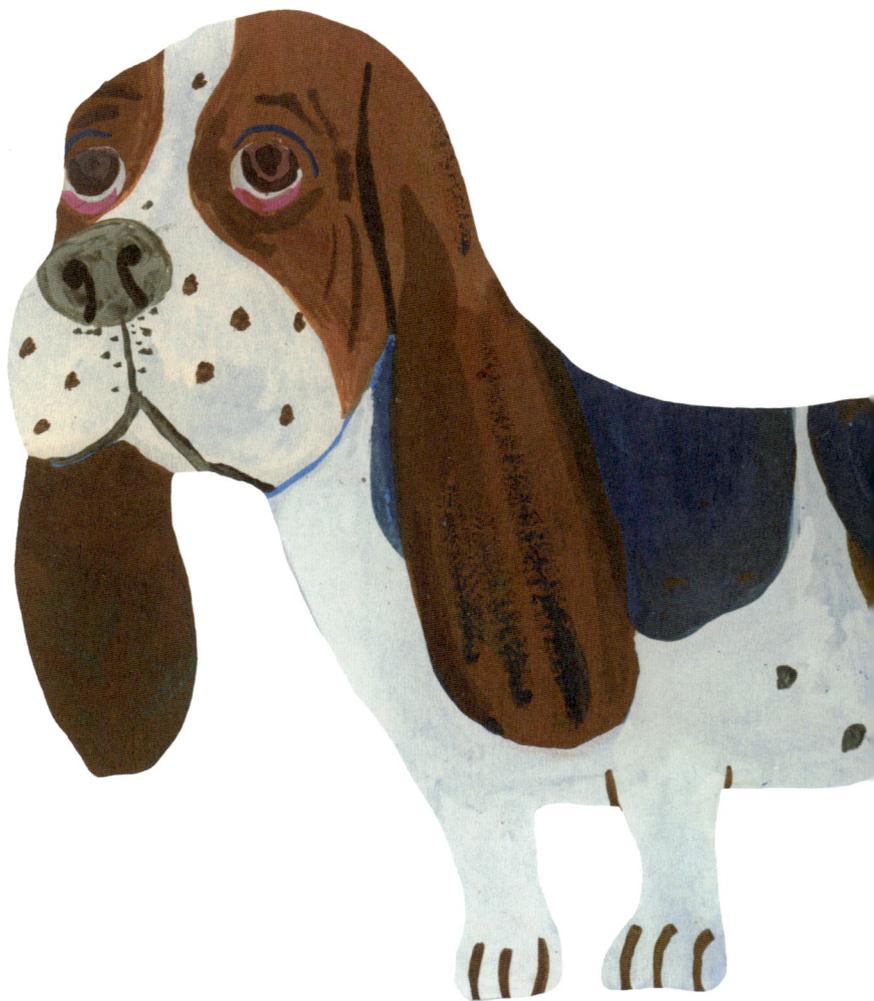

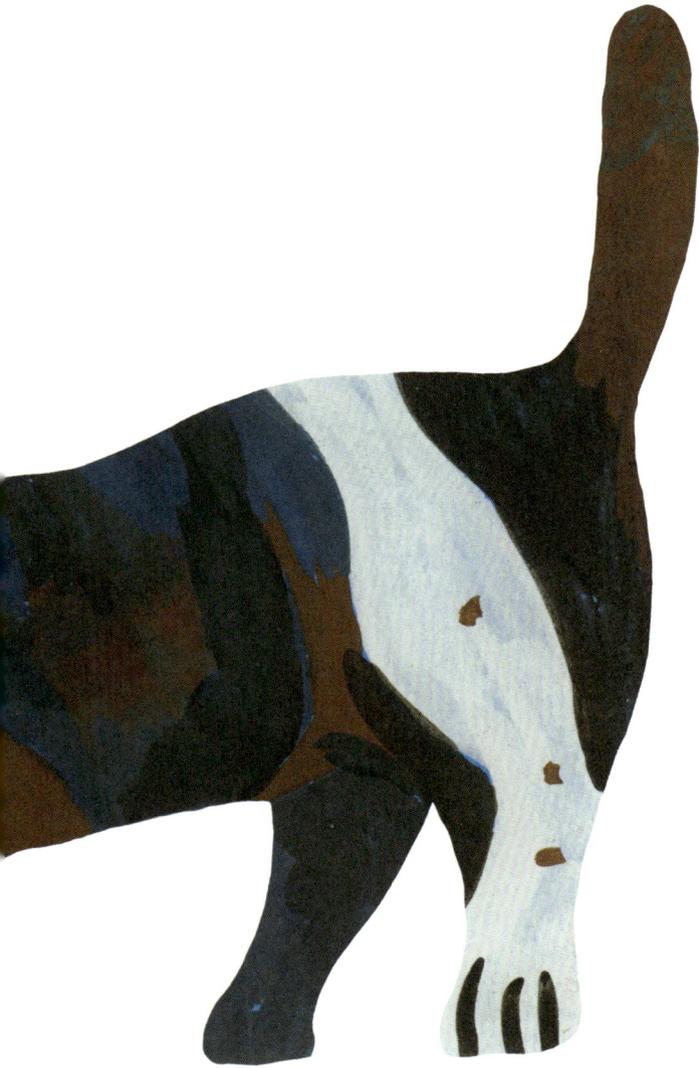

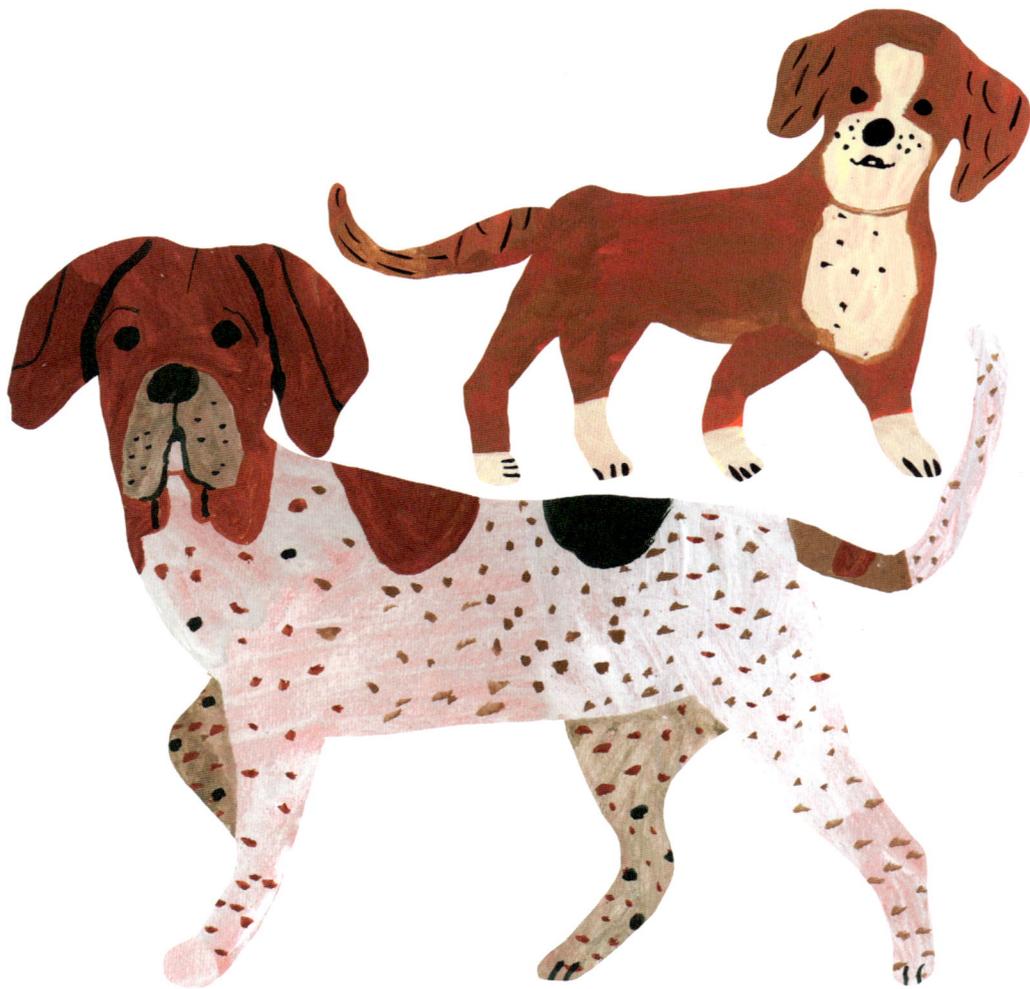

Dogs 21
210 x 297 mm, Gouache, Paper

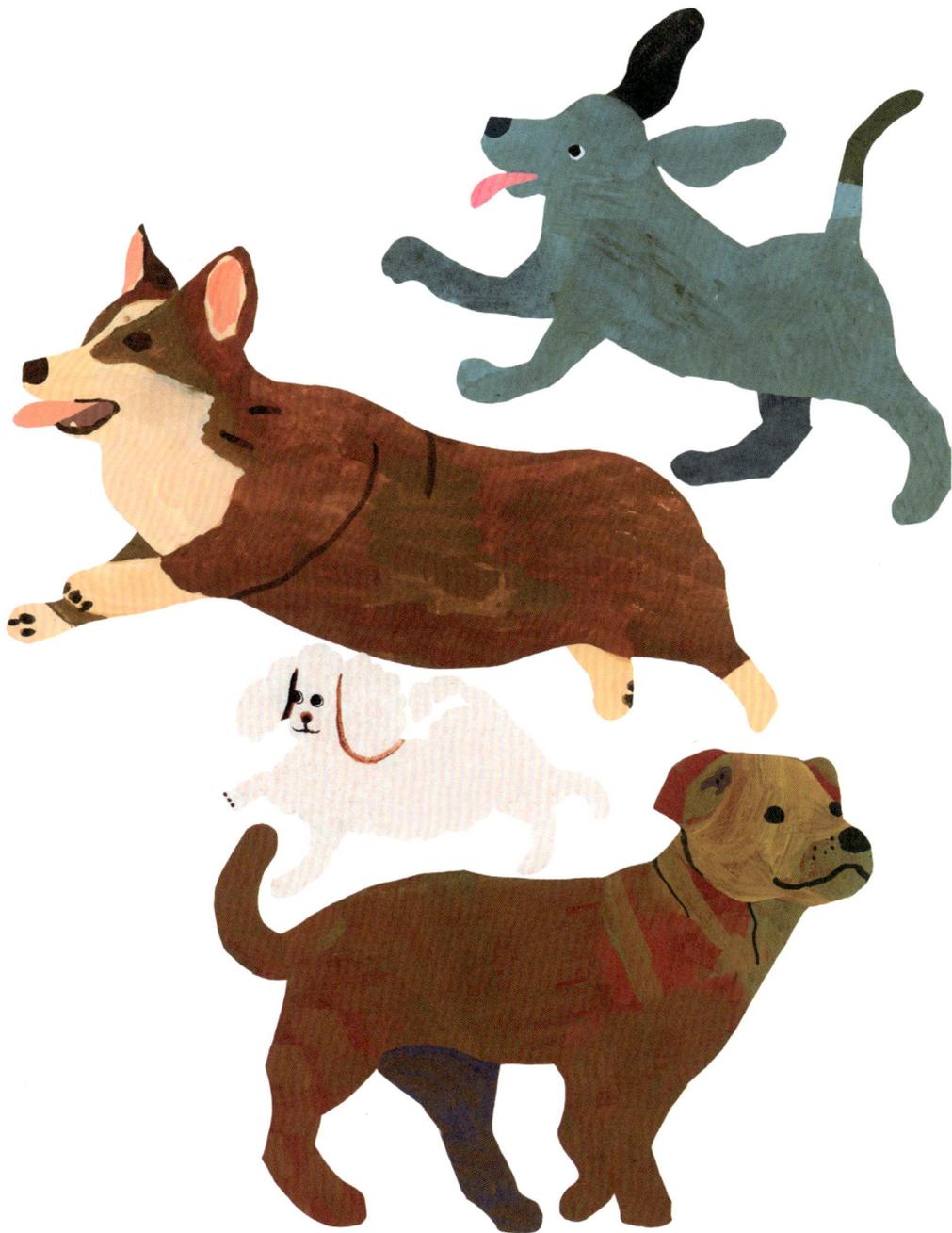

Dogs 20
210 x 297 mm, Gouache, Paper

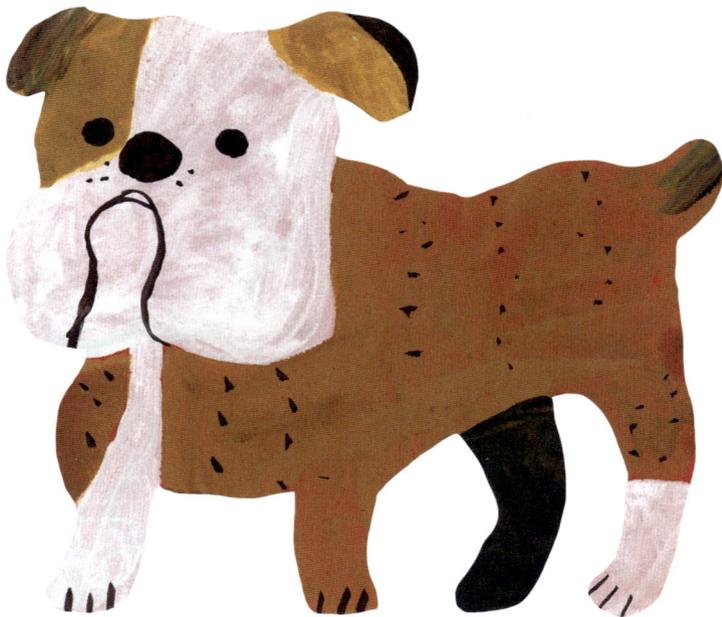

Dog 19
210 x 297 mm, Gouache, Paper

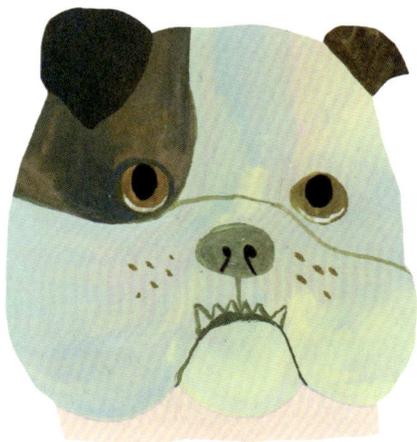
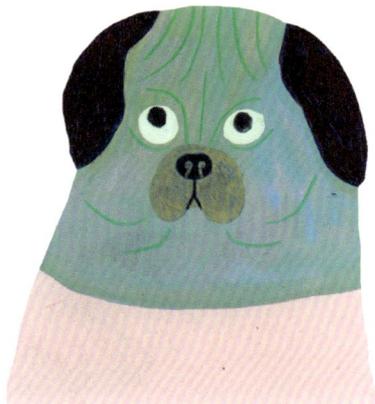
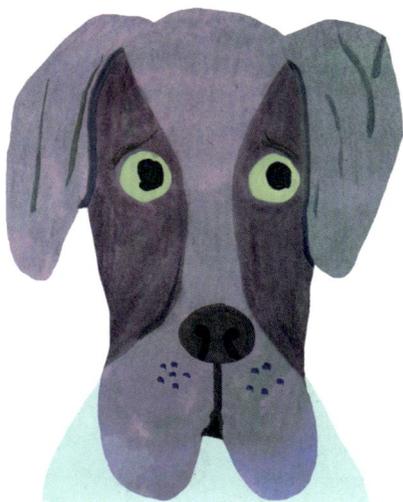
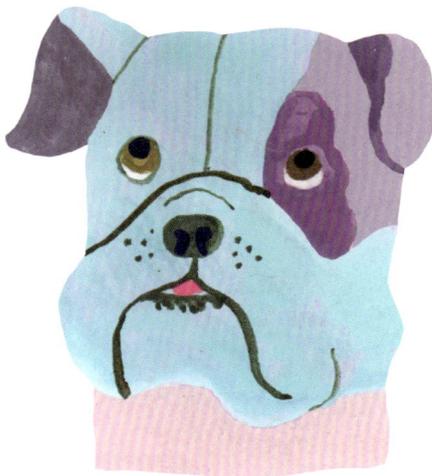

Line Up
210 x 297 mm, Gouache

71

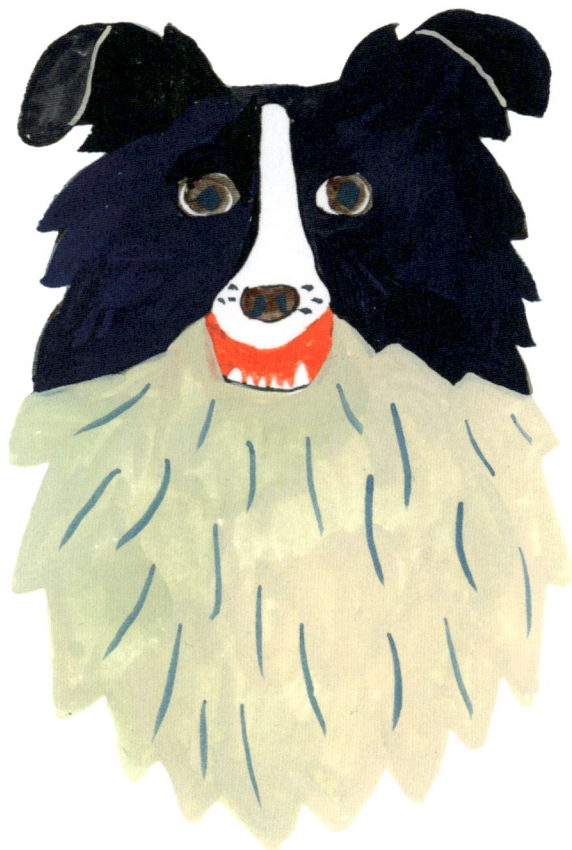

Dog 3
210 x 297 mm, Gouache, Paper

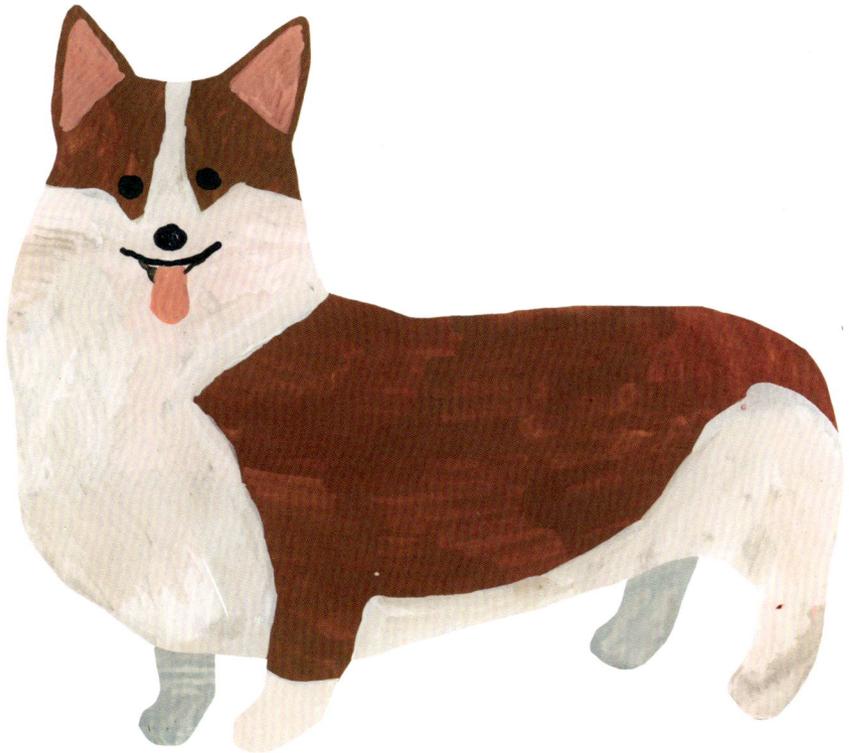

Dog 22
210 x 297 mm, Gouache, Paper

jeanjullien.com

Jean

Jullien

Jean Jullien is a Paris-based artist who graduated from Central Saint Martins and the Royal College of Art, working mainly in painting, illustration, and installation. He has collaborated with notable brands and hosted exhibitions worldwide, and his first retrospective monograph was published in 2022. He recently presented a solo exhibition at MIMA in Brussels and participated in the NGV Triennial in Melbourne.

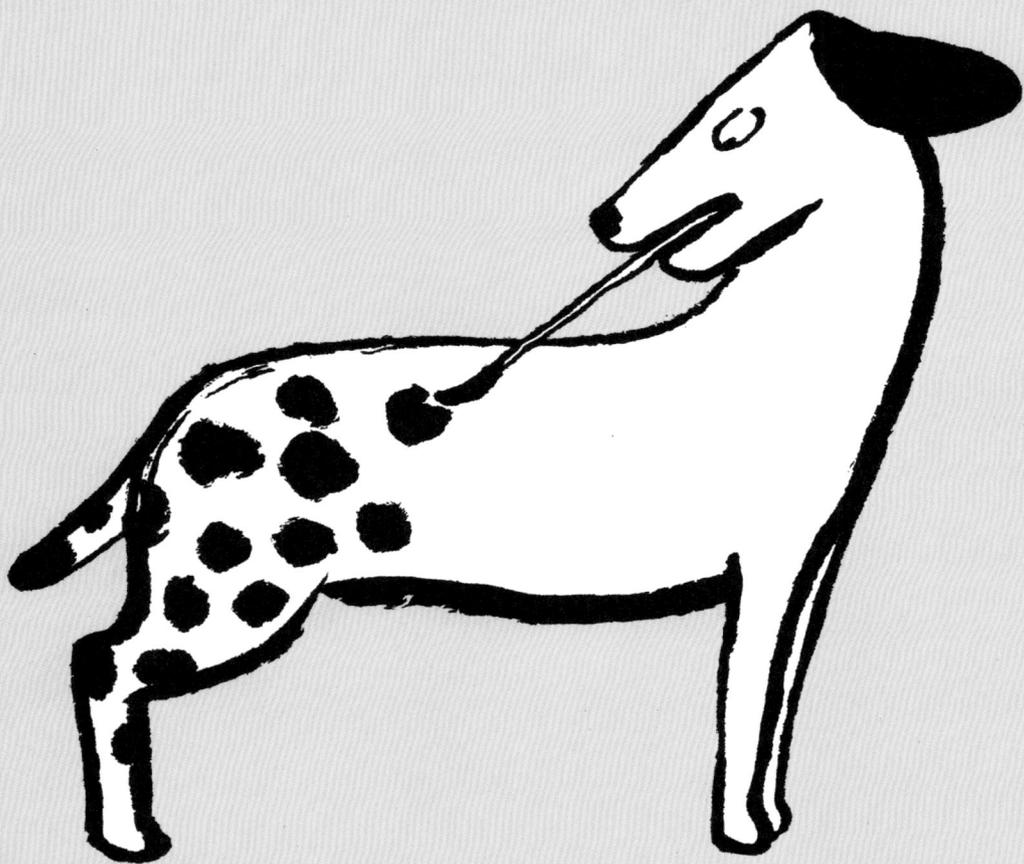

Spots
420 x 594 mm, Brush Pen, Paper, Digital

75

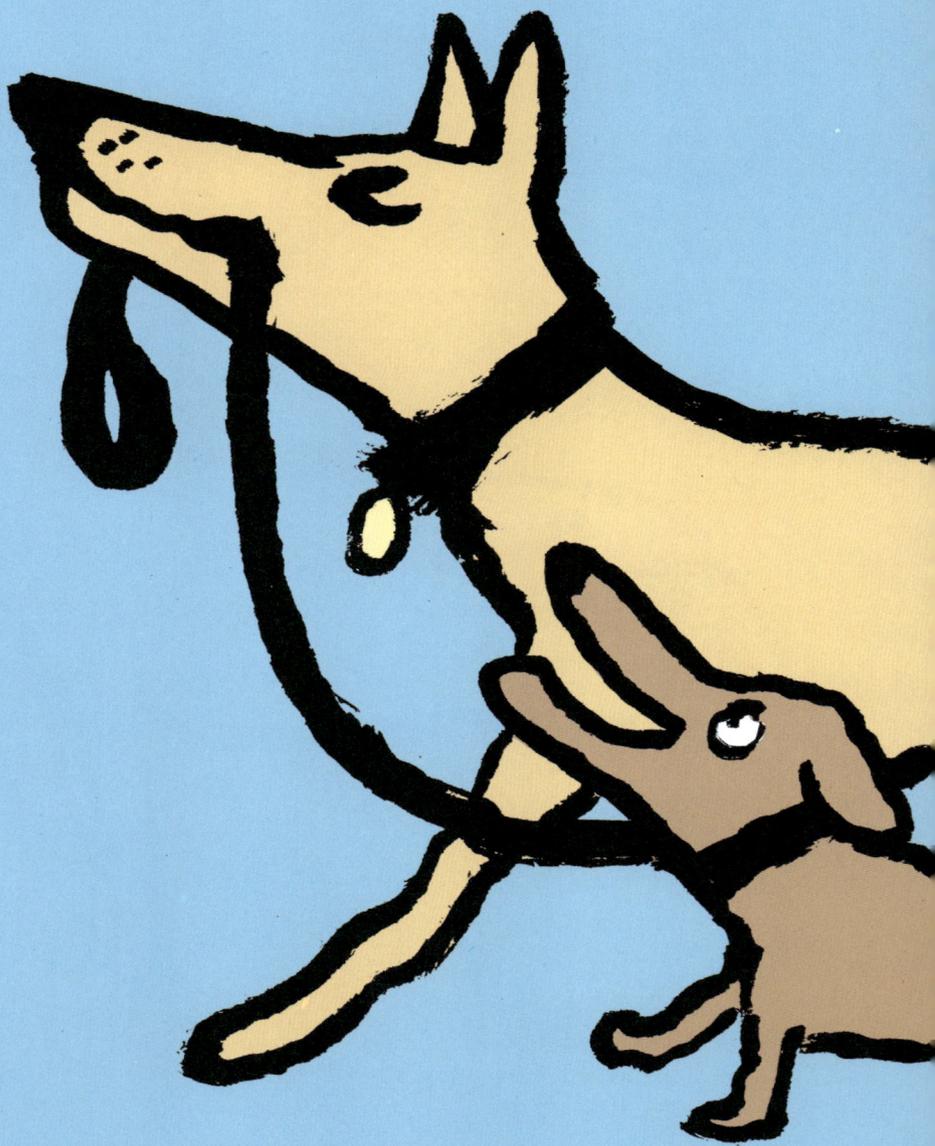

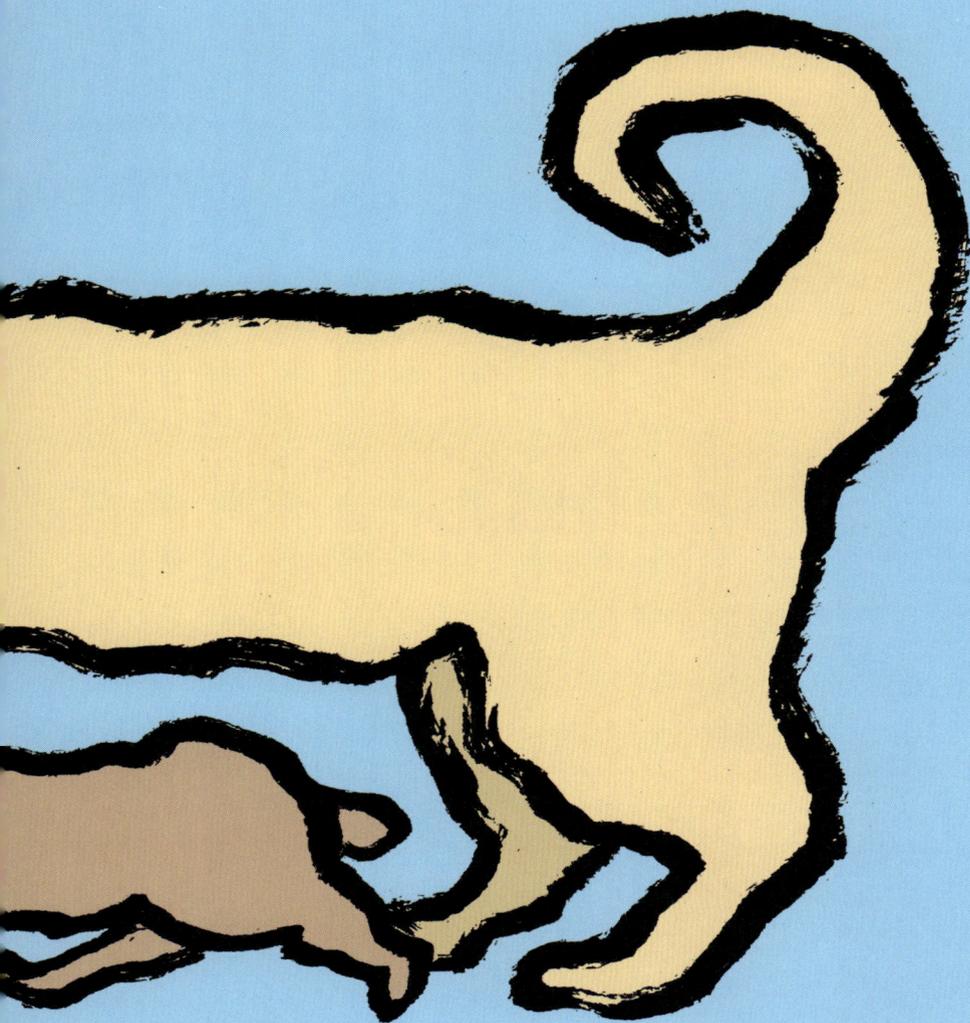

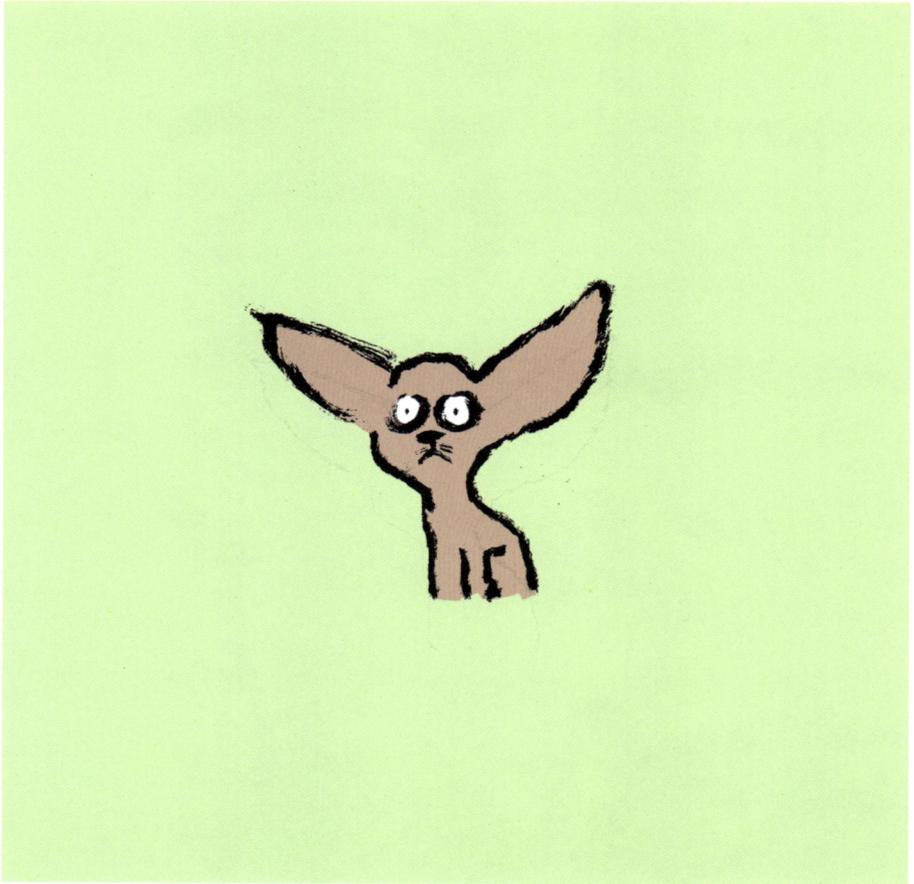

Youness Amrani
793.58 x 793.58 mm, Brush Pen, Paper, Digital

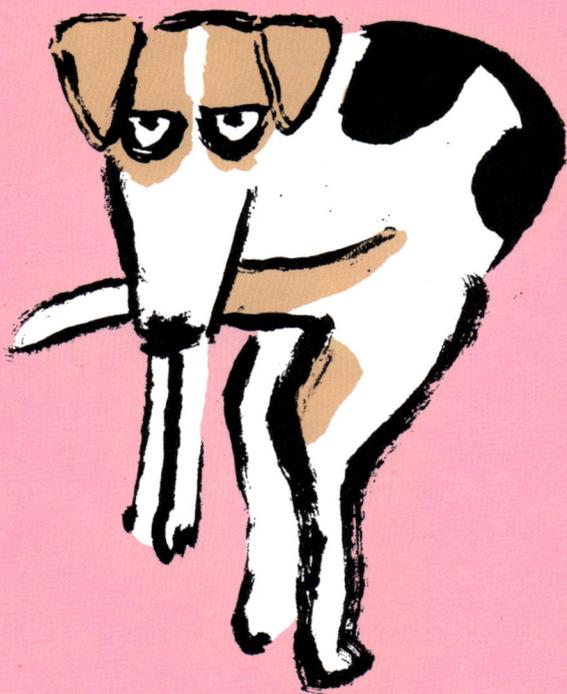

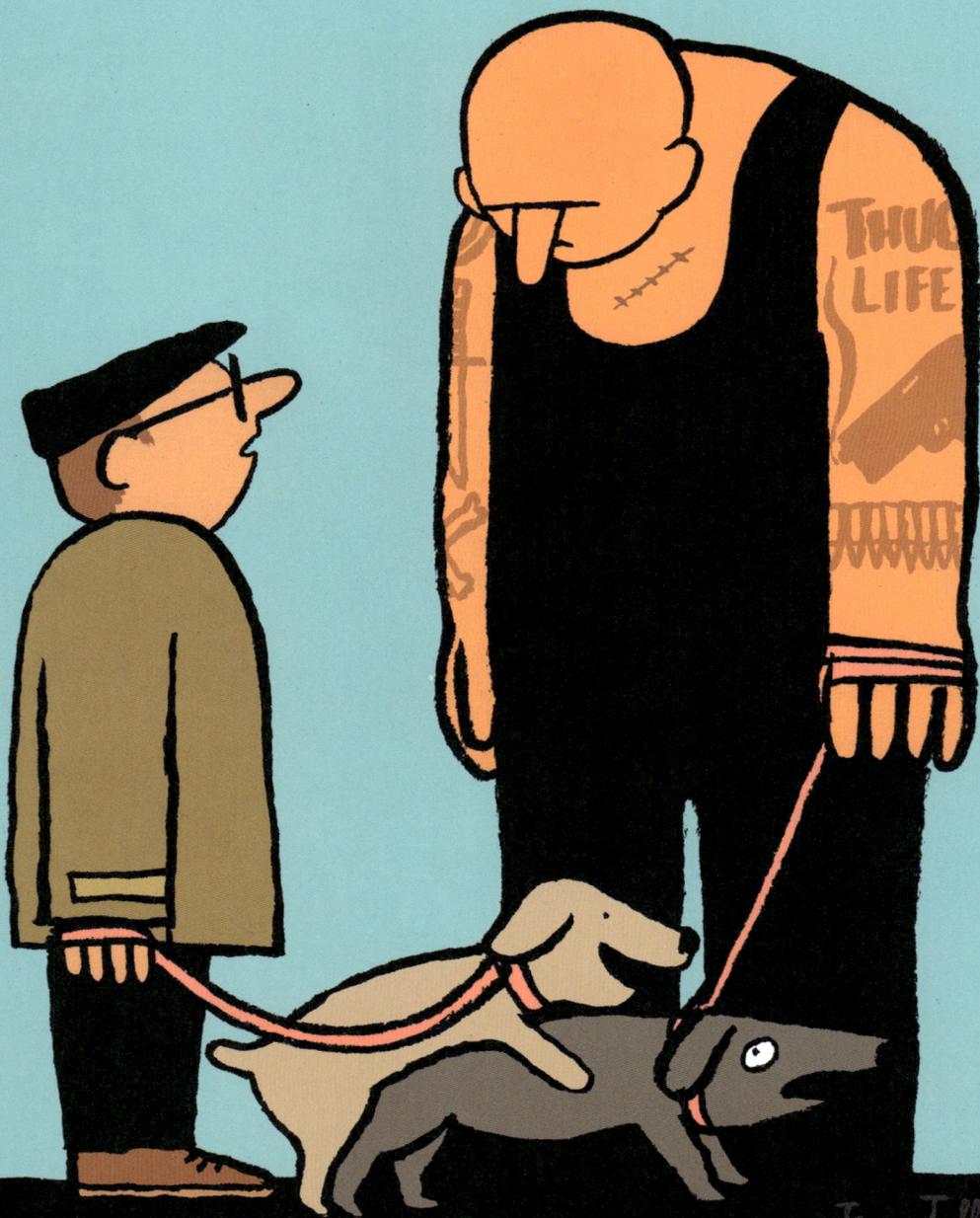

Jean Jullien

Dog Owners
594 x 841 mm, Brush Pen, Paper, Digital

Rade Tepavčević is a visual artist who completed his BA and MA at the Academy of Arts in Novi Sad, and his artistic research contains both traditional and digital mediums. He has received several awards for his work in the field of fine and applied arts. He is a teaching assistant in the drawing department at his alma mater.

@radetepavcevic

Rade Tepav-čević

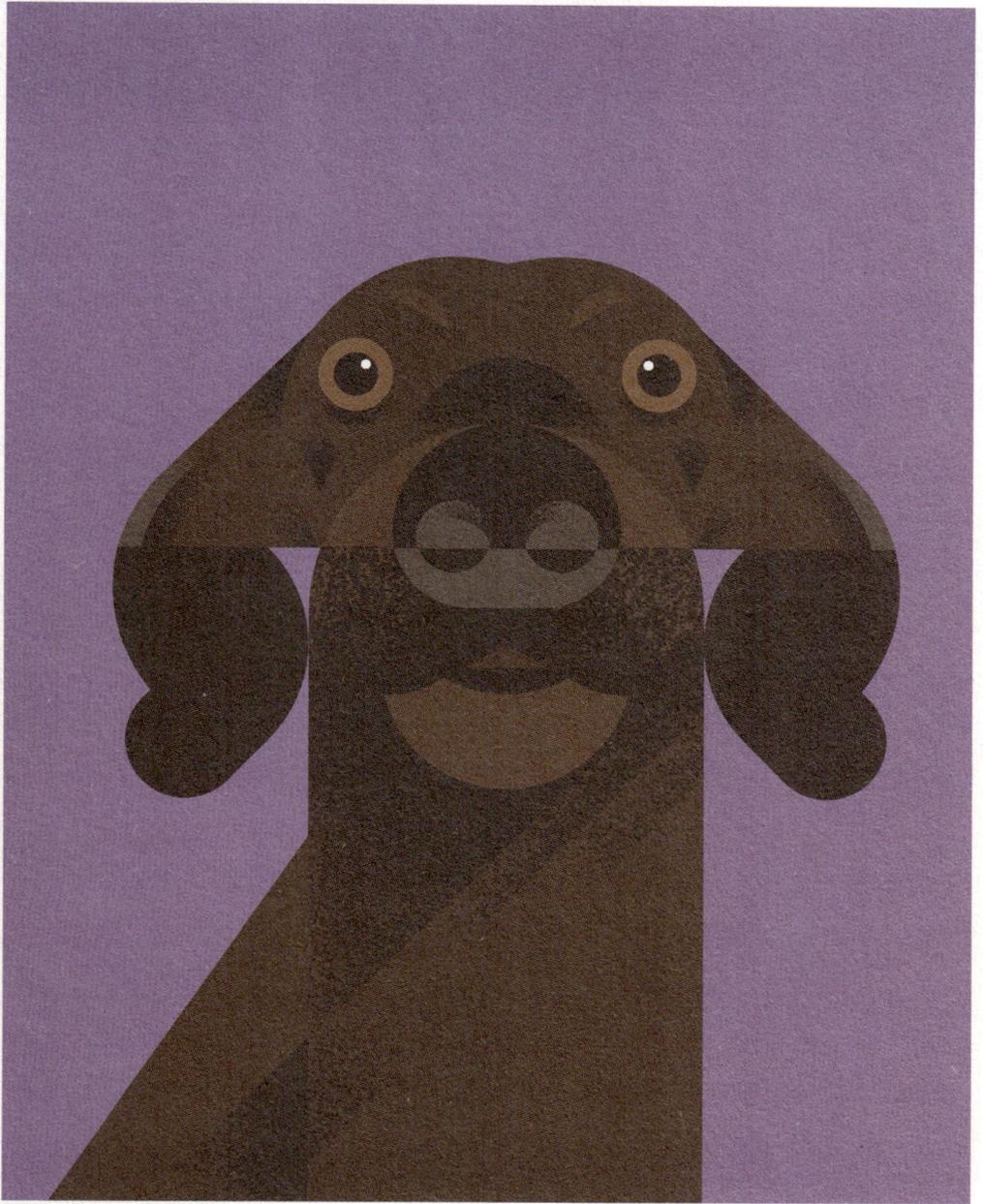

Dachshund
300 x 380 mm, Digital

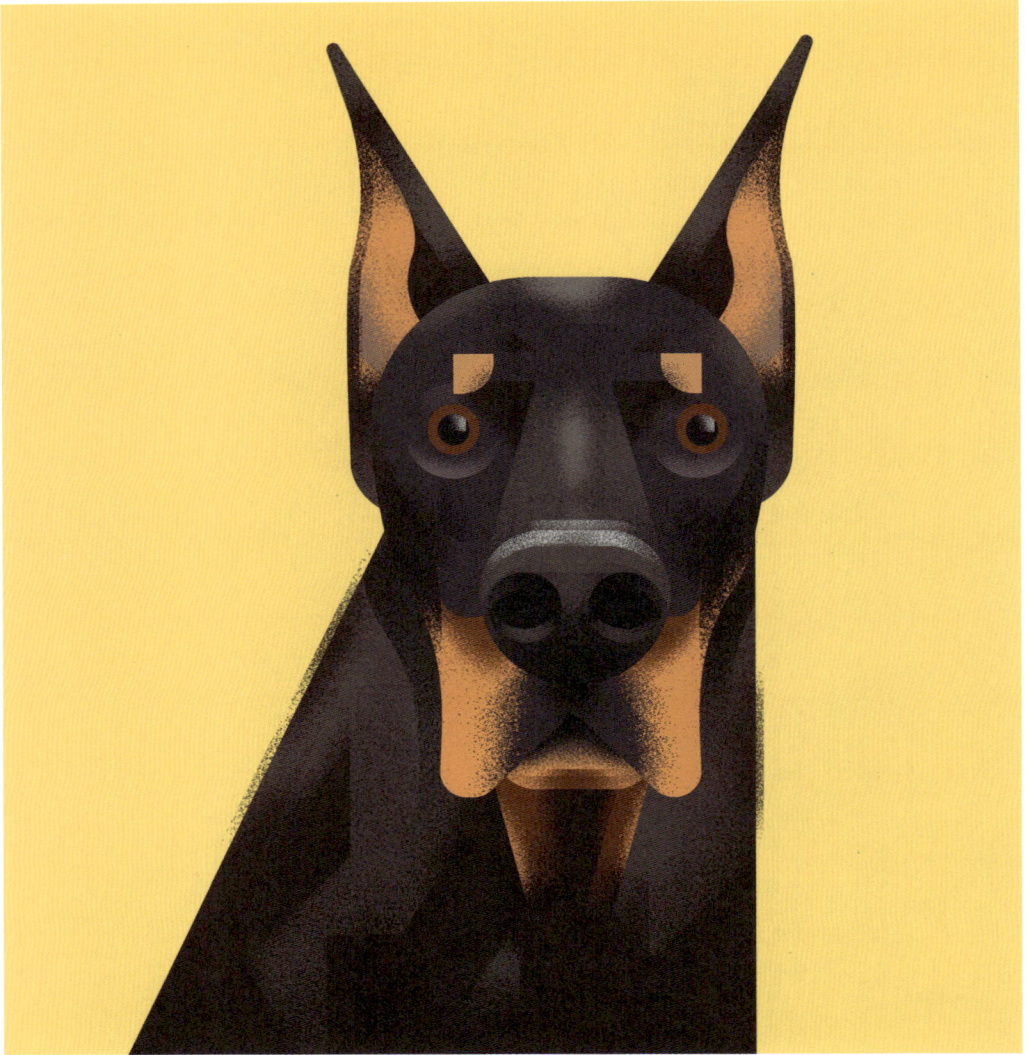

Doberman
504 x 536 mm, Digital

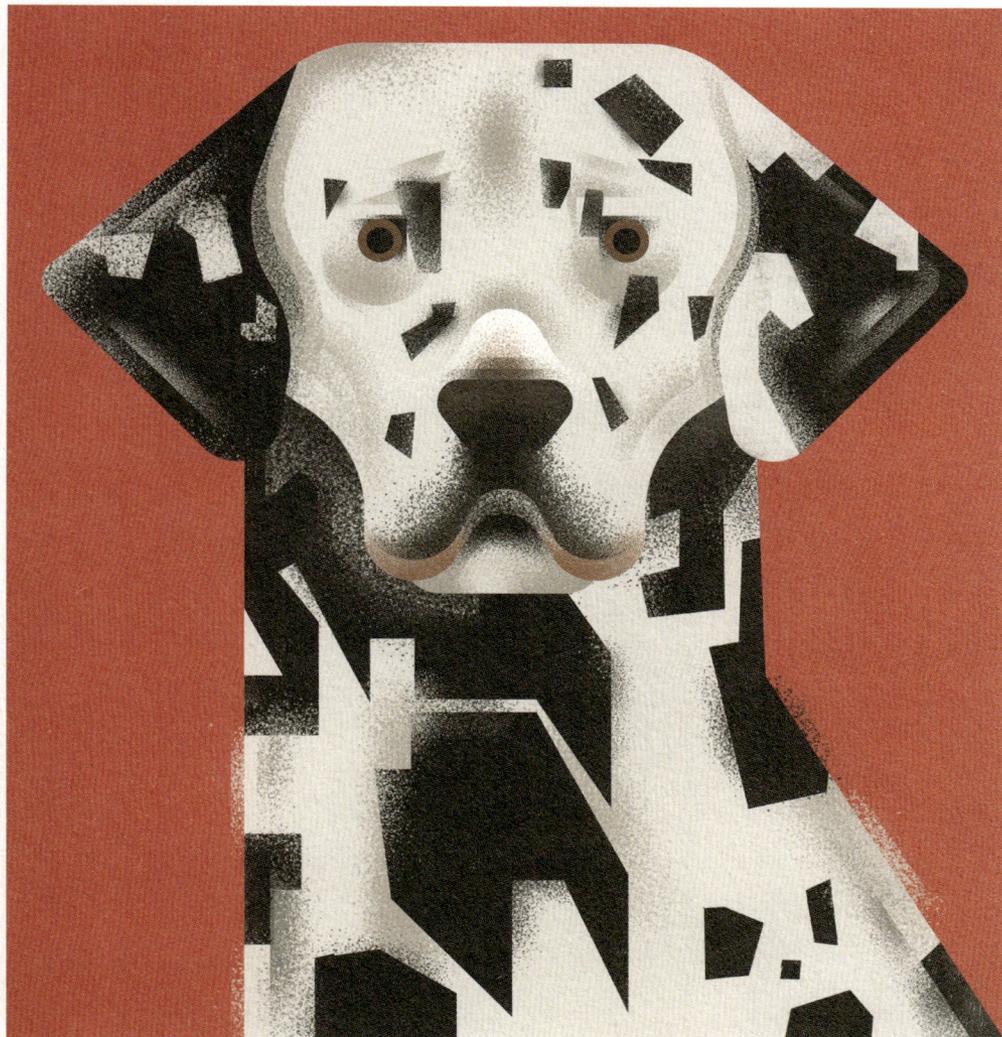

Dalmatian
300 x 320 mm, Digital

Dzeki
300 x 300 mm, Digital

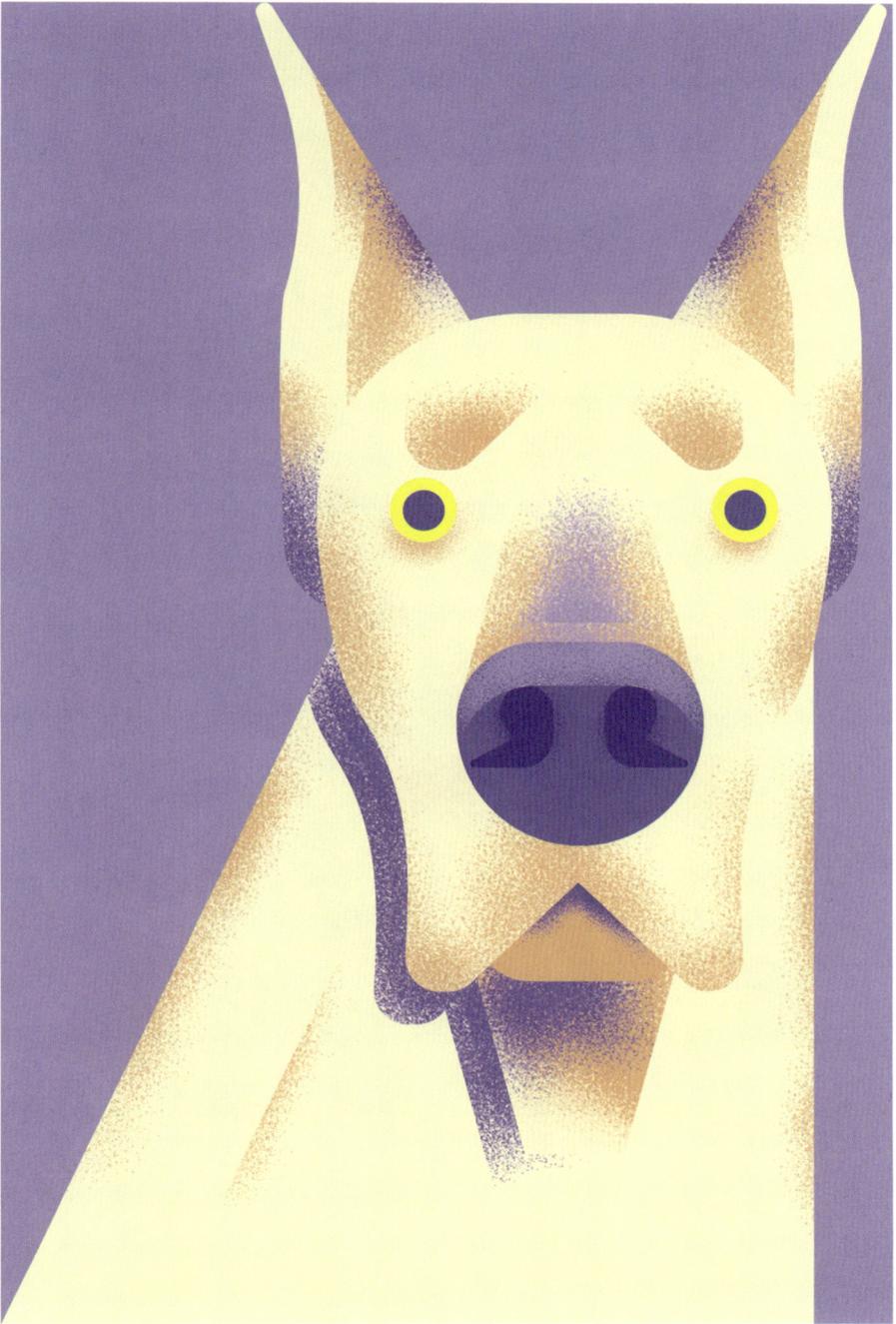

Doberman
322 x 490 mm, Digital

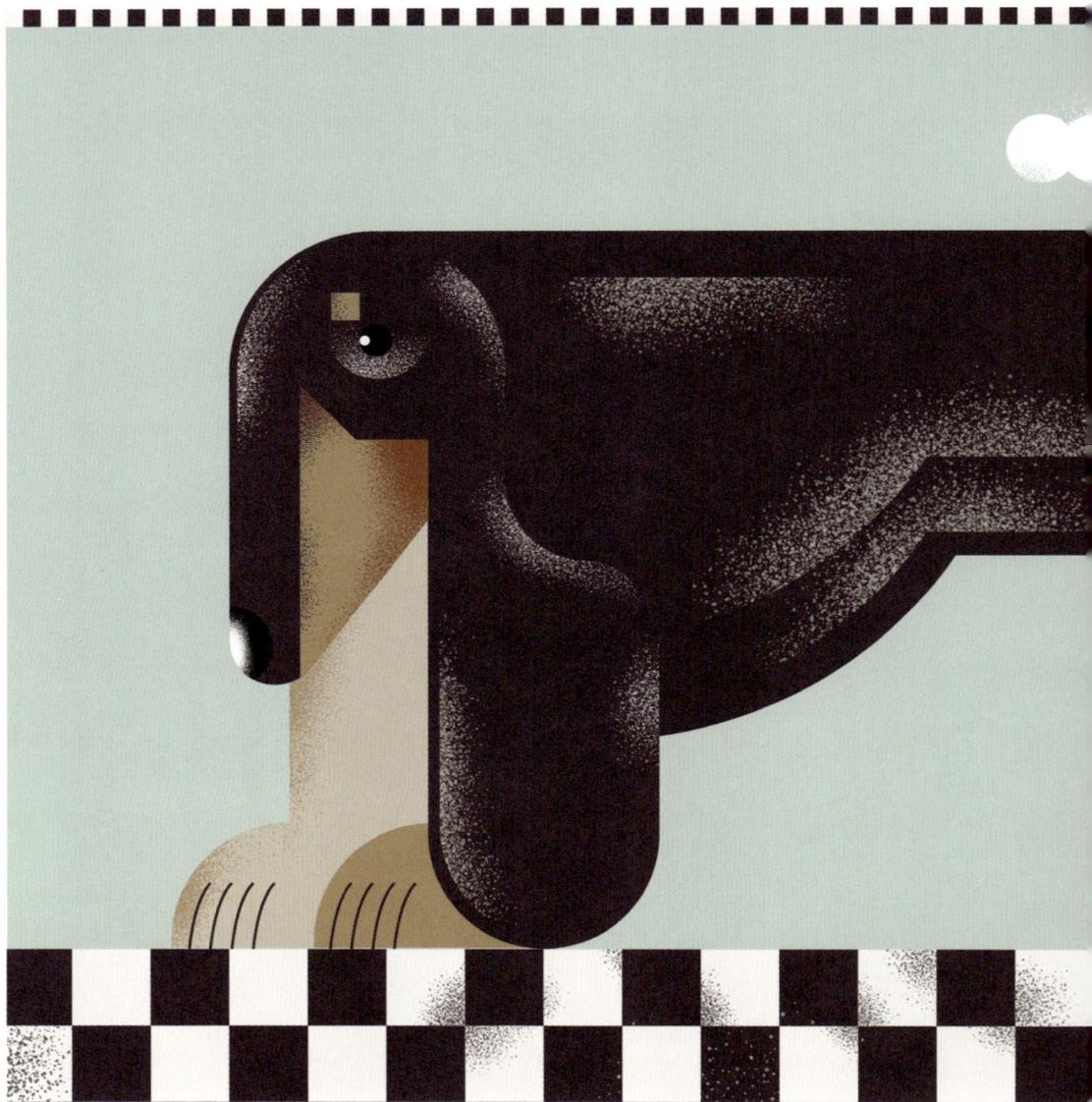

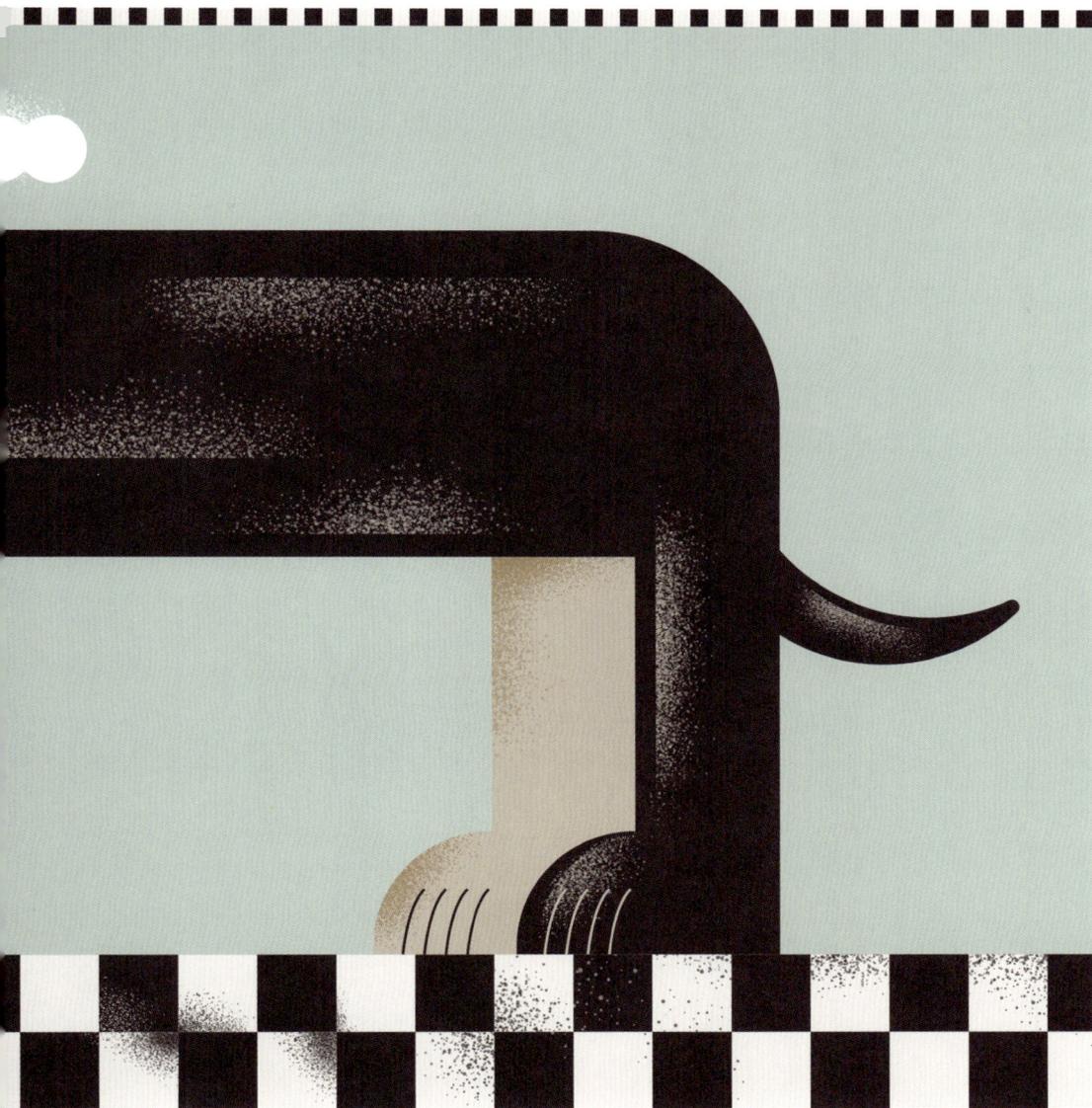

Dachshund
590 x 297 mm, Digital

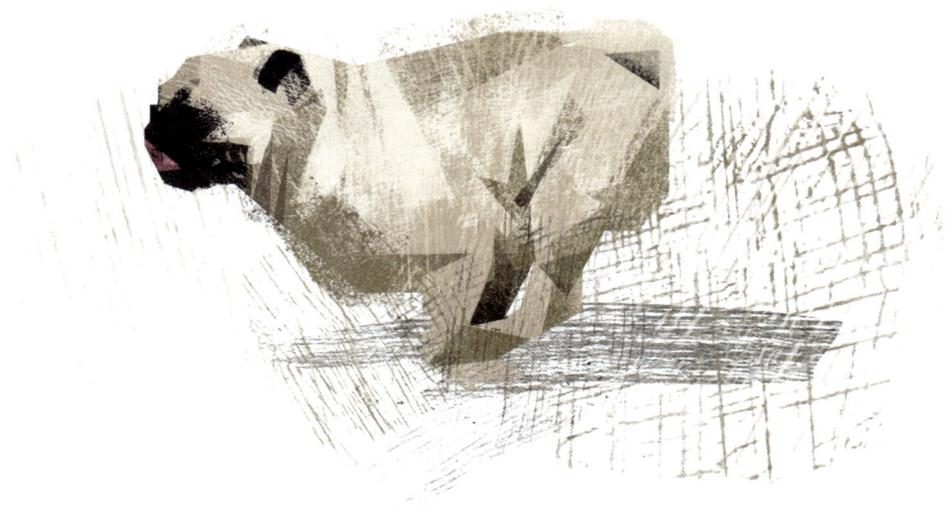

Pug (↑)
297 x 210 mm, Digital

Doberman (→)
297 x 210 mm, Digital

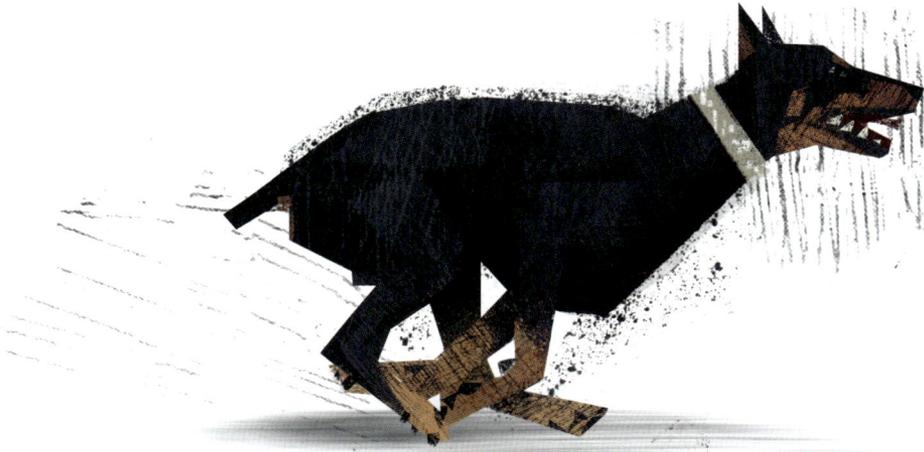

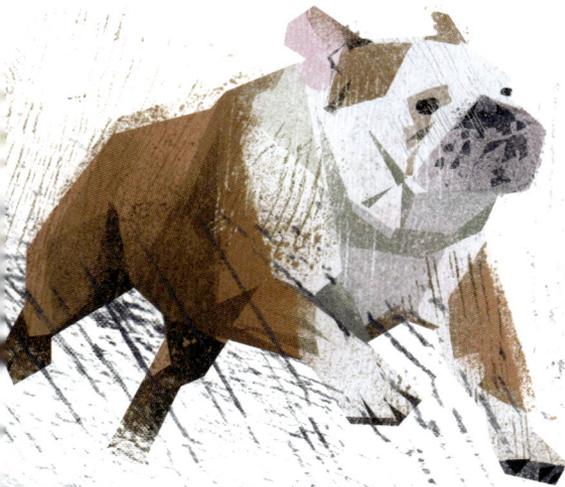

Bulldog (↑)
297 x 210 mm, Digital

Lubek

Born in 1992 in Gdańsk, Lubek studied Architecture and Design and later Graphics at the Academy of Fine Arts in Gdańsk, where he earned his MA in 2017. Specialising in illustration and printmaking, he is passionate about serigraphy, intaglio techniques, and crayon drawing, creating most of his works by hand. He also enjoys collecting vintage items.

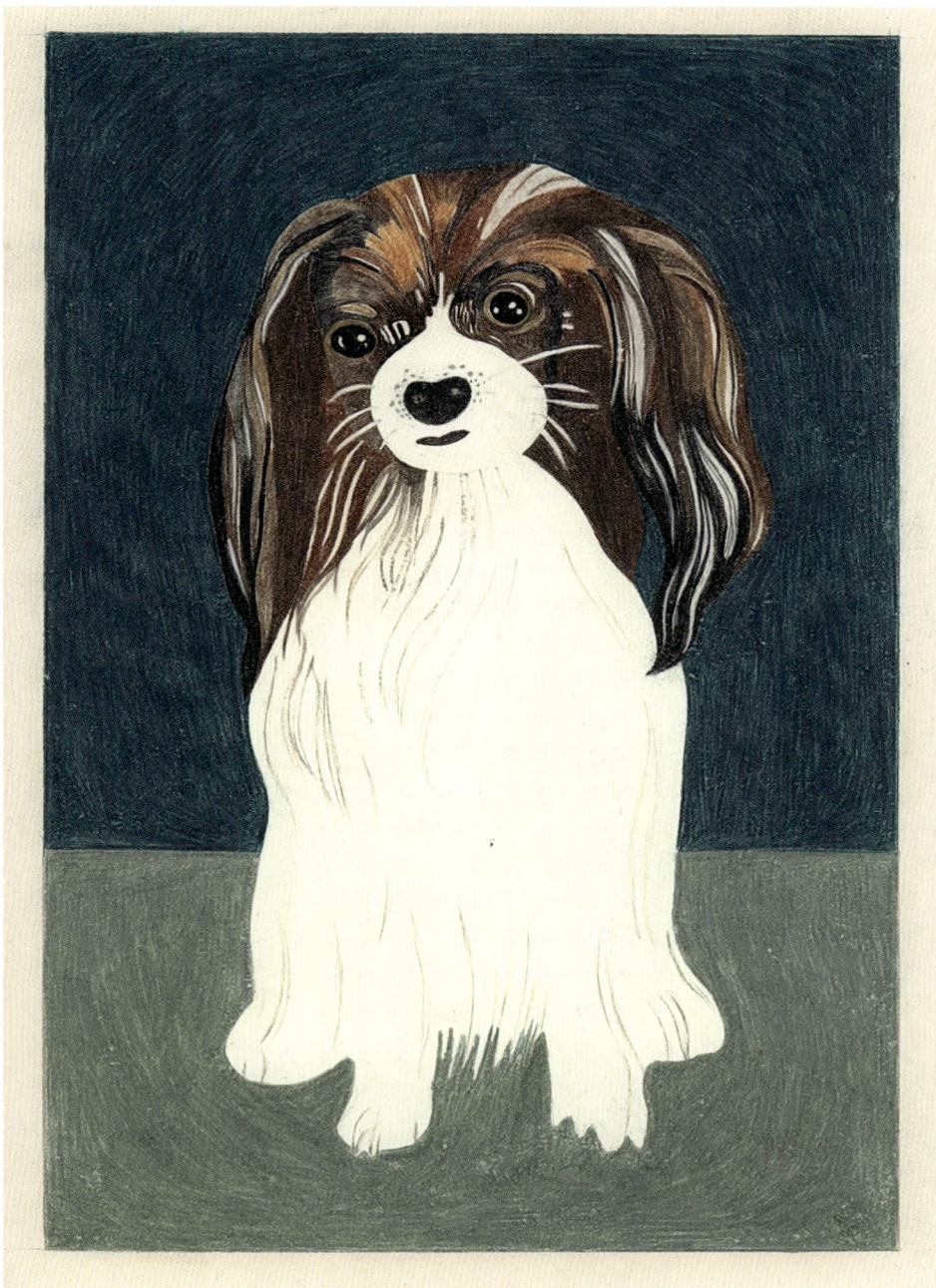

Fendi
210 x 297 mm, Crayons, Paper

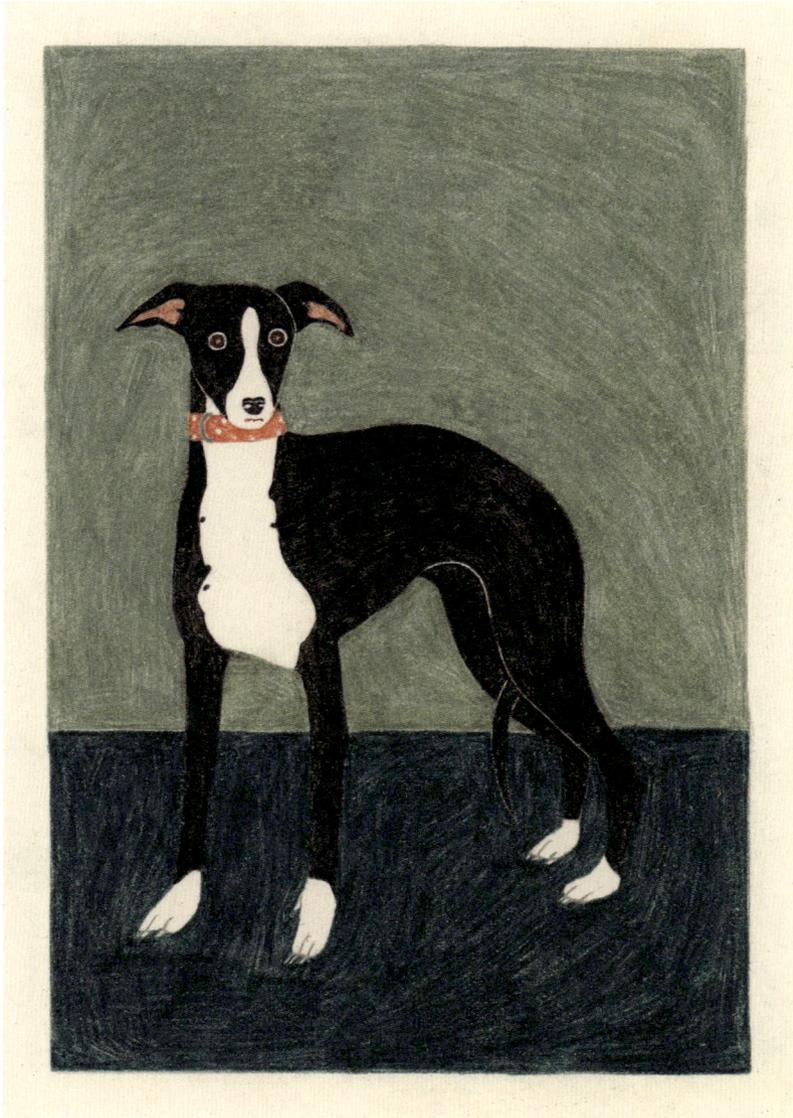

Joona
100 x 150 mm, Crayons, Paper

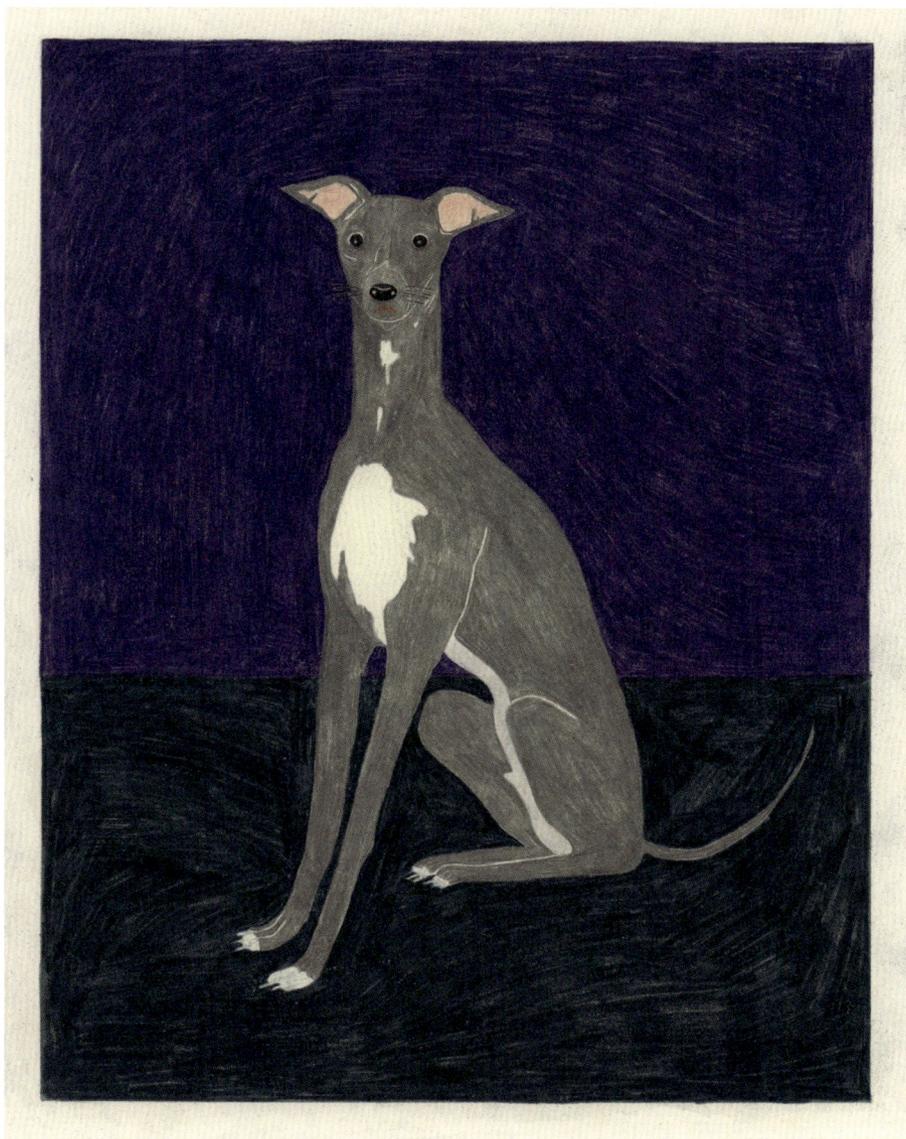

Hidan
210 x 270 mm, Crayons, Paper

95

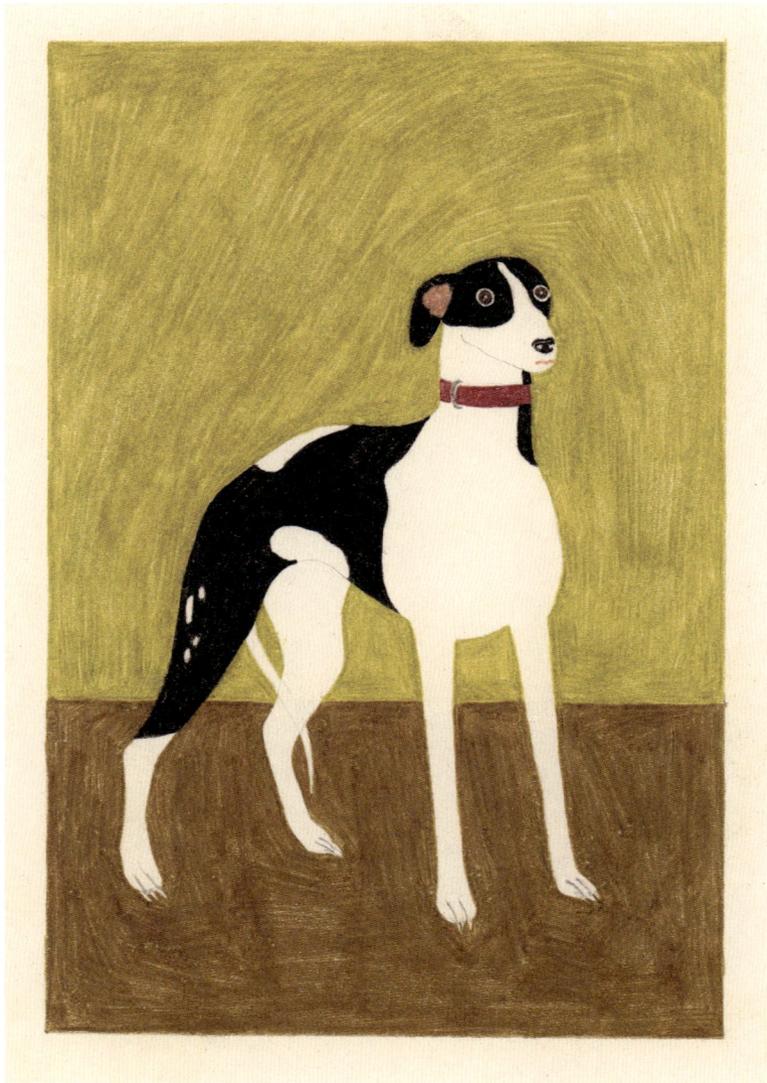

Tengo
100 x 150 mm, Crayons, Paper

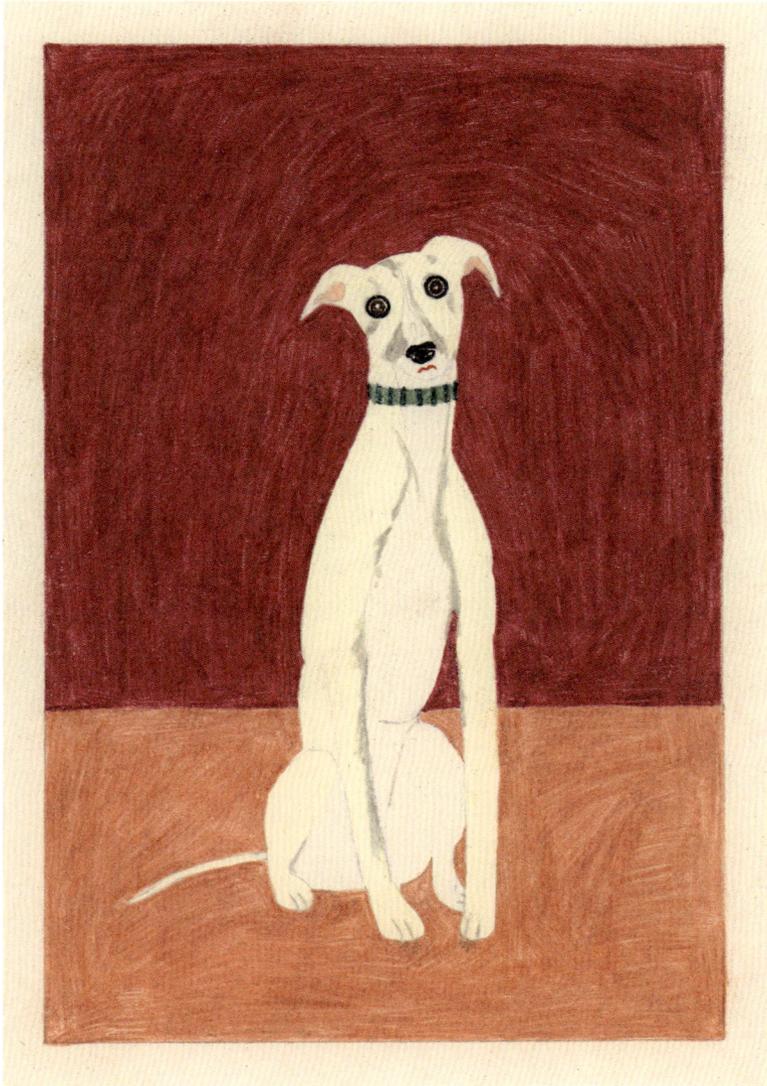

Zoya
100 x 150 mm, Crayons, Paper

97

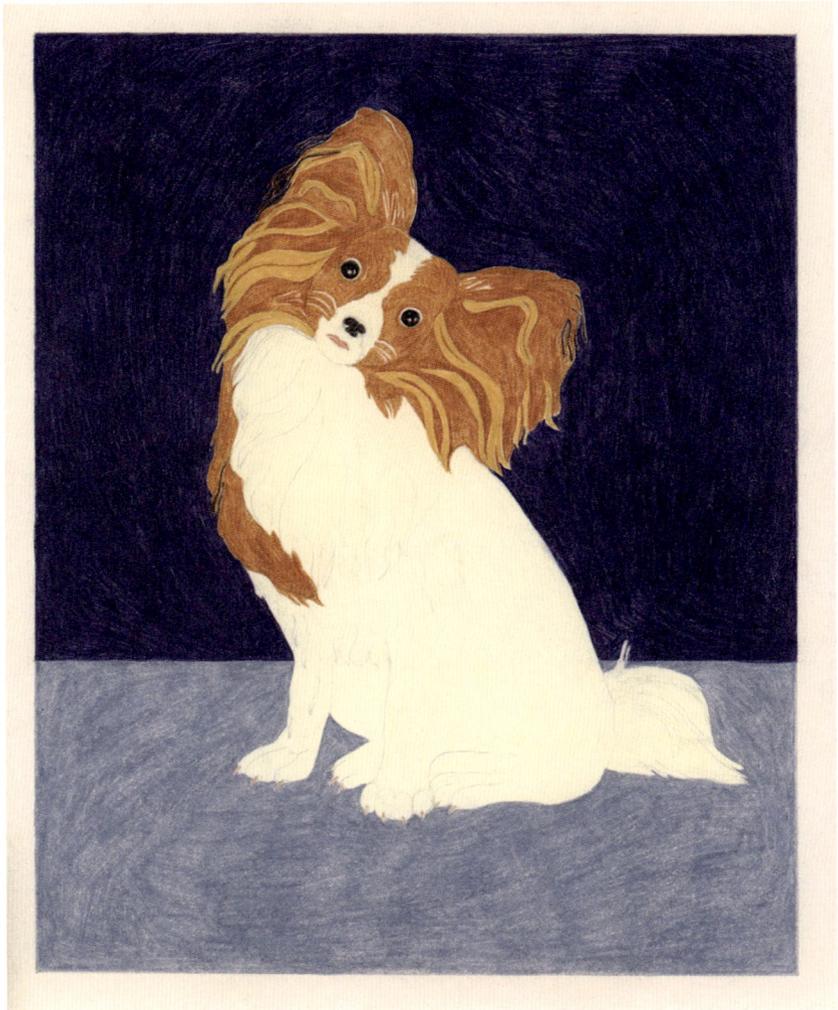

Ofelia
200 x 260 mm, Crayons, Paper

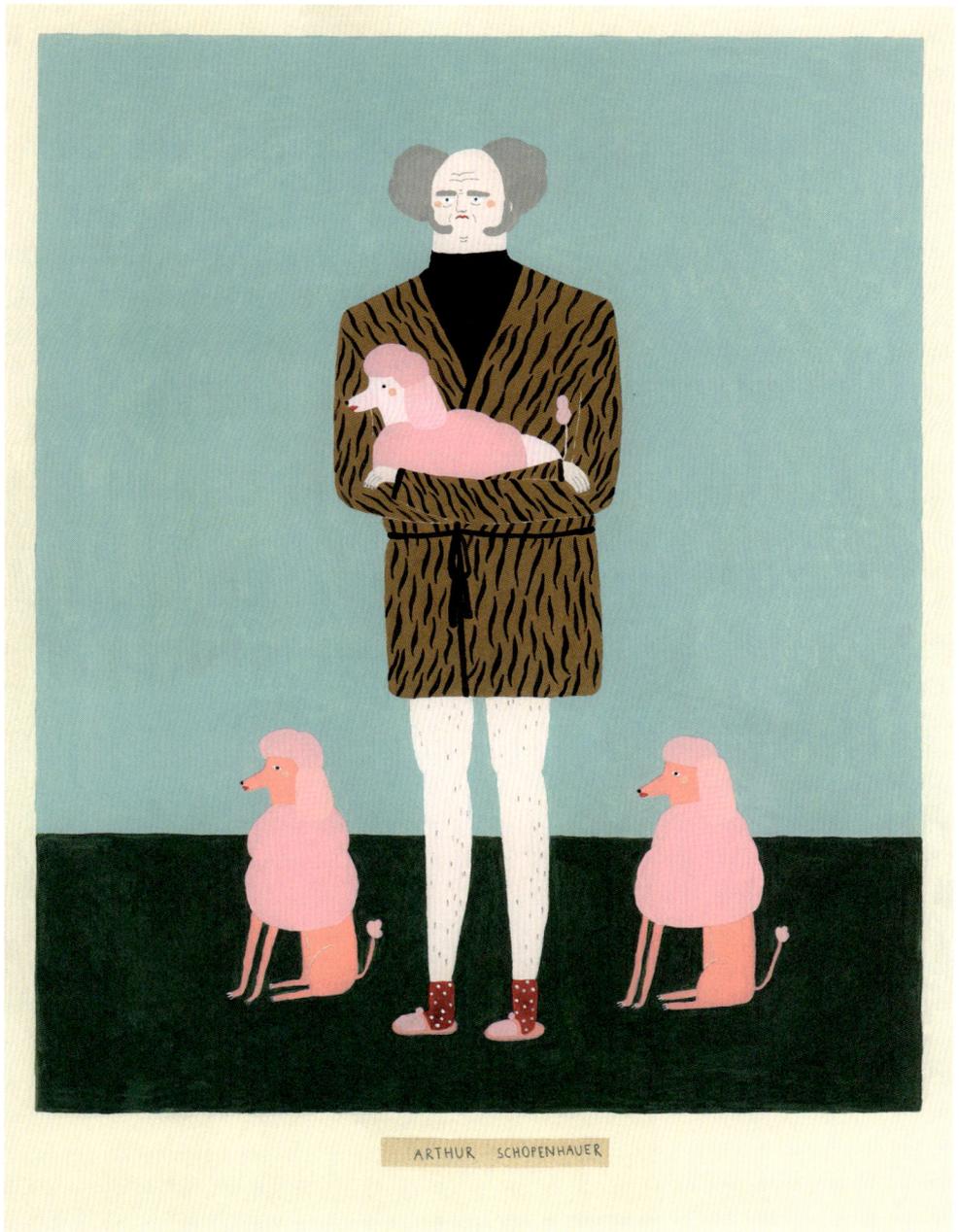

ARTHUR SCHOPENHAUER

Arthur Shopenhauer
300 x 400 mm, Acrylic, Paper, Client: zatoka.store

99

Fumi Koike

@fumi_koike

Fumi Koike, a Japan-based illustrator from Fukuoka, graduated from Musashino Art University. Her work spans advertisements, books, magazines, picture books, and artworks. Her major clients include Tokyu Agency, NHK, Shogakukan, Yakult, MUJI, Nabisco, and The Washington Post.

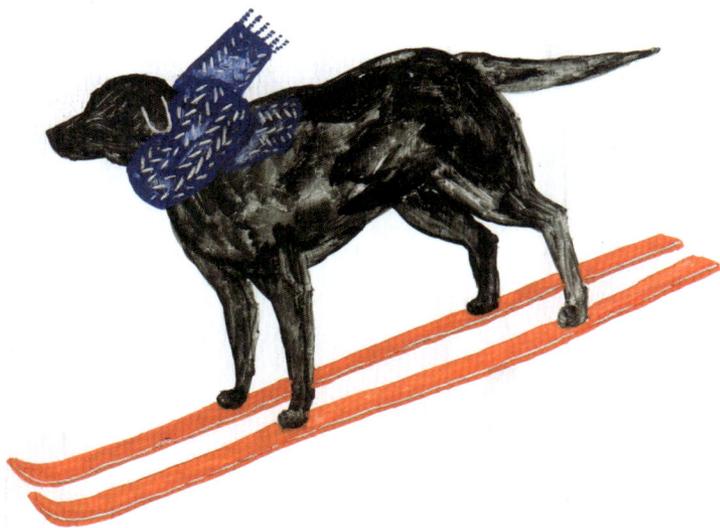

SKY-KEN
178 x 264 mm, Acrylic Gouache, Paper

101

Boston Terrier
178 x 262 mm, Acrylic Gouache, Paper

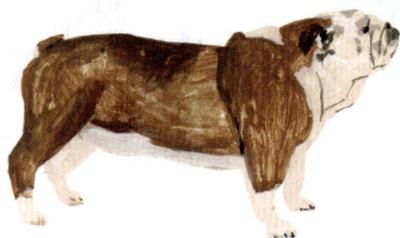

Bulldog
178 x 262 mm, Acrylic Gouache, Paper

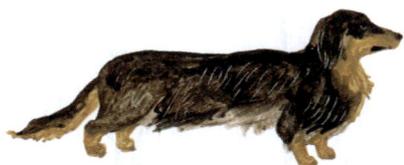

Dachshund (↑)
178 x 262 mm, Acrylic Gouache, Paper

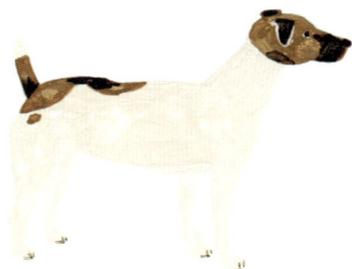

Jack Russell Terrier (↓)
178 x 262 mm, Acrylic Gouache, Paper

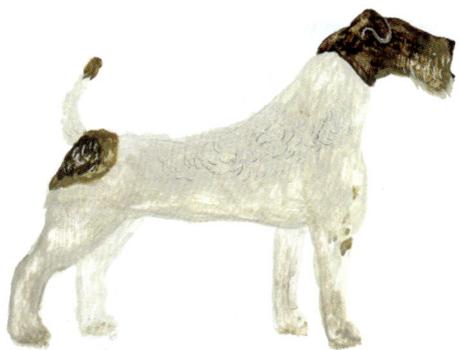

Fox Terrier (↑)
178 x 262 mm, Acrylic Gouache, Paper

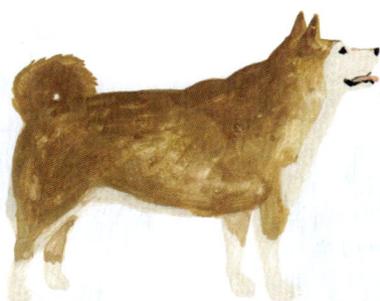

Shiba Inu (↓)
178 x 262 mm, Acrylic Gouache, Paper

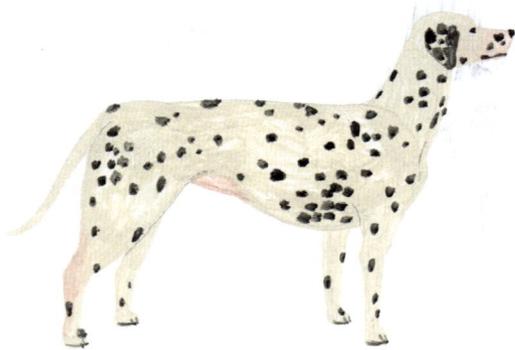

Dalmatian
178 x 262 mm, Acrylic Gouache, Paper

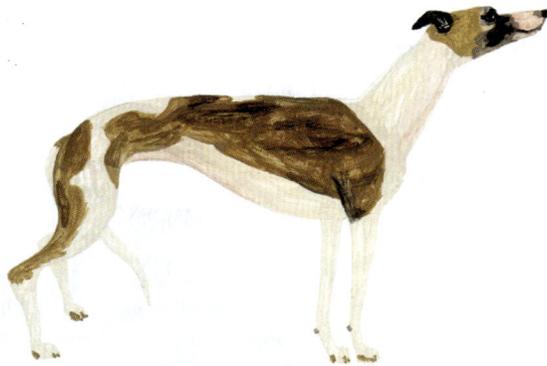

Whippet
178 x 262 mm, Acrylic Gouache, Paper

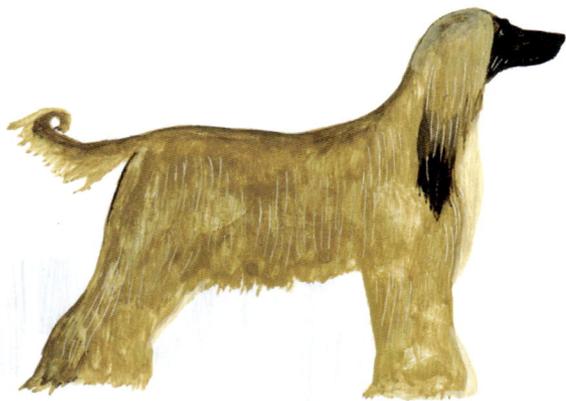

Afghan Hound
178 x 262 mm, Acrylic Gouache, Paper

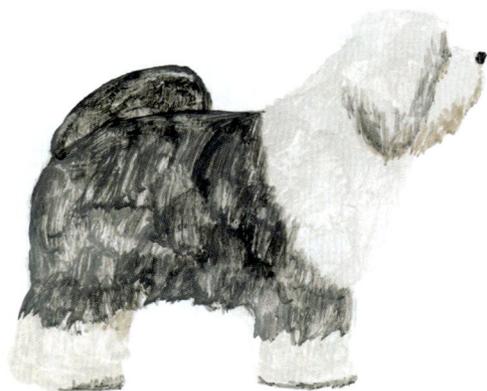

Old English Sheepdog
178 x 262 mm, Acrylic Gouache, Paper

Kamwei Fong is an artist who works mainly on the animal world and is known for his poetic, humourous, imaginative, playful and dream-like creations. His artwork has received global recognition including the exhibitions at Salon des Beaux Arts in Paris, and Art Expo Malaysia in Kuala Lumpur.

Kamwei Fong

kamweifong.com

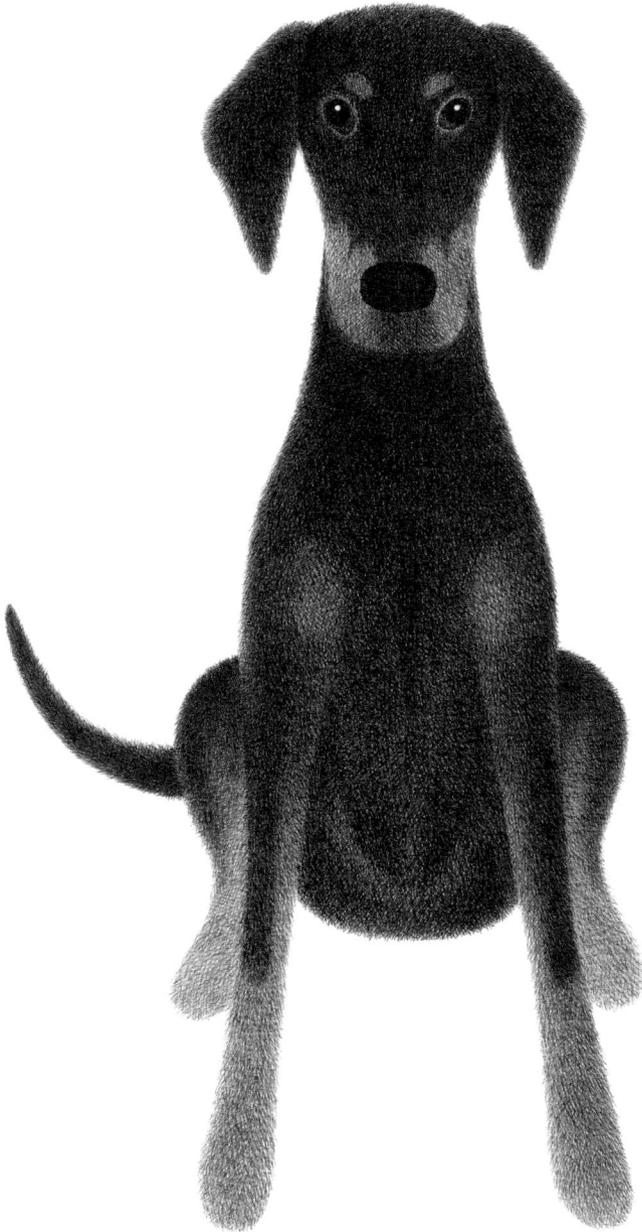

The Furry Thing – Damon
297 x 420 mm, Micro-pigment Ink Pen

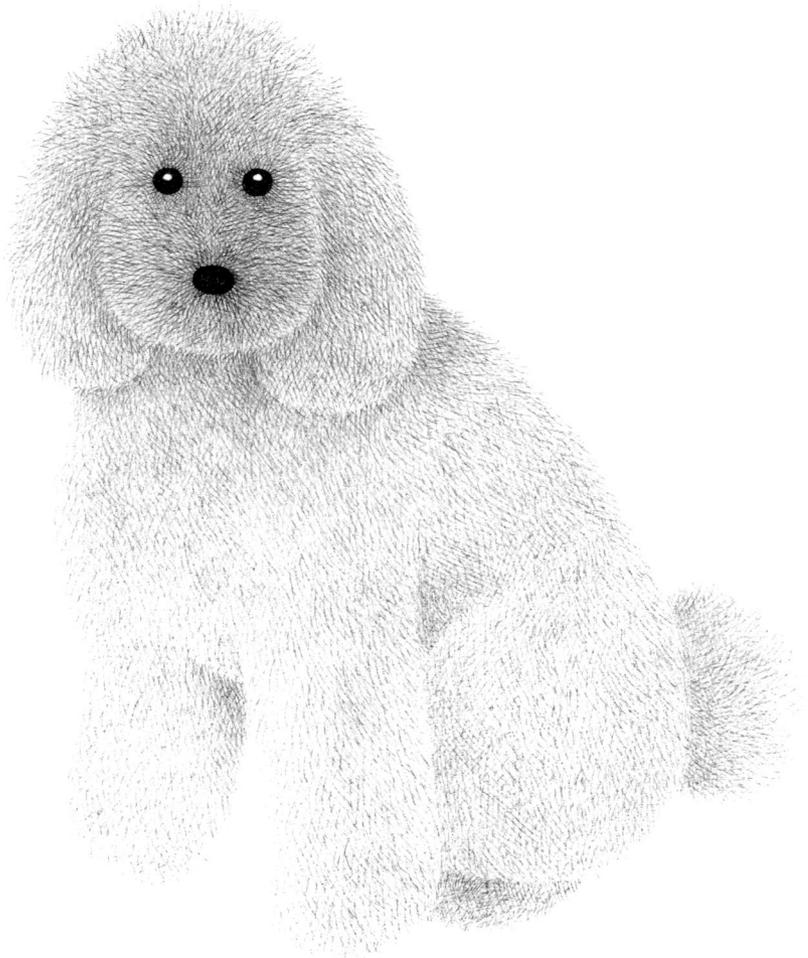

The Furry Thing – Buffy Ebrahim
210 x 297 mm, Micro-pigment Ink Pen

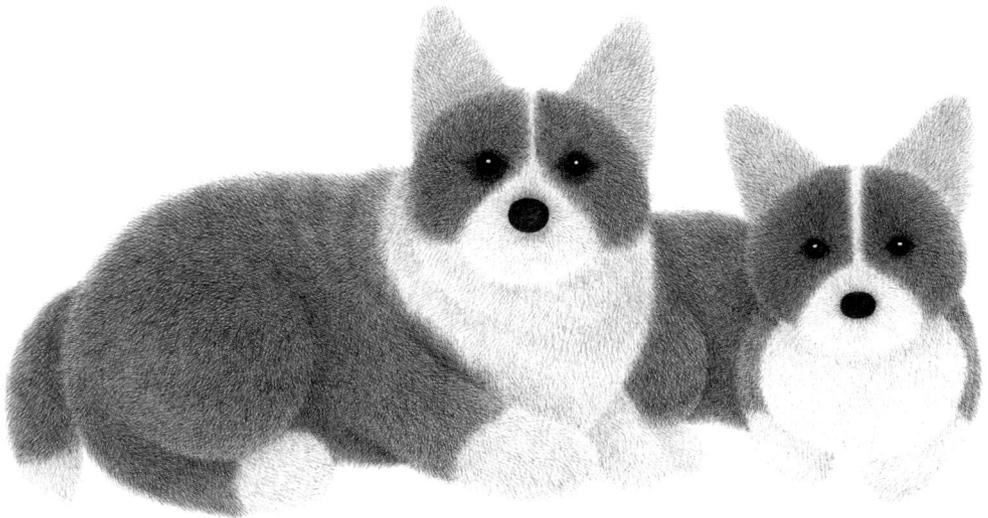

The Furry Thing – Marcus And Barley
297 x 420 mm, Micro-pigment Ink Pen

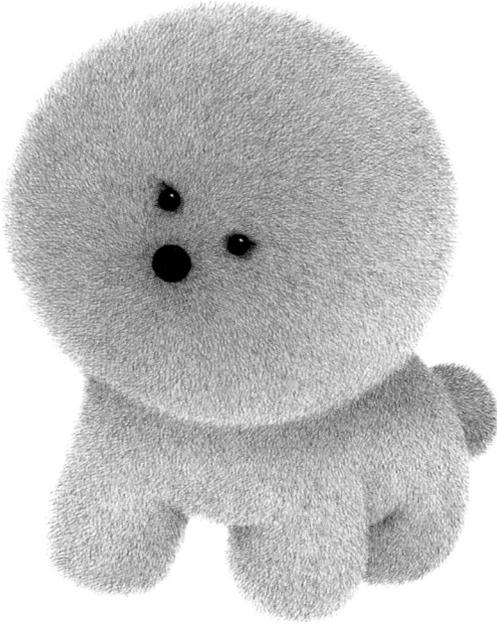

The Furry Thing – Doggy No.5 (←)
297 x 420 mm, Micro-pigment Ink Pen

The Furry Thing – Doggy No.6 (↑)
297 x 420 mm, Micro-pigment Ink Pen, Client: Uniqlo

The Furry Thing – Doggy No.7
297 x 420 mm, Micro-pigment Ink Pen

The Furry Thing – Jack
420 x 297 mm, Micro-pigment Ink Pen

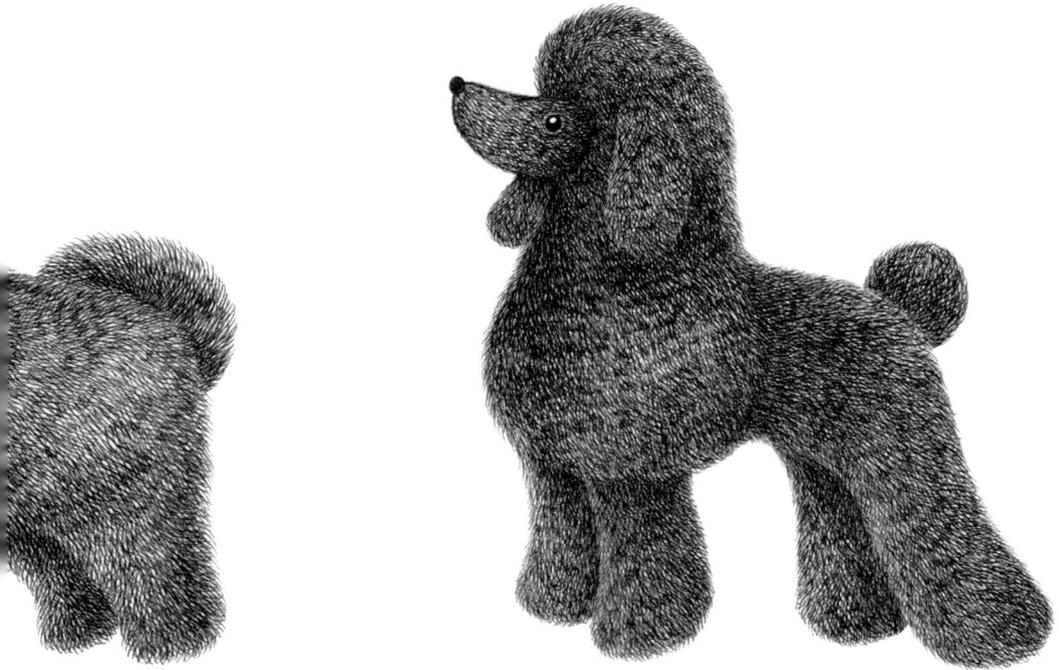

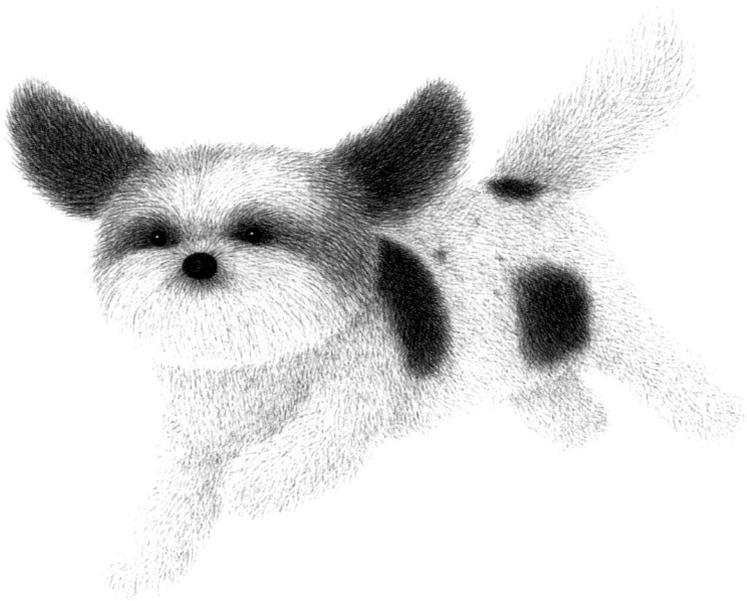

The Furry Thing – Fido
210 x 297 mm, Micro-pigment Ink Pen

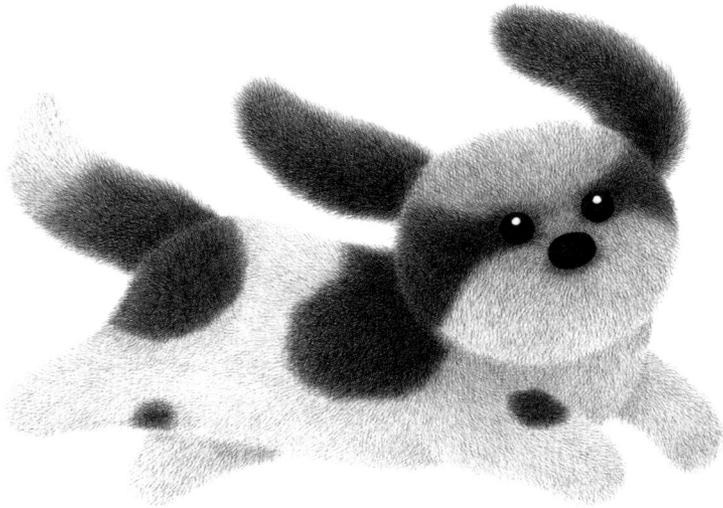

The Furry Thing – Doggy No.9
297 x 420 mm, Micro-pigment Ink Pen

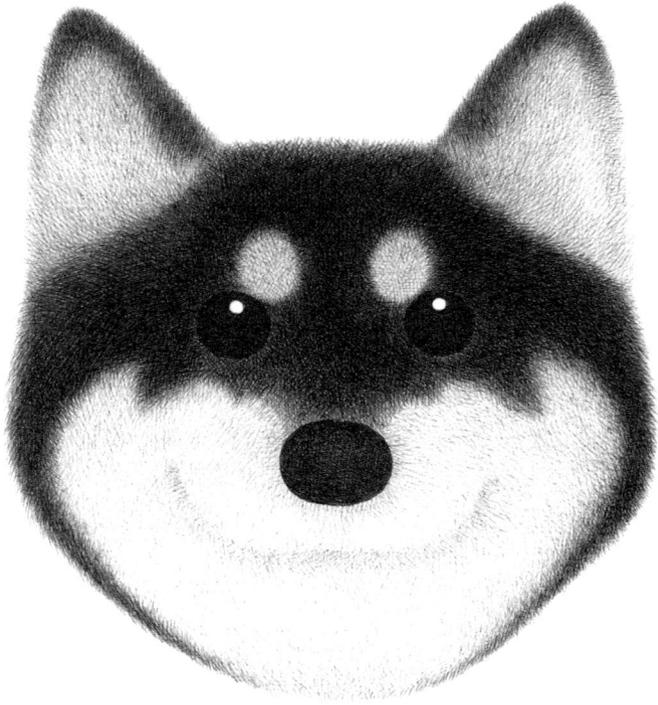

The Furry Thing – Bado
210 x 297 mm, Micro-pigment Ink Pen

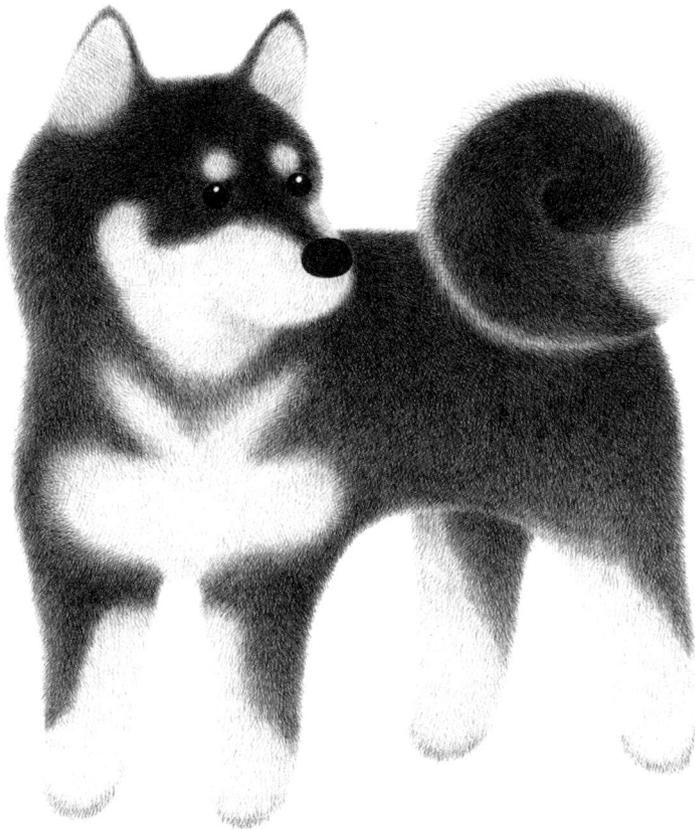

The Furry Thing – Bado
297 x 420 mm, Micro-pigment Ink Pen

Seungyoun Kim

@textcontext

Seungyoun Kim is a Korean illustrator and children's book author. She lives in Seoul with her puppy, Kim Pingu, a favourite subject of her illustrations and a loyal workmate who loves to sleep on her lap while she is painting.

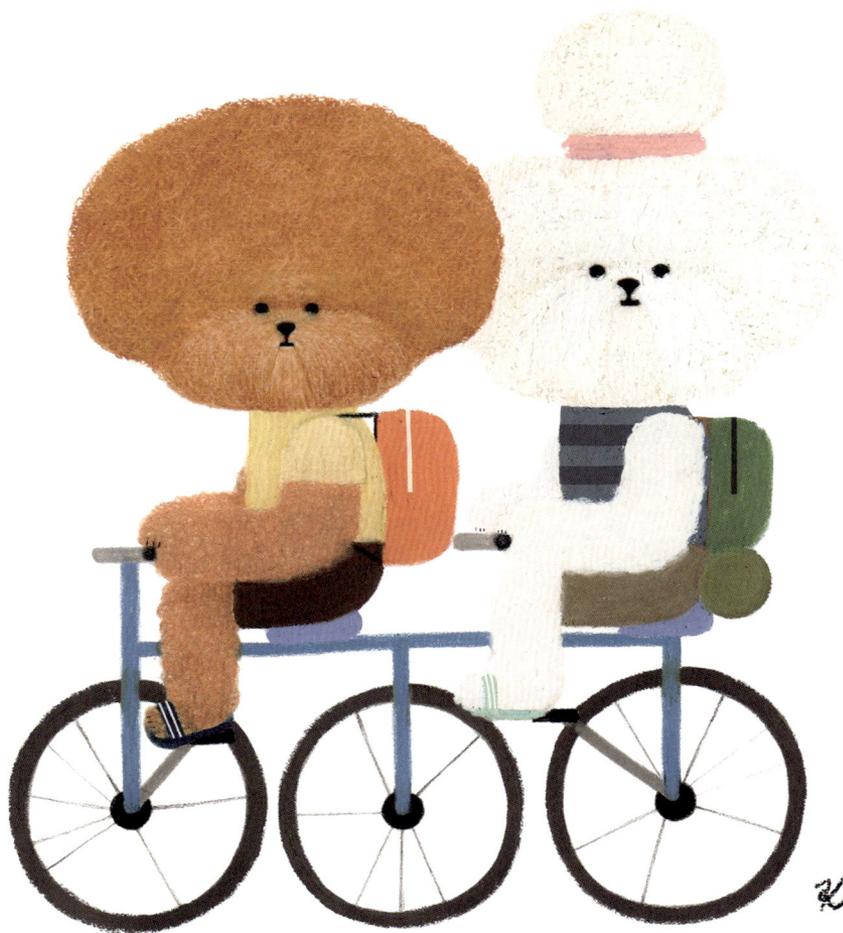

Better Together
300 x 300 mm, Oil Pastels, Coloured Pencils, Paper,
Client: Topten (SPA Fashion Brand)

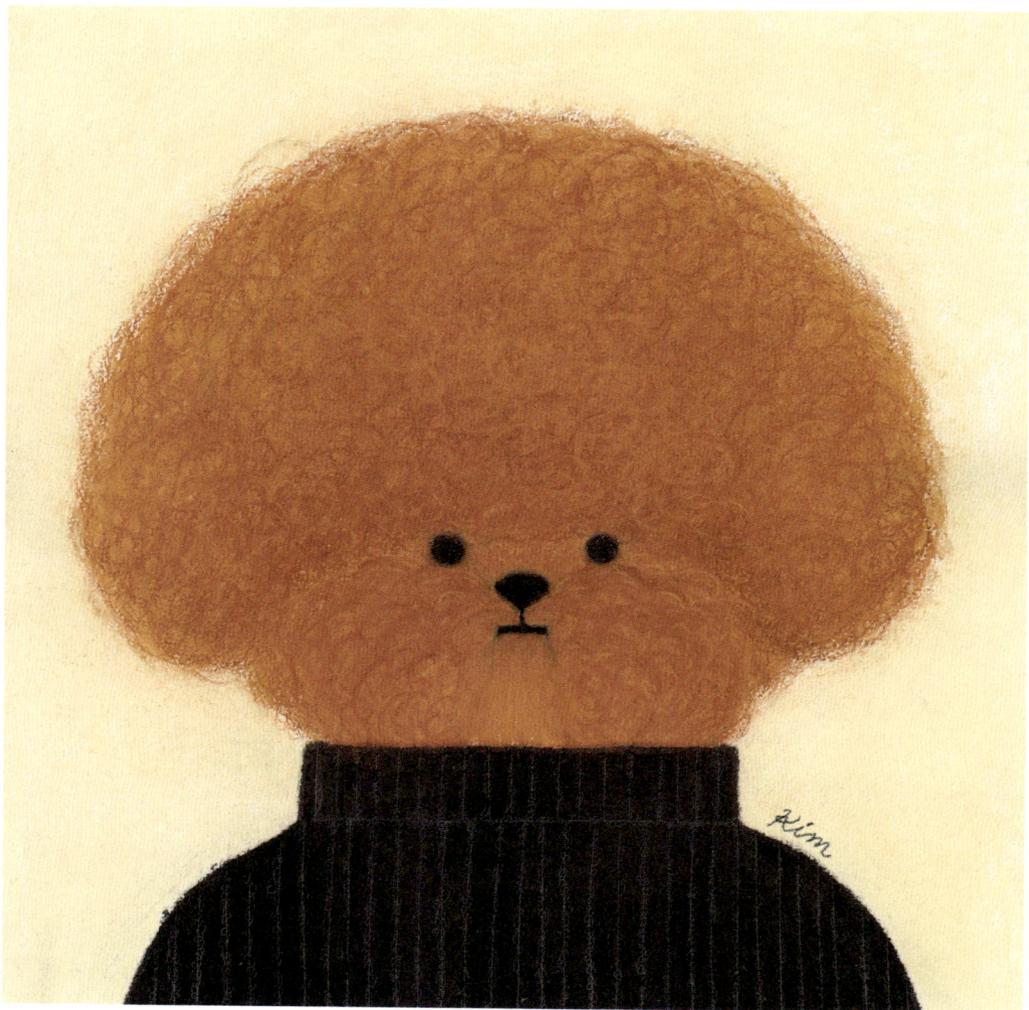

Pingu Kim
480 x 430 mm, Oil Pastels, Coloured Pencils, Paper

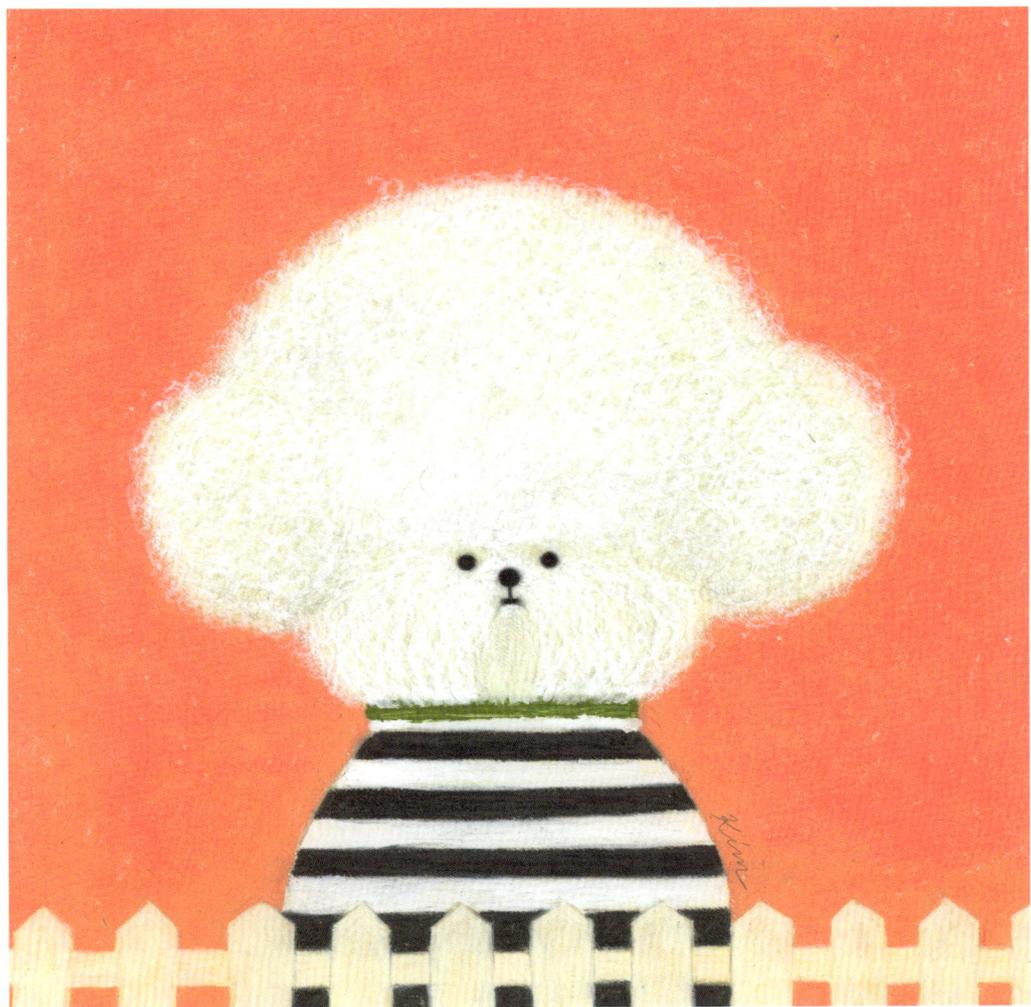

Poodle In A Striped T-Shirt
290 x 330 mm, Oil Pastels, Coloured Pencils, Paper, Client: Gucci Kids

125

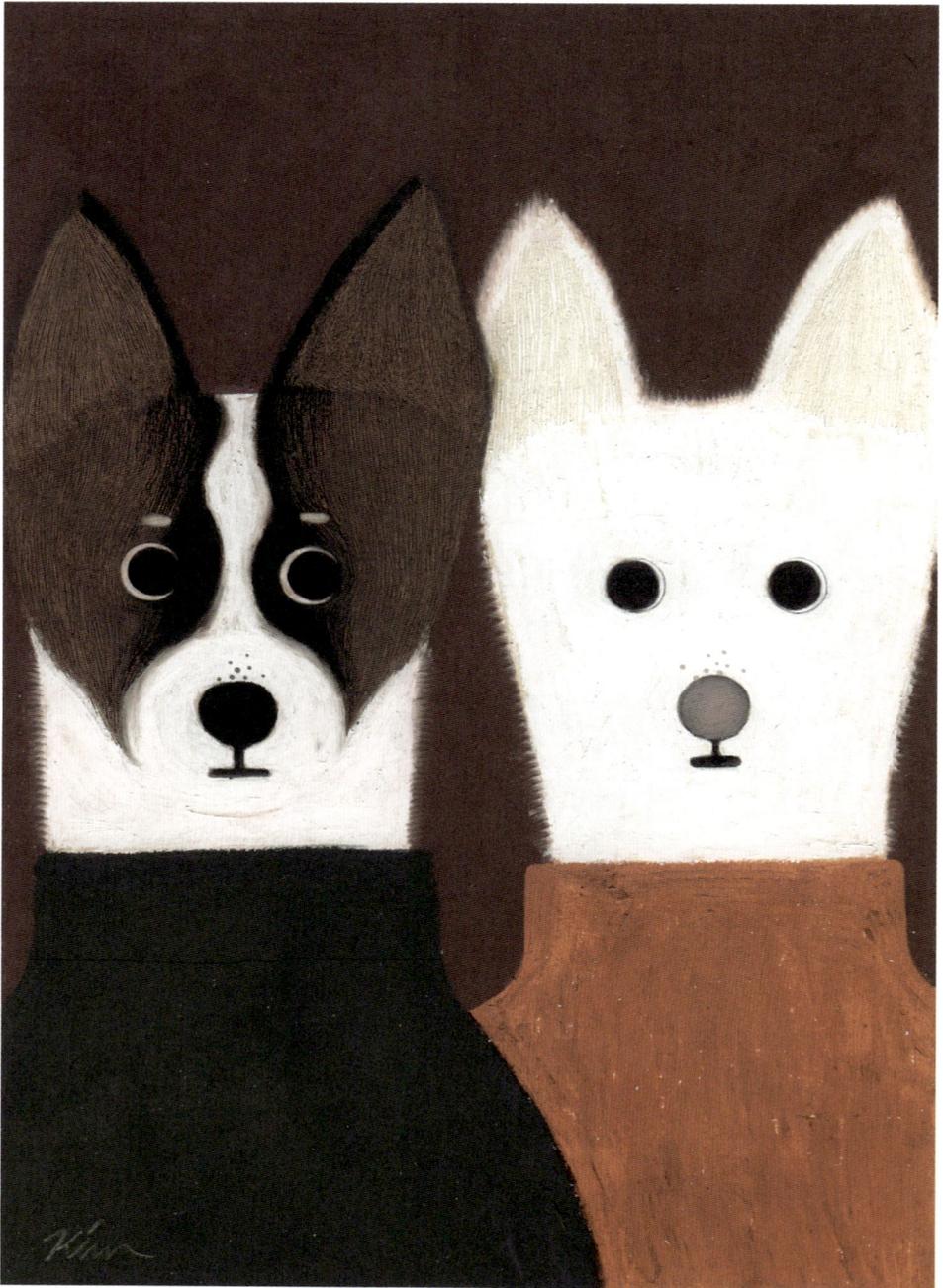

Chamo And Mile
290 x 210 mm, Oil Pastels, Coloured Pencils, Paper,
Client: KARA(Korea Animal Rights Advocates)

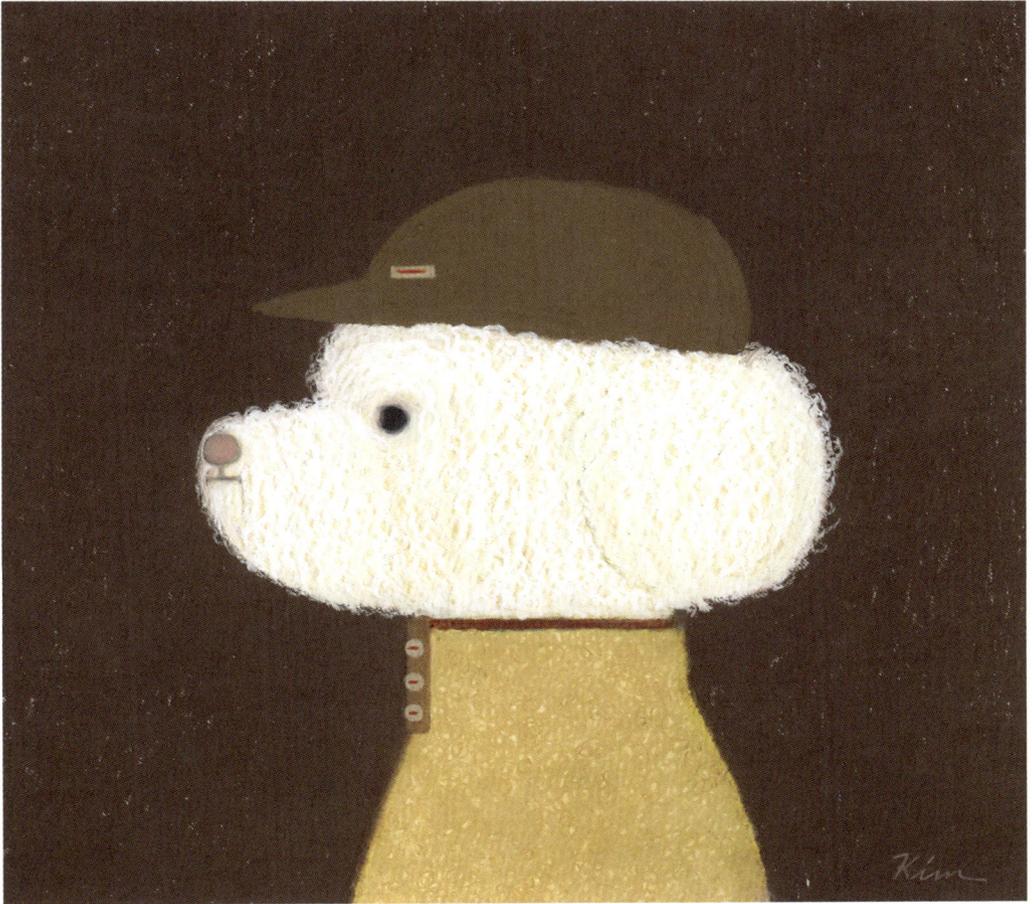

Bichon With A Cap
290 x 310 mm, Oil Pastels, Coloured Pencils, Paper, Client: Gucci Kids

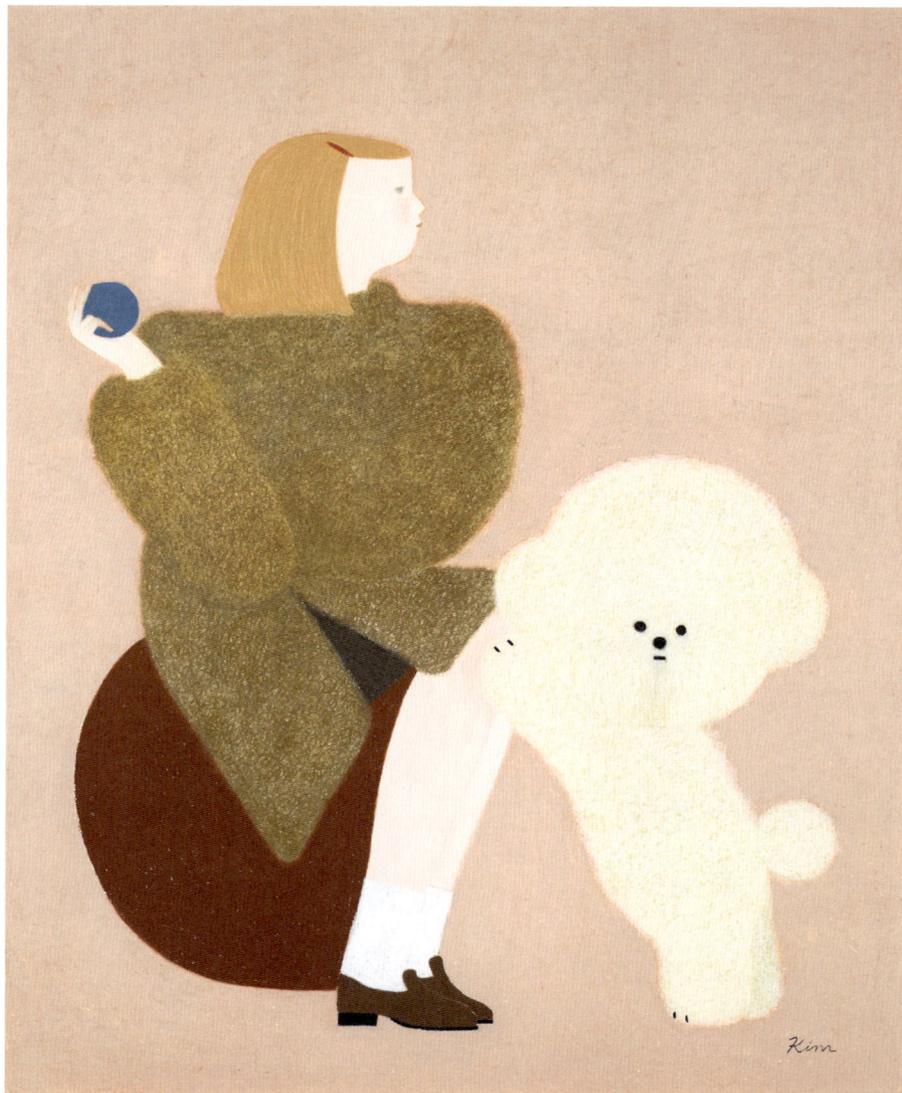

Family Portrait : Alternative Family A (↑)
800 x 650 mm, Oil Pastels, Coloured Pencils, Paper

The Forest Of Hats / The Day It Snowed (→)
370 x 295 mm, Oil Pastels, Coloured Pencils, Paper

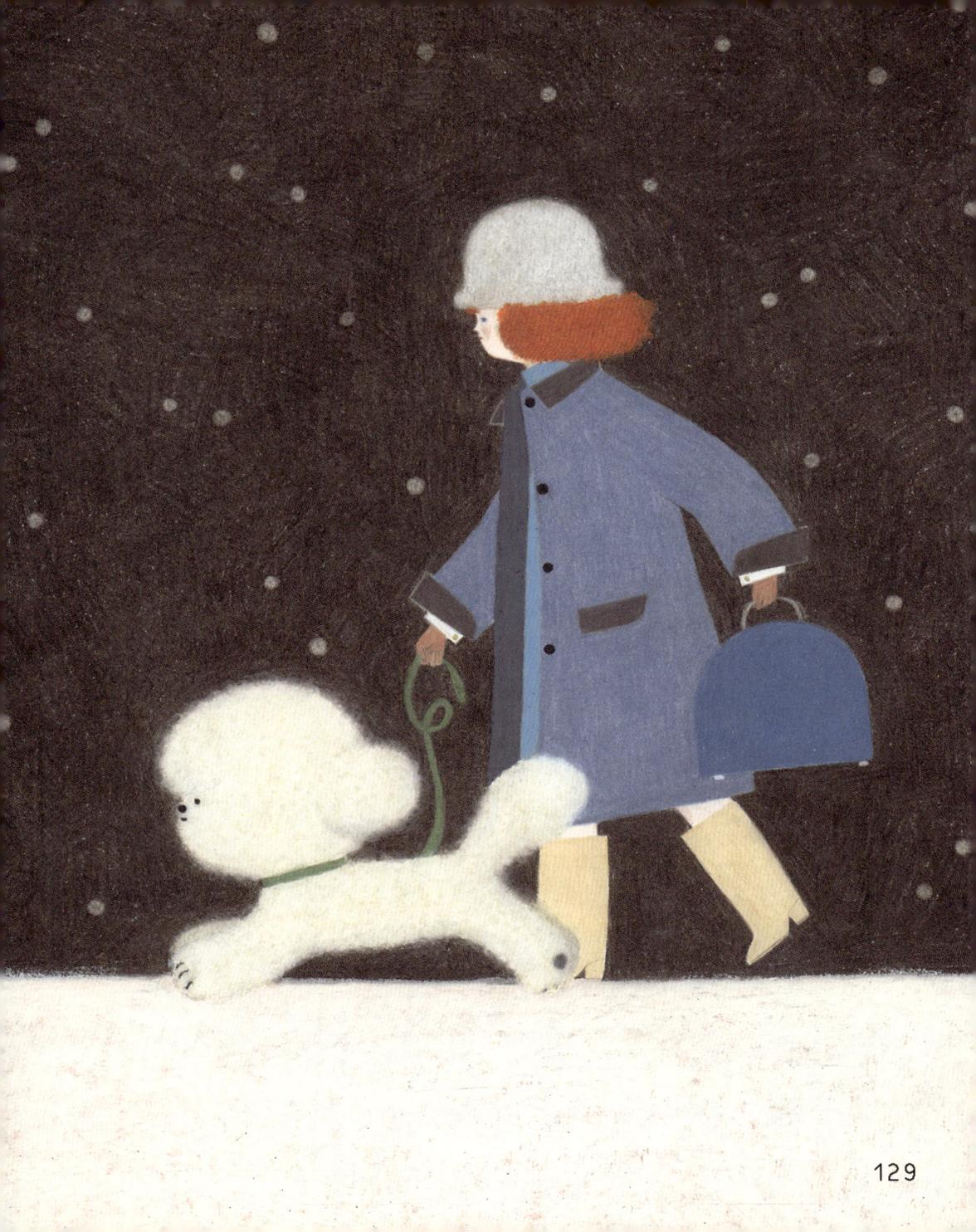

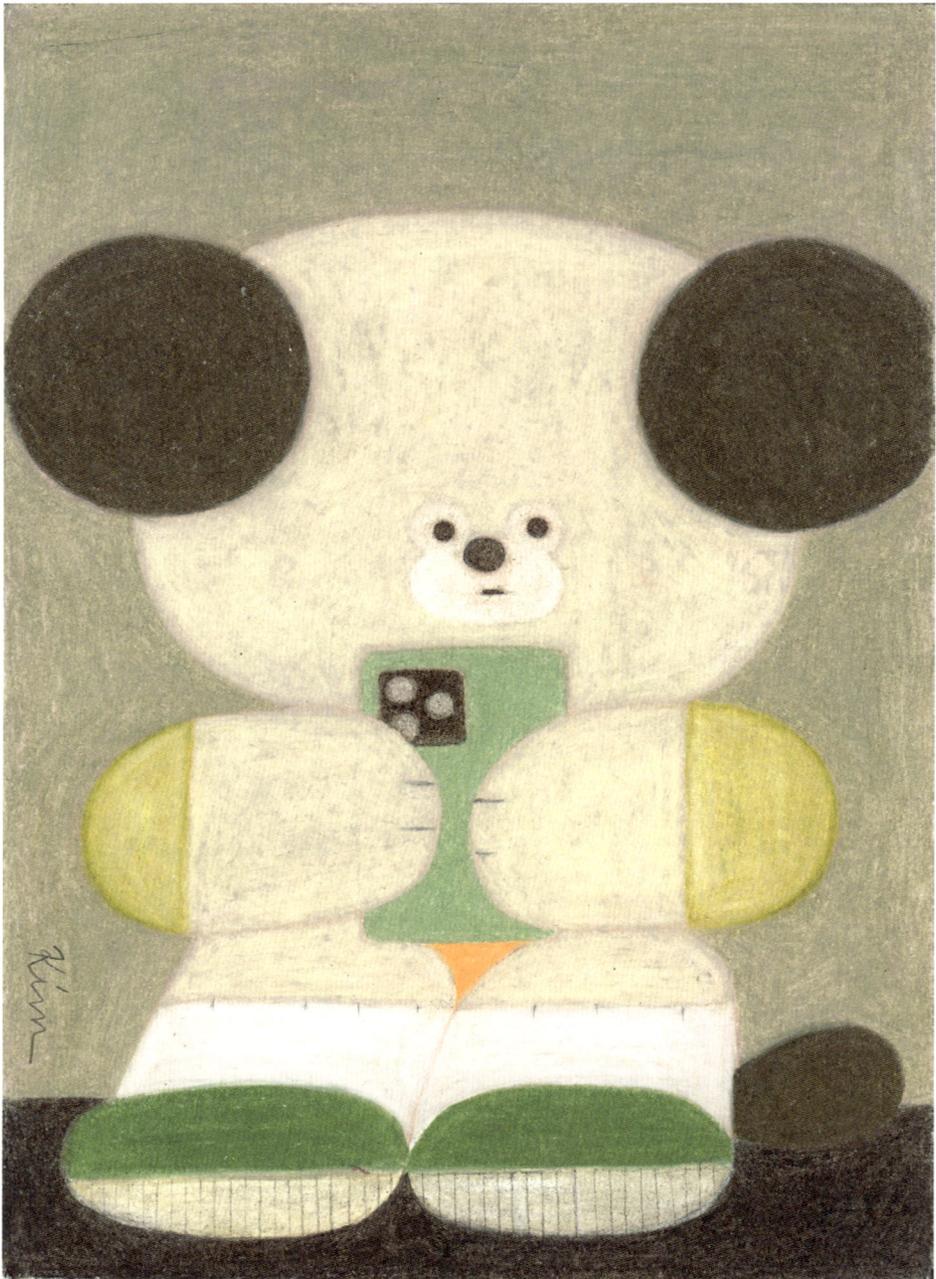

Selfie 1
220 x 150 mm, Oil Pastels, Coloured Pencils, Paper

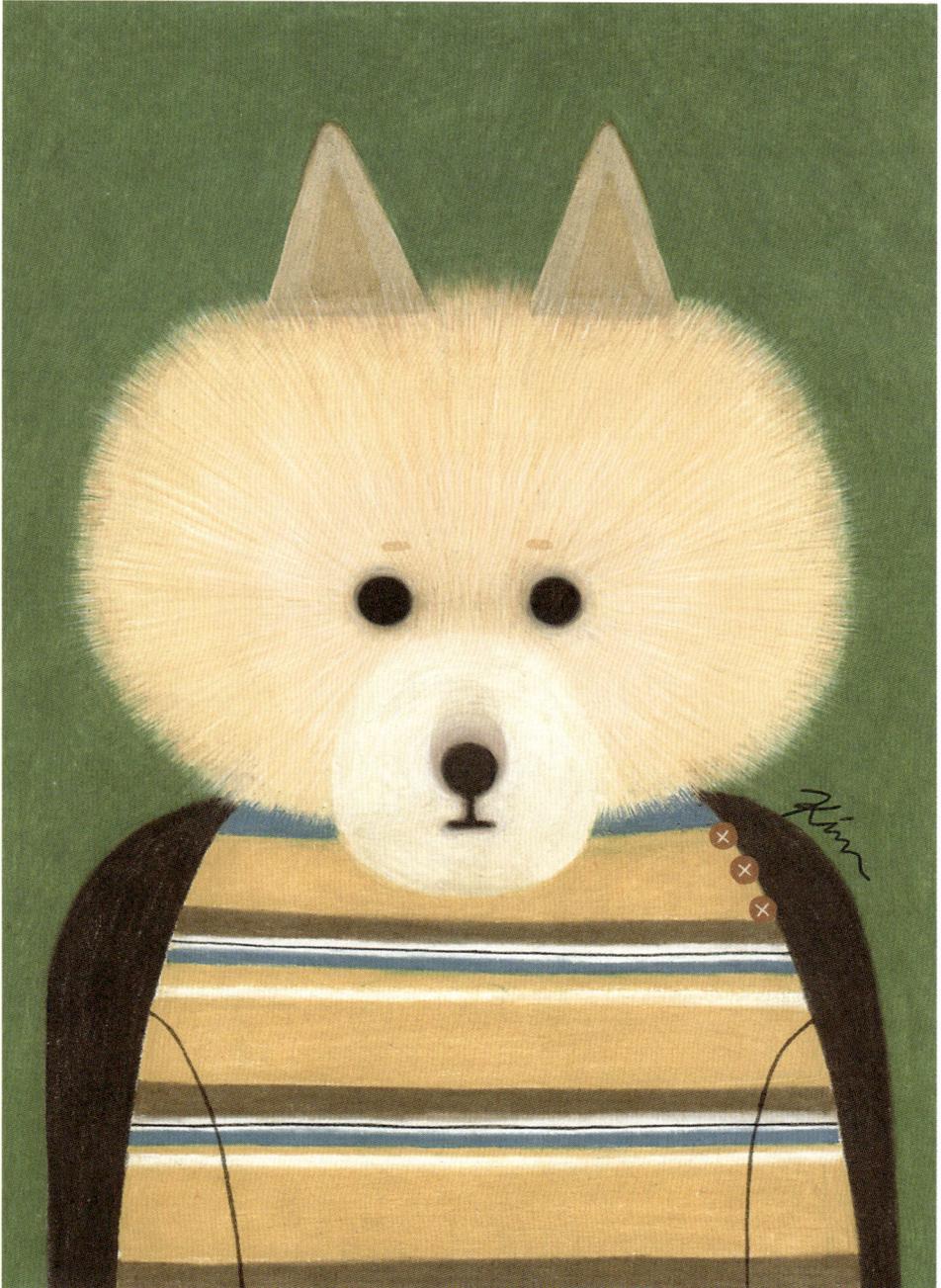

Jaram
290 x 210 mm, Oil Pastels, Coloured Pencils, Paper,
Client: KARA(Korea Animal Rights Advocates)

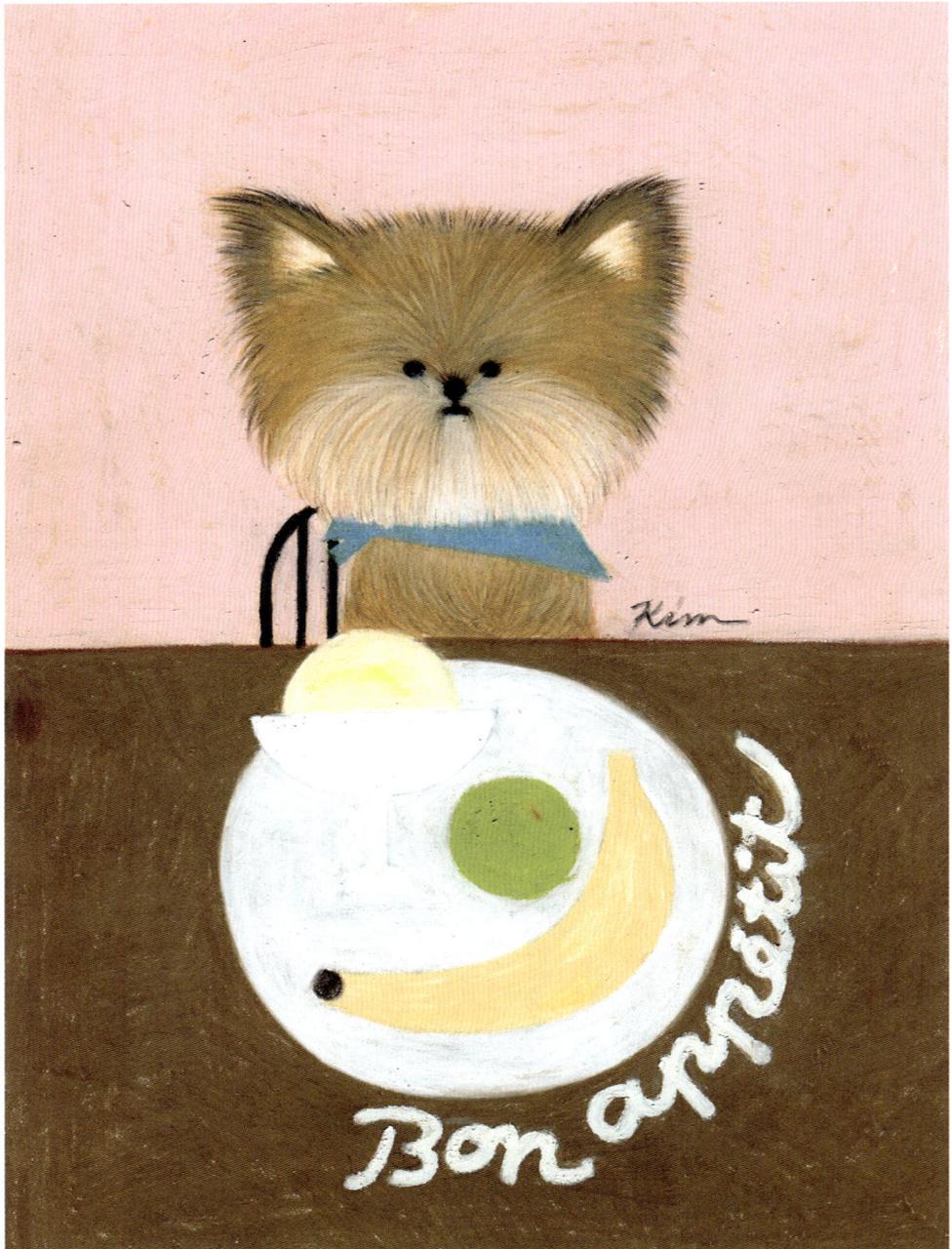

Bon Appetit
290 x 210 mm, Oil Pastels, Coloured Pencils, Paper,
Client: Topten (SPA Fashion Brand)

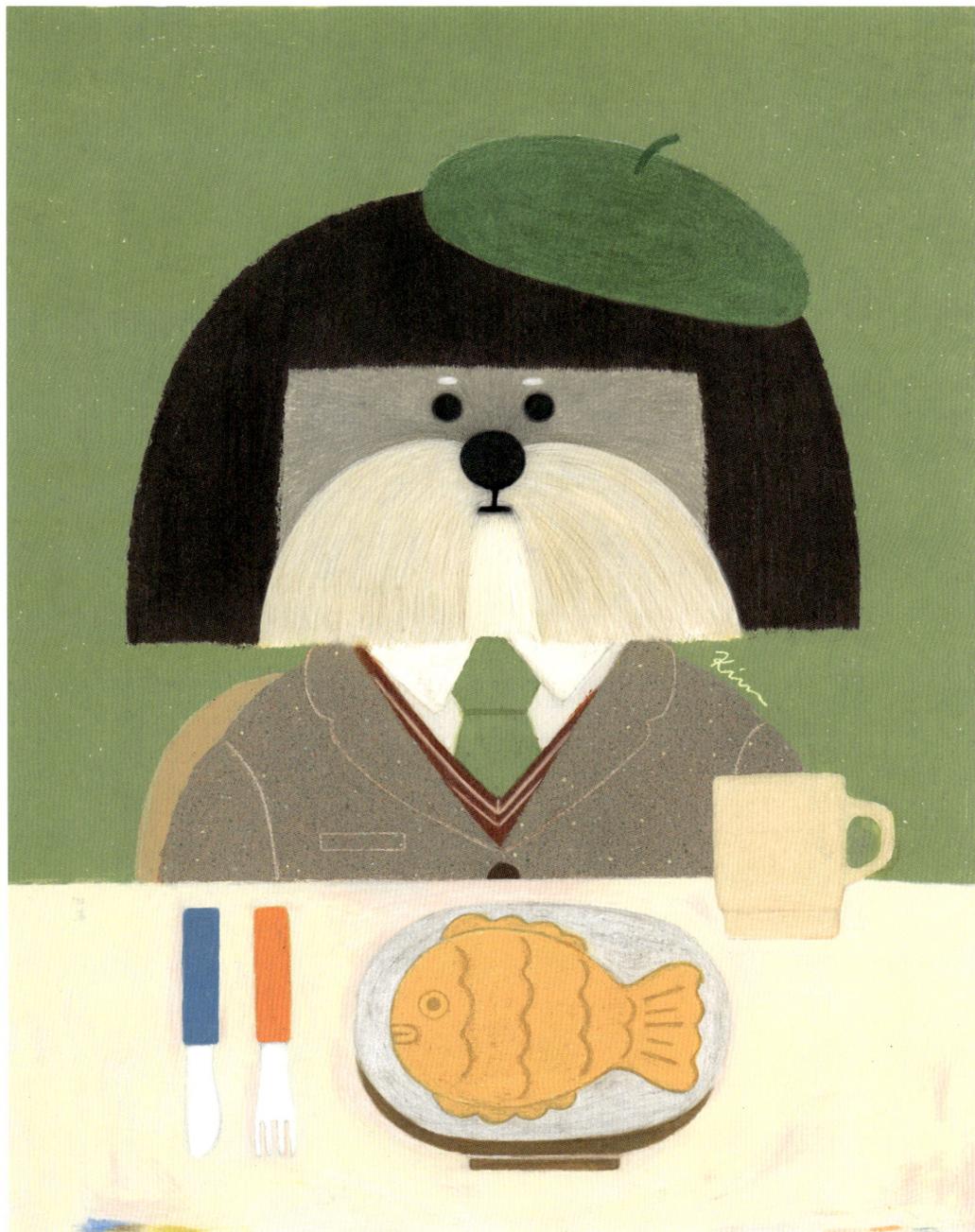

Changdeok And A Fish-Shaped Bun
520 x 400 mm, Oil Pastels, Coloured Pencils, Paper

Olivia Pecini

Olivia Pecini is an illustrator and animator originally from New York, now based in Los Angeles. She has worked professionally as a background painter, storyboard artist, colour designer, and comic book colourist. In her free time, she creates whimsical, vibrant colour pencil illustrations.

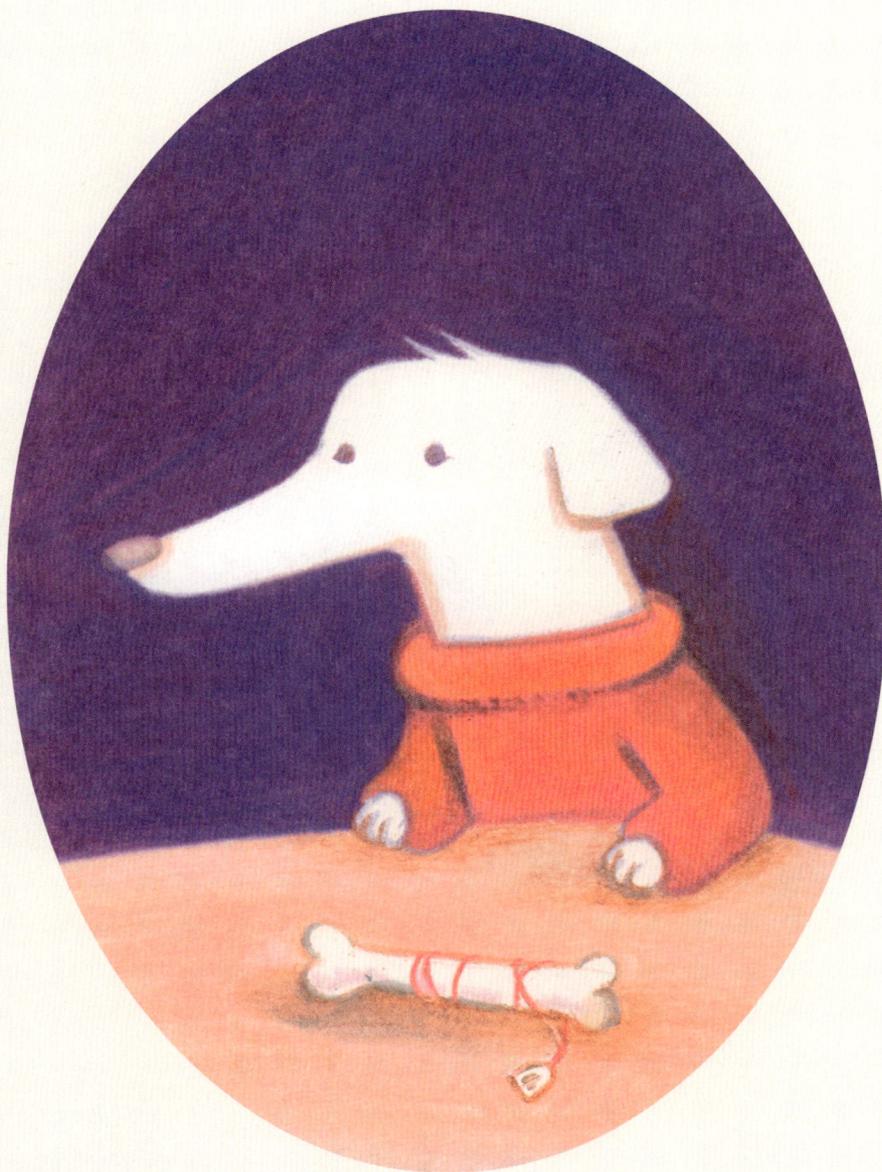

The Gift
127 x 177.8 mm, Coloured Pencils, Digital

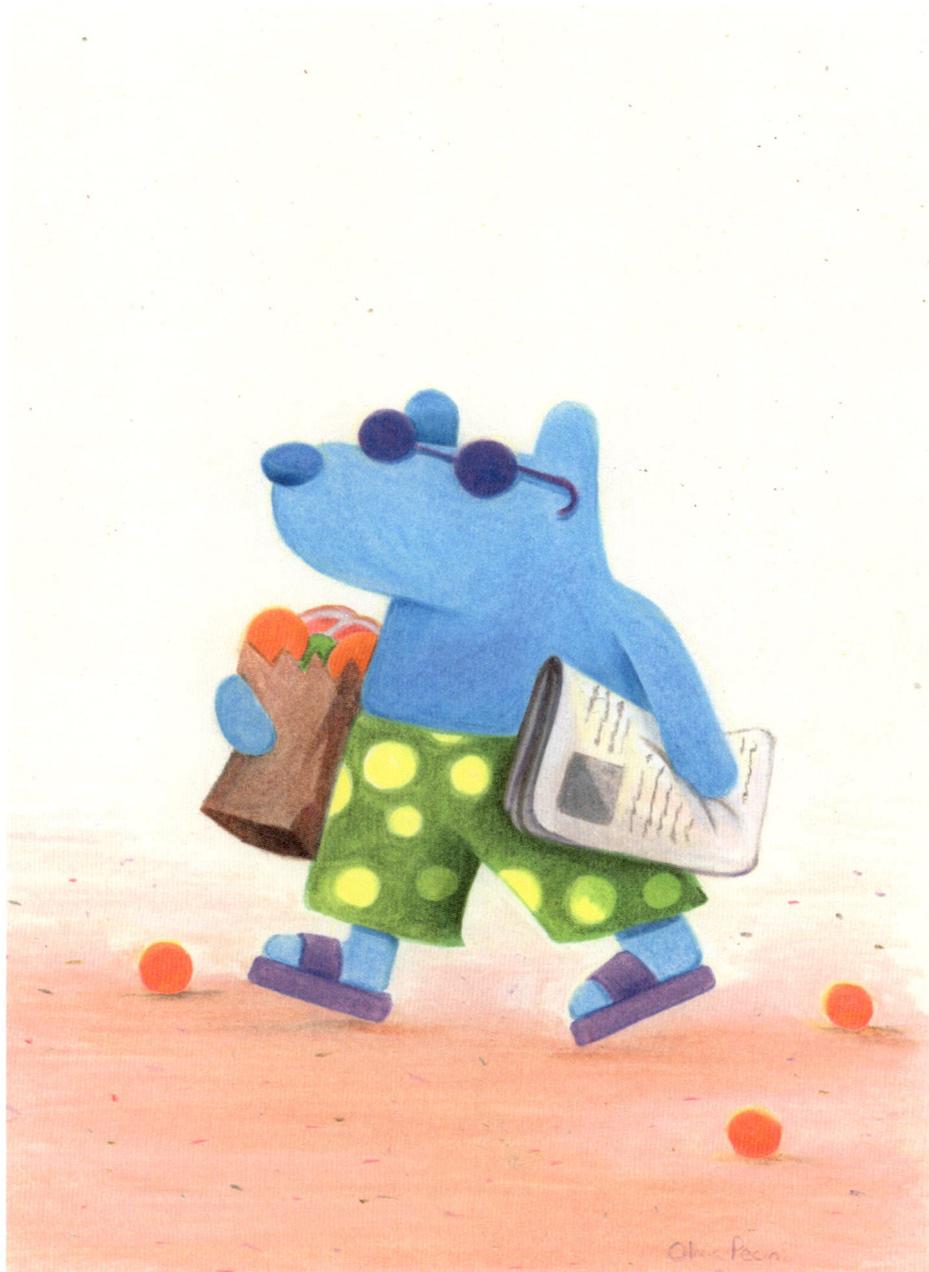

Errands (↑)
127 x 177.8 mm, Coloured Pencils, Digital

Poodle (→)
127 x 177.8 mm, Coloured Pencils, Digital

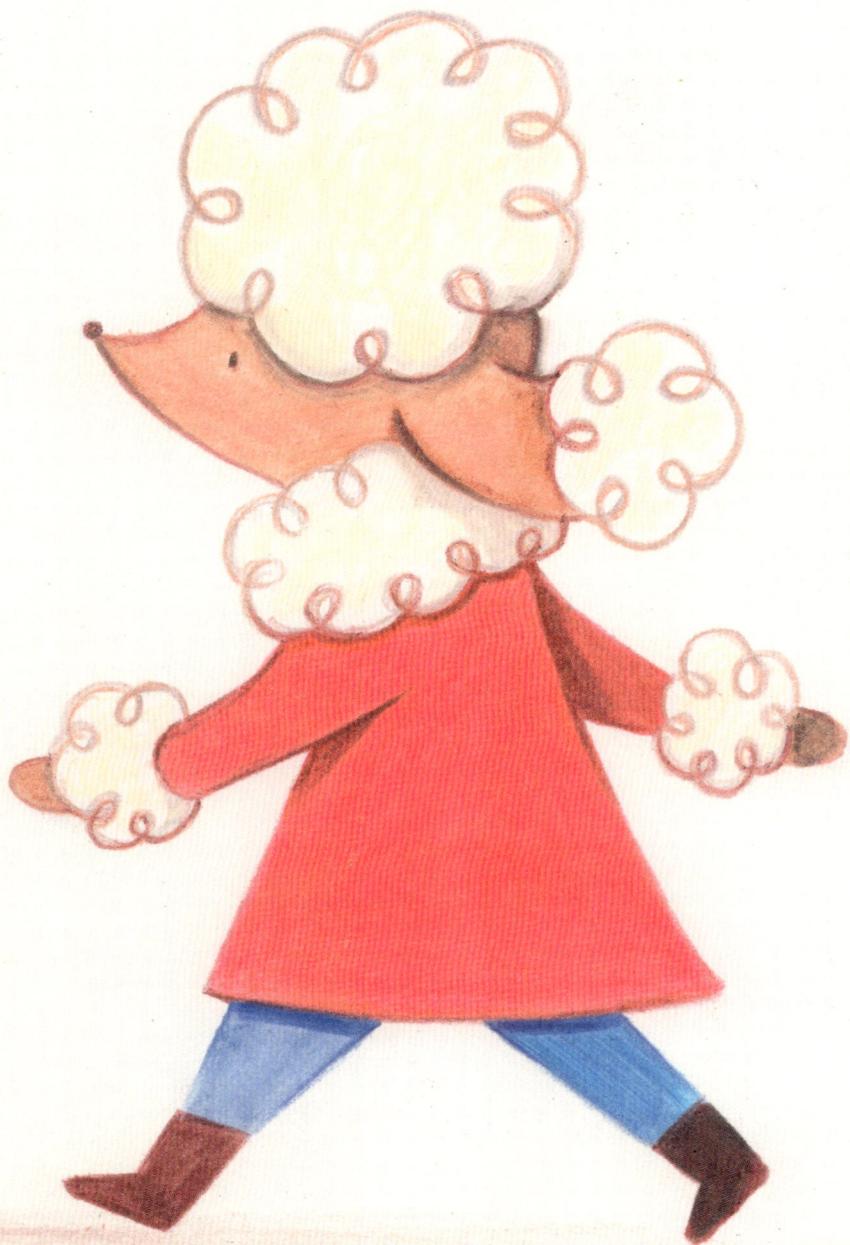

Dog With Steak
177.8 x 127 mm,
Coloured Pencils, Digital

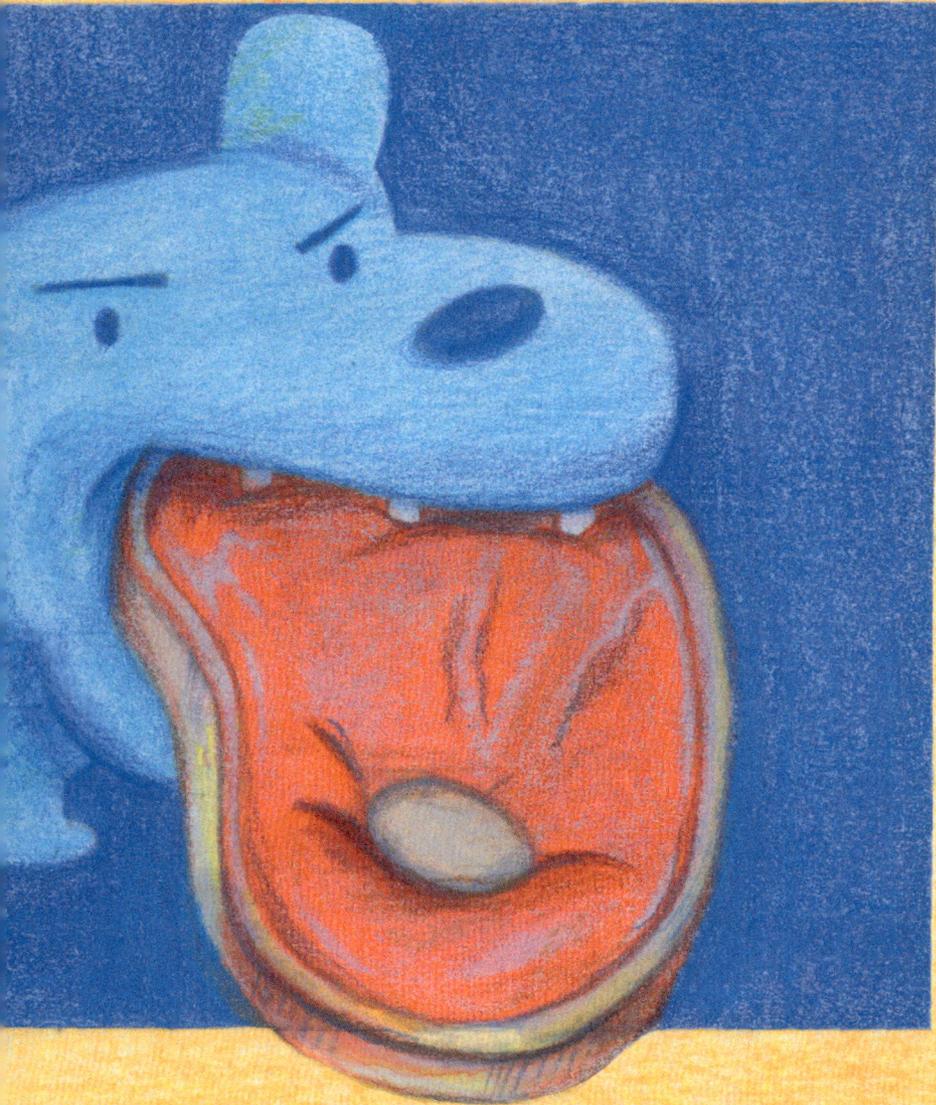

Shiori Tamura

Shiori Tamura is an illustrator and graphic designer based in Tokyo who primarily uses crayons to create illustrations featuring food, animals, plants, and everyday objects. She aims to make familiar things a bit more special, producing simple yet memorable illustrations daily.

shioritamura.com

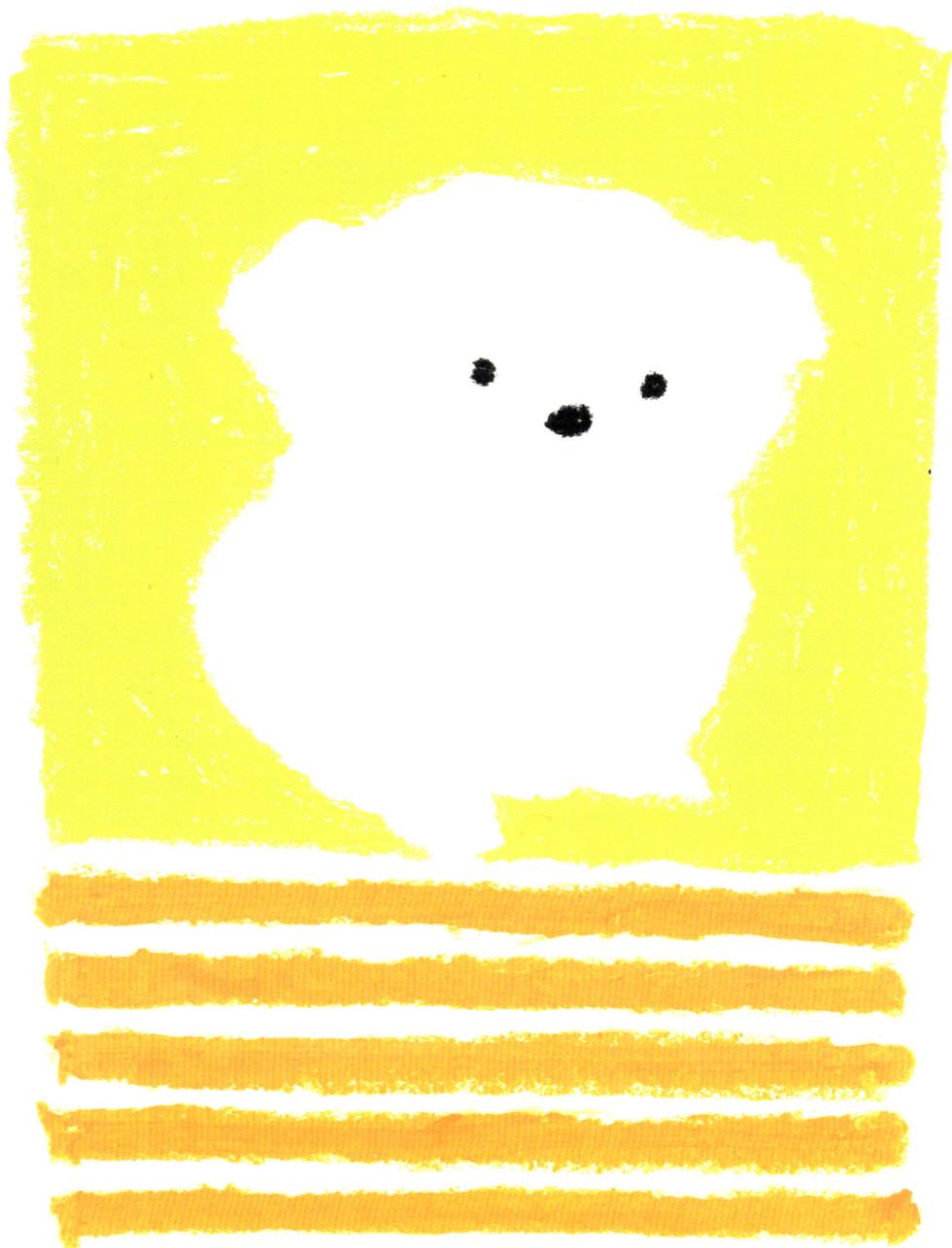

White Dog
330.96 x 444.42 mm, Crayons

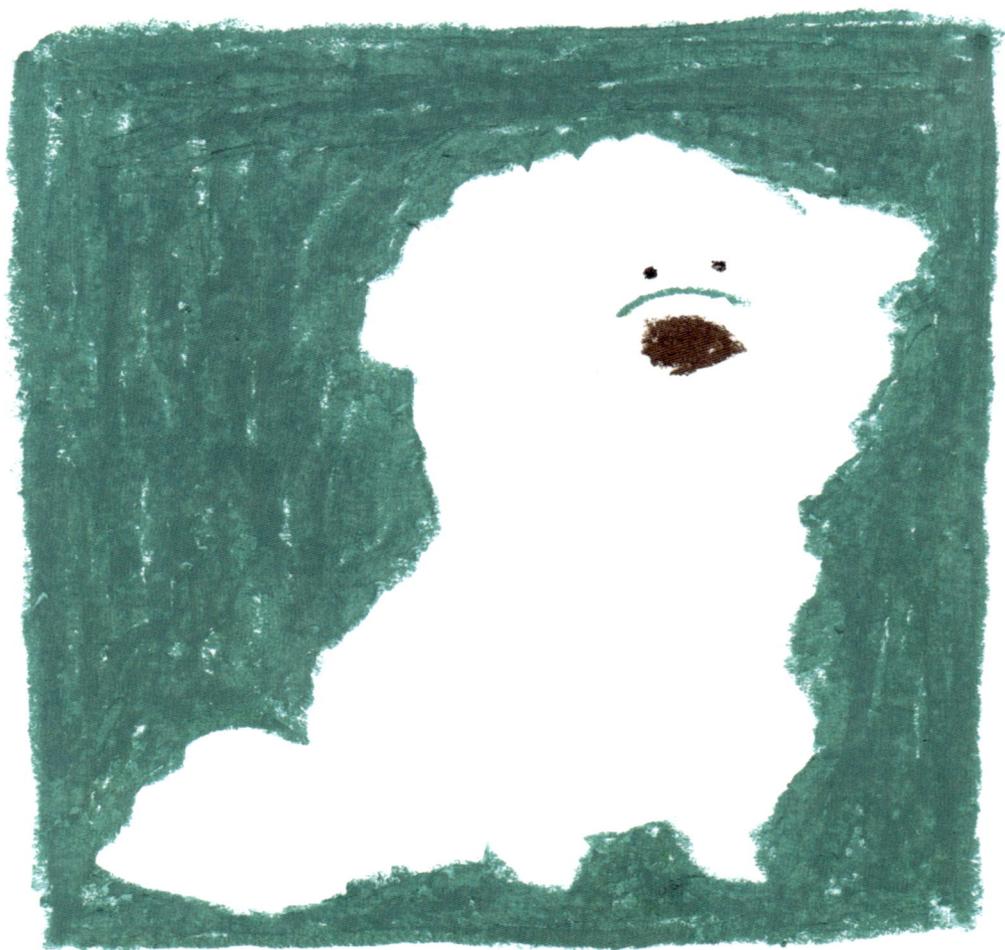

Dog On The Lawn
218.19 x 222.67 mm, Crayons

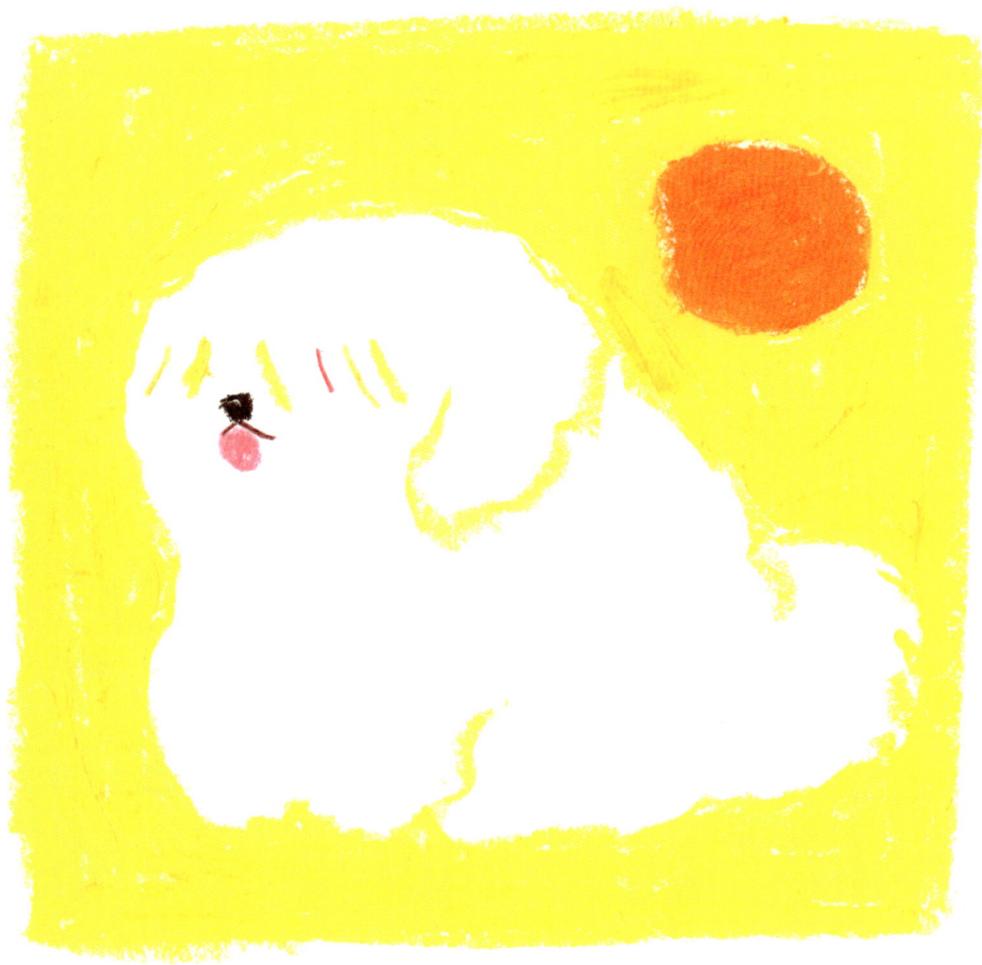

Fluffy Puppy
110.74 x 110.74 mm, Crayons

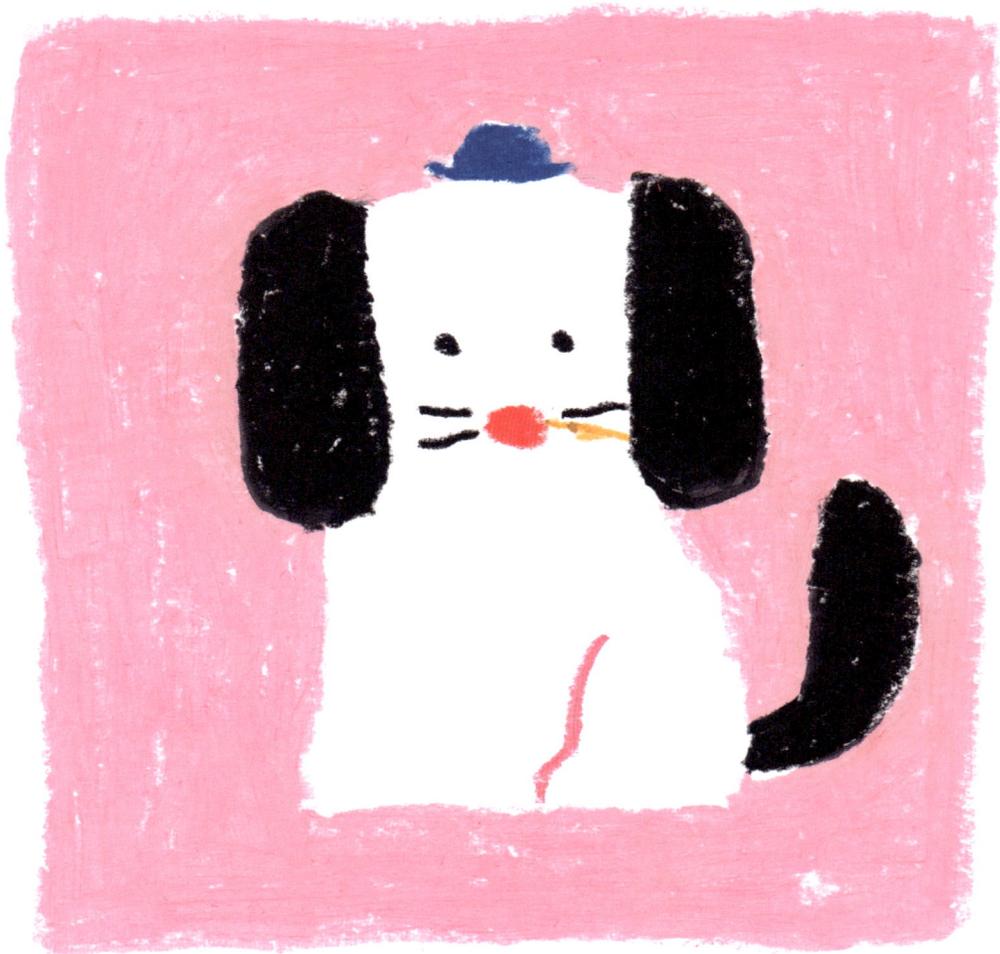

Look At Me
237.57 x 237.57 mm, Crayons

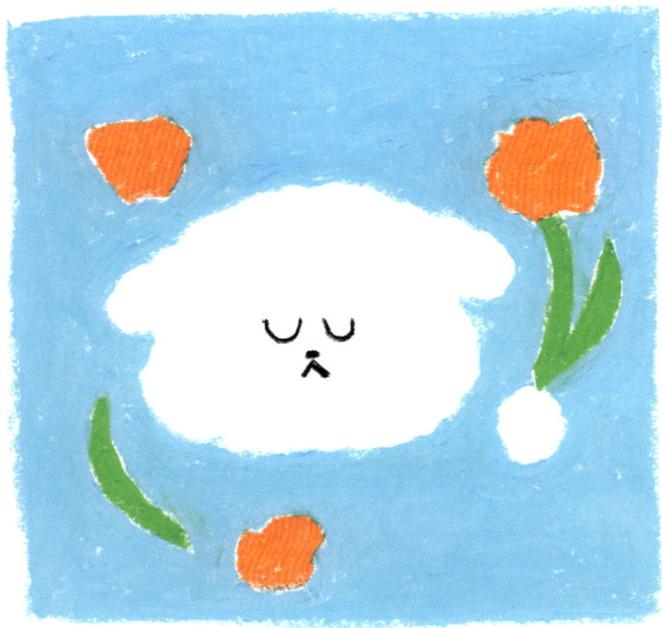

Flower & Dog
241.98 x 238.68 mm, Crayons

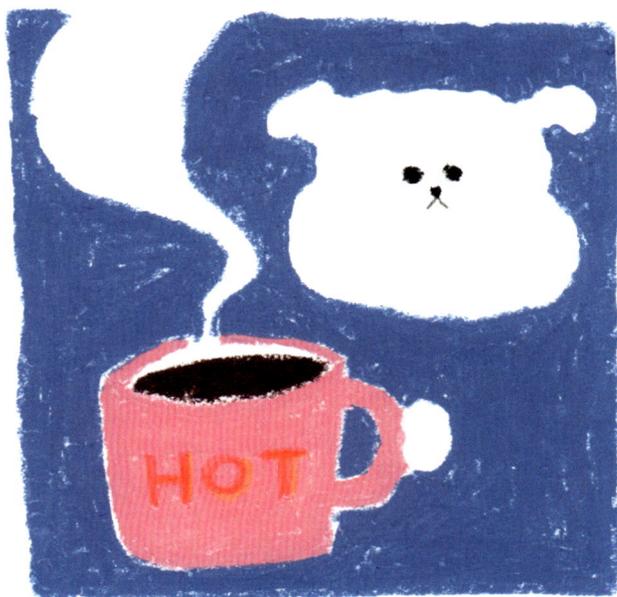

Coffee & Dog
214.12 x 210.99 mm, Crayons

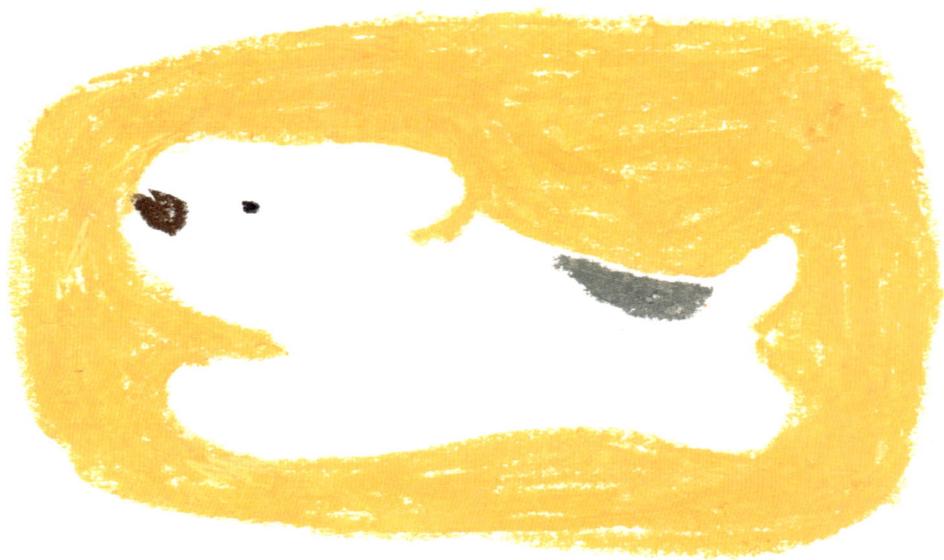

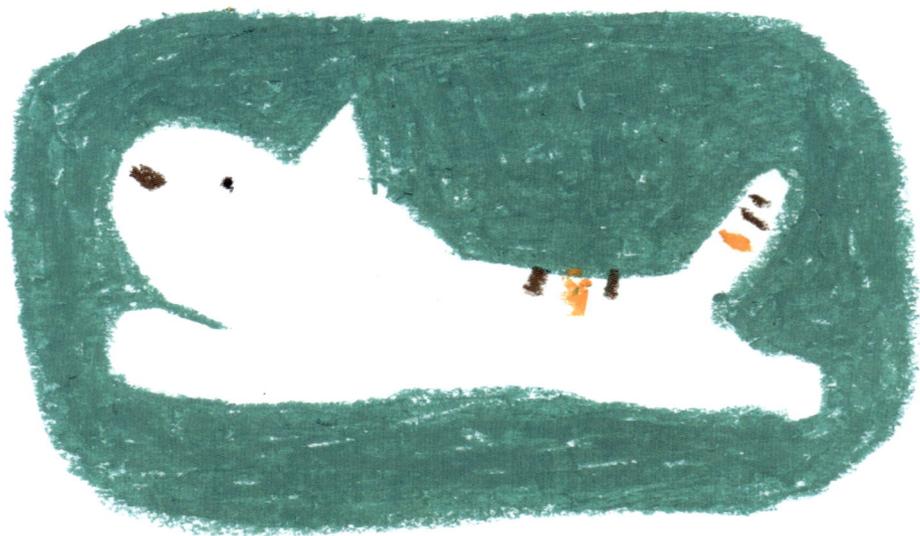

Running Dog
243.16 x 297.1 mm, Crayons

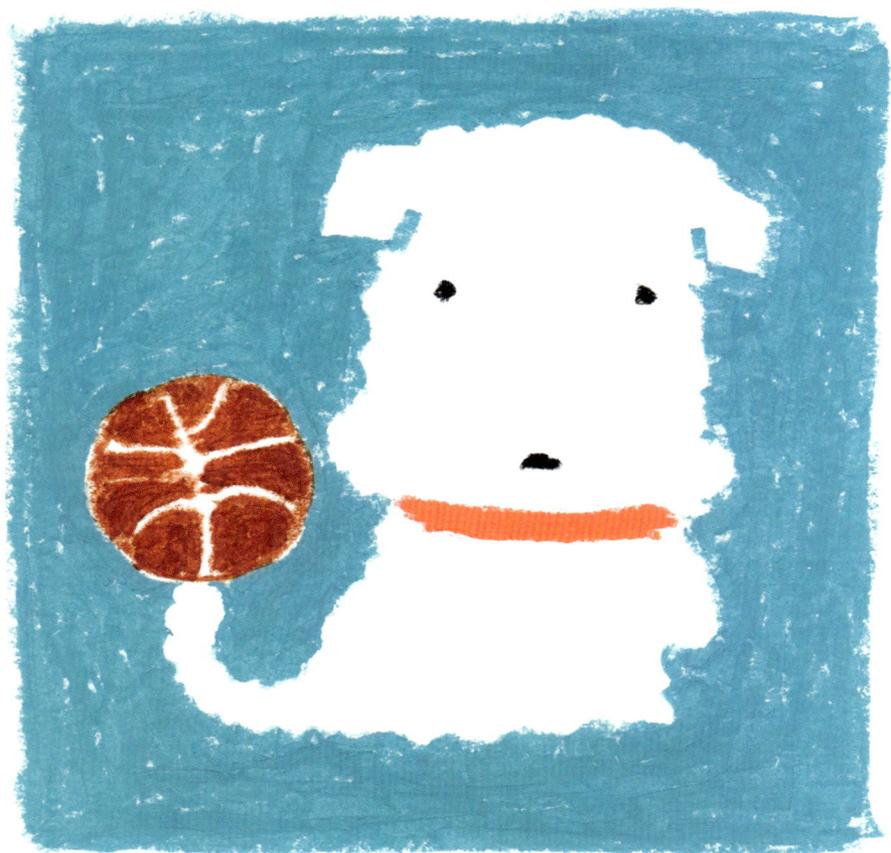

Play With A Ball
549.99 x 549.99 mm, Crayons

147

Christian
Leon
Guerrero

christianleonguerrero.com

Christian Leon Guerrero is a freelance illustrator and fine artist in Los Angeles who earned his Bachelor of Arts degree from the California College of the Arts. His choice of medium is a diverse range of traditional materials. He strives to depict dreamy and nostalgic imagery through colour, shape, and form.

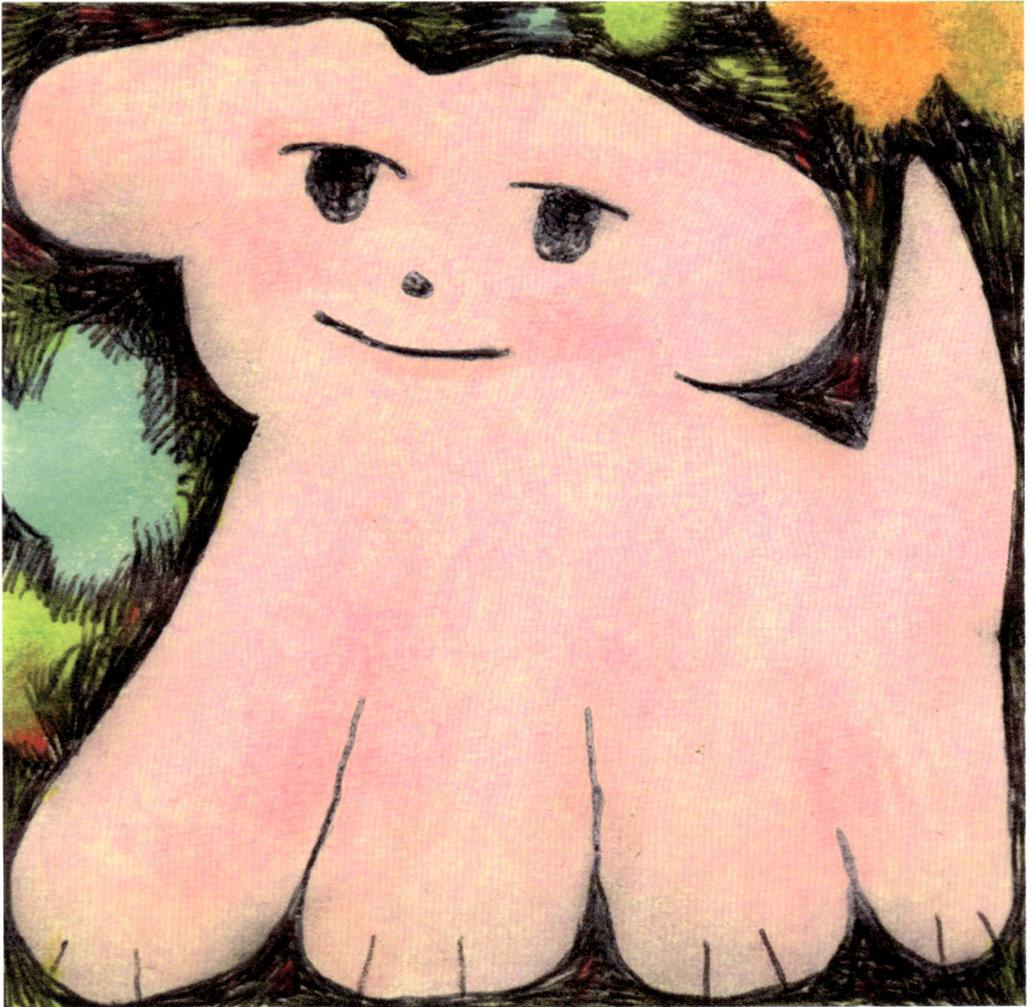

Spam Dog
76.2 x 76.2 mm, Coloured Pencils

I See You
203 x 203 mm, Coloured Pencils

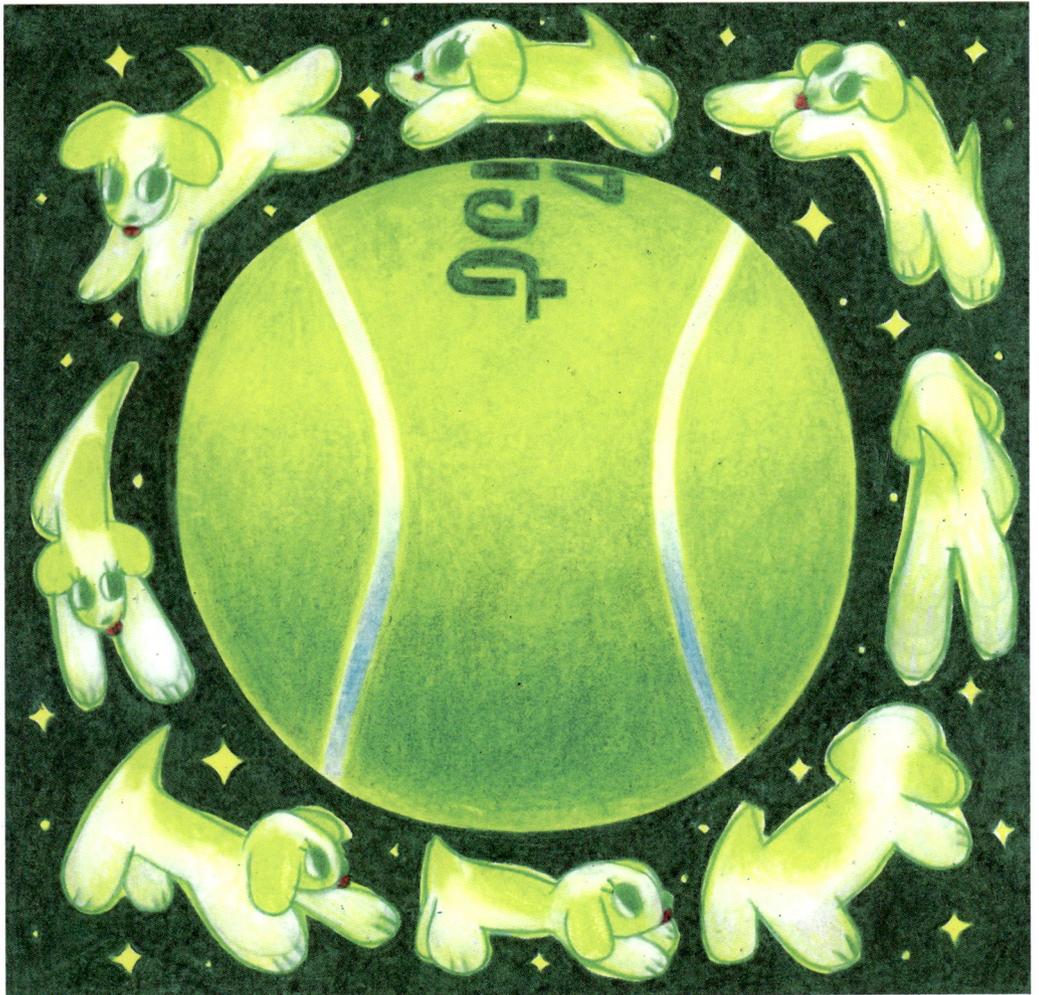

Puppy Love
203 x 203 mm, Coloured Pencils

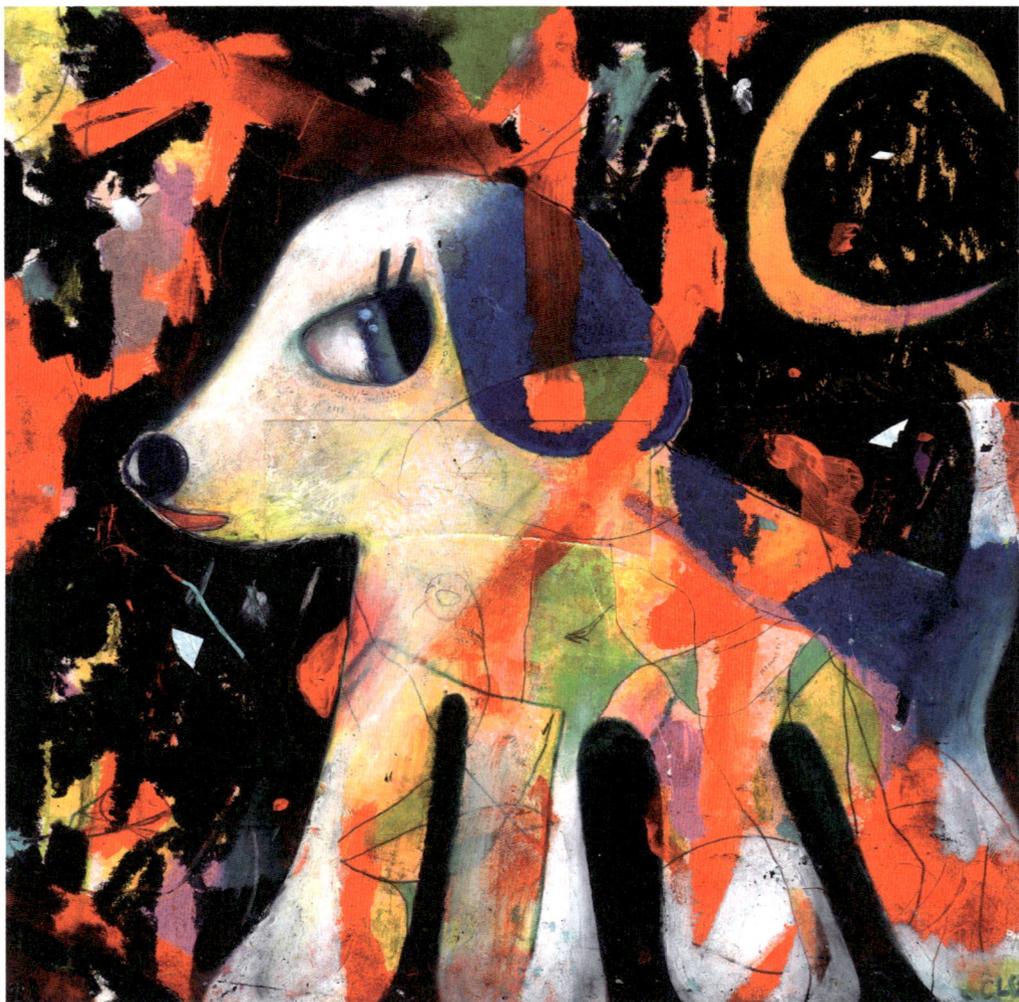

Shaved Ice
203 x 203 mm, Coloured Pencils

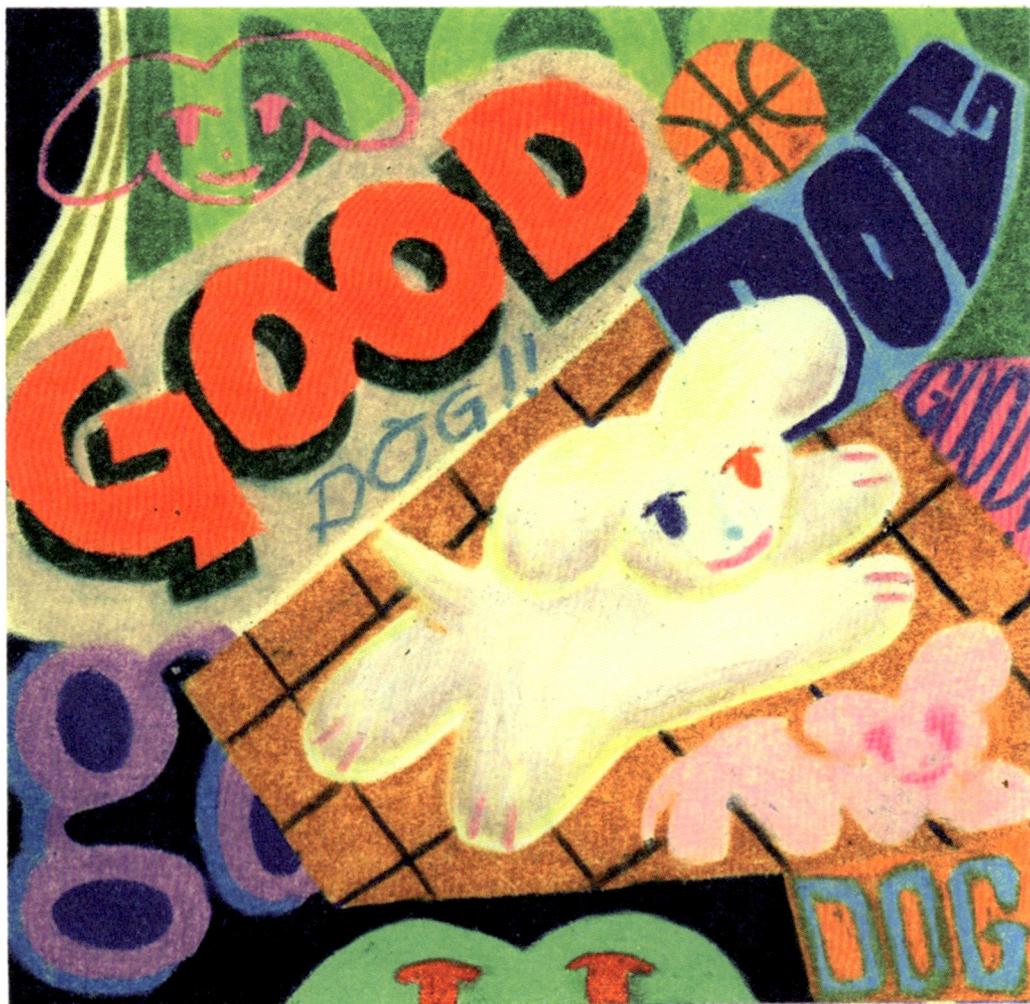

Good Dog #2
76.2 x 76.2 mm, Coloured Pencils

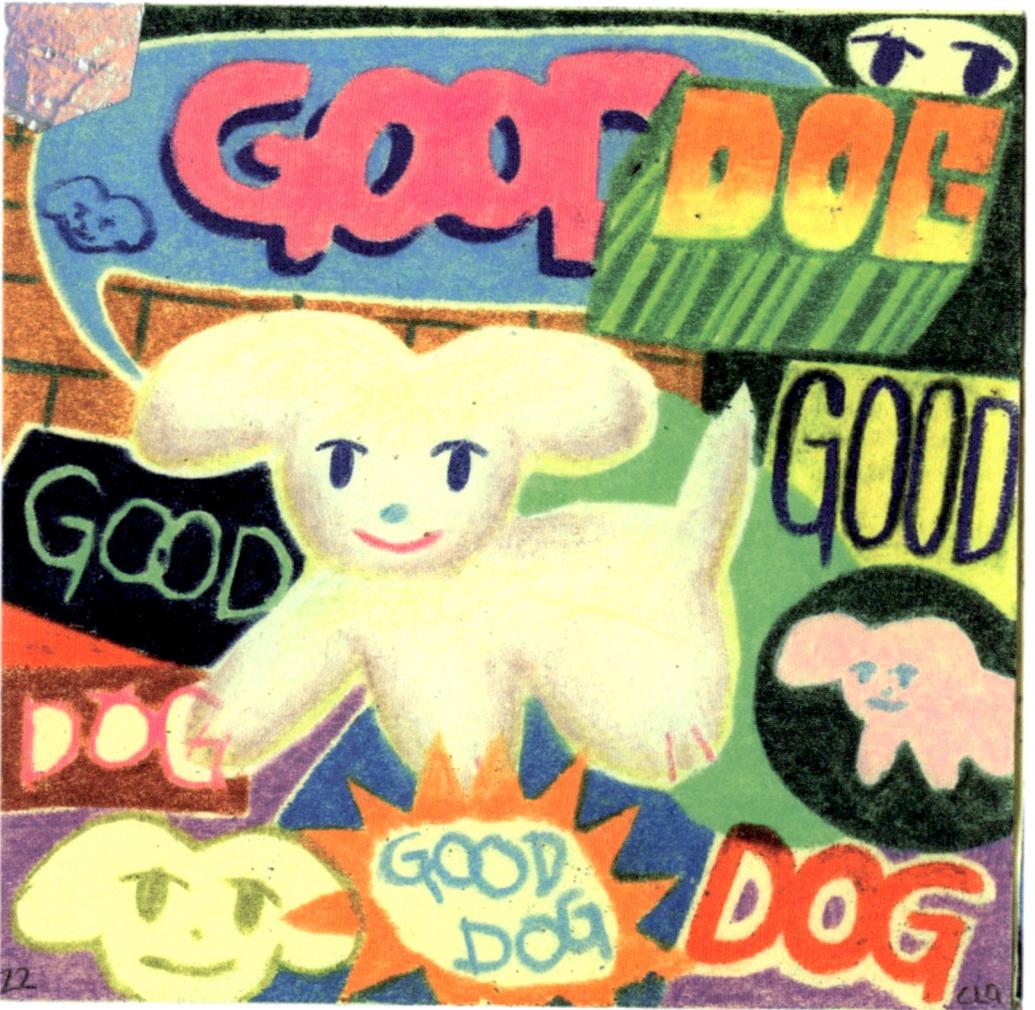

154

Good Dog #1
76.2 x 76.2 mm, Coloured Pencils

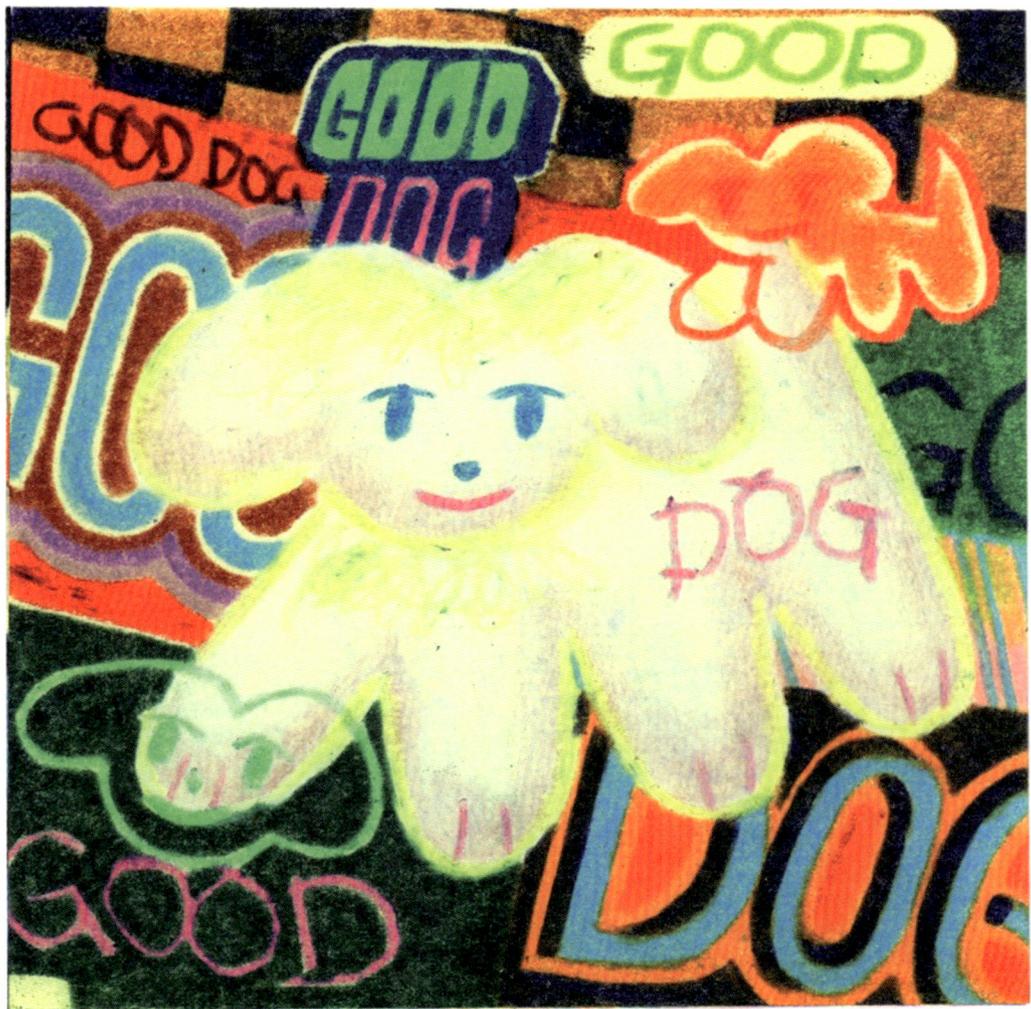

Good Dog #3
76.2 x 76.2 mm, Coloured Pencils

Andy Shaw, a contemporary artist blending pop, abstract, and realism, has been a best-seller on Saatchi Art since 2016. His work is in collections of notable figures like David Bowie and Marco Pierre White, and has been exhibited in prestigious venues worldwide. He has also collaborated with White on restaurant paintings and exhibited with Andy Warhol in Quo Vadis.

saatchiart.com/andyshawart

ANDY SHAW

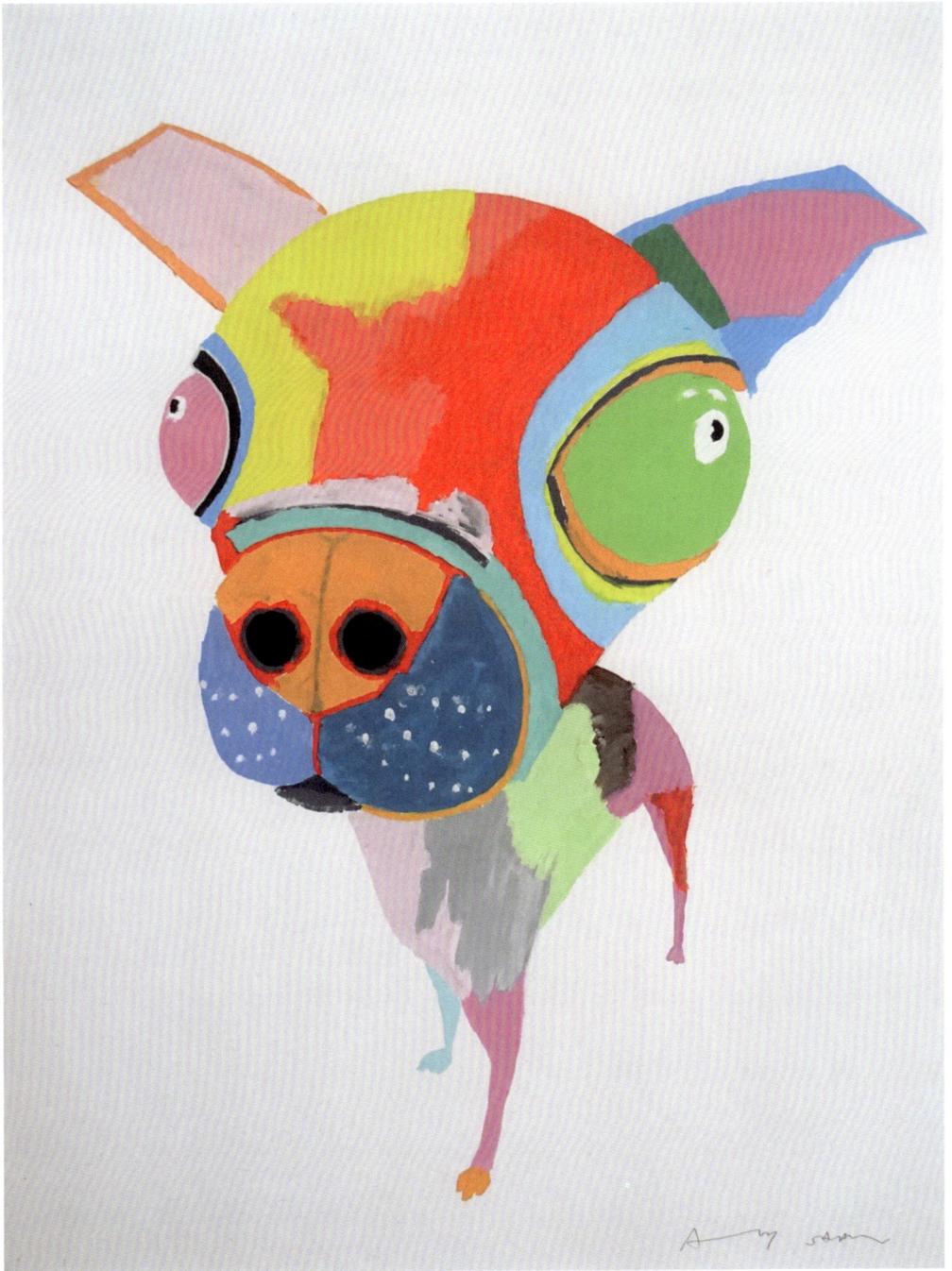

Chihuahua
420 x 580 mm, Acrylic, Paper

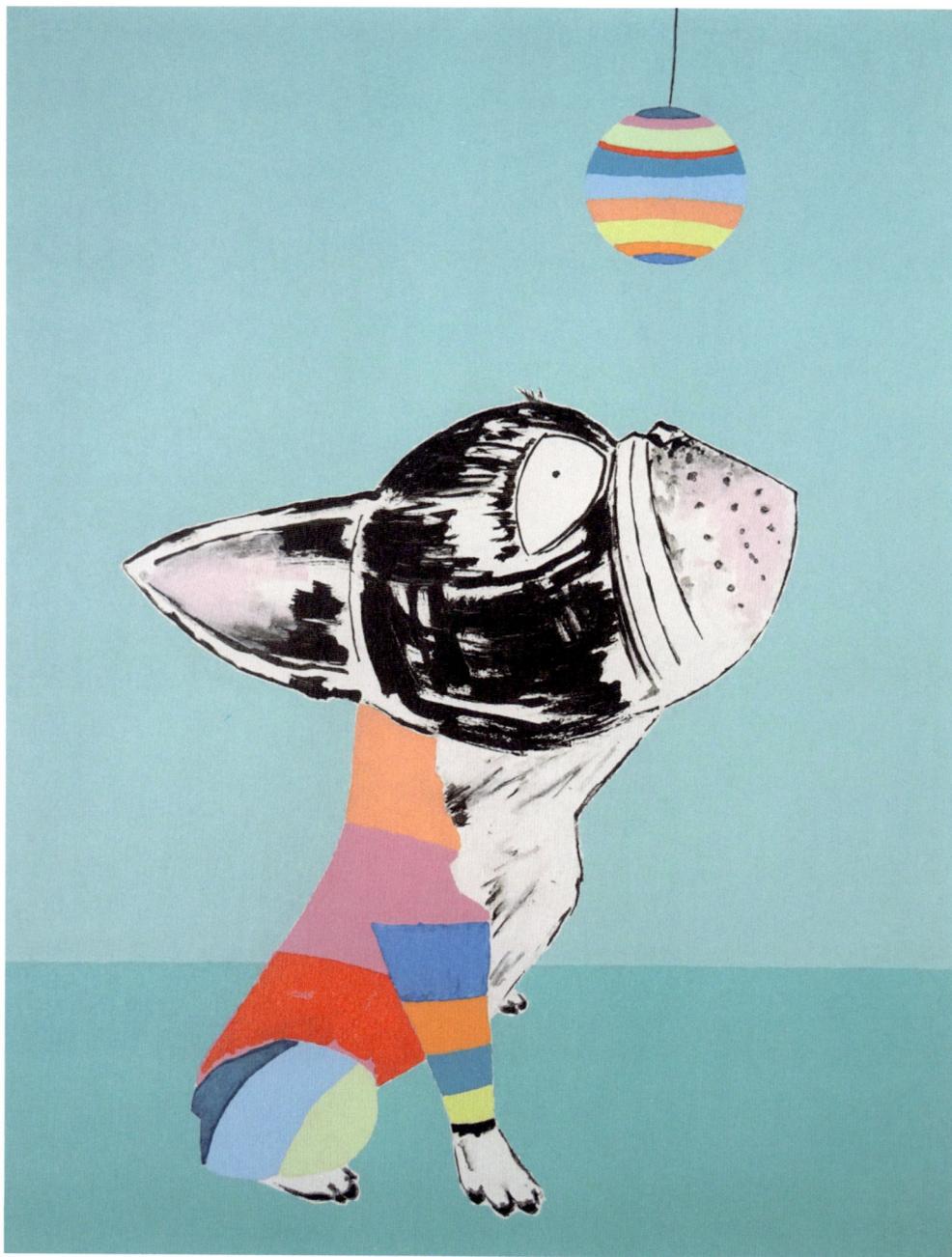

Boston Terrier 'Avin a Ball
450 x 600 mm, Acrylic, Canvas

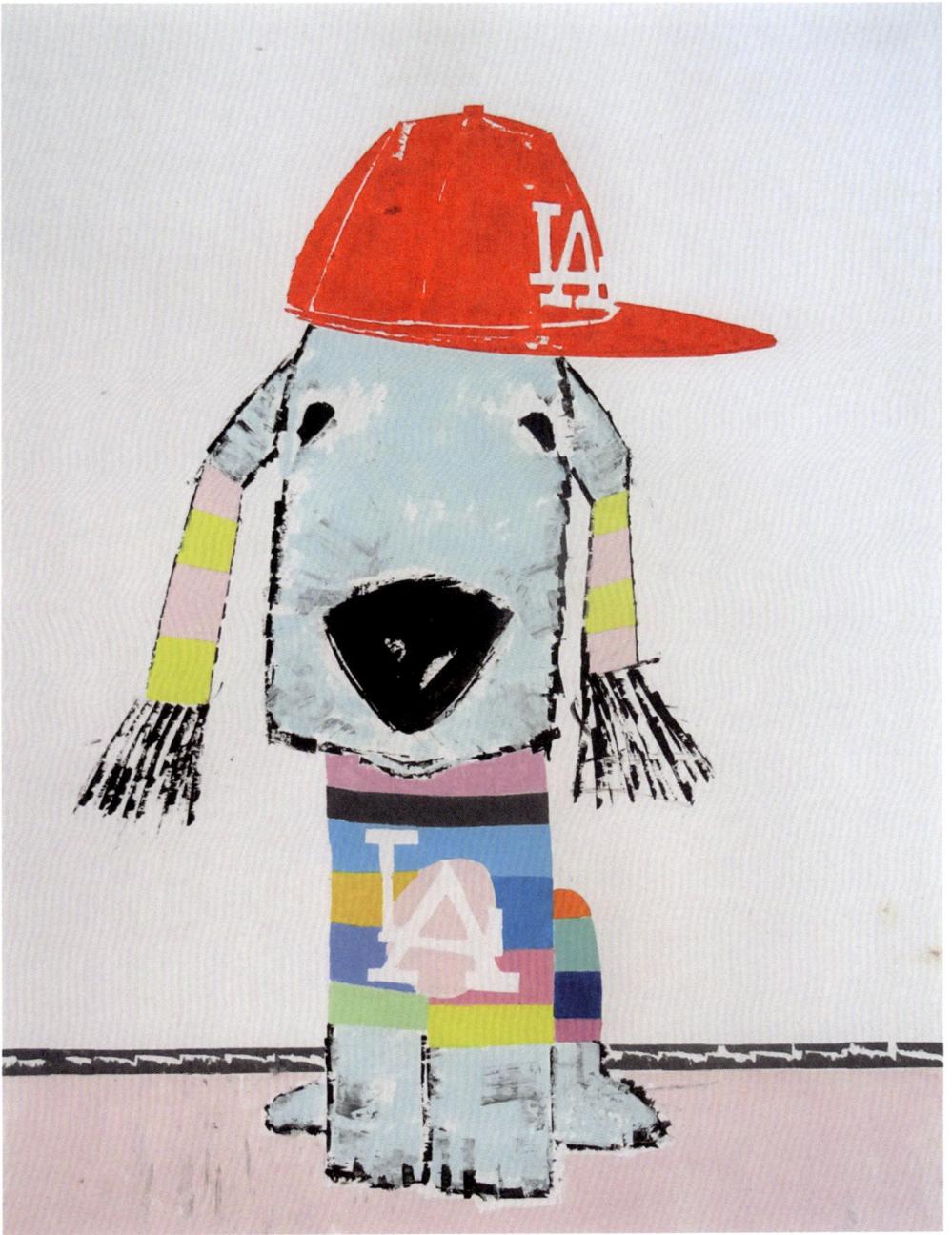

L.A. Dodgers Bedlington Terrier
490 x 700 mm, Acrylic, Paper

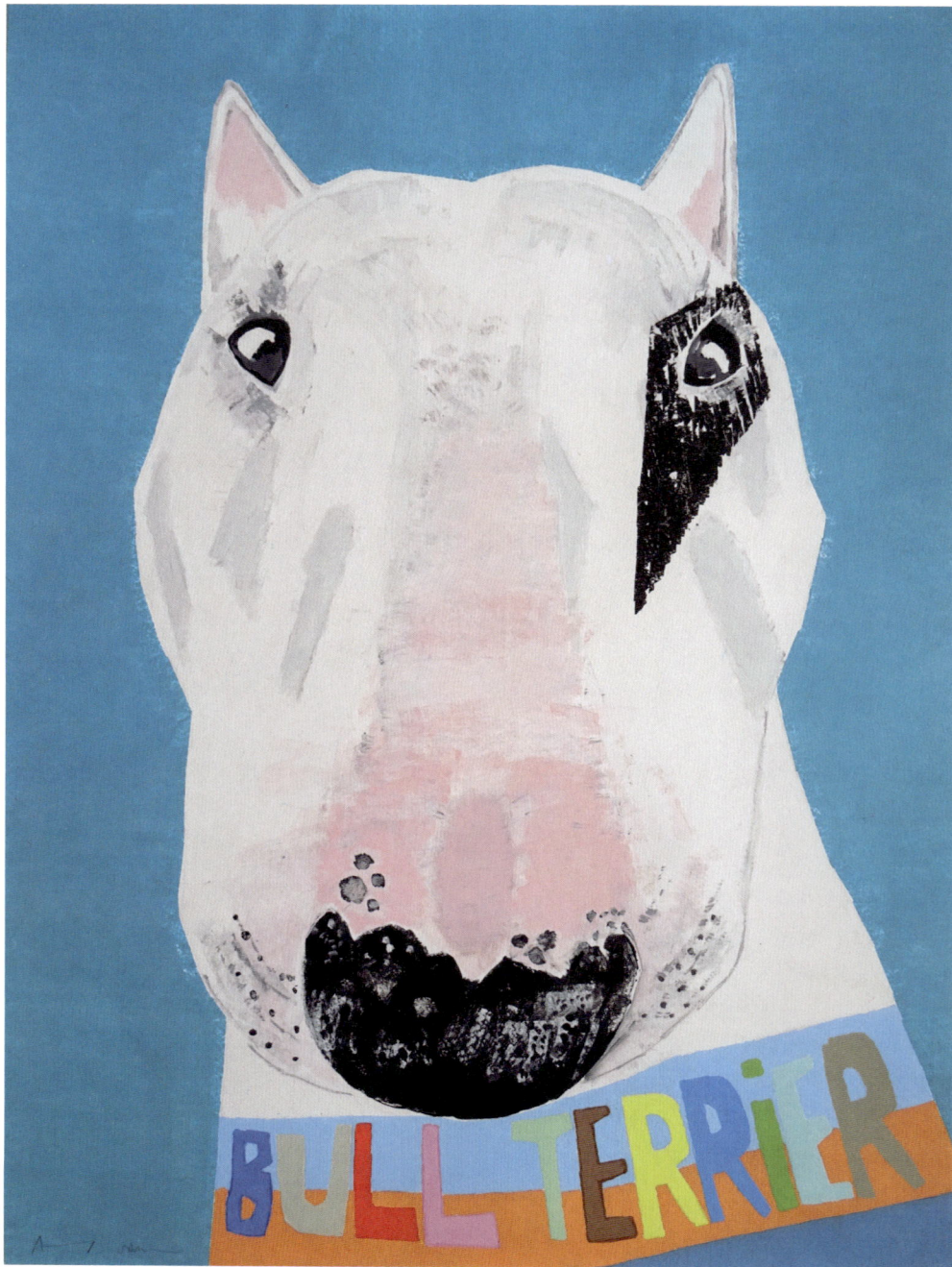

160

Bull Terrier
440 x 600 mm, Acrylic, Paper

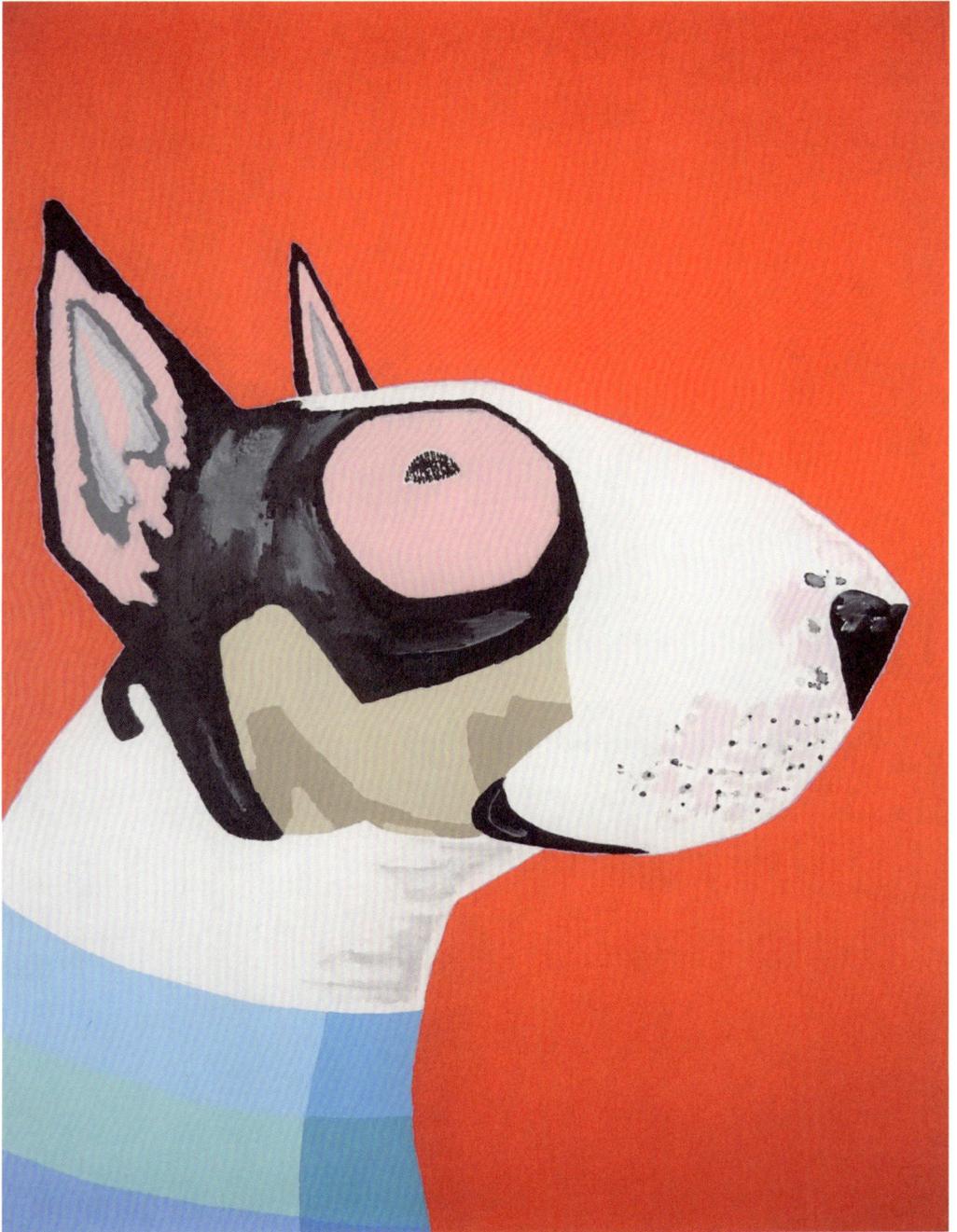

Bull Terrier
440 x 600 mm, Acrylic, Paper

Leandro
Alzate

Leandro Alzate, originally from Bilbao, Spain, studied Arts
there and now lives in Barcelona after over a decade in Berlin.
As a freelance illustrator, he works with international clients,
drawing inspiration from the bizarre aspects of daily life. He
illustrated Anja Rützel's column in German magazine DOGS
from 2019 to 2022, chronicling life with her dog Juri.

leandroalzate.com

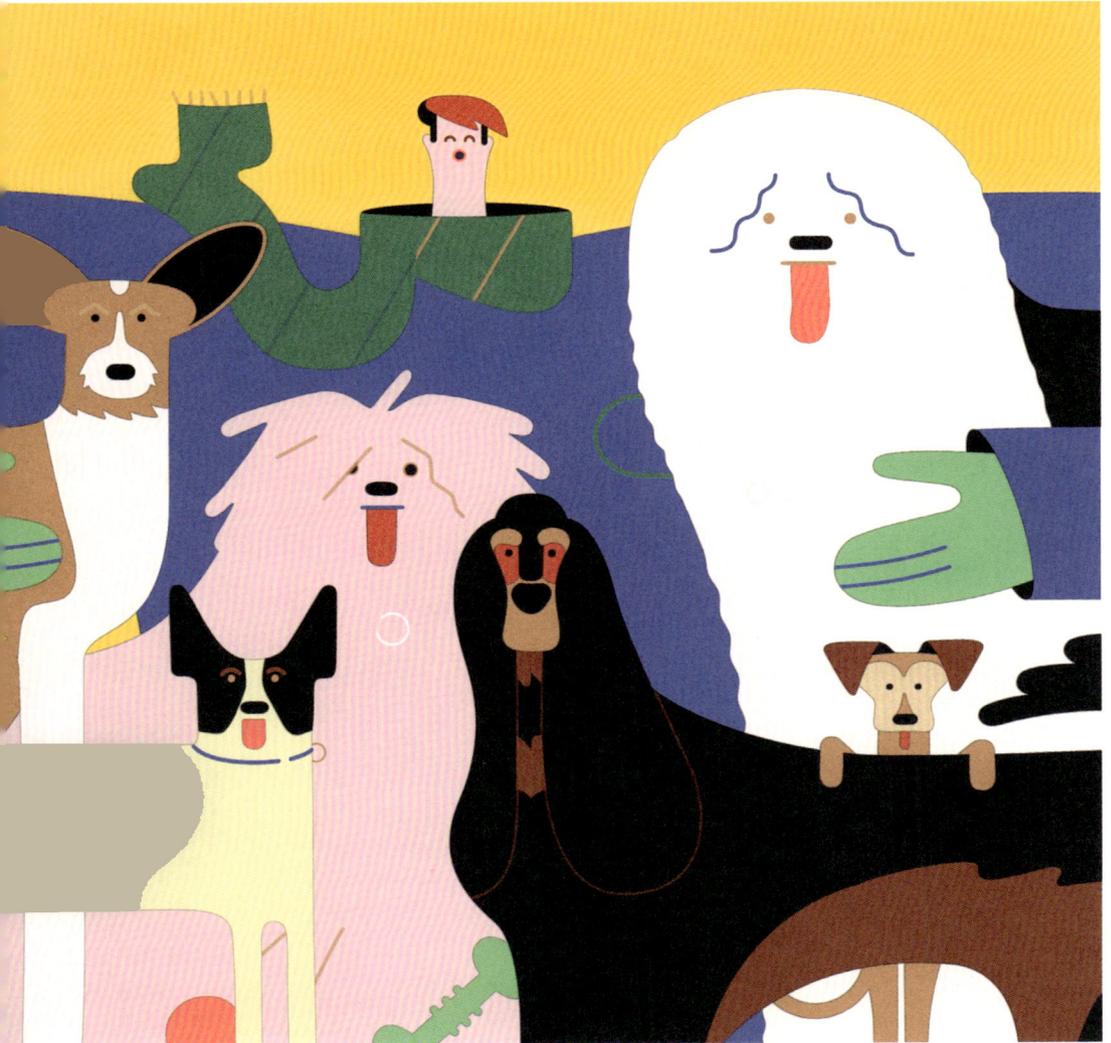

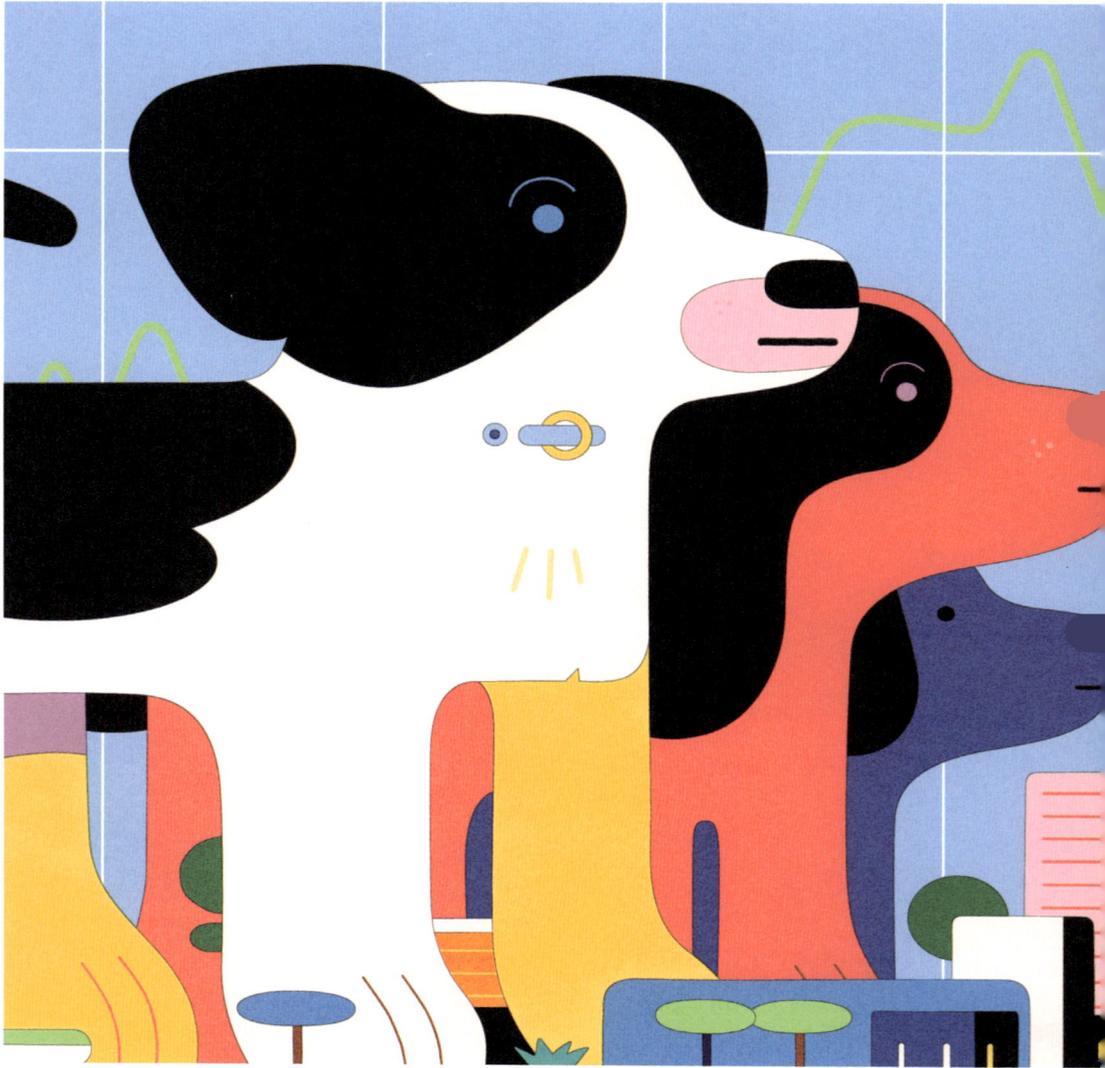

Puppies Take The City
257 x 214 mm, Digital, Client: DOGS Magazin

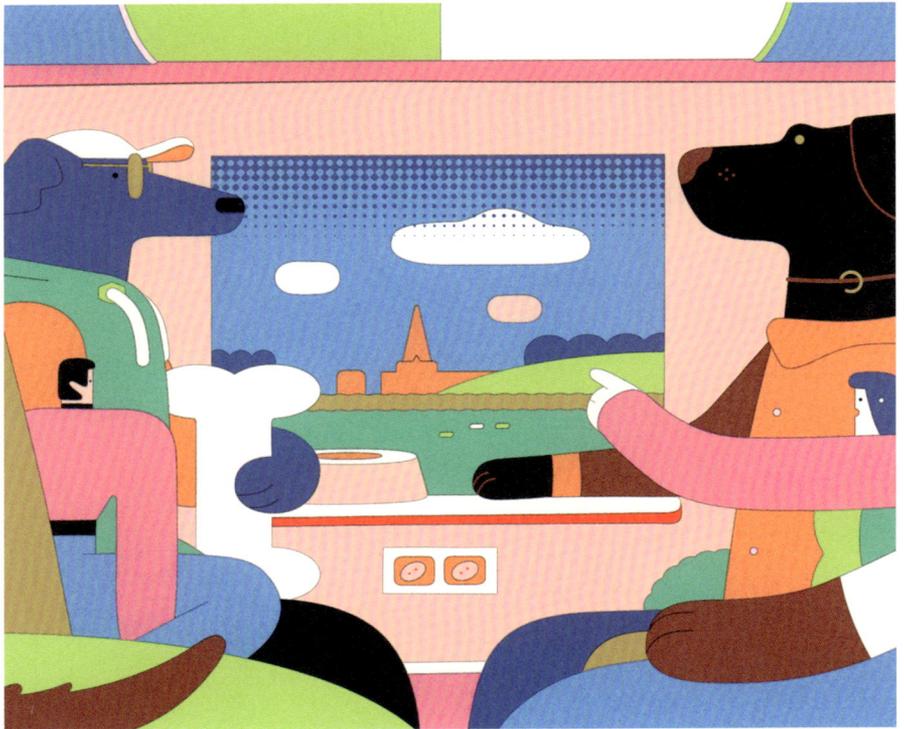

Dog Train Compartment
180 x 150 mm, Digital, Client: DOGS Magazin

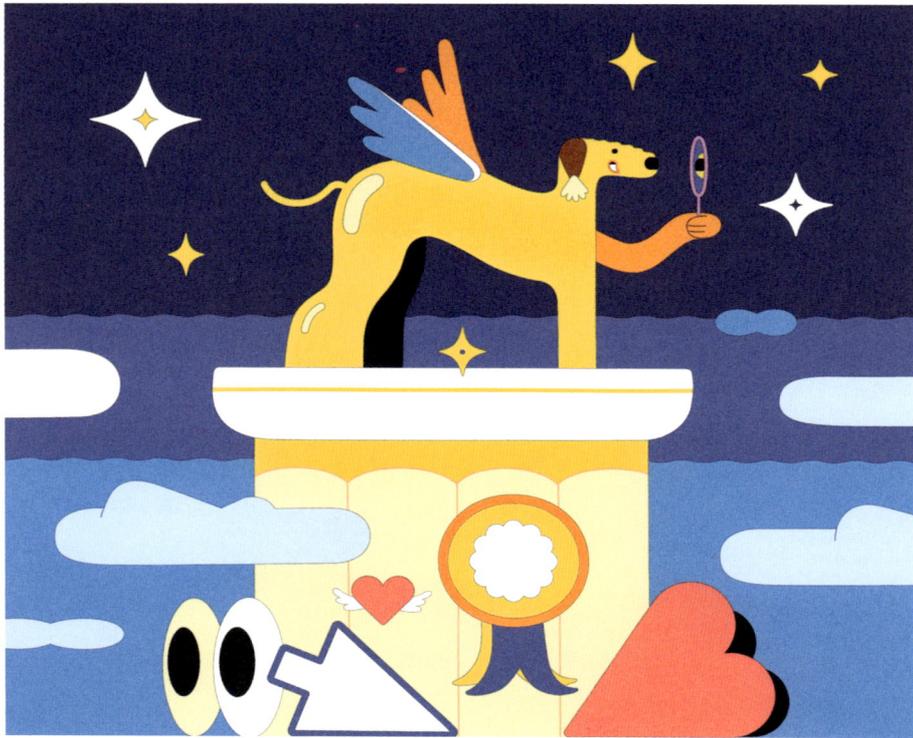

Idol Dog
257 x 214 mm, Digital, Client: DOGS Magazin

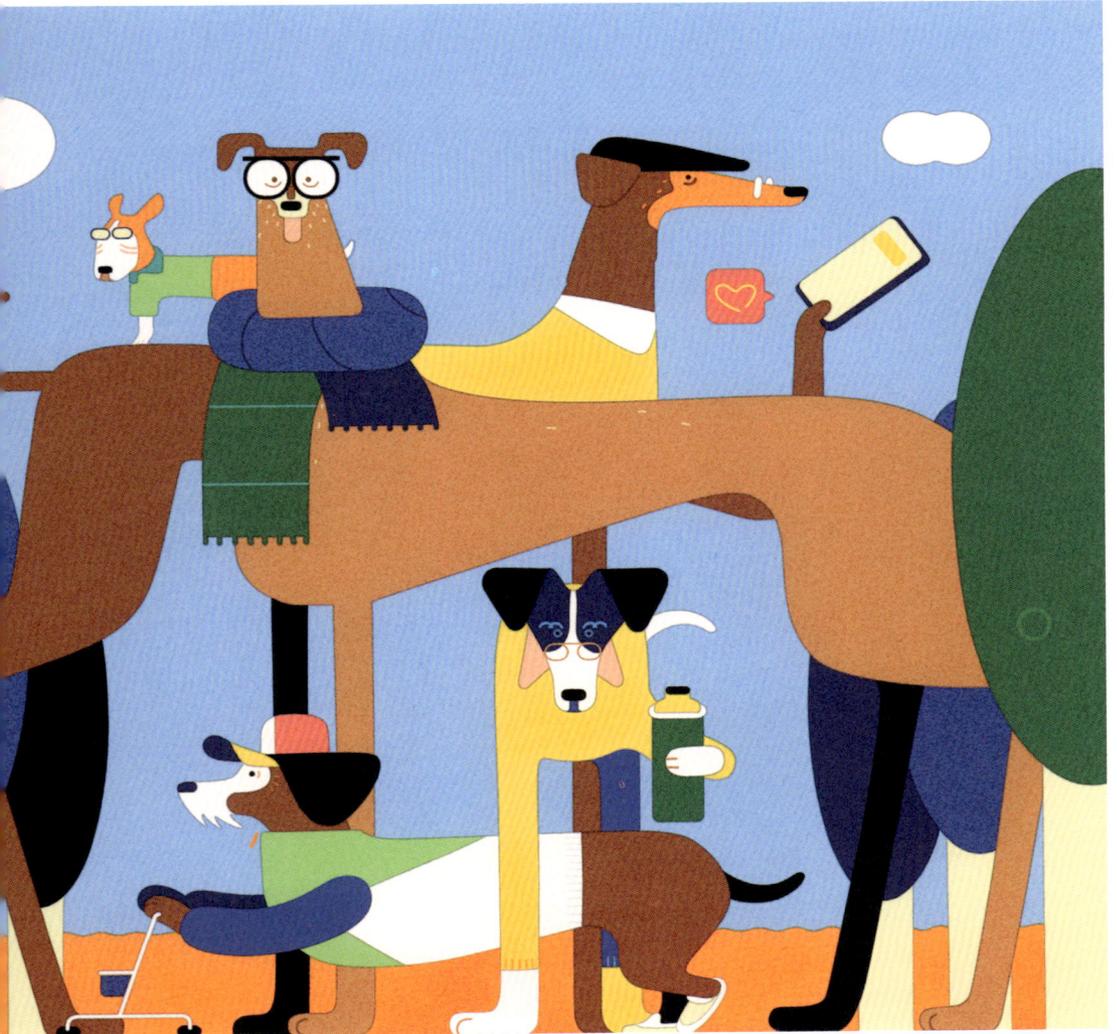

@iamdykim

Daye Kim is an illustrator based in Seoul known for creating fun and colourful images featuring people or animals as the main characters. She has collaborated with several well-known companies, including Adobe, Apple, and Samsung.

Daye Kim

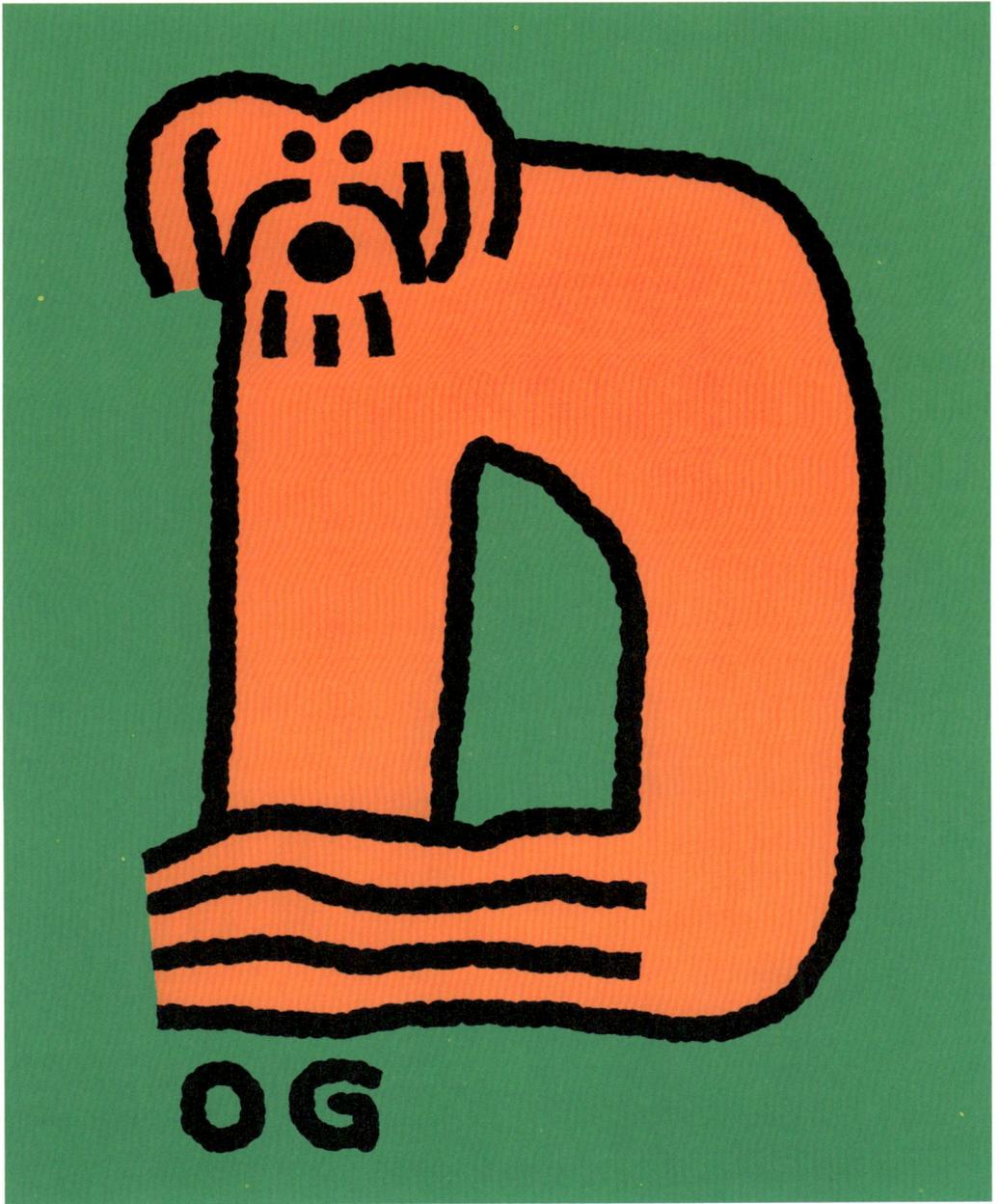

Start With D
211 x 264 mm, Digital

169

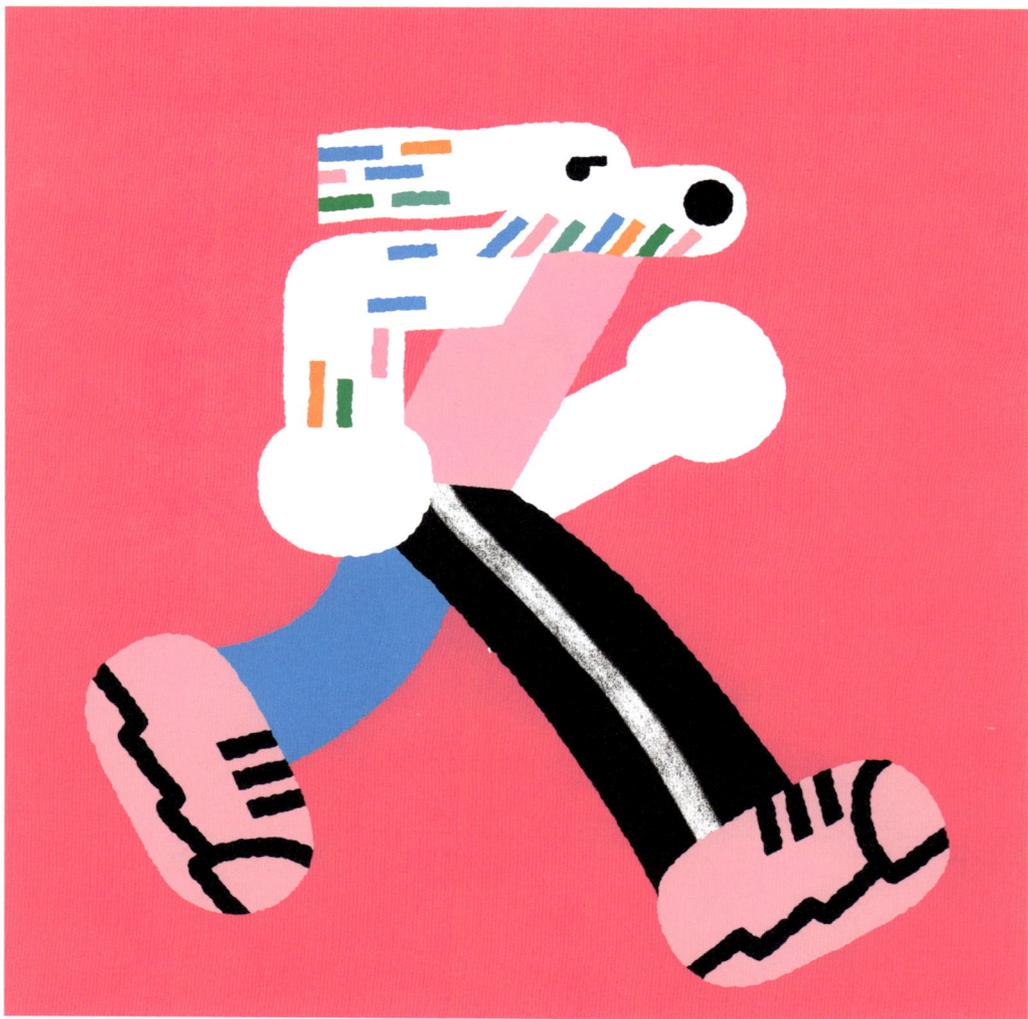

Run Run Run
274 x 300 mm, Digital

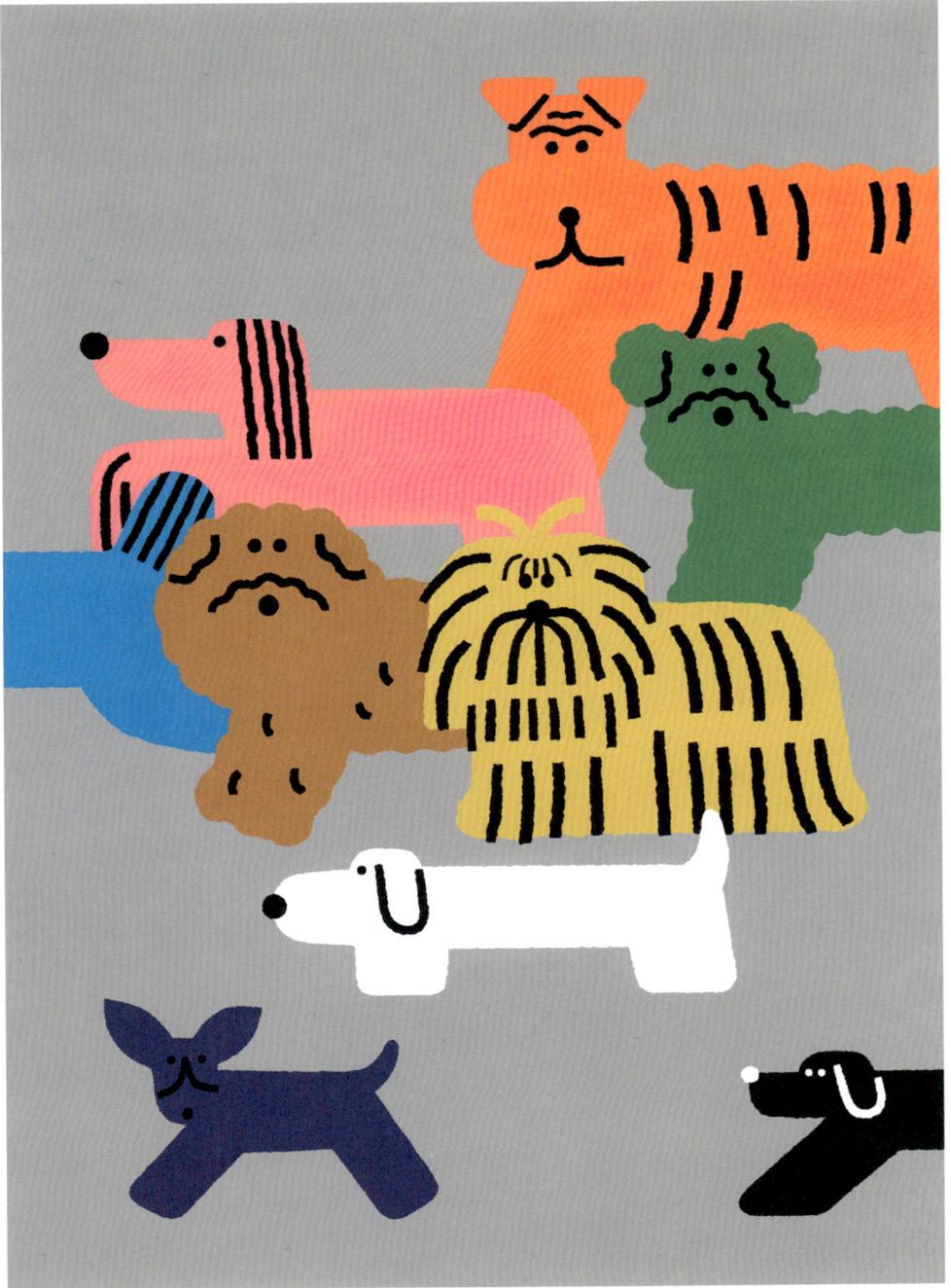

Woof
210 x 297 mm, Digital

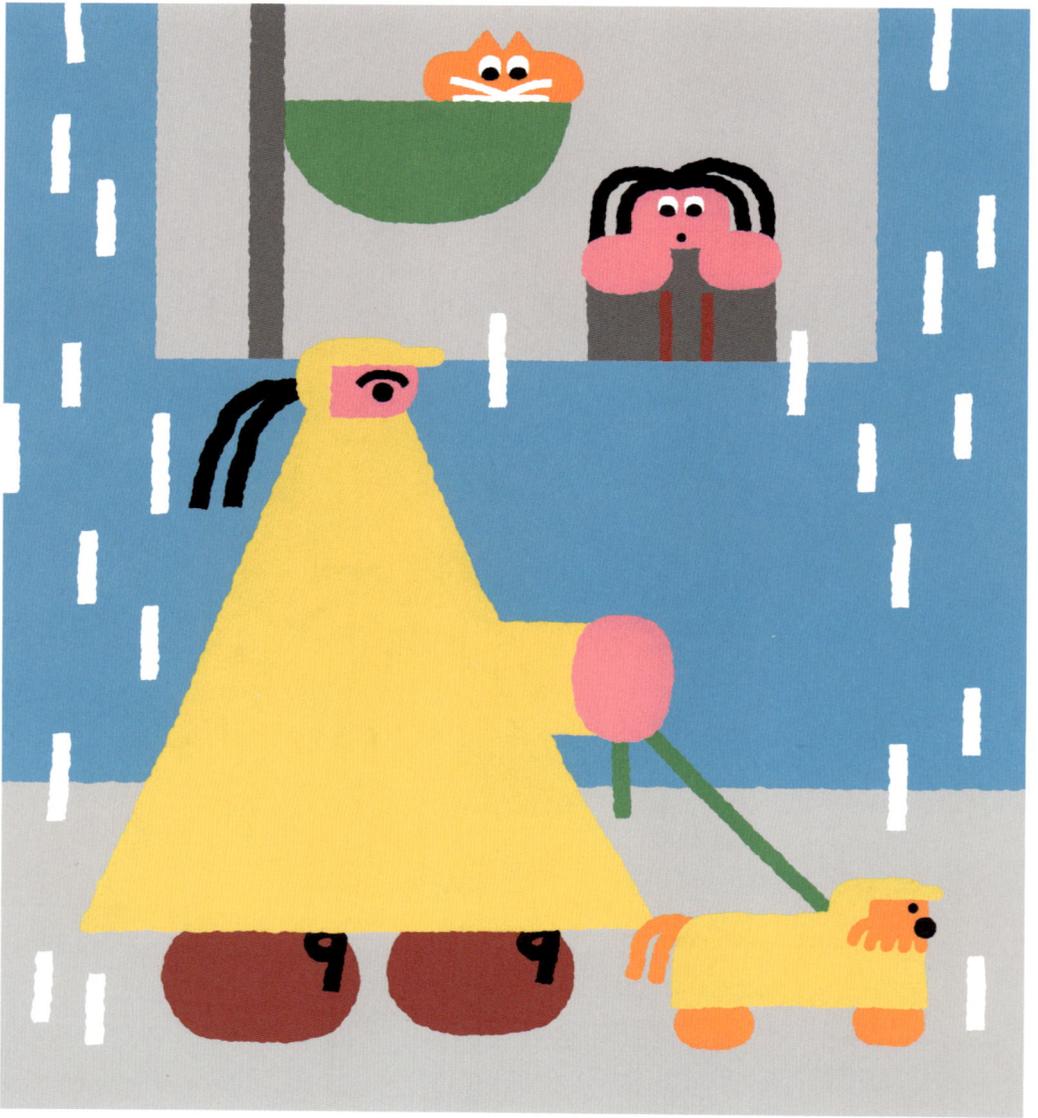

172

Walk In Rain
223 x 248 mm, Digital

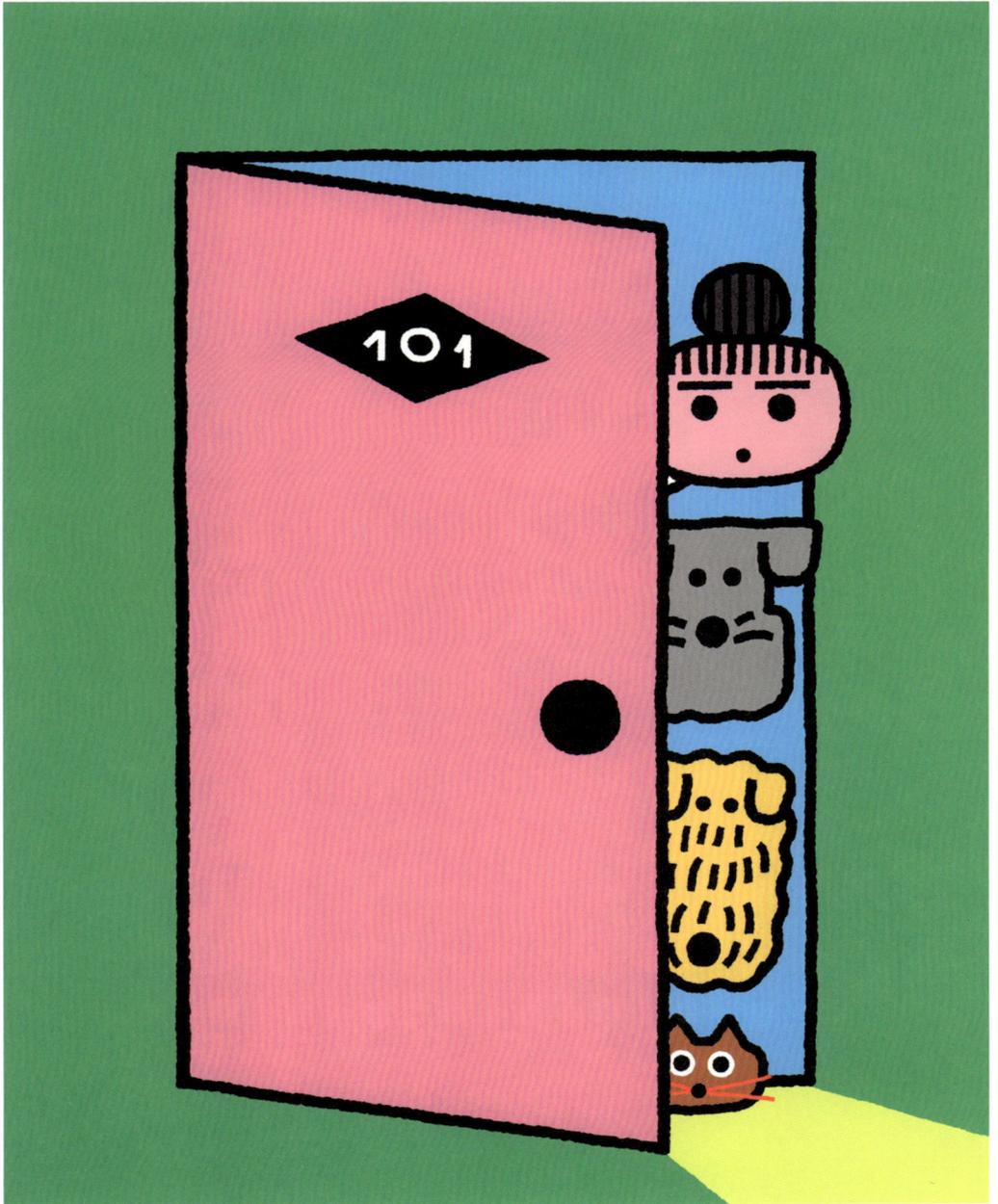

What is Happening
230 x 299 mm, Digital

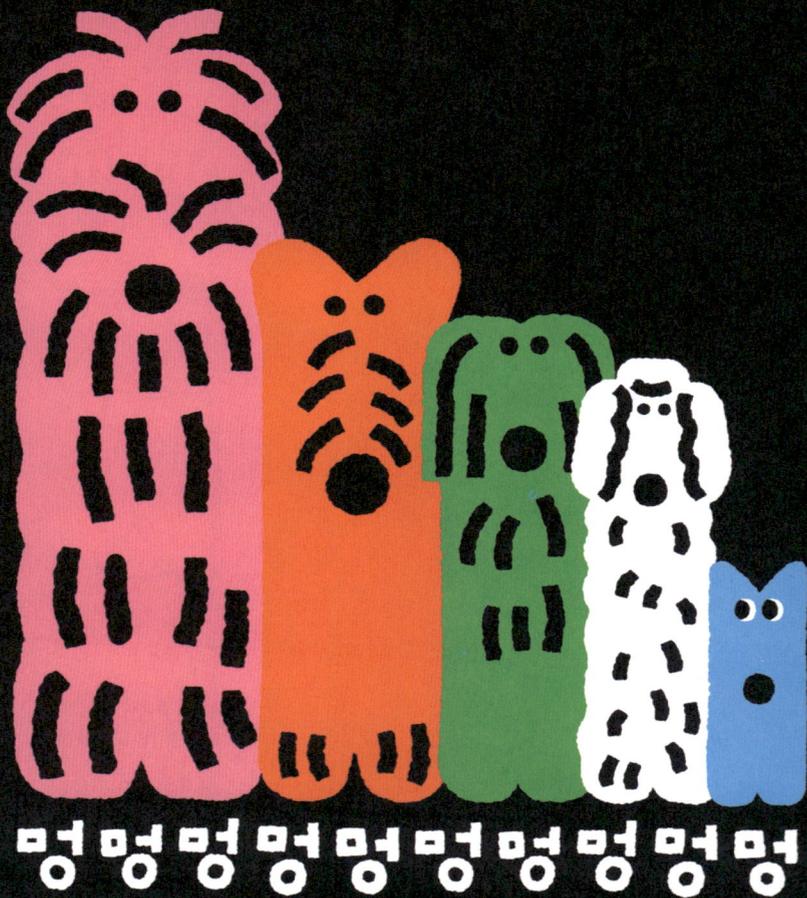

멍멍멍멍멍멍멍멍멍멍

Dogs Lined Up
263 x 296 mm, Digital

dog

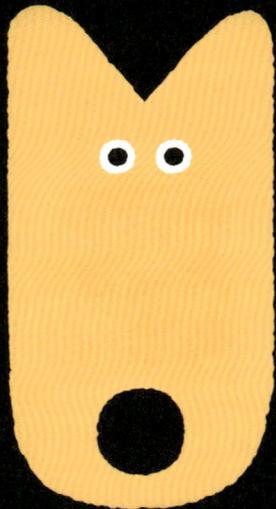
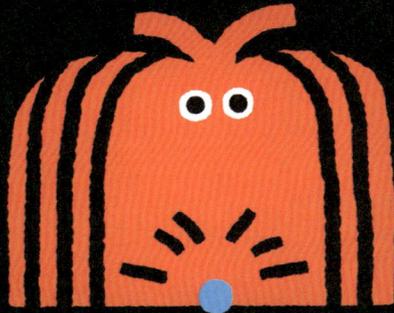
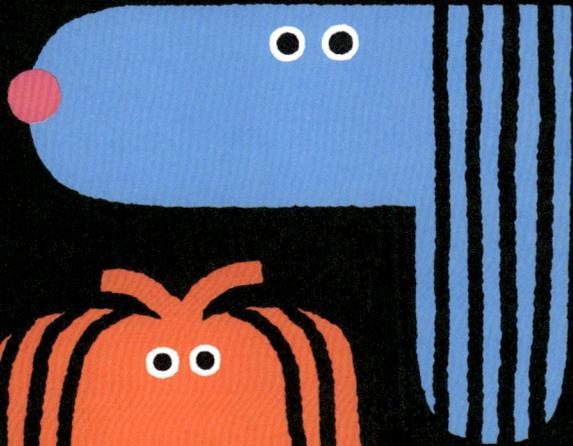
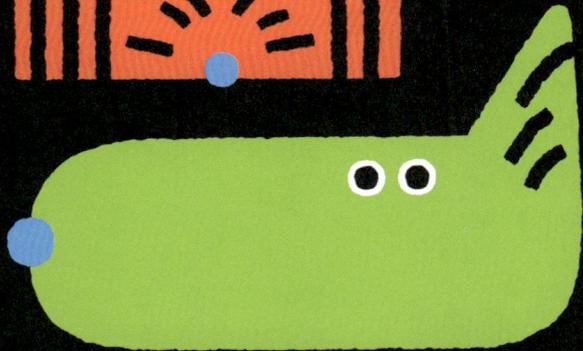
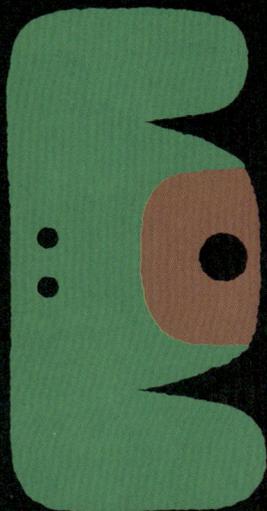
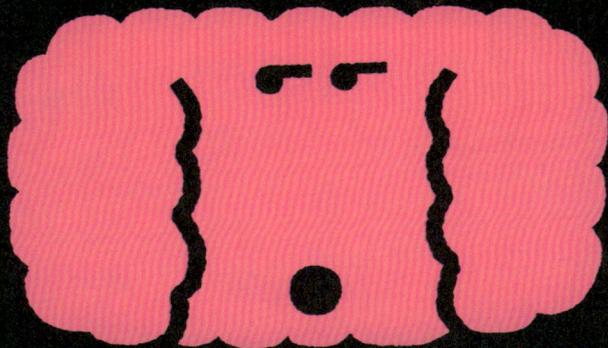

Colourful Dogs
254 x 319 mm, Digital

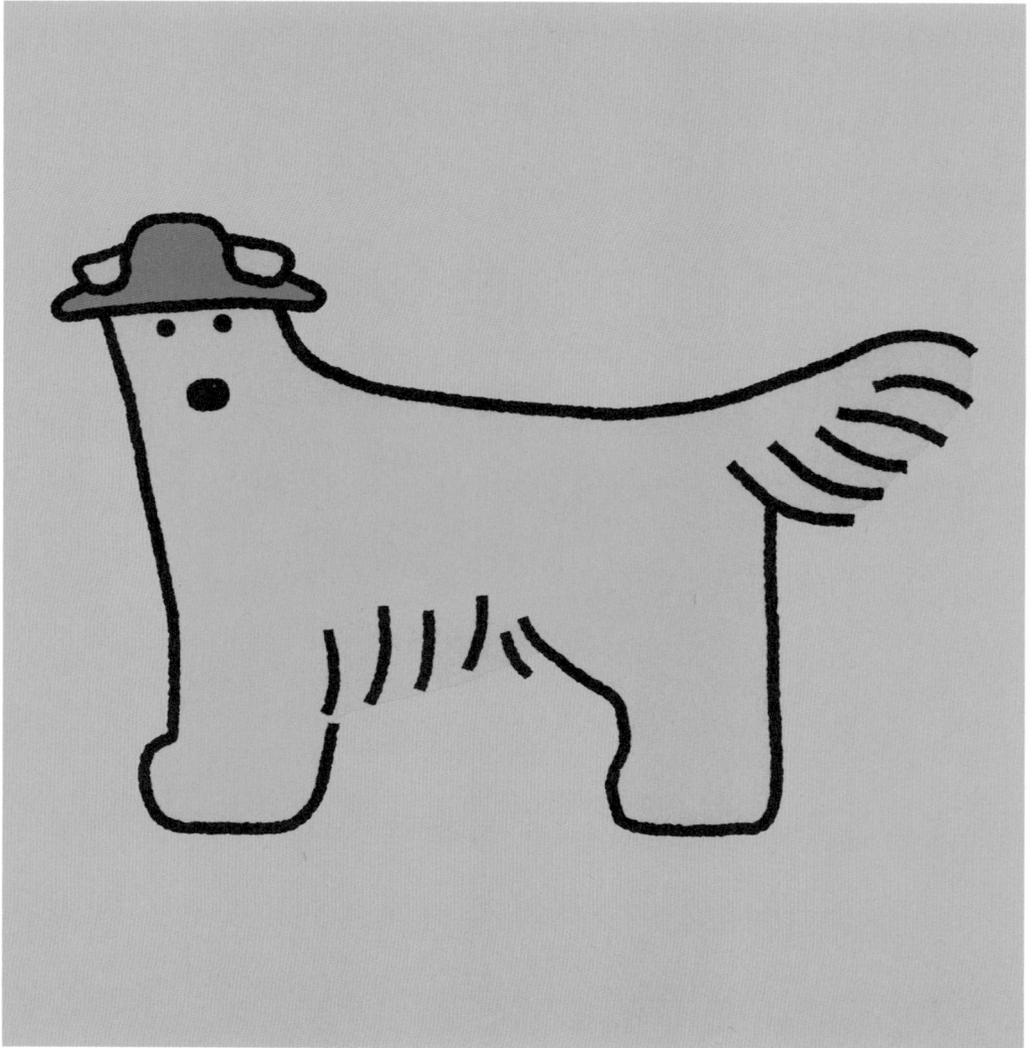

Dog Wearing Hat
281 x 296 mm, Digital

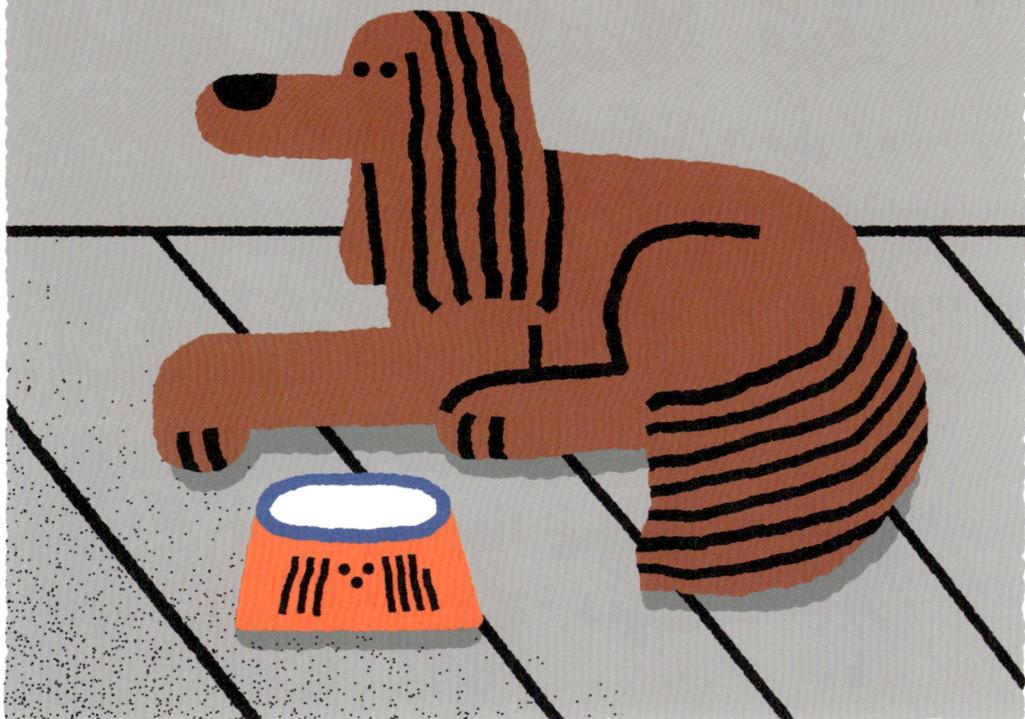

Dogs Allowed
296 x 296 mm, Digital

Born in 1989, Odile Ferraille is an artist from the west coast of France, known for her naive, minimalist illustrations celebrating pets. With a style that seeks the right mix of clumsiness and precision, she creates images that she hopes to be both funny and comforting.

odileferraille.com

Odile Ferraille

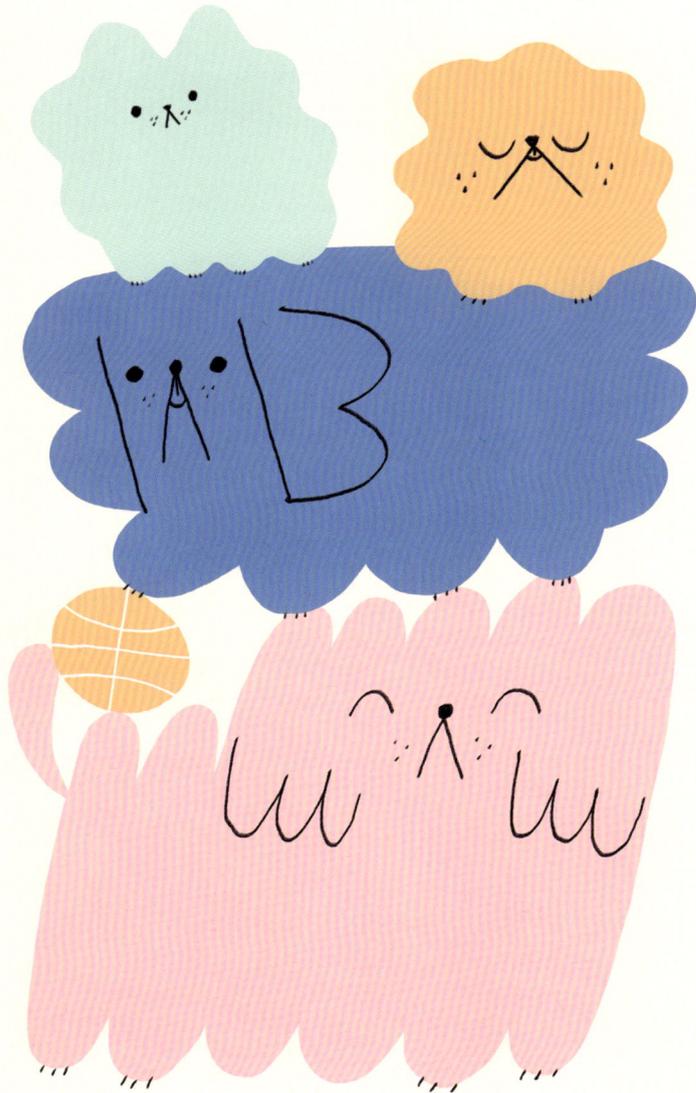

Basketball
210 x 297 mm, Digital

179

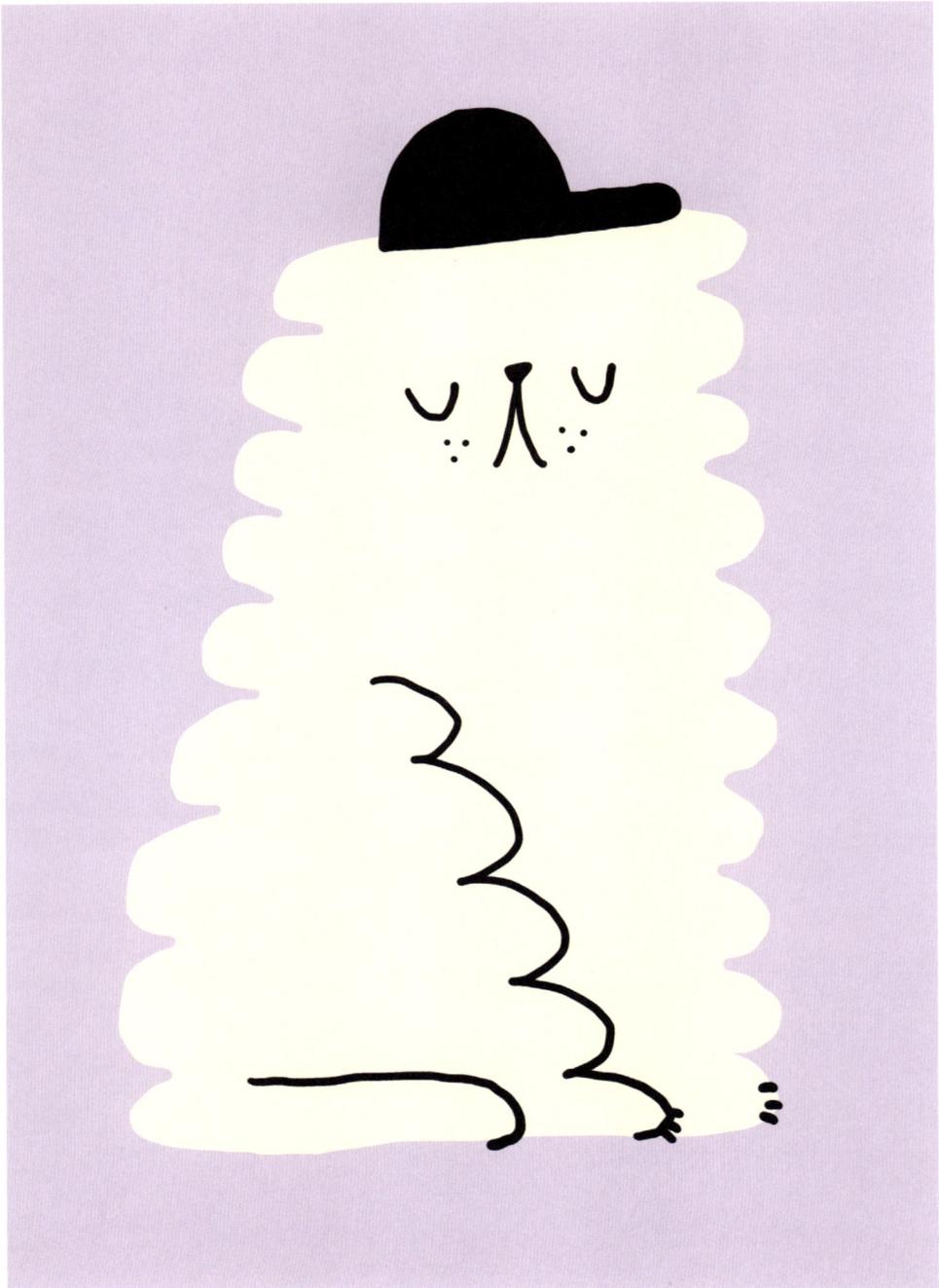

Purple Dog
210 x 297 mm, Digital

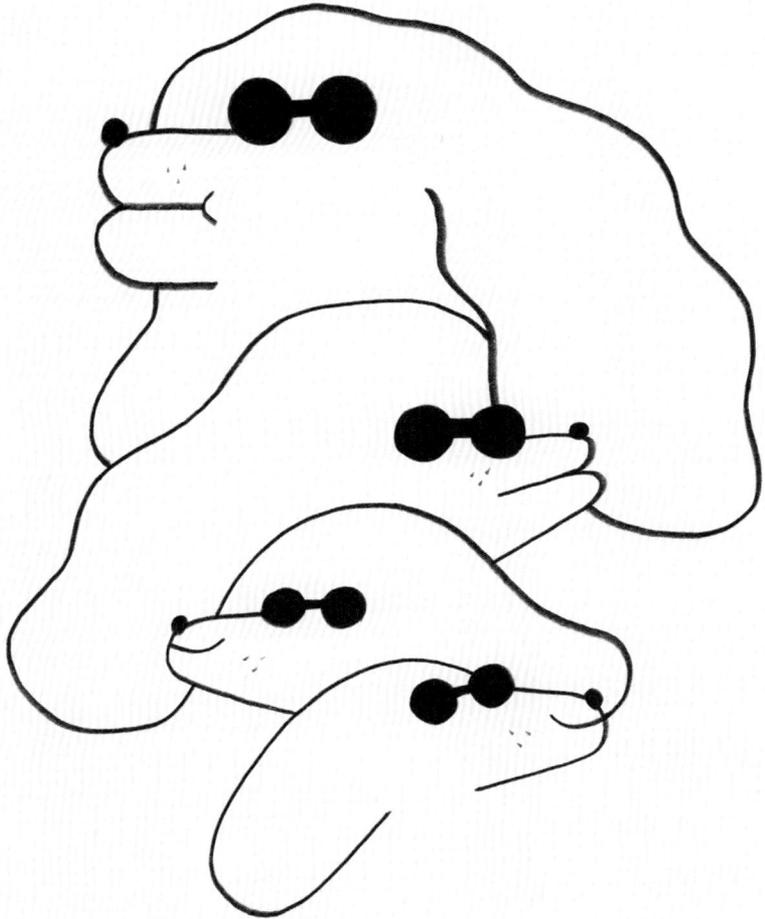

Dogs
210 x 297 mm, Digital

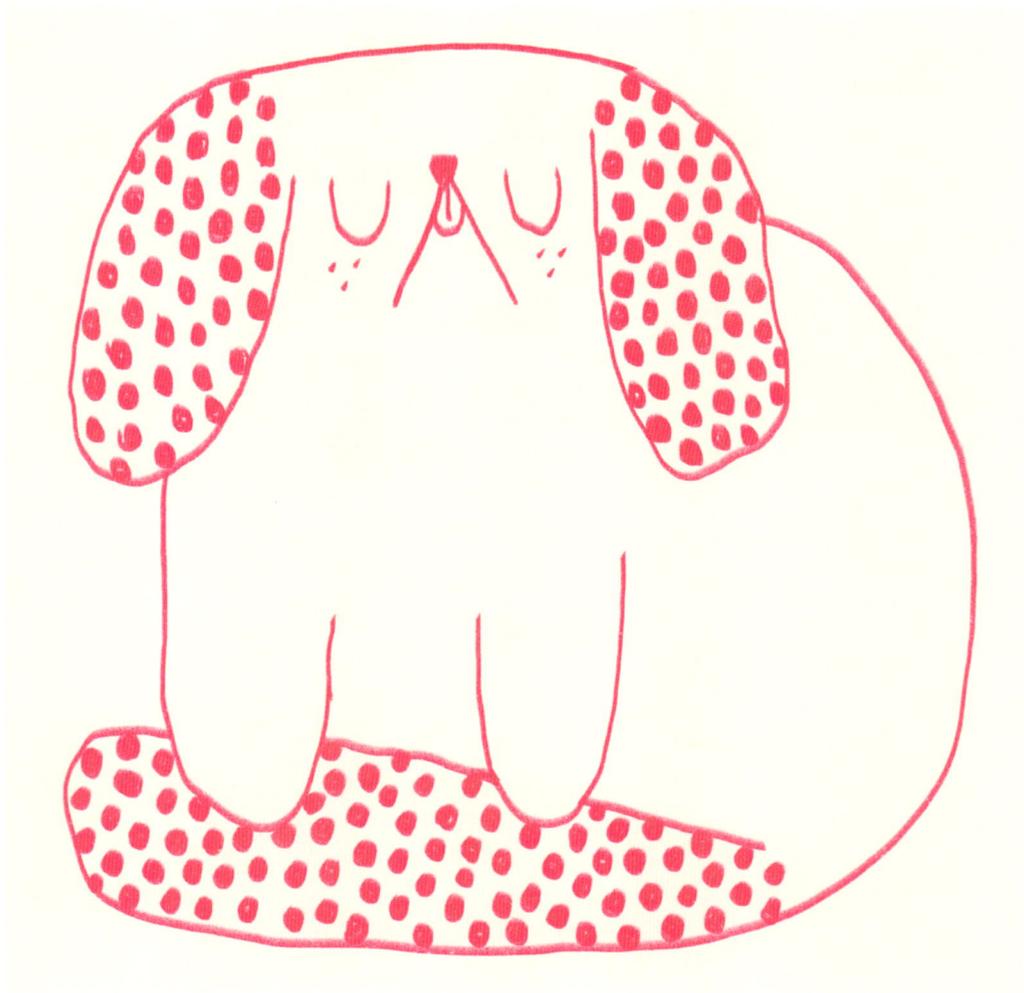

Polka Dog 3
250 x 250 mm, Digital

Polka Dog 2
250 x 250 mm, Digital

Fluffy Dog (←)
250 x 250 mm, Digital

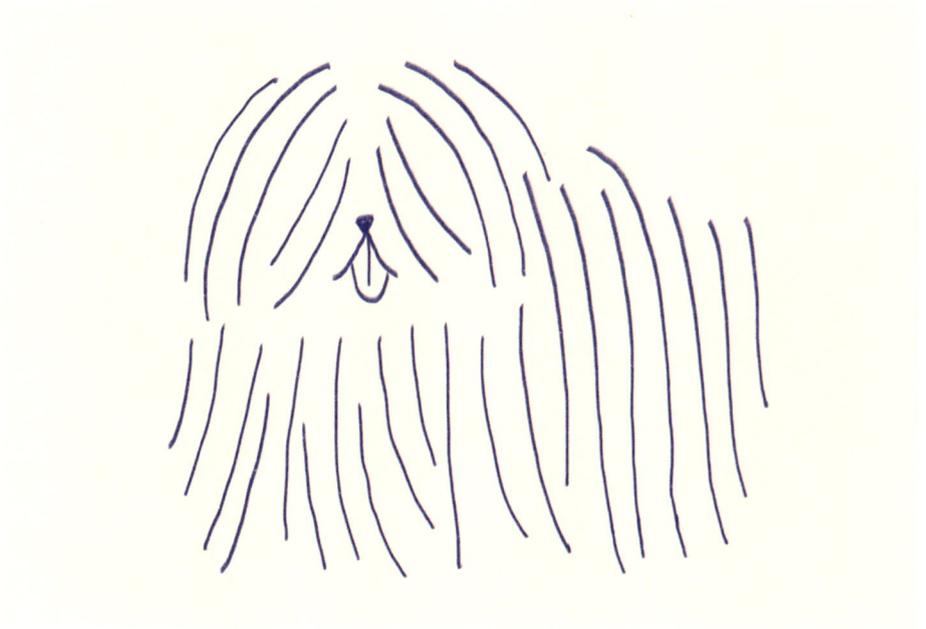

Hairy Dog
297 x 210 mm, Digital

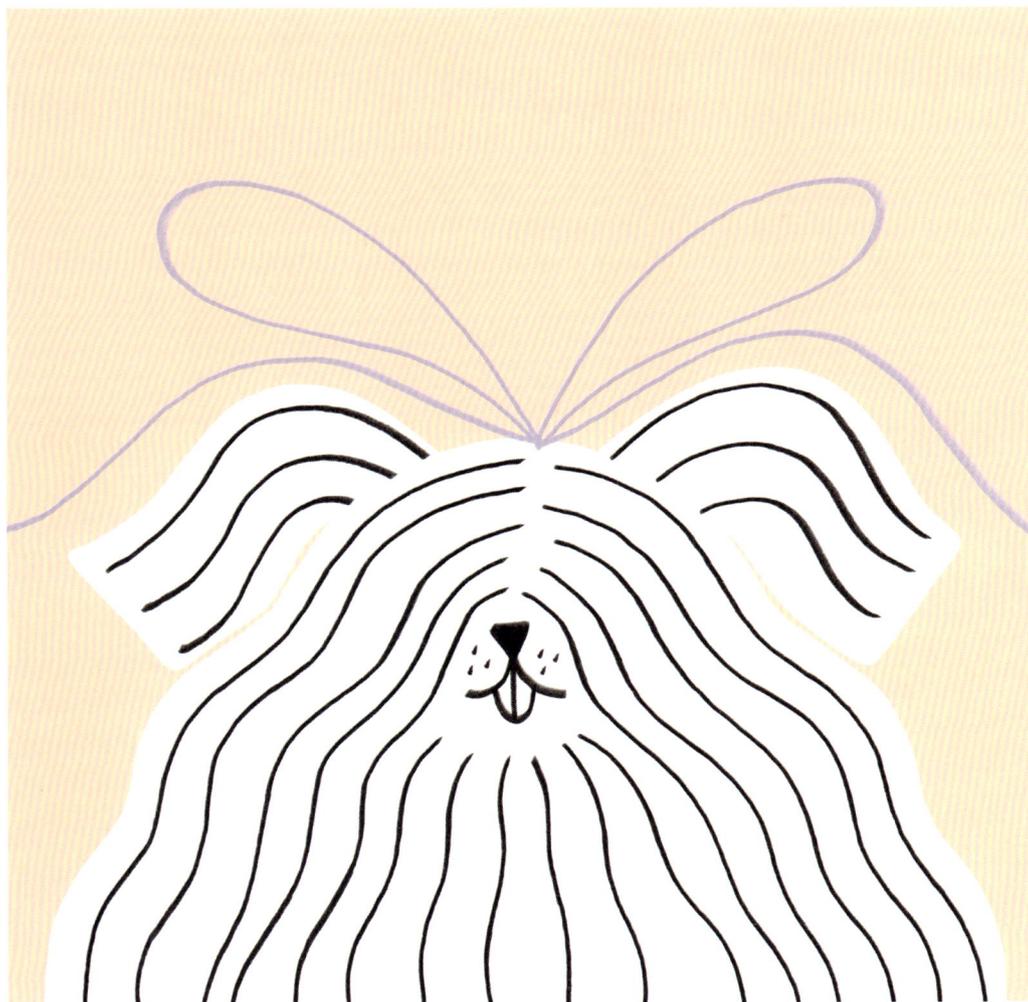

Hair Ribbon
300 x 300 mm, Digital

185

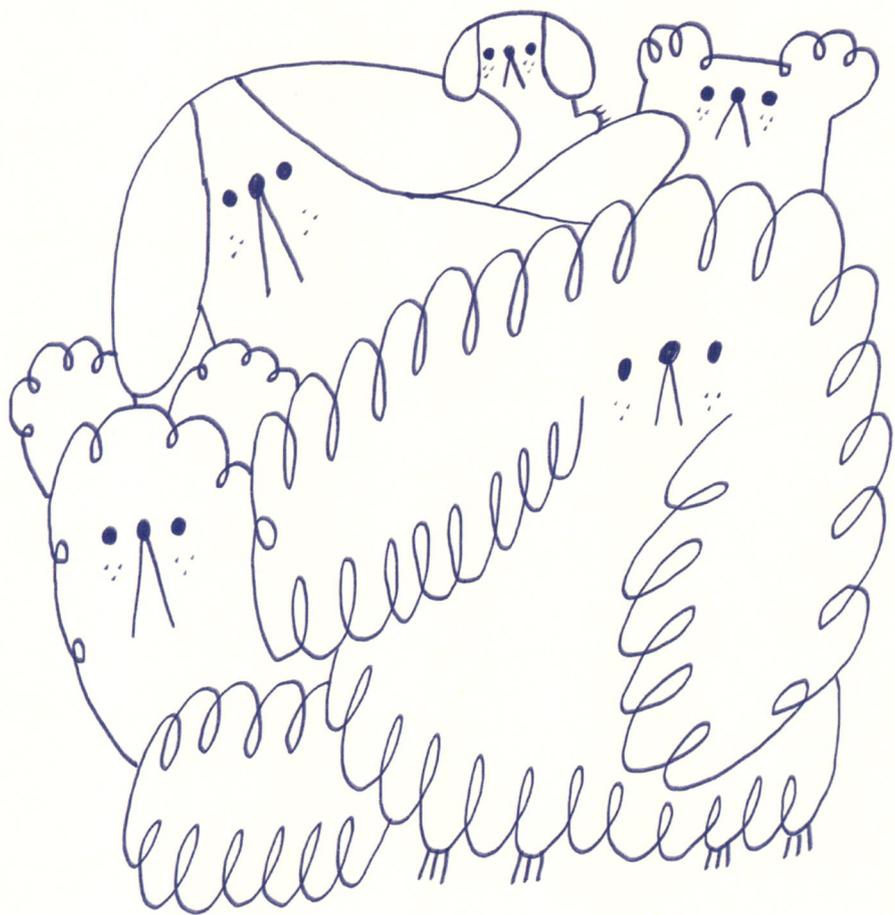

Multiple Dogs
300 x 300 mm, Digital

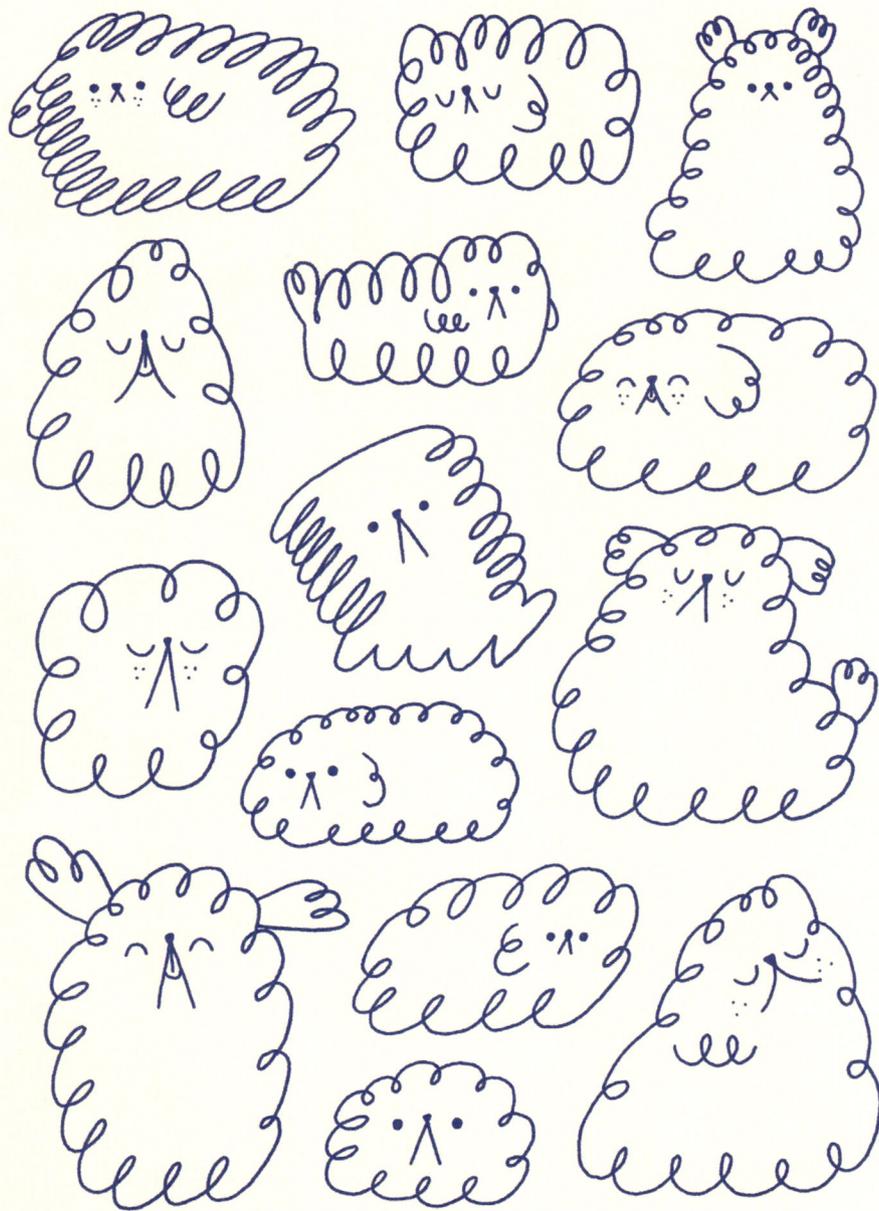

Curls Curls Curls
210 x 297 mm, Digital

Tess Smith-Roberts

tesssmithroberts.co.uk

Dogs
297 x 210 mm, Digital,
Client: O Galleria

Tess Smith-Roberts is an illustrator based in London. She approaches her work with humour, bold shapes, and a playful use of colour. Classic still life paintings, bad dance moves, and food (especially fruit!) are the main inspirations for her work.

Dogs I Saw On My Travels
237 x 297 mm, Digital

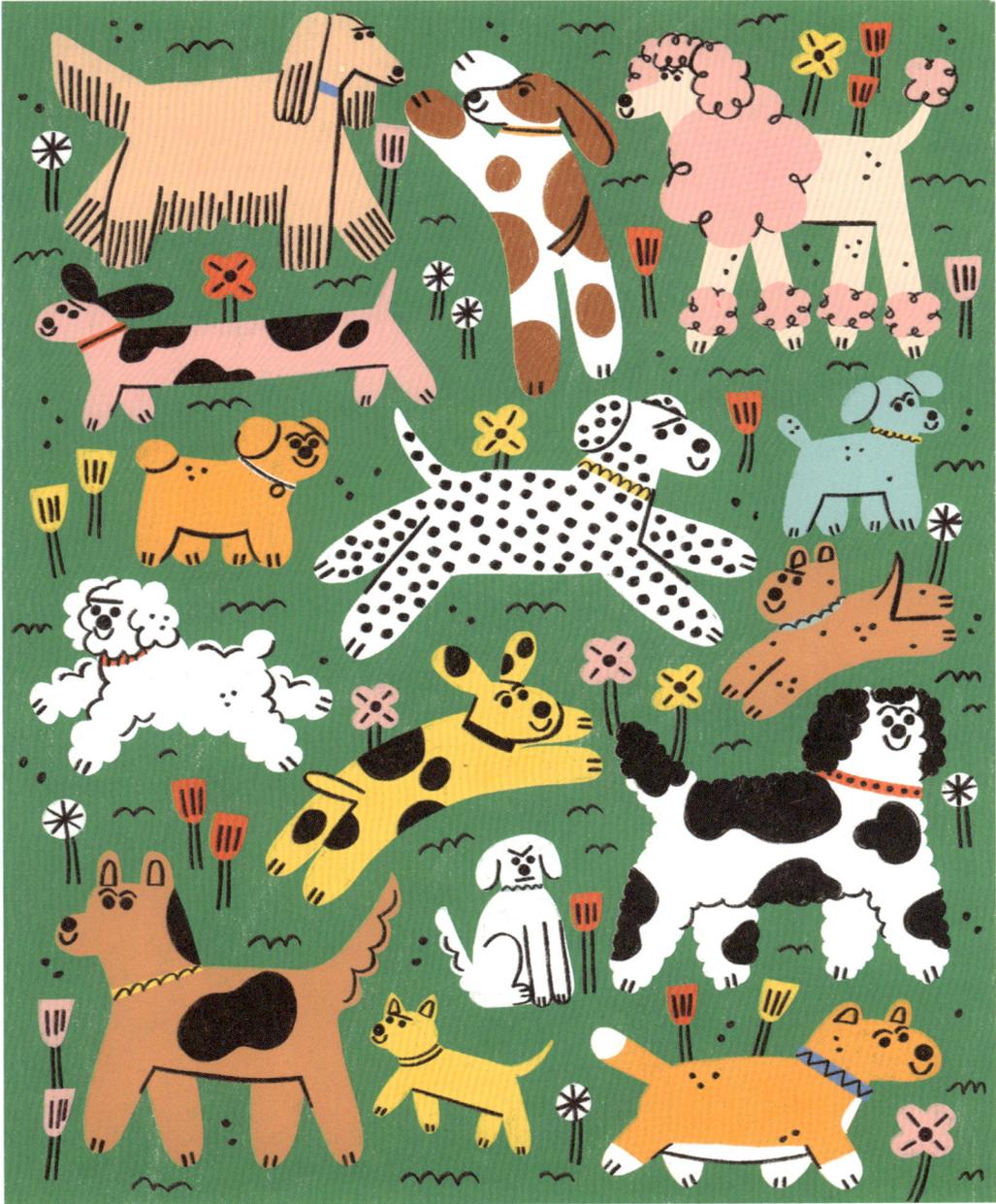

Dog Park
238.51 x 297.01 mm, Digital

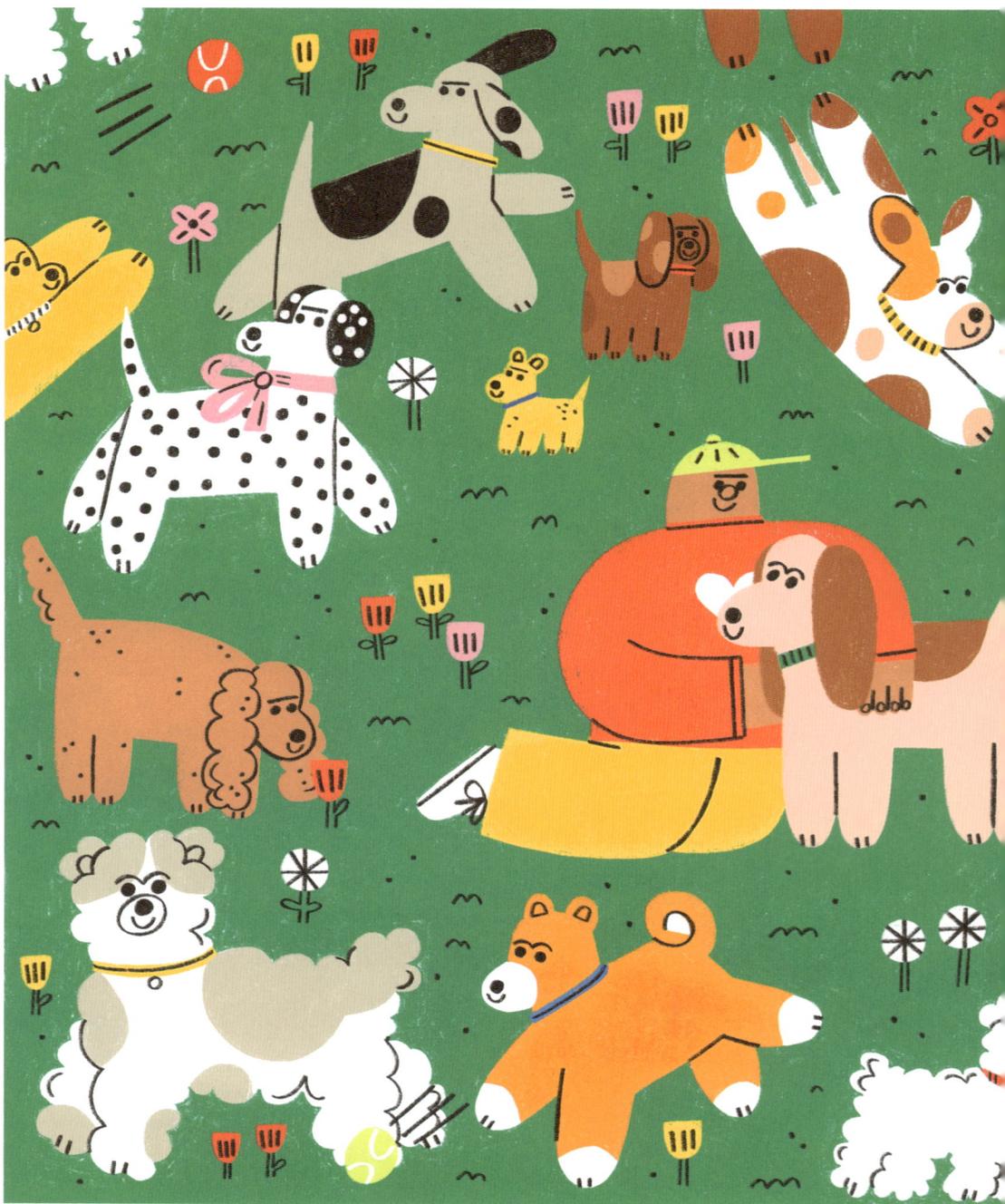

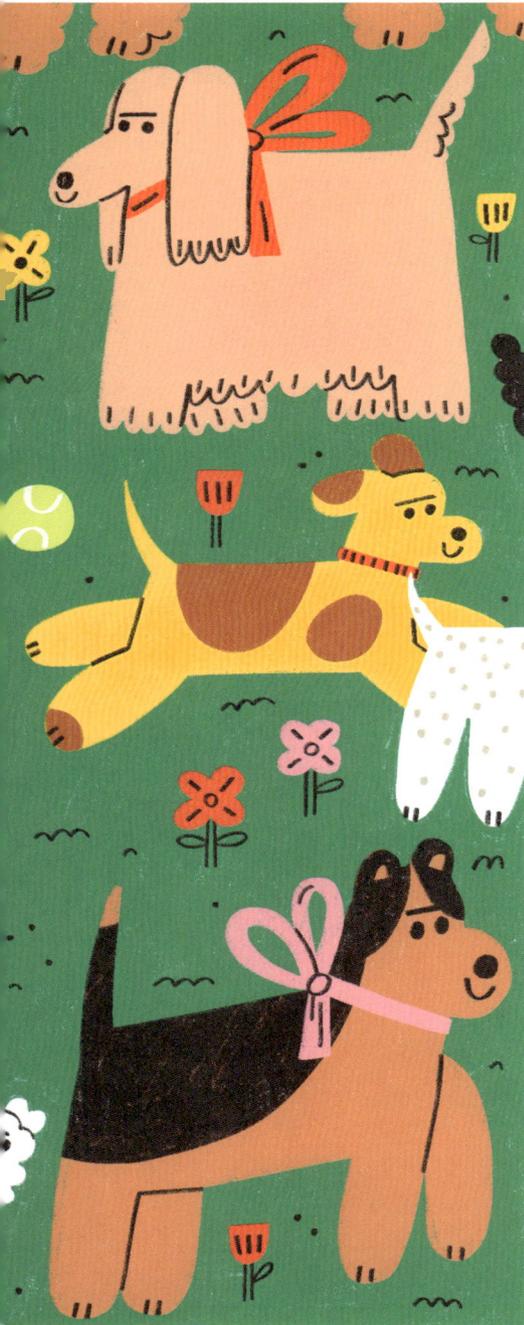

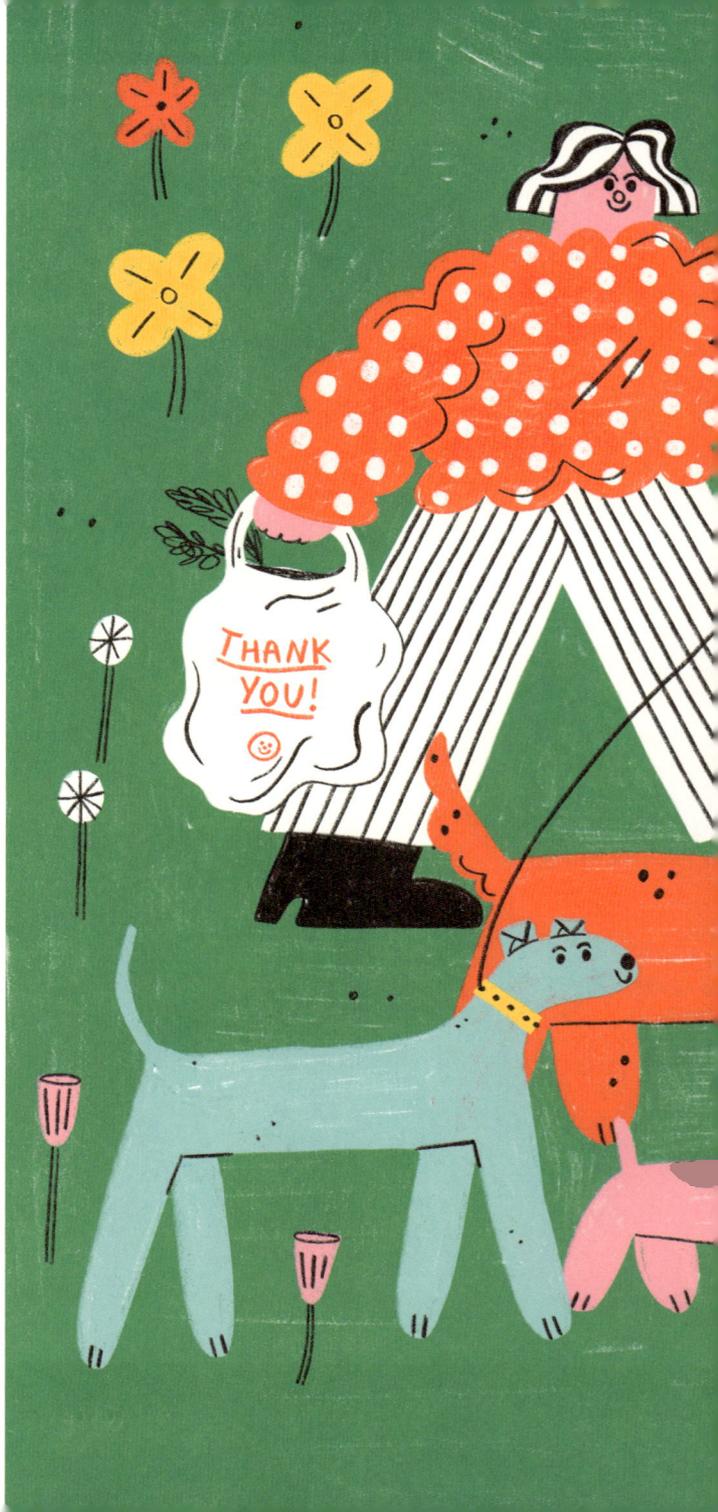

Dog Walker
320 x 240 mm, Digital

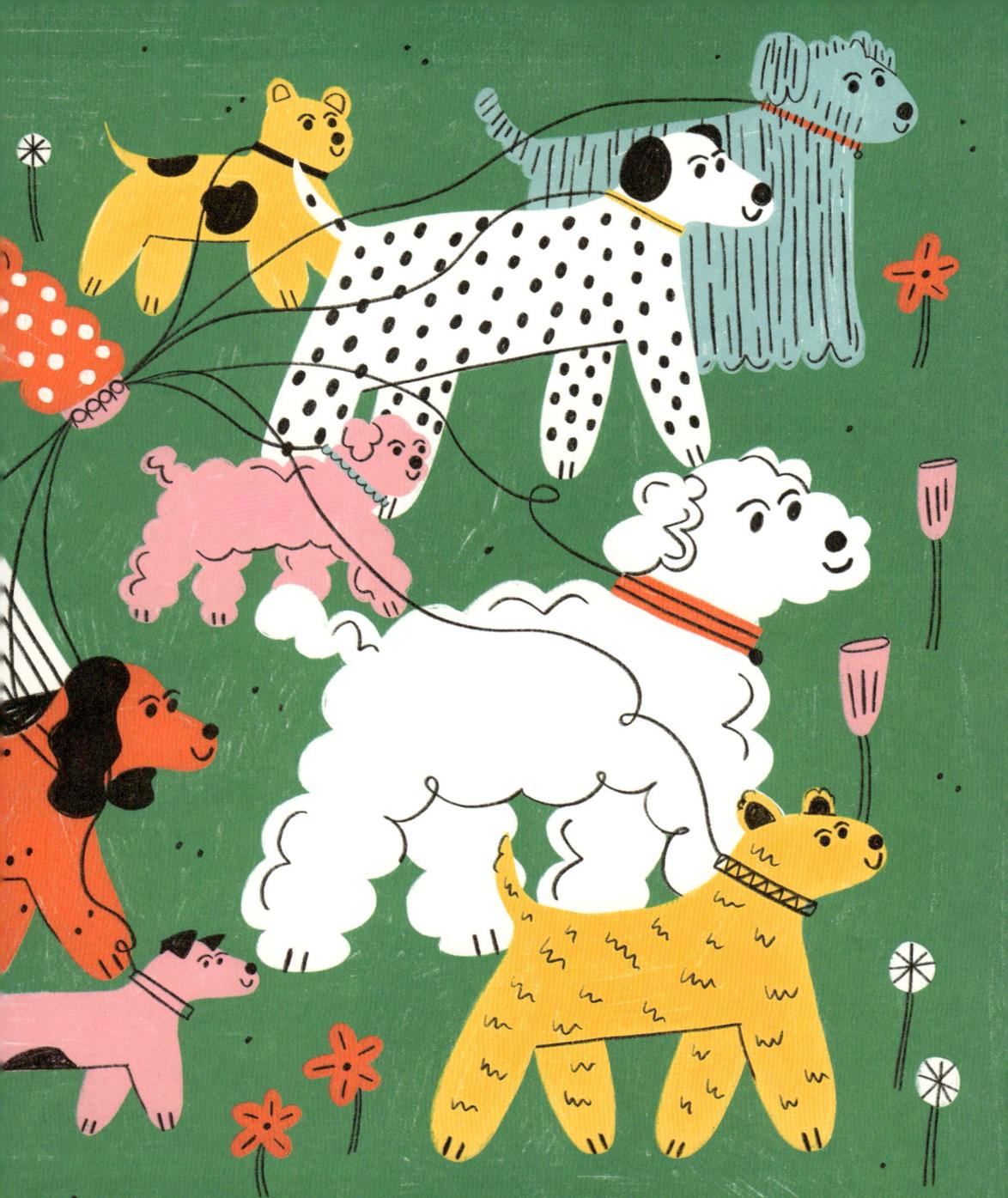

Hayley Deti

Hayley Deti is an American artist and illustrator who uses drawing and painting to memorialise the past and present by blending fiction with reality. She currently lives in Seattle with her fiance and their dog, Toby. When she is not working her day job, Hayley spends most of her time in her bayside studio with Toby—drawing and painting things.

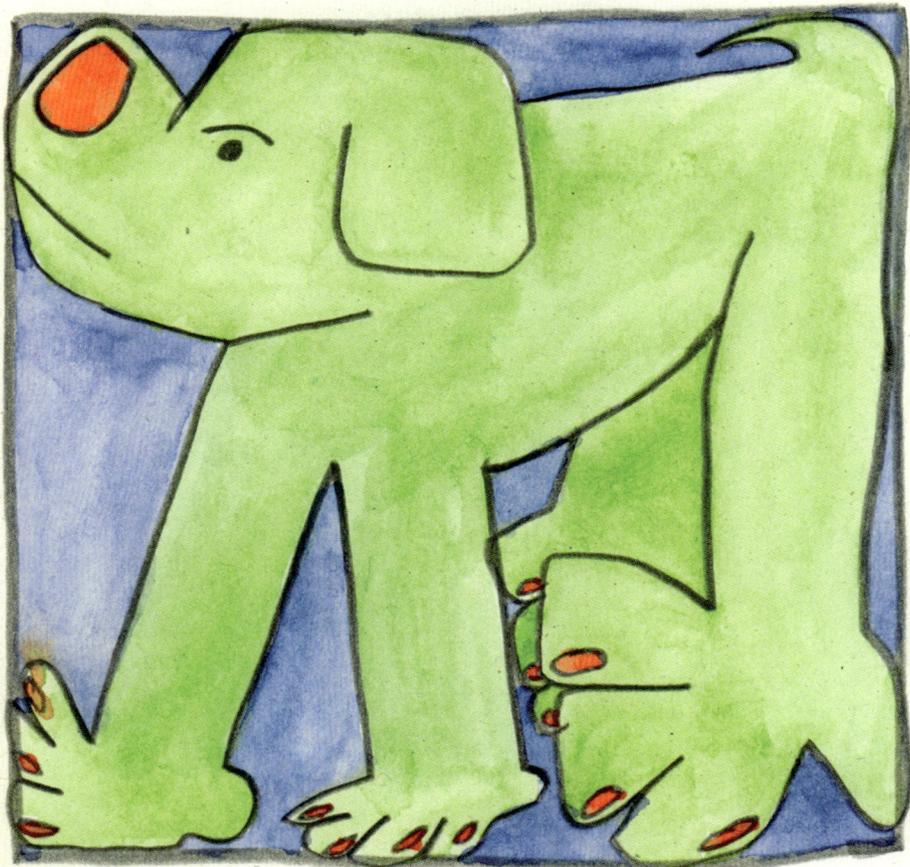

Green Dog
95 x 90 mm, Graphite, Watercolour, Paper

197

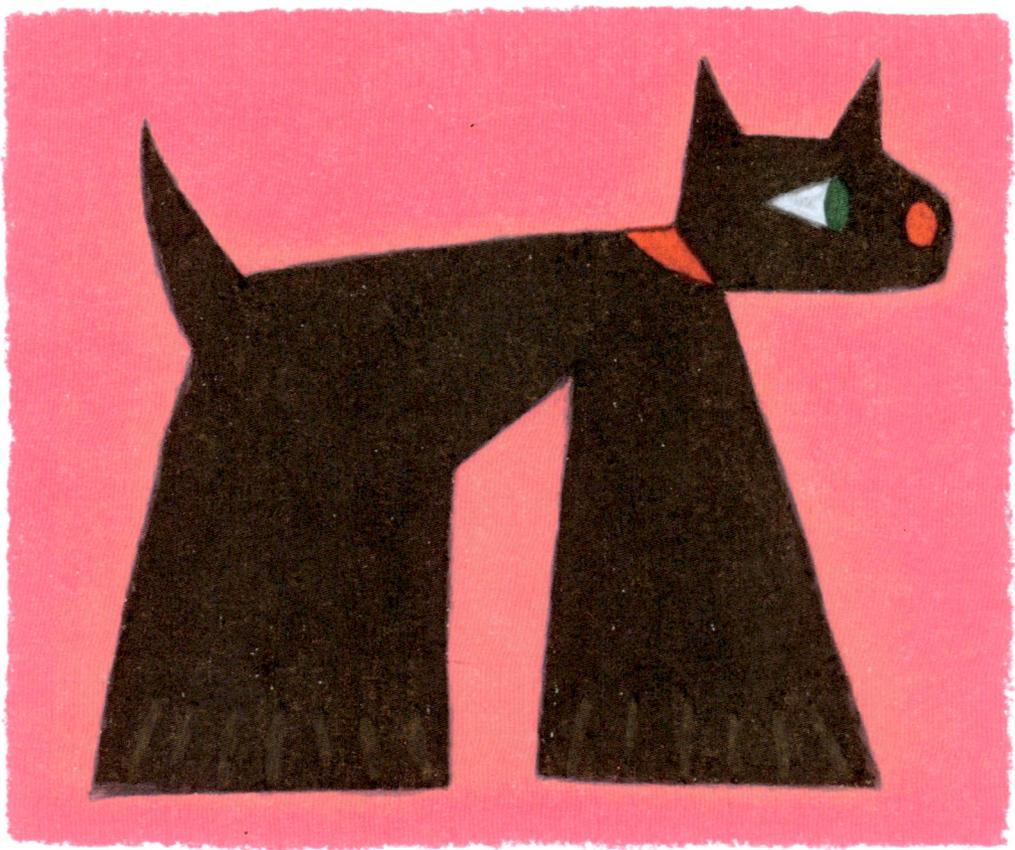

Brown Dog
120 x 103 mm, Graphite, Coloured Pencils

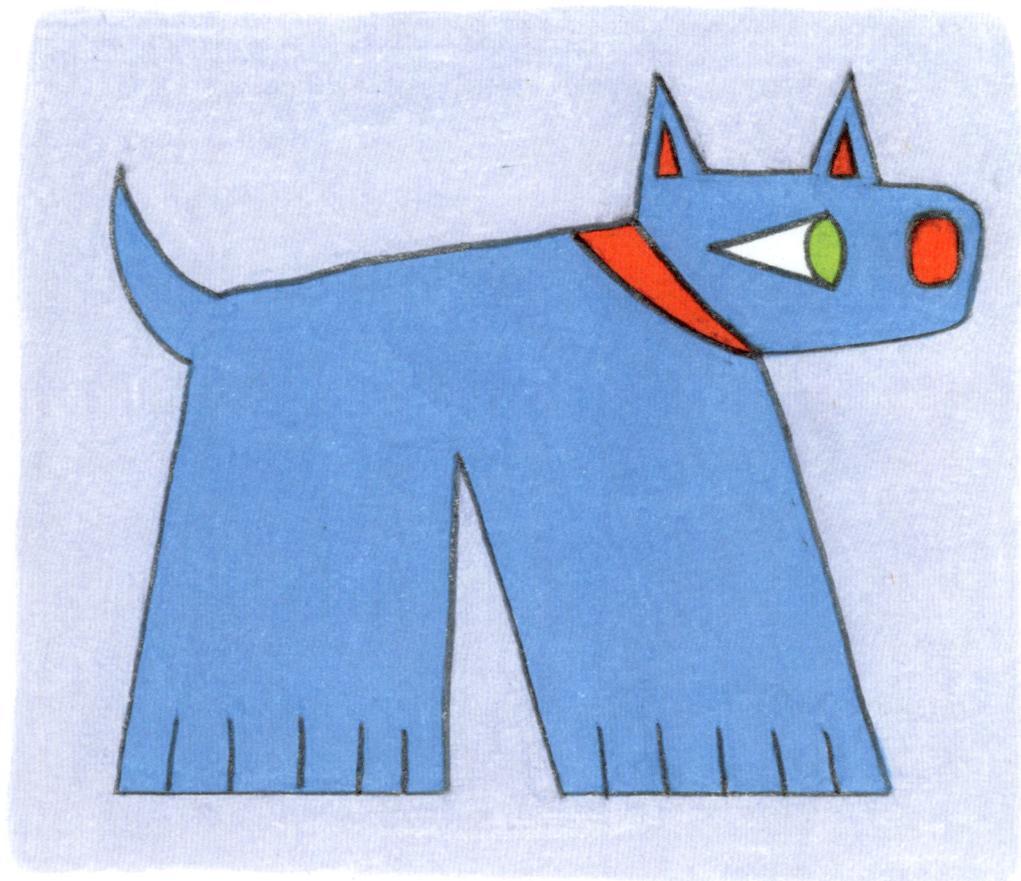

Blue Dog
125 x 115 mm, Graphite, Coloured Pencils

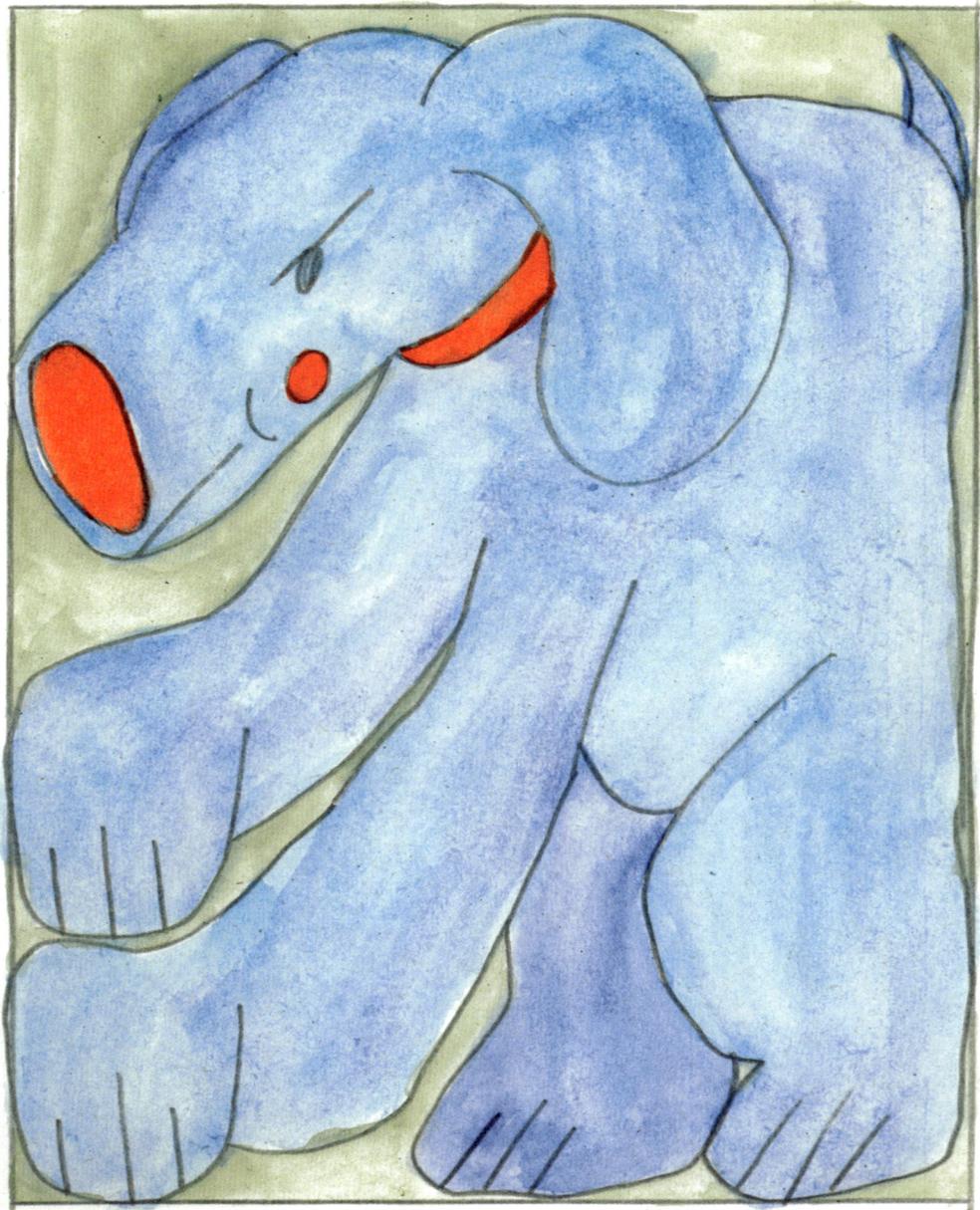

200

Boog 2 (Mischief)
122 x 150 mm, Graphite, Watercolour, Paper

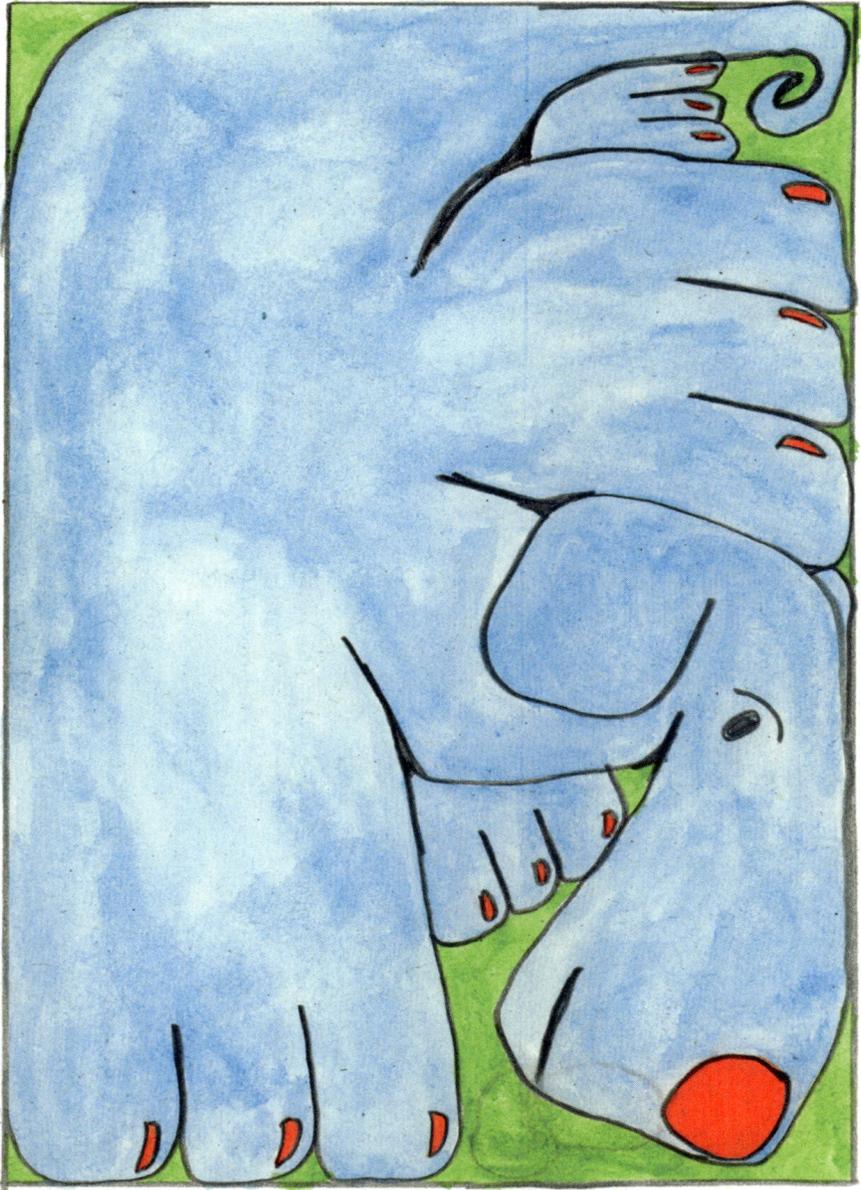

Boog 1
130 x 170 mm, Graphite, Watercolour, Paper

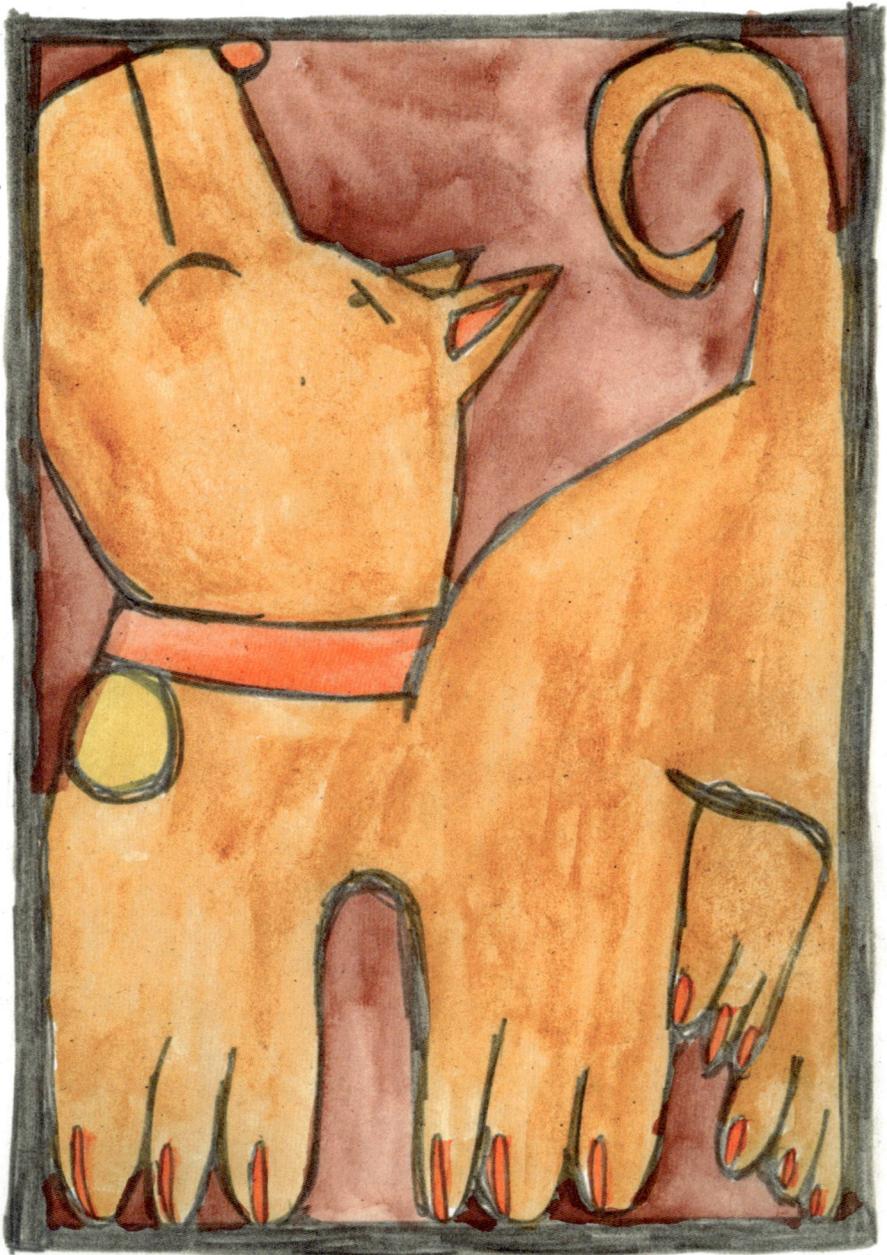

Tan Dog
120 x 160 mm, Graphite, Watercolour, Paper

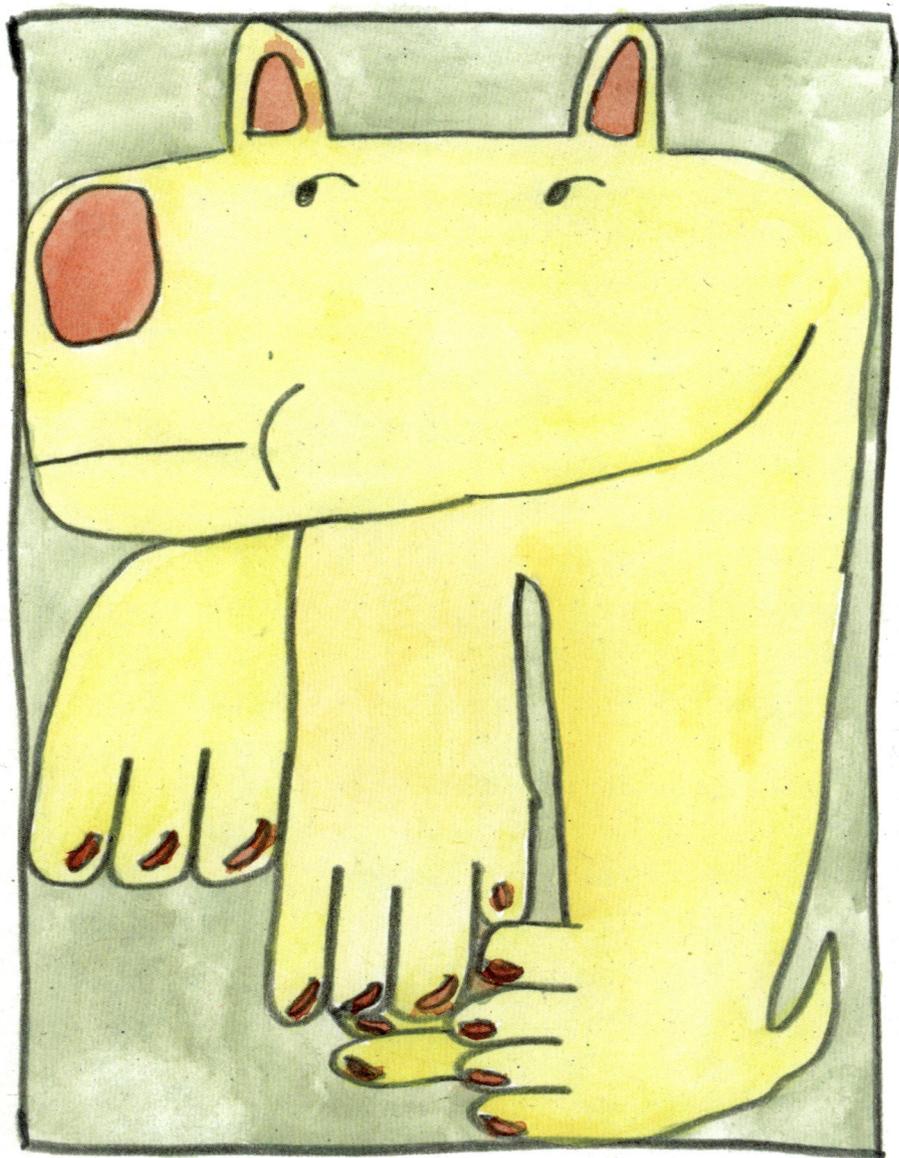

Yellow Dog
95 x 130 cm, Graphite, Watercolour, Paper

Francesca Albergo is an Italian illustrator and designer. Inspired by self-taught artists, her creative practice is characterised by experiments, abstraction, and humour. Francesca holds a BA from IUAV Venice and an MA in Illustration from ISIA Urbino. She spent a year between studies at Fabrica, a visual communication research centre in Treviso, working on the Colors magazine.

@fralbergo

Francesca Albergo

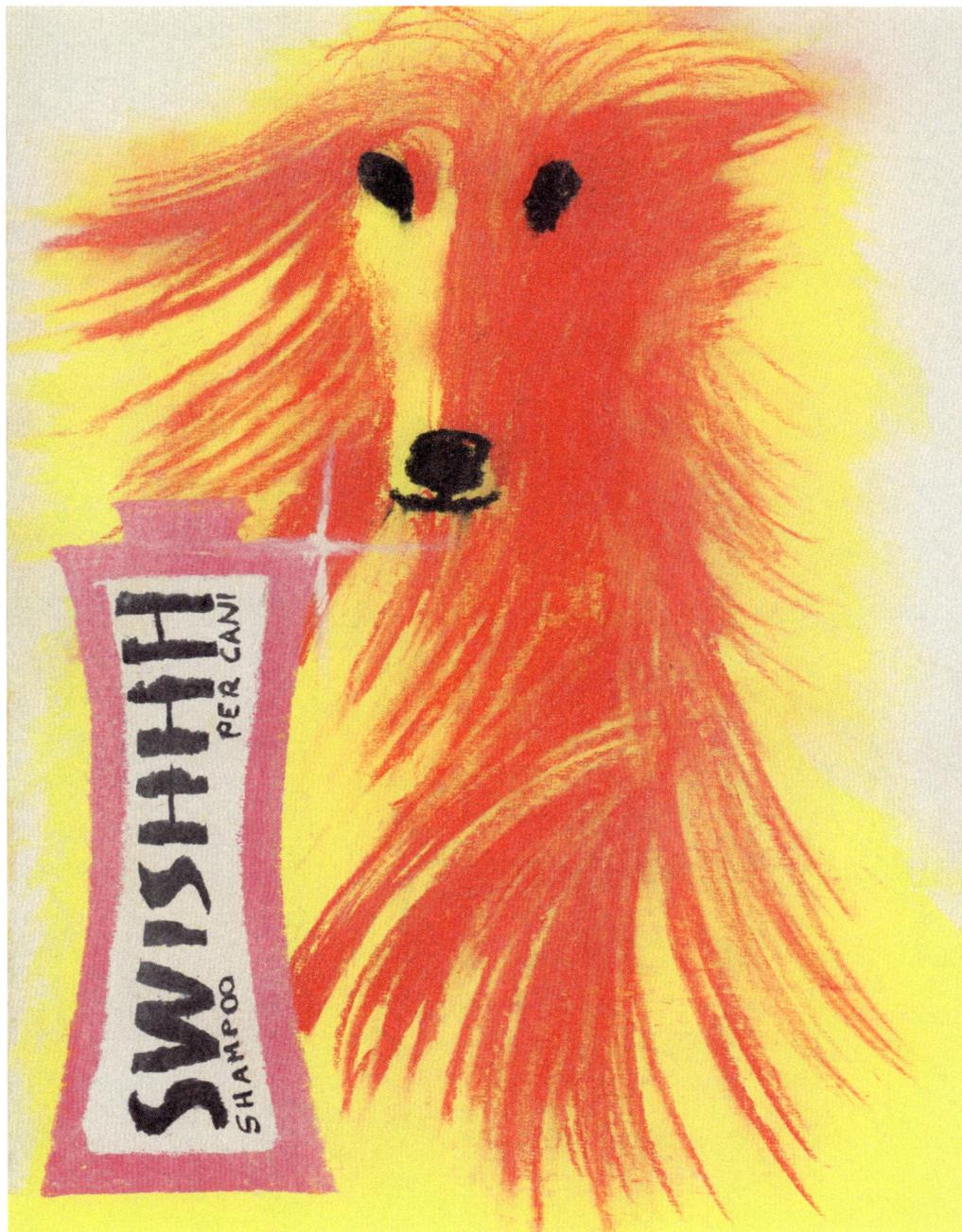

Zampa Profumata
190 x 250 mm, Pastels,
Project Supervision: Federica Iacobelli, Mauro Bubbico

205

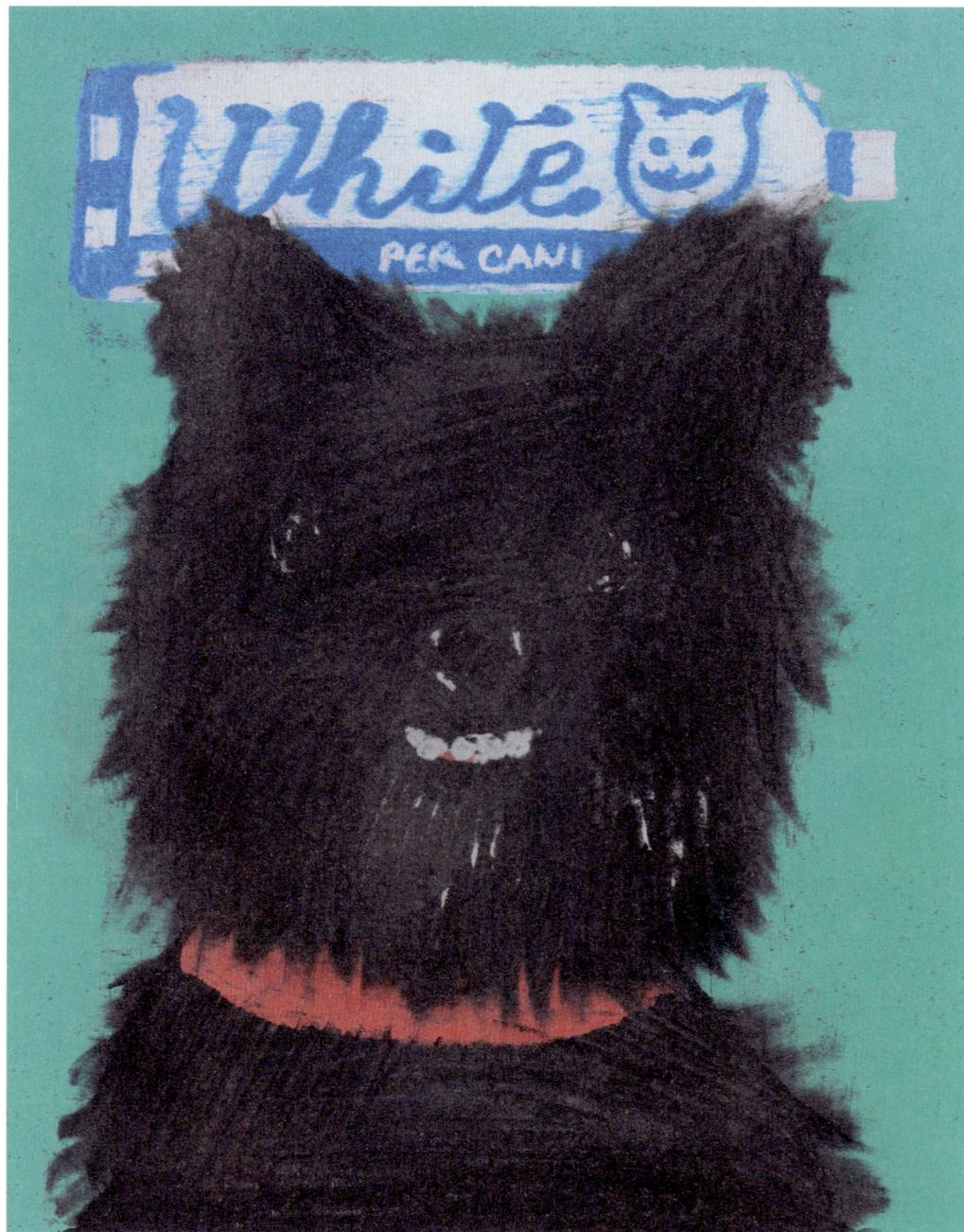

Zampa Profumata
190 x 250 mm, Pastels,
Project Supervision: Federica Iacobelli, Mauro Bubbico

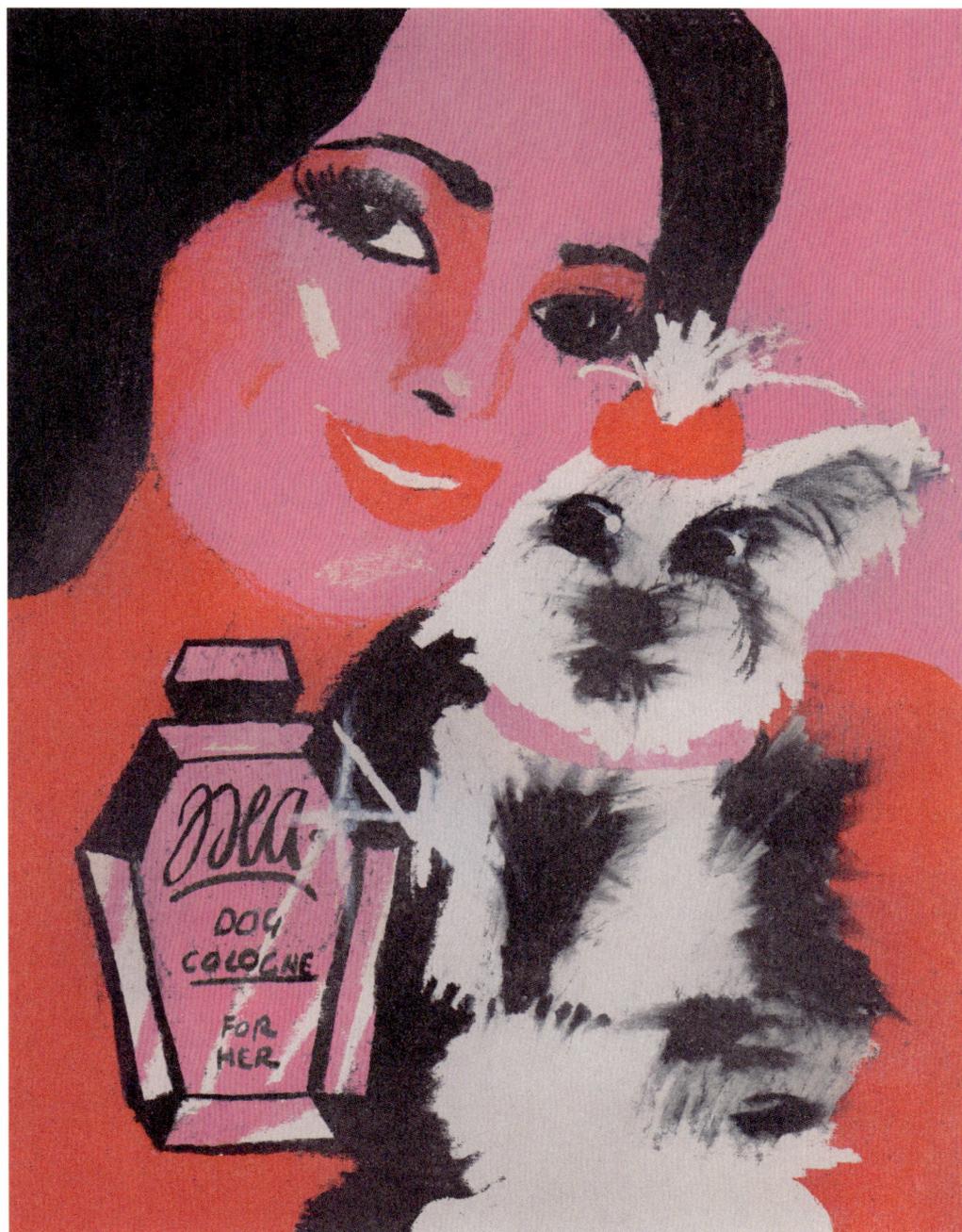

Zampa Profumata
190 x 250 mm, Pastels,
Project Supervision: Federica Iacobelli, Mauro Bubbico

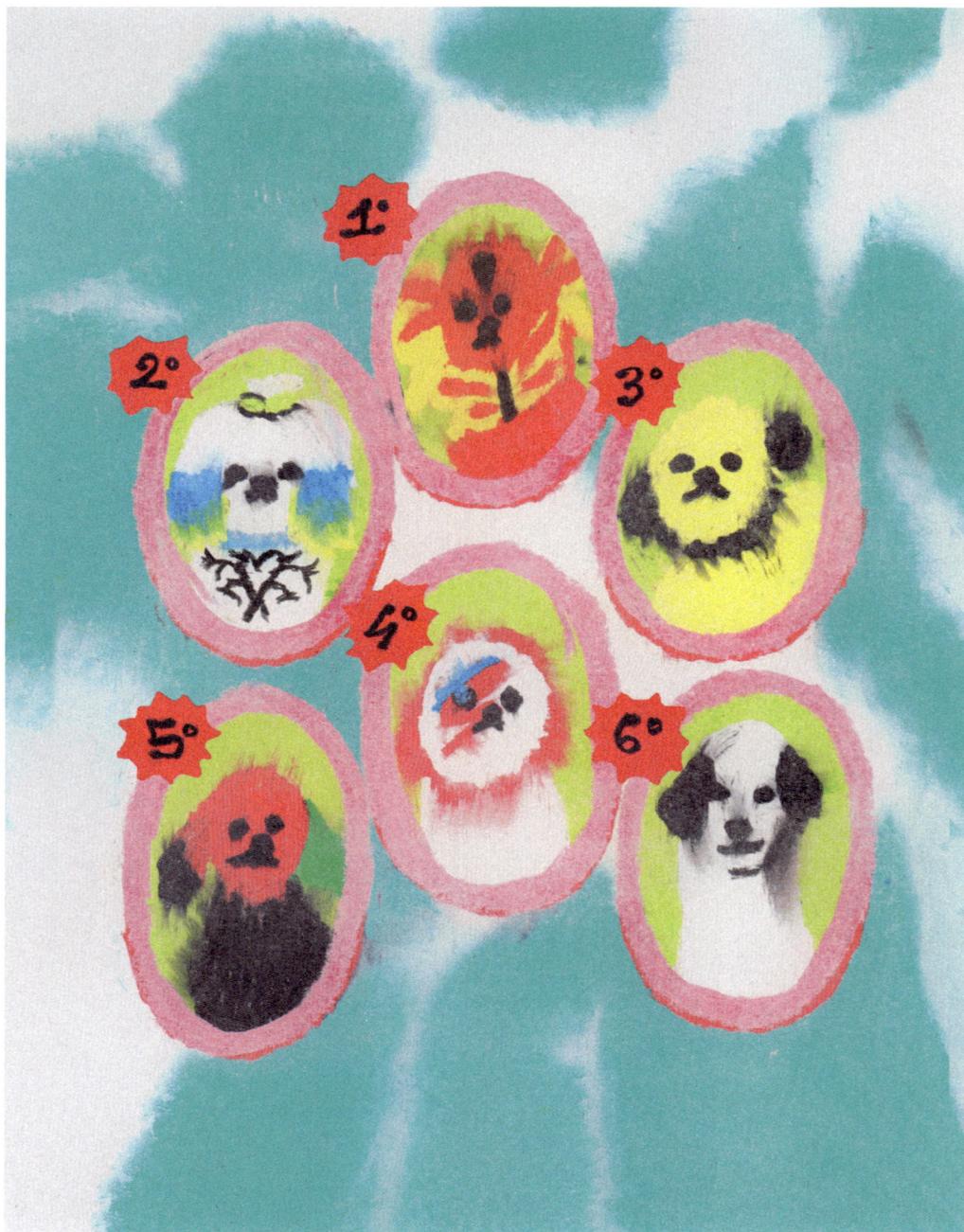

Zampa Profumata
190 x 250 mm, Pastels,
Project Supervision: Federica Iacobelli, Mauro Bubbico

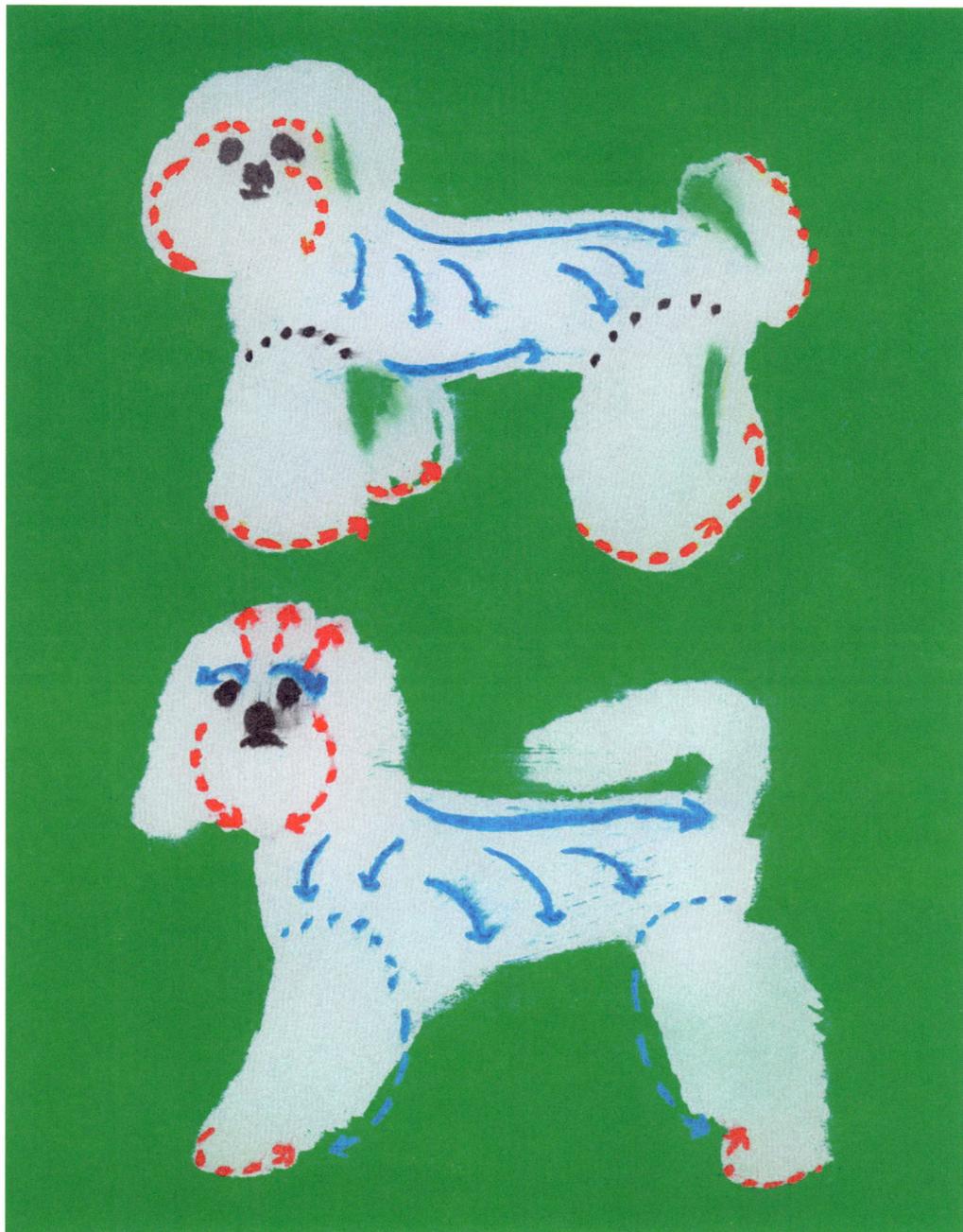

Zampa Profumata
190 x 250 mm, Pastels,
Project Supervision: Federica Iacobelli, Mauro Bubbico

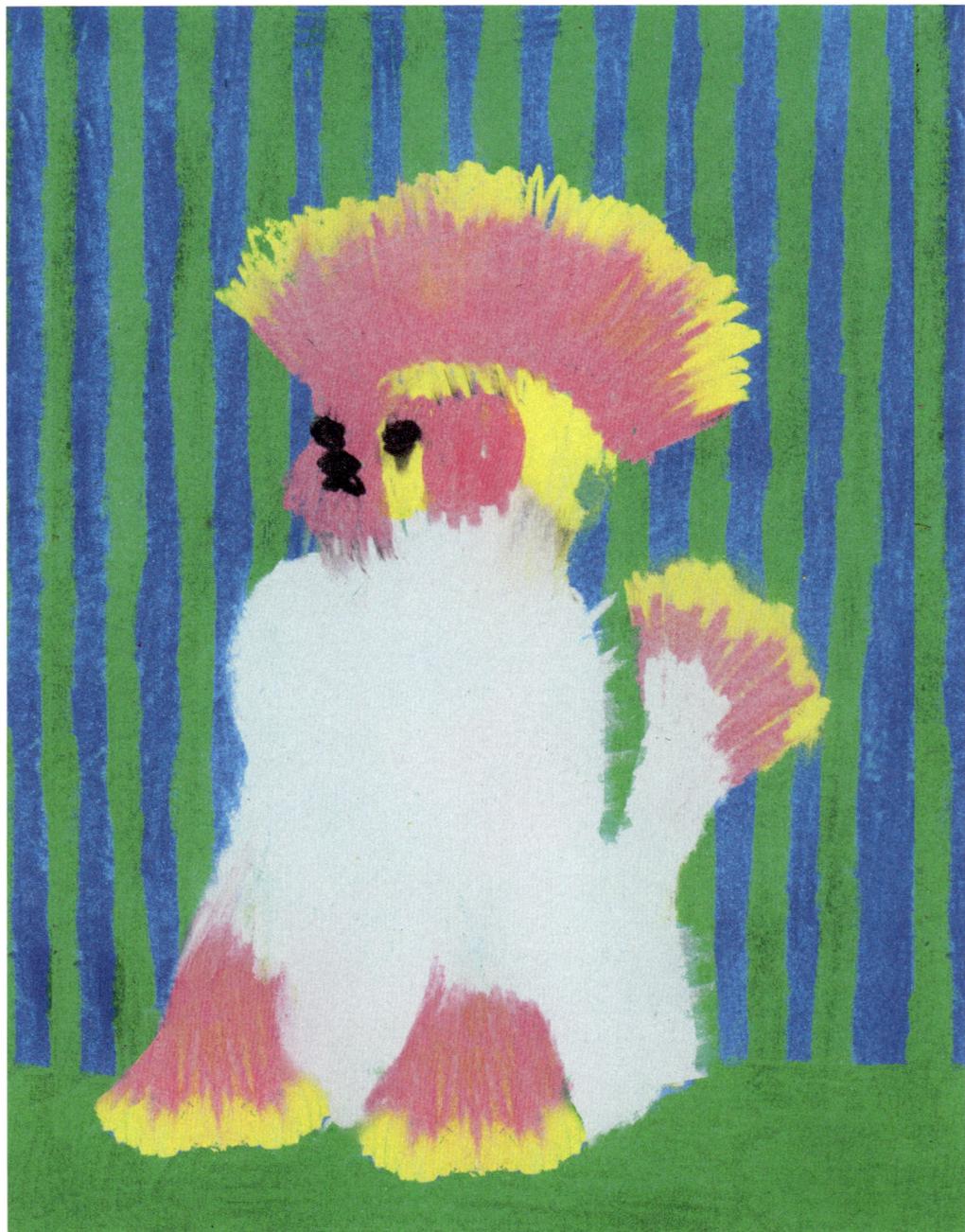

Zampa Profumata
190 x 250 mm, Pastels,
Project Supervision: Federica Iacobelli, Mauro Bubbico

Zampa Profumata
190 x 250 mm, Pastels,
Project Supervision: Federica Iacobelli, Mauro Bubbico

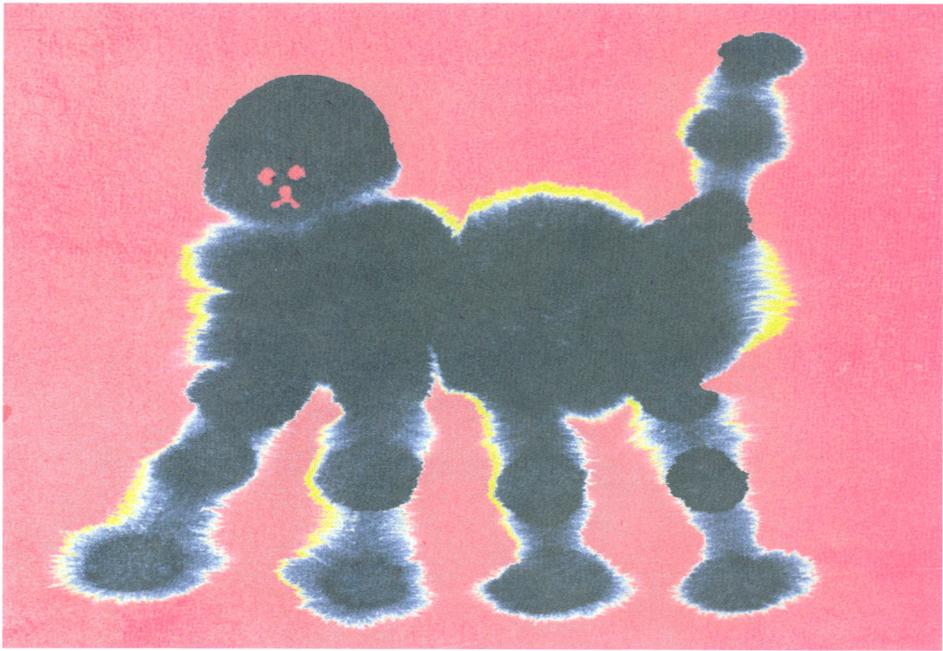
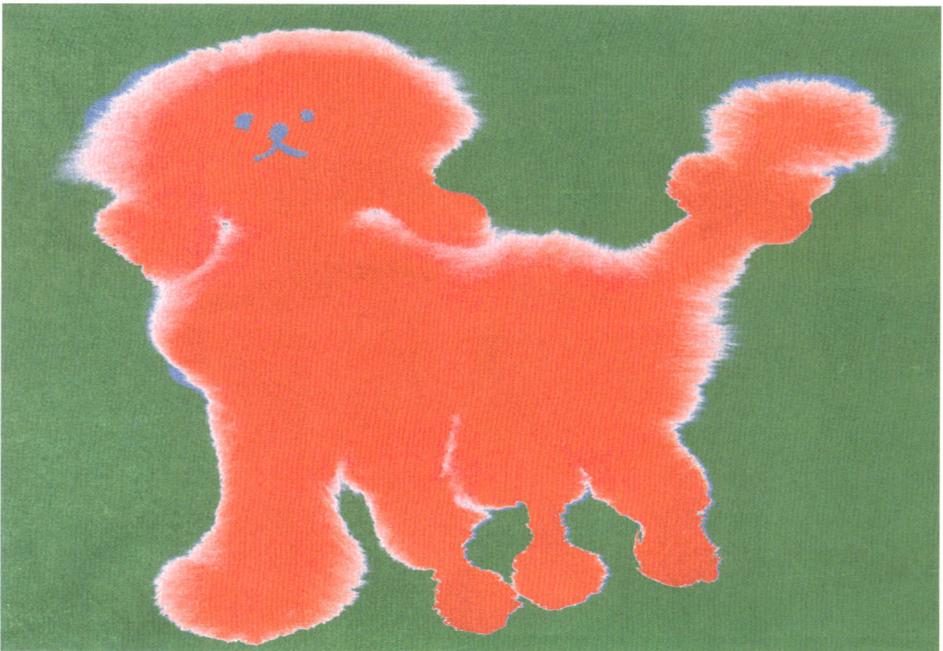

212

Dog On A Windy Day
148.5 x 105 mm, Ink Stains, Digital

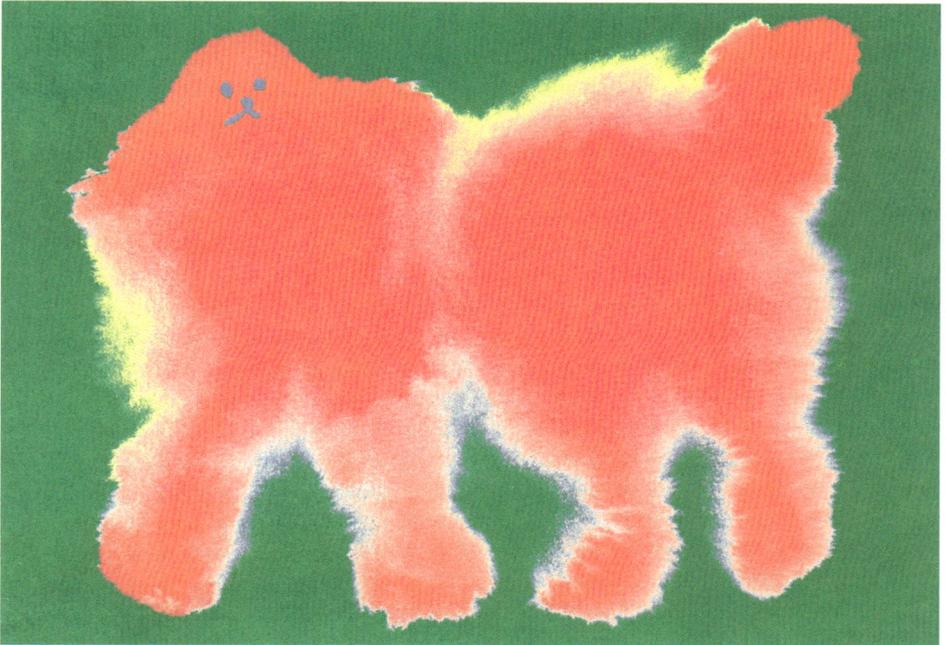
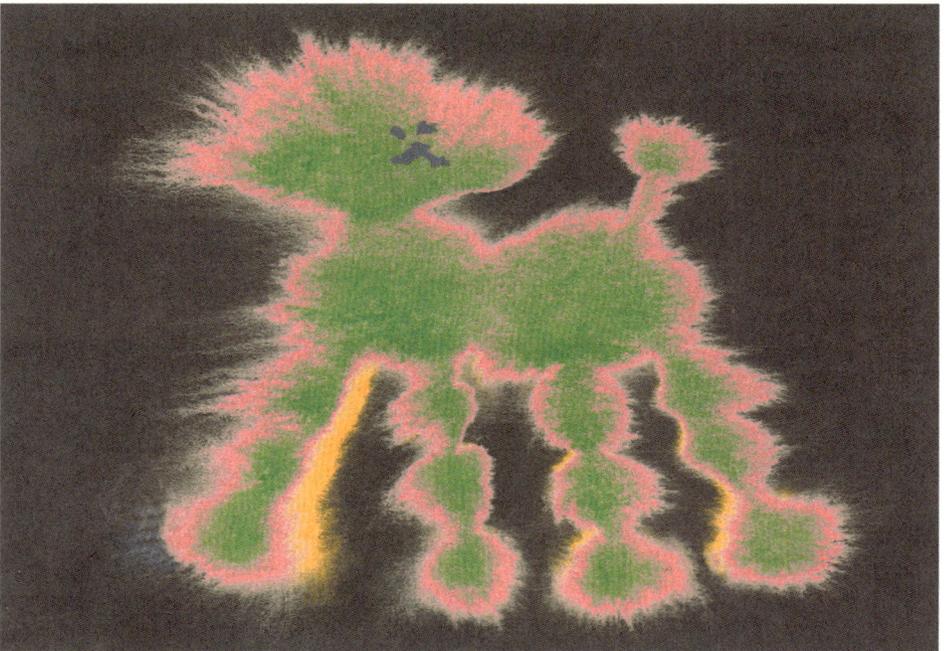

Dog On A Windy Day
148.5 x 105 mm, Ink Stains, Digital

Zoey is a freelance illustrator from South Korea. Her drawings embrace various emotions and stories with happiness, loneliness, and humour. She portrays her style through a blurred and fuzzy texture, which adds softness and warmth to her artwork. Zoey loves to let people create their own narrative and imagination by looking at her drawings.

zoeykimm.com

Zoey Kim

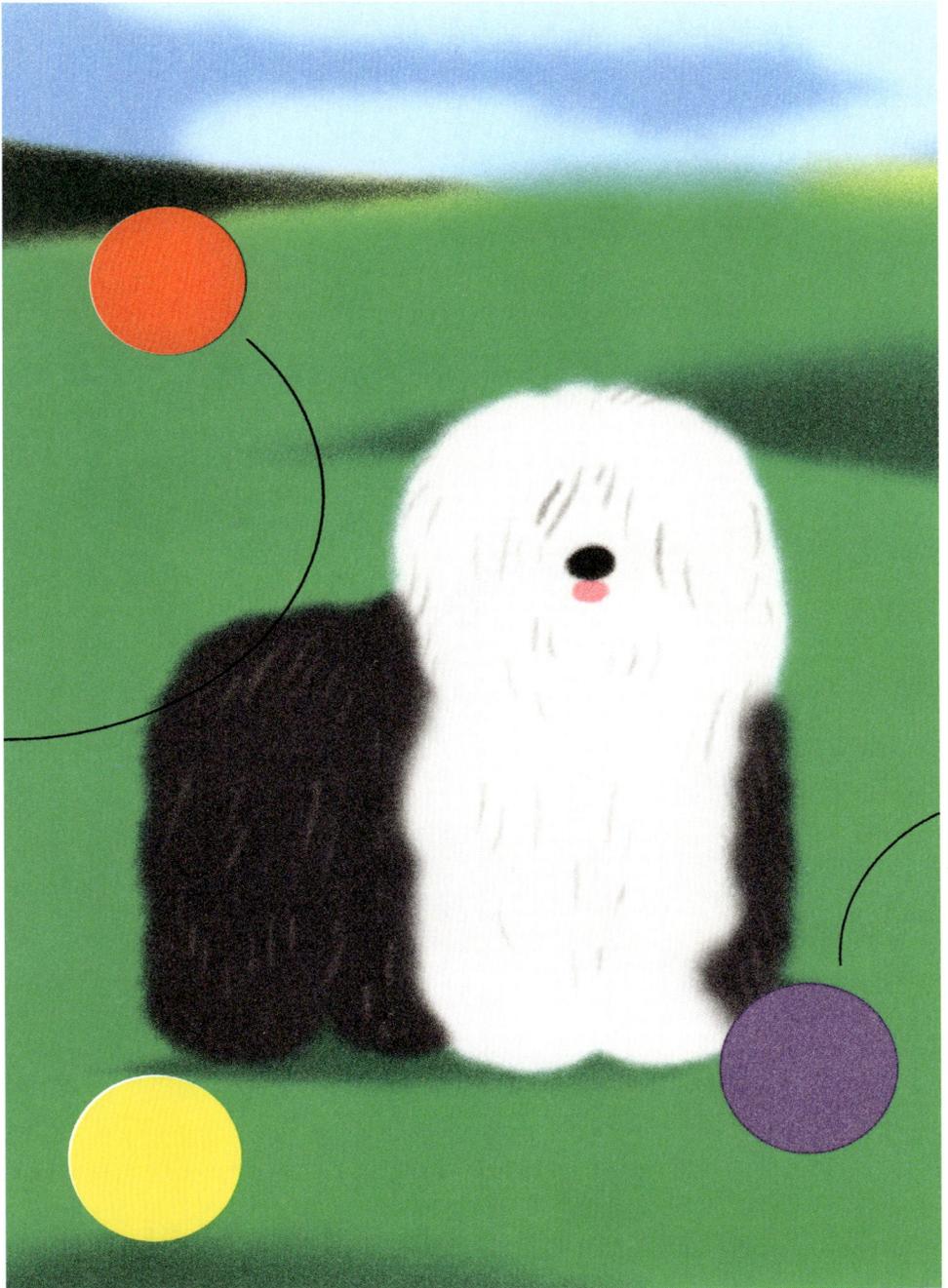

Dream Dog
594 x 840 mm, Digital

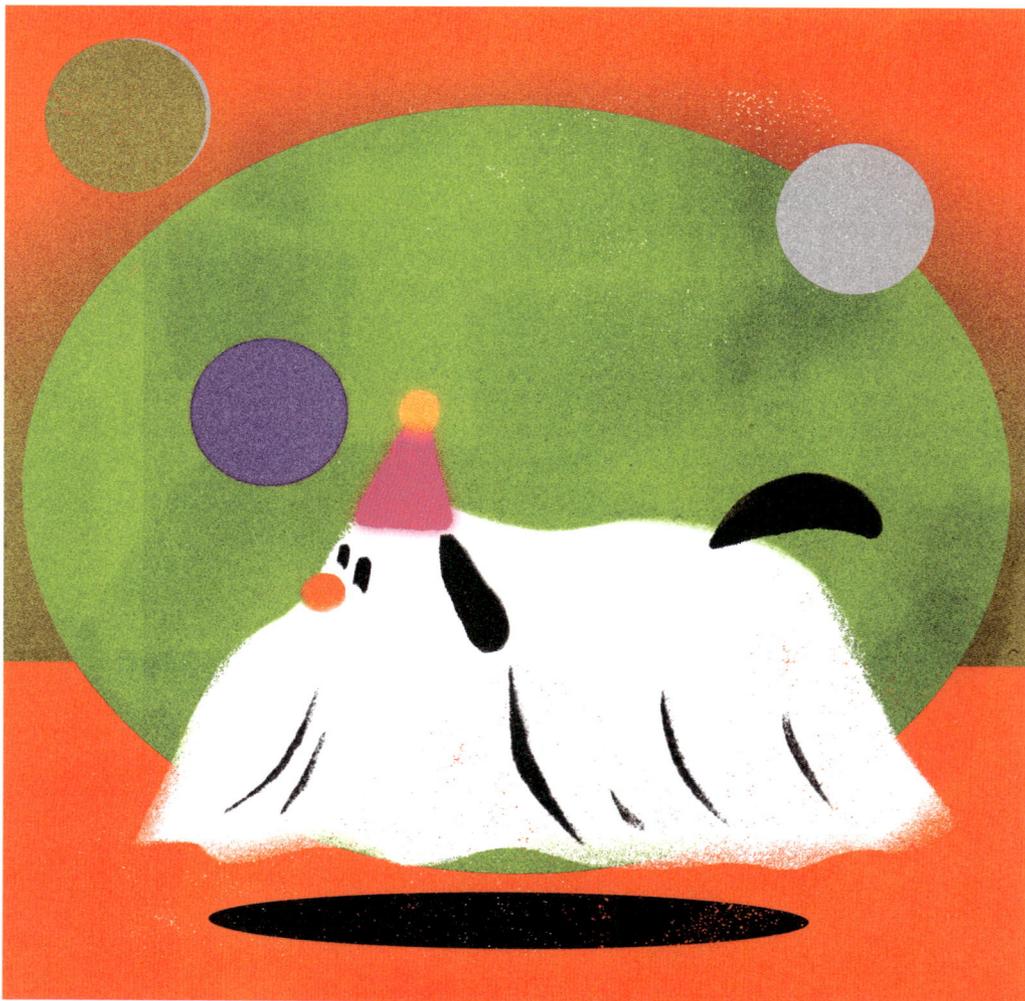

Halloween
200 x 200 mm, Digital

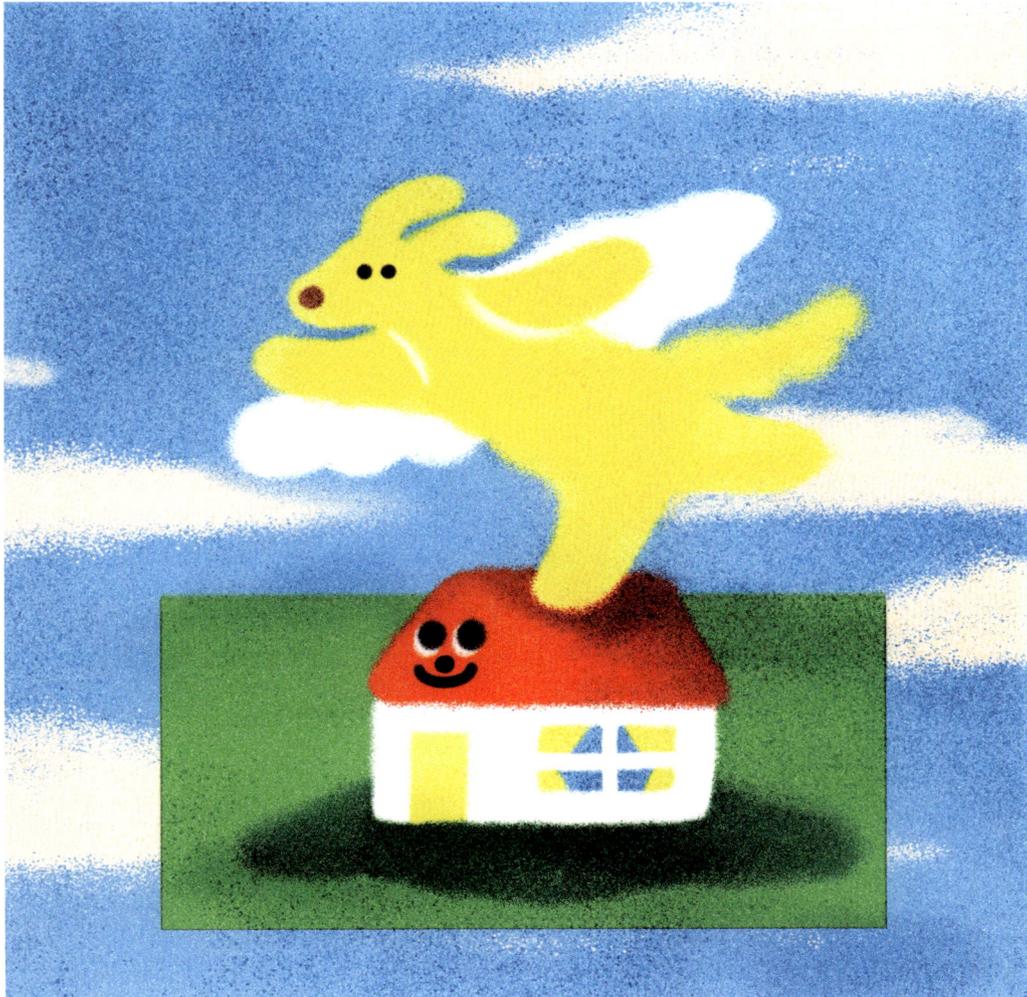

Learn To Fly
254 x 254 mm, Digital

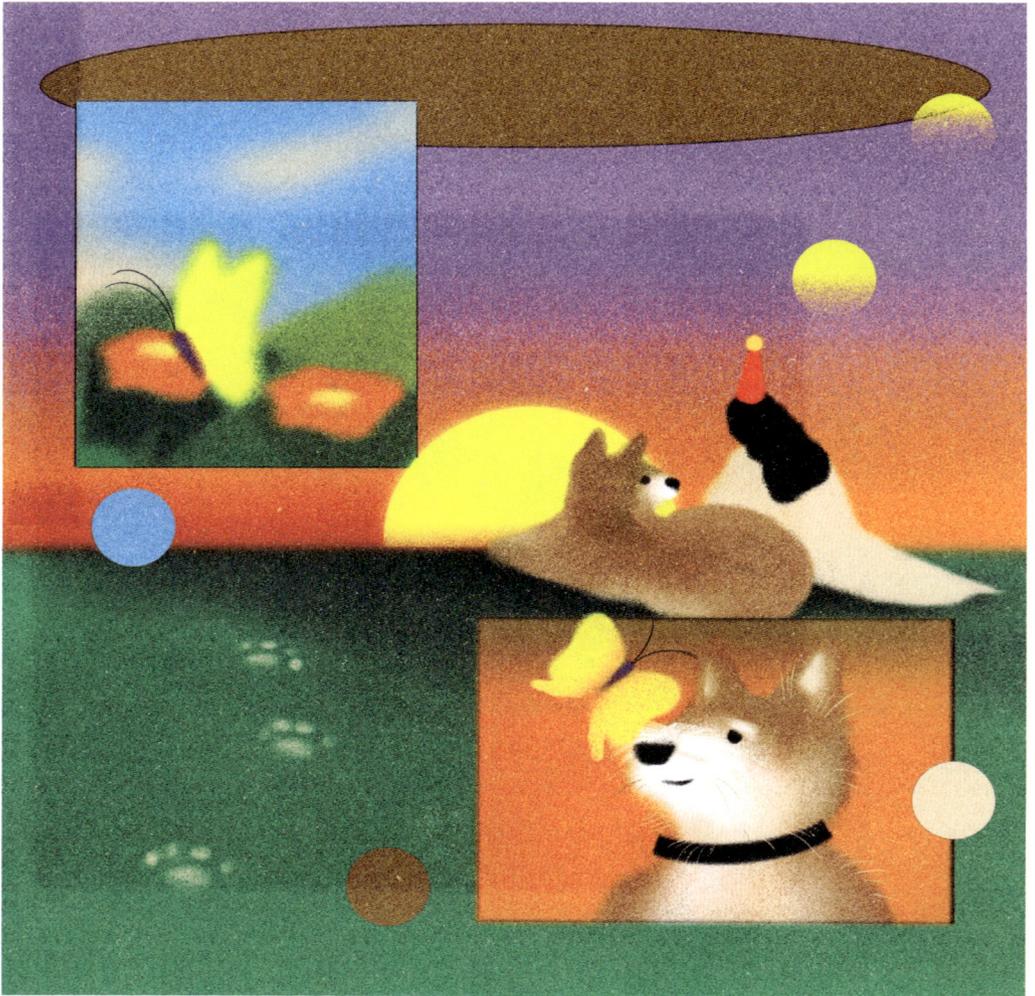

Single Cover Artwork for Yebit
254 x 254 mm, Digital, Client: Yebit (beamz / MoundMedia)
A&R, Management: Boyeon Marta Shin, Hyejin Choi, Yoona Kim

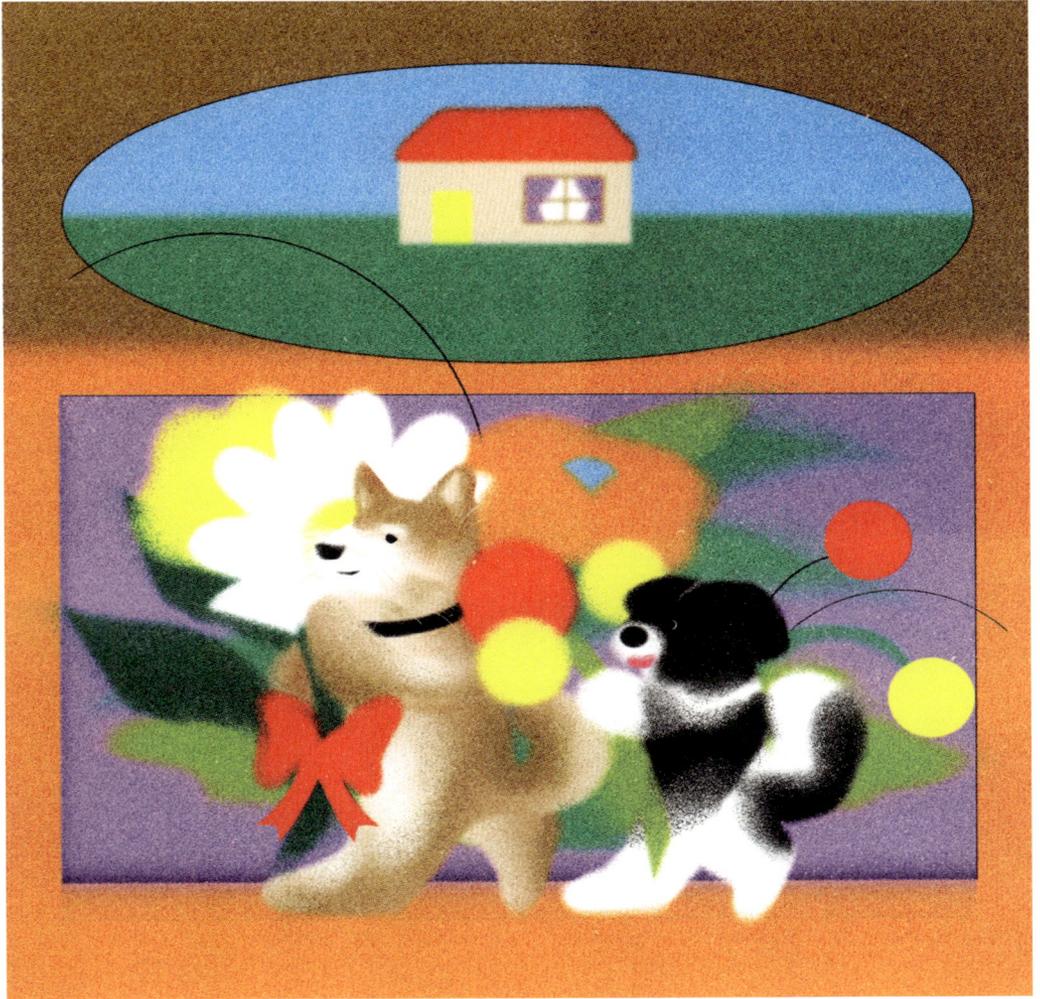

Single Cover Artwork for Yebit
254 x 254 mm, Digital, Client: Yebit (beamz / MoundMedia)
A&R, Management: Boyeon Marta Shin, Hyejin Choi, Yoona Kim

All The Love For You
420 x 297 mm, Digital

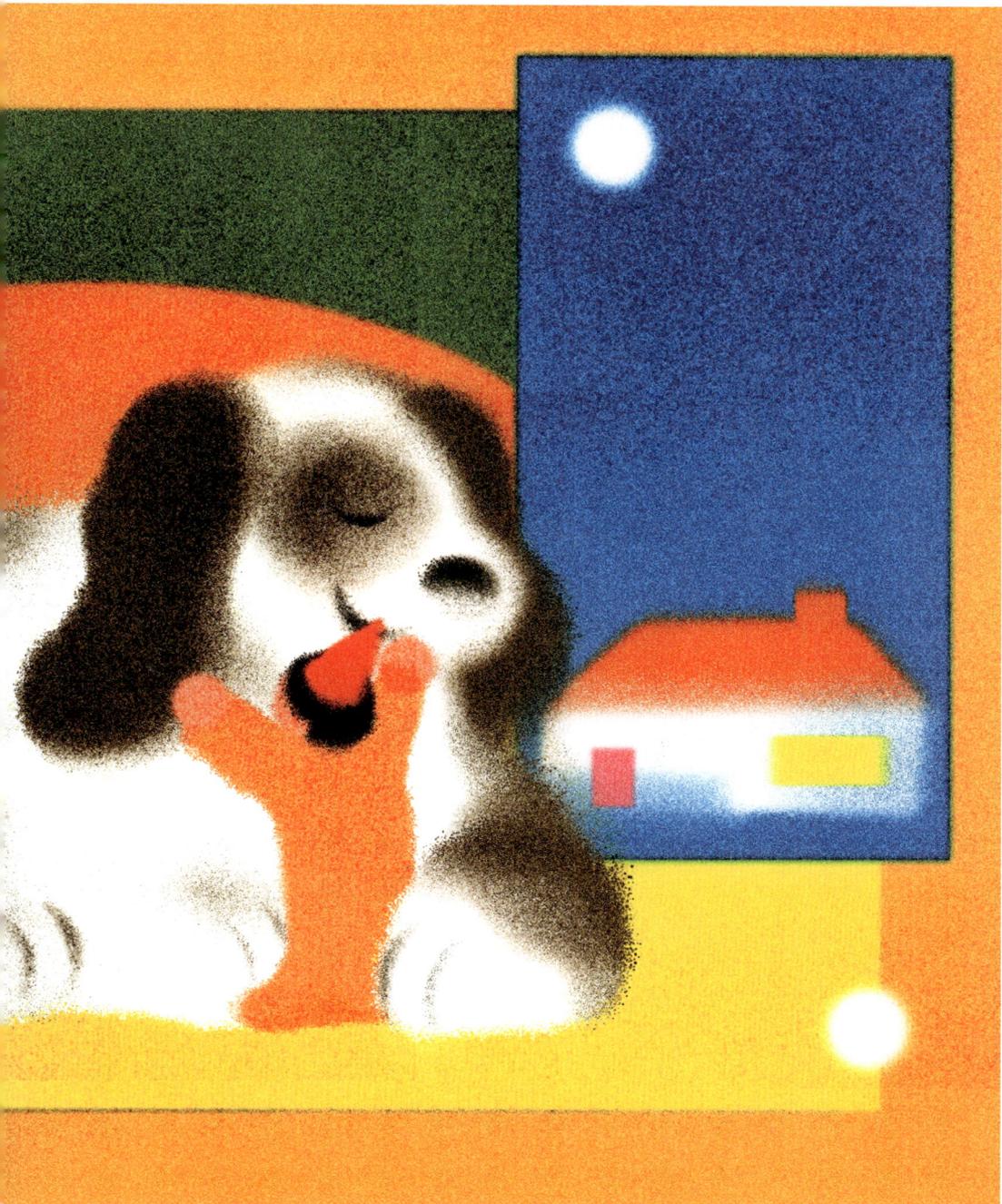

GYOZA

GYOZA, a visual designer and illustrator based in Seoul, majored in Visual Design. Specialising in drawing animals, particularly dogs, they capture the unique, lovable emotions of animals. They have collaborated with companies to evoke a sense of loveliness and held a solo exhibition, "A Heart of Celebration", at the Moment Series Gallery in Seoul in 2023.

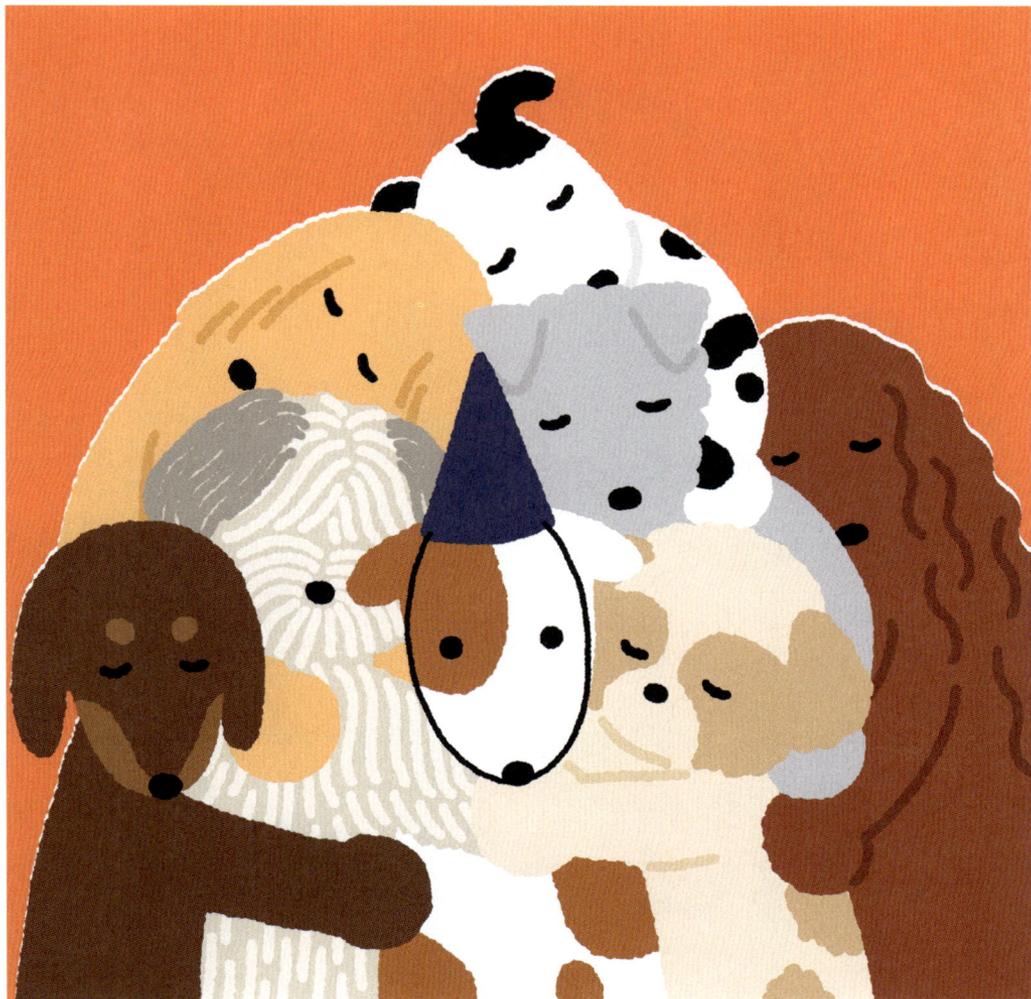

Hug
297 x 297 mm, Digital

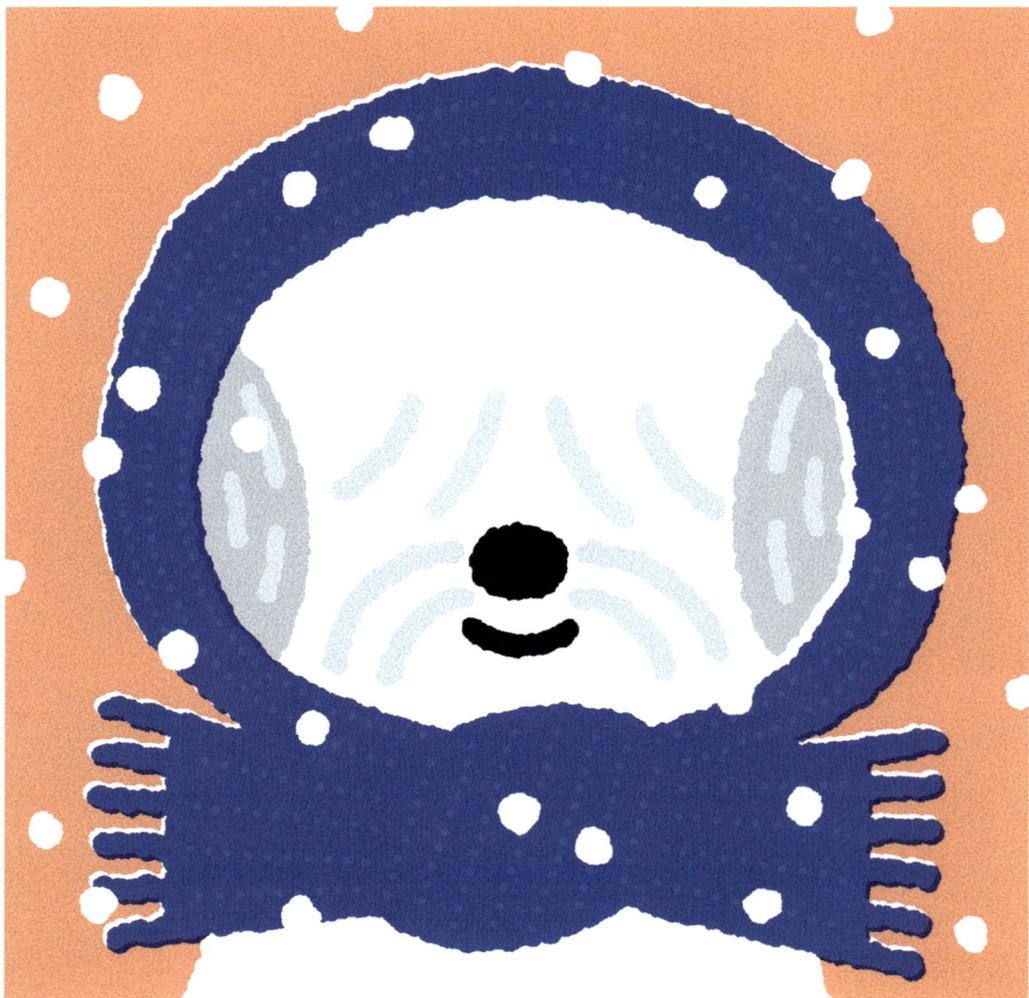

Winter 02
297 x 297 mm, Digital

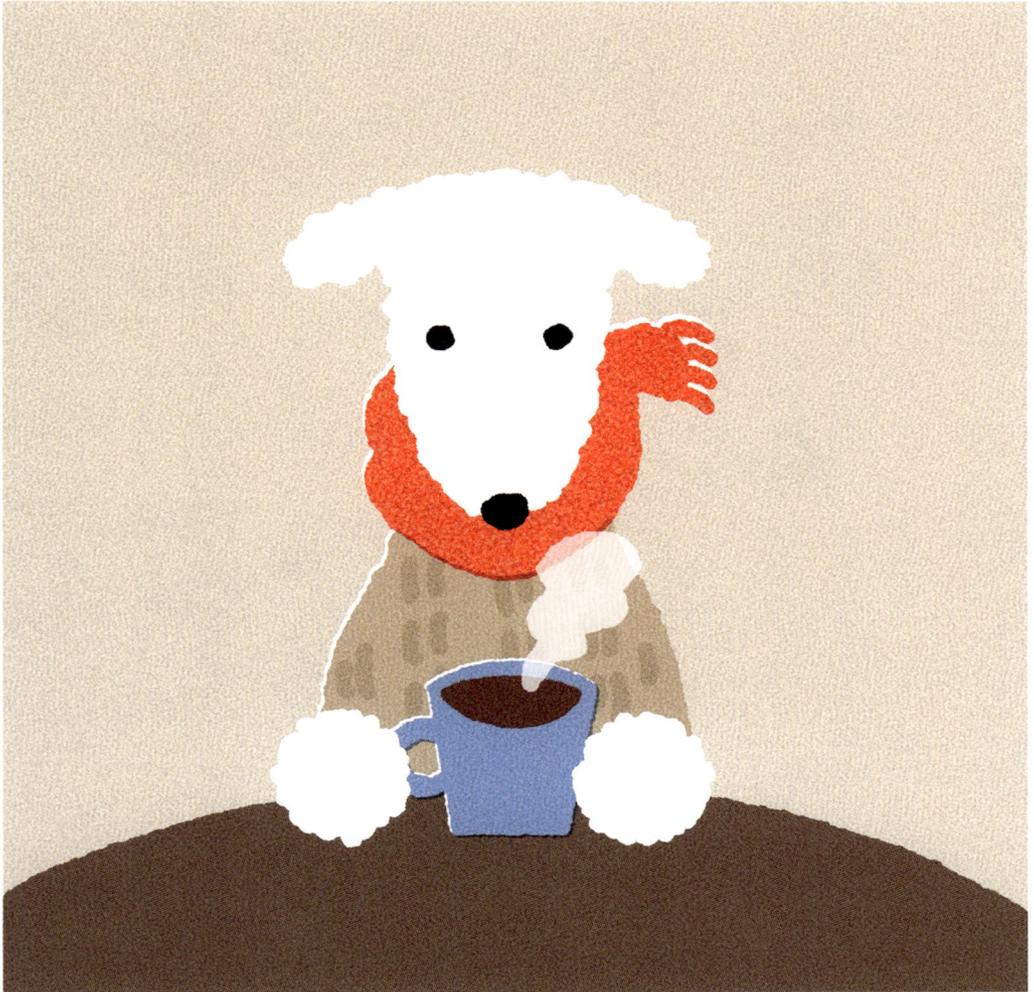

Tea Time
297 x 297 mm, Digital

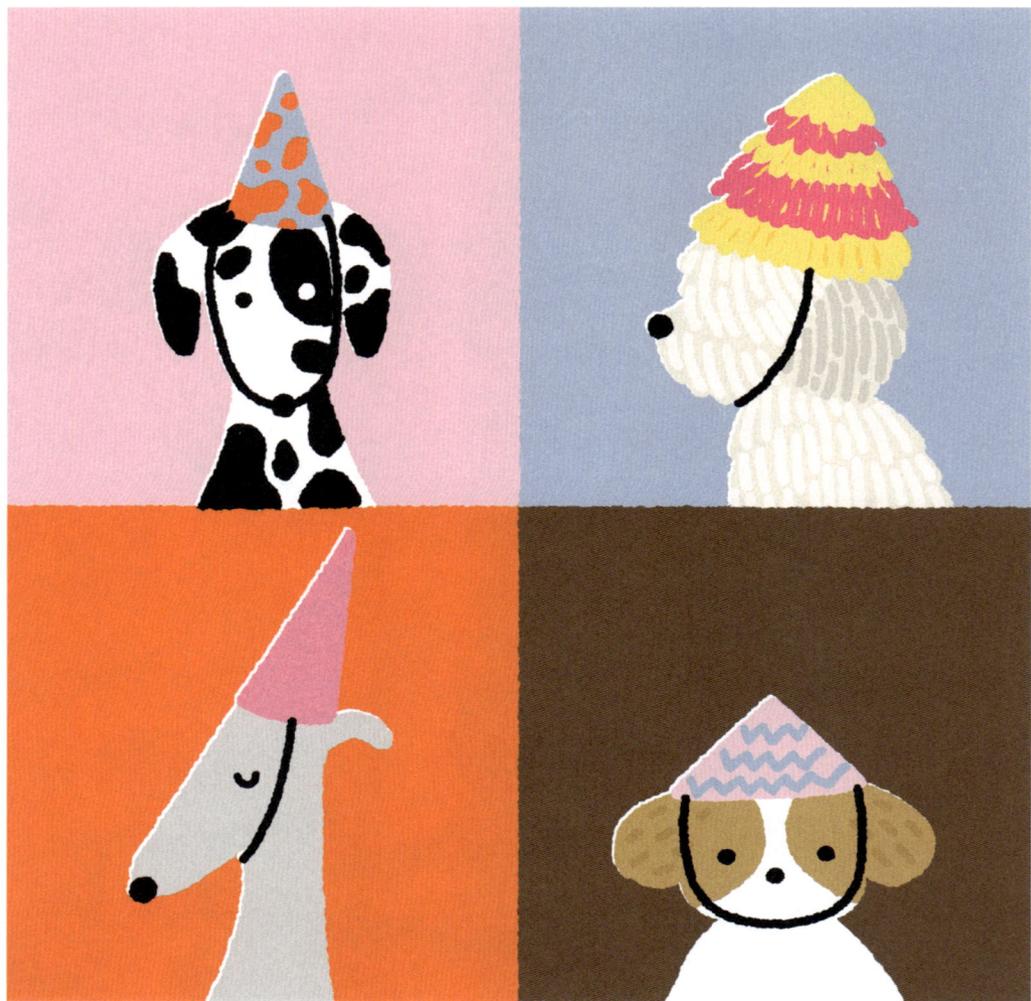

Pick
297 x 297 mm, Digital

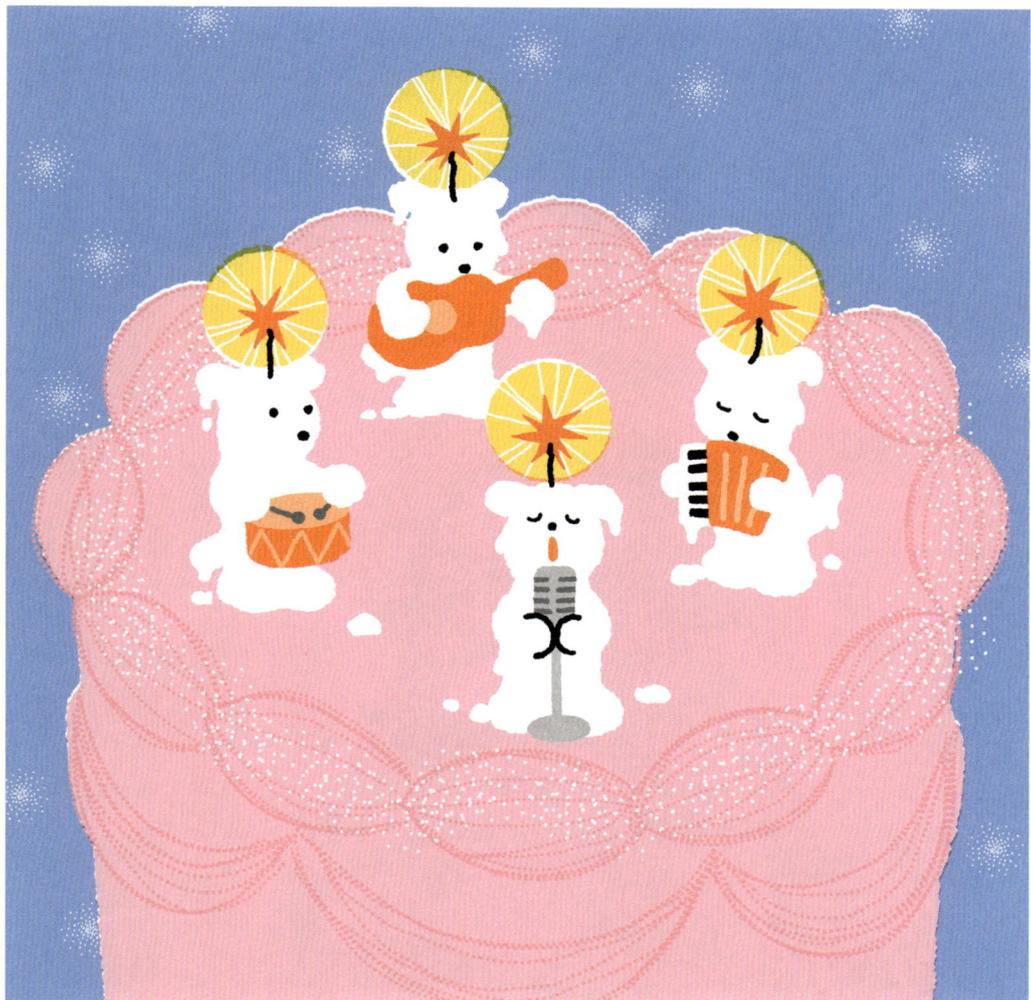

Dear Oo
297 x 297 mm, Digital

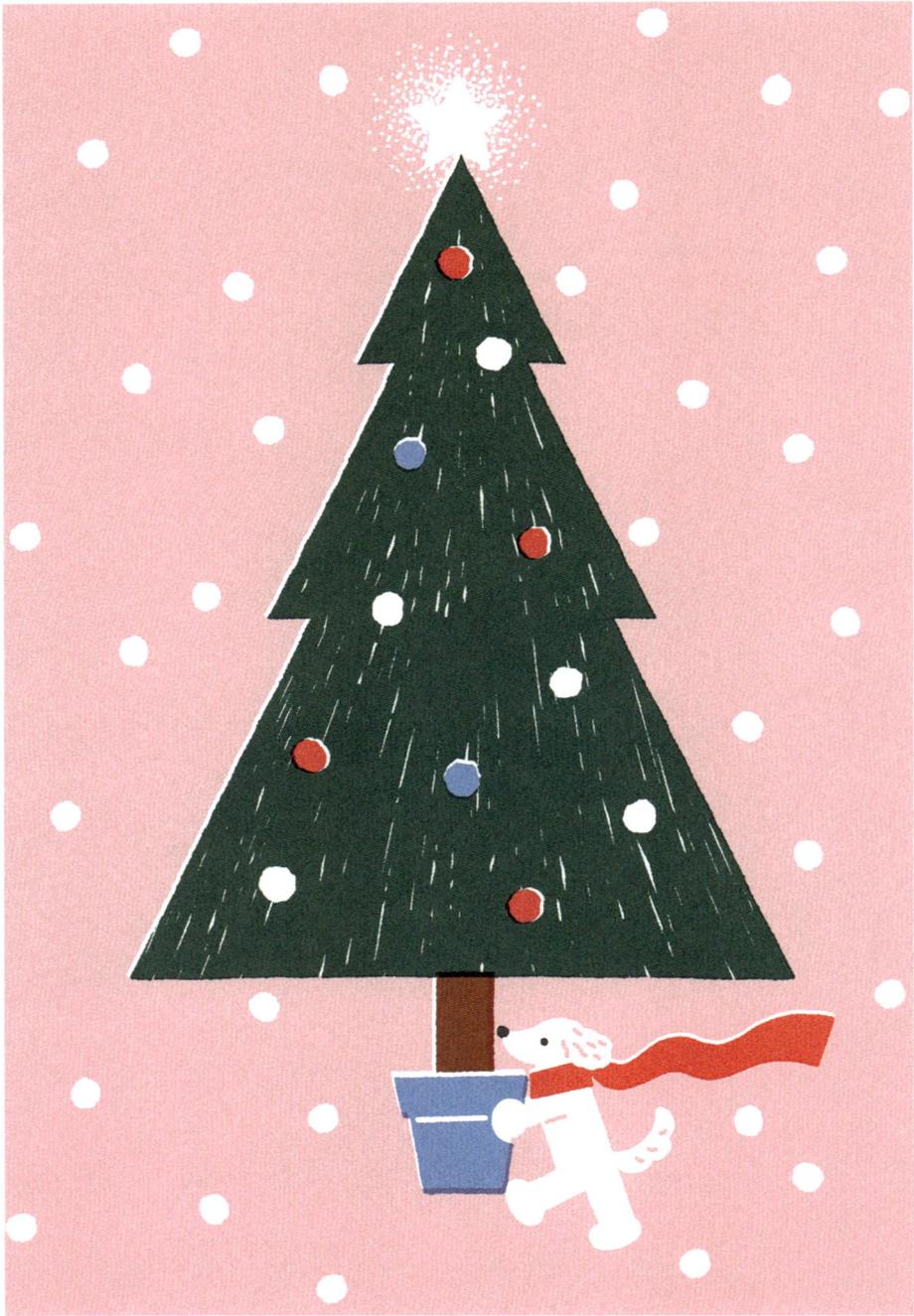

Tree 02
104 x 154 mm, Digital

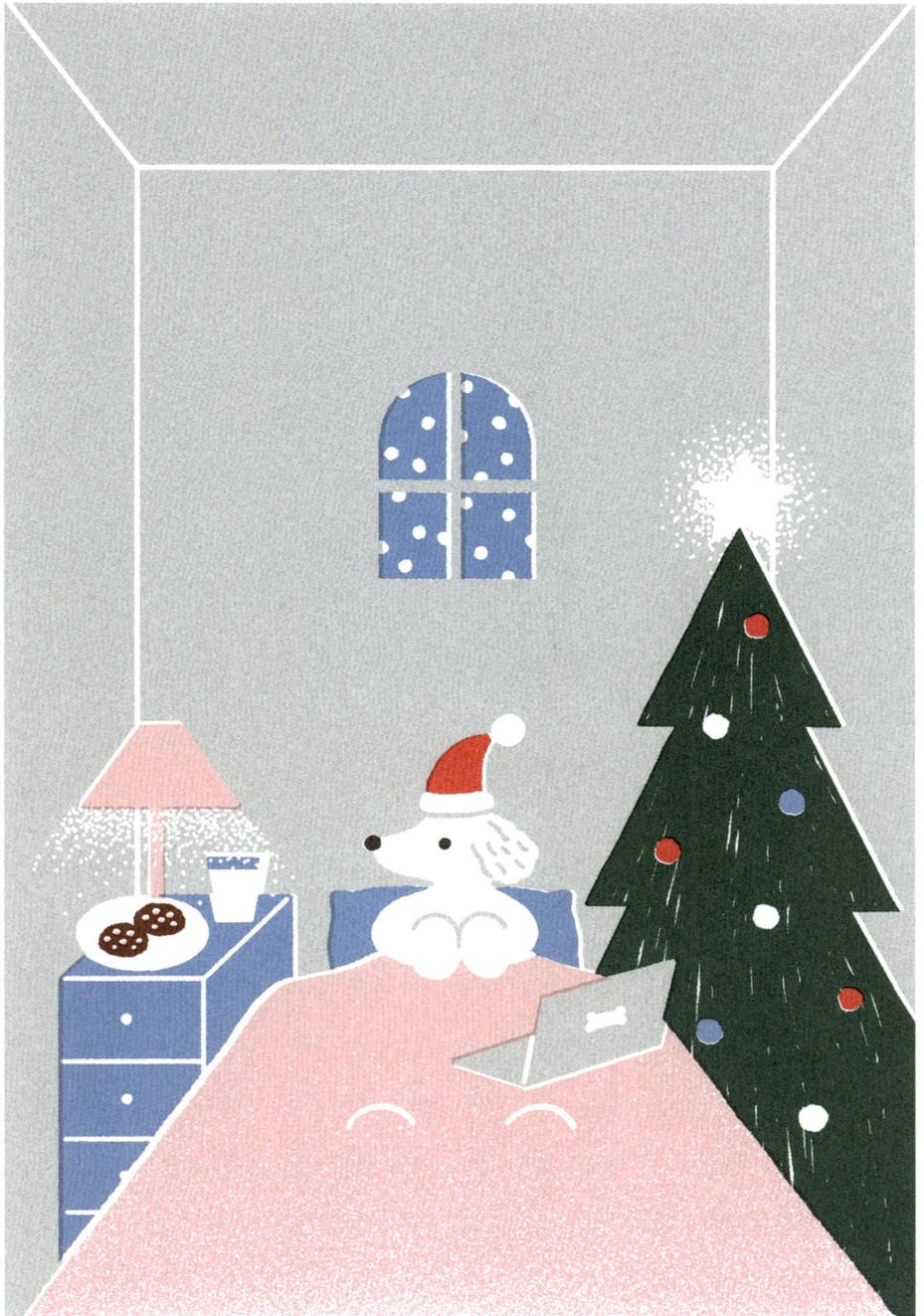

Tree 03
104 x 154 mm, Digital

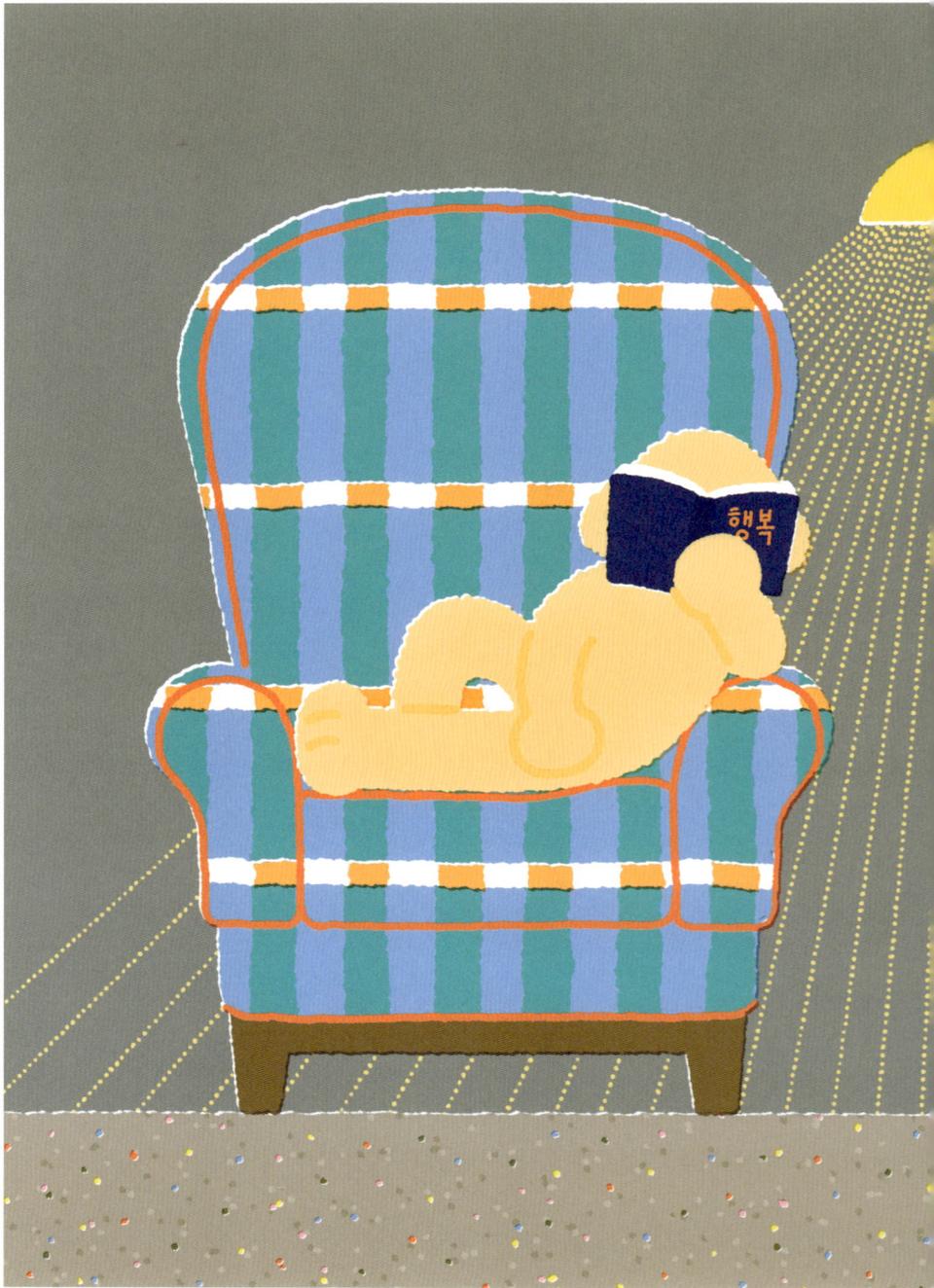

Happiness, Love
348 x 248 mm, Digital

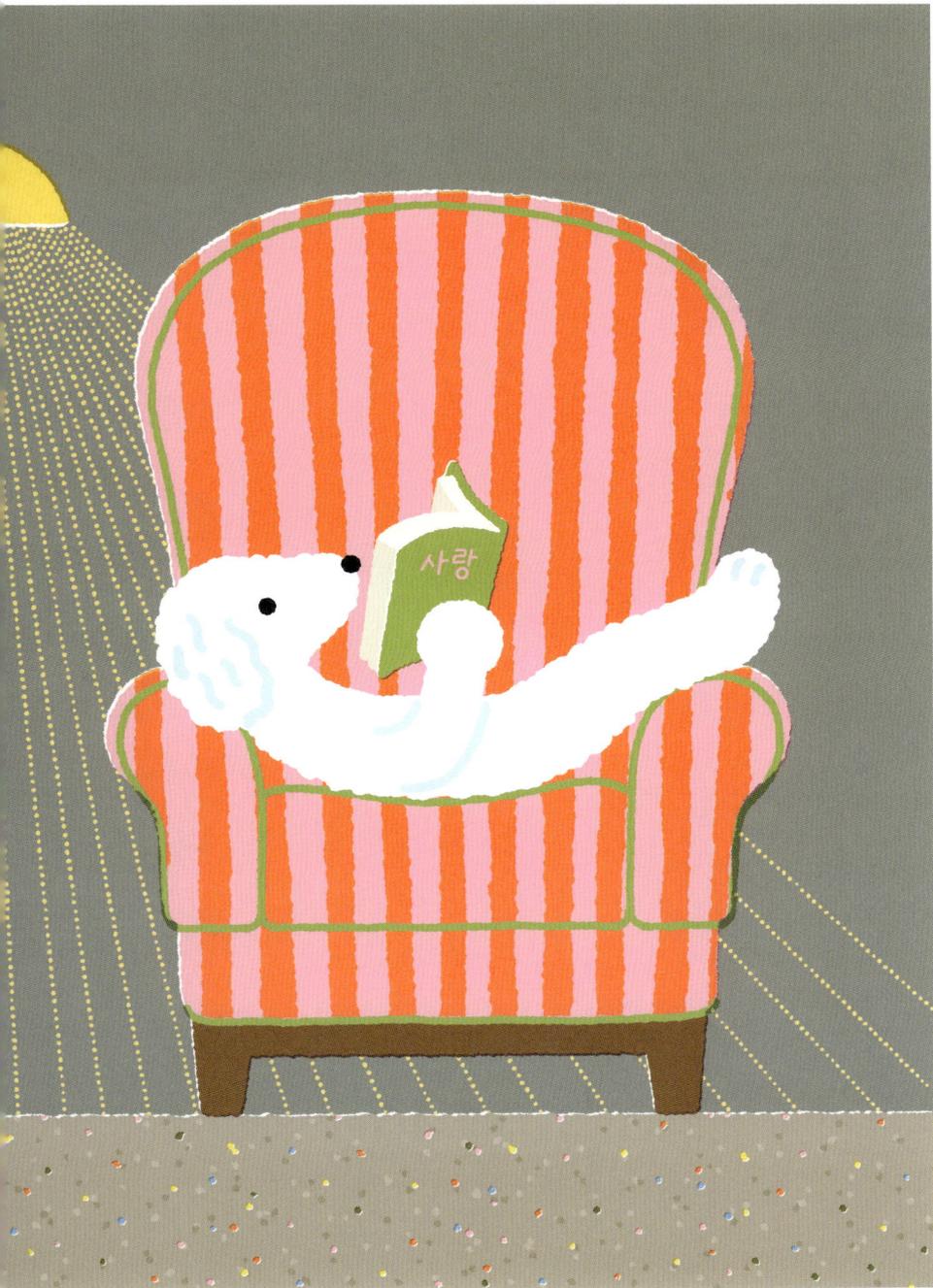

Essi
Kimpimäki

essillustration.com

Essi Kimpimäki, a Finnish freelance illustrator based in Edinburgh, studied illustration at the Glasgow School of Art. She uses bold, simplified shapes and vivid colours to draw her favourite things including animals, plants, food, landscapes, travel, people, and little everyday moments. Her whimsical work is created digitally, using texture brushes to add a handmade touch.

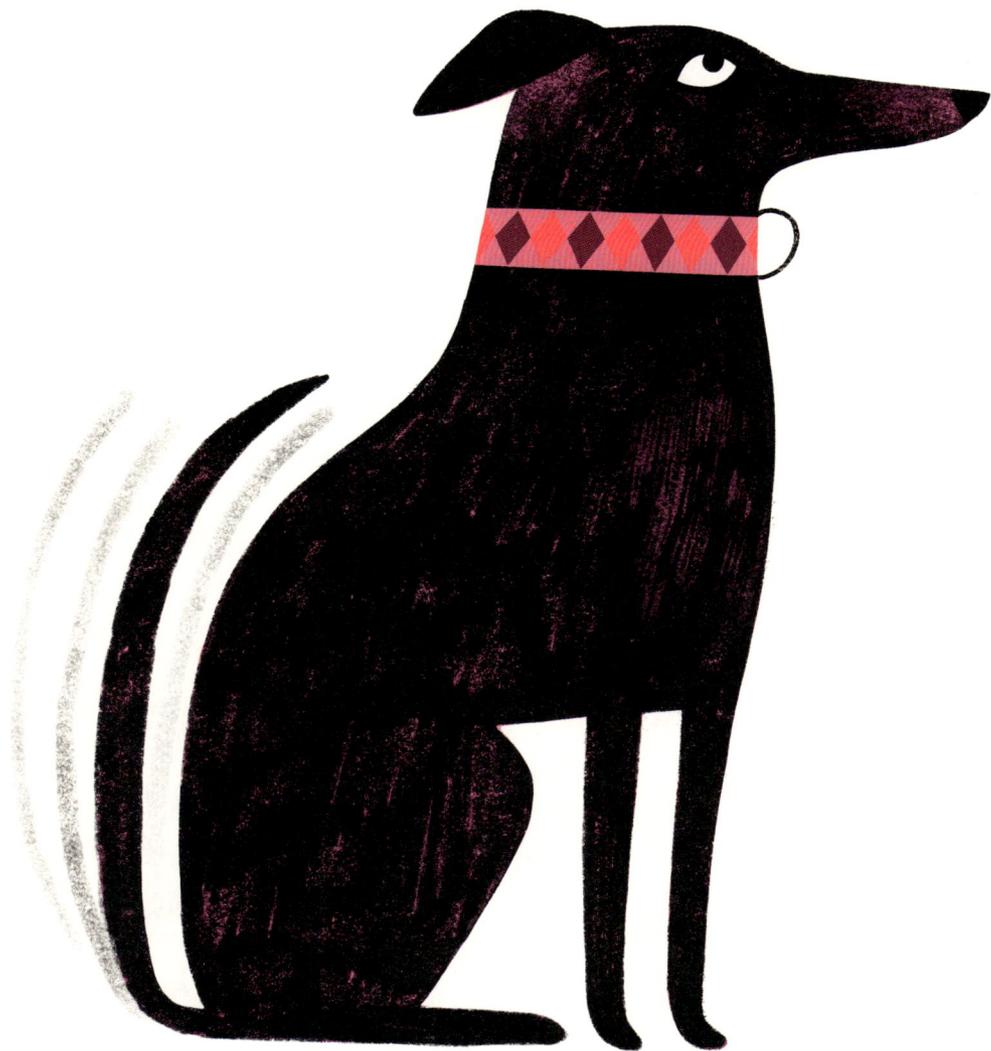

Good Boy
233 x 233 mm, Digital

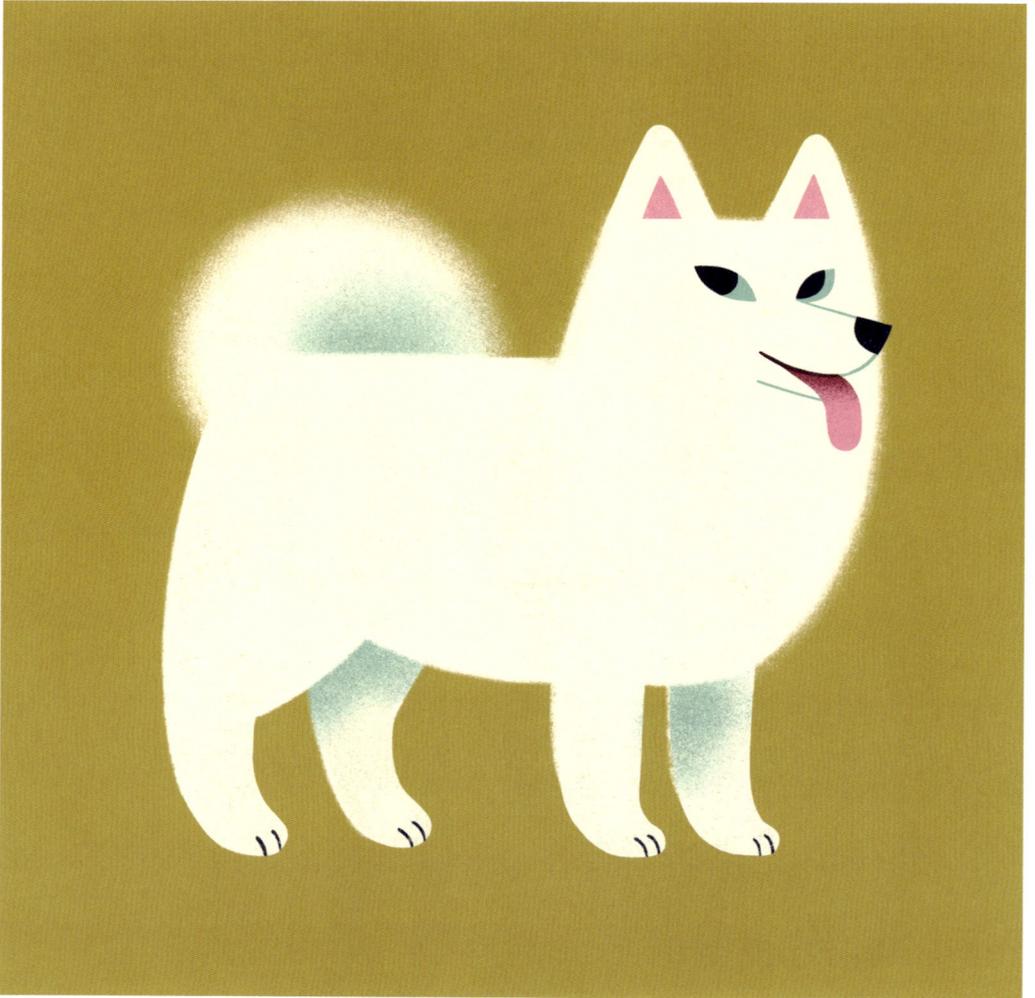

234

Samoyed
355 x 355 mm, Digital

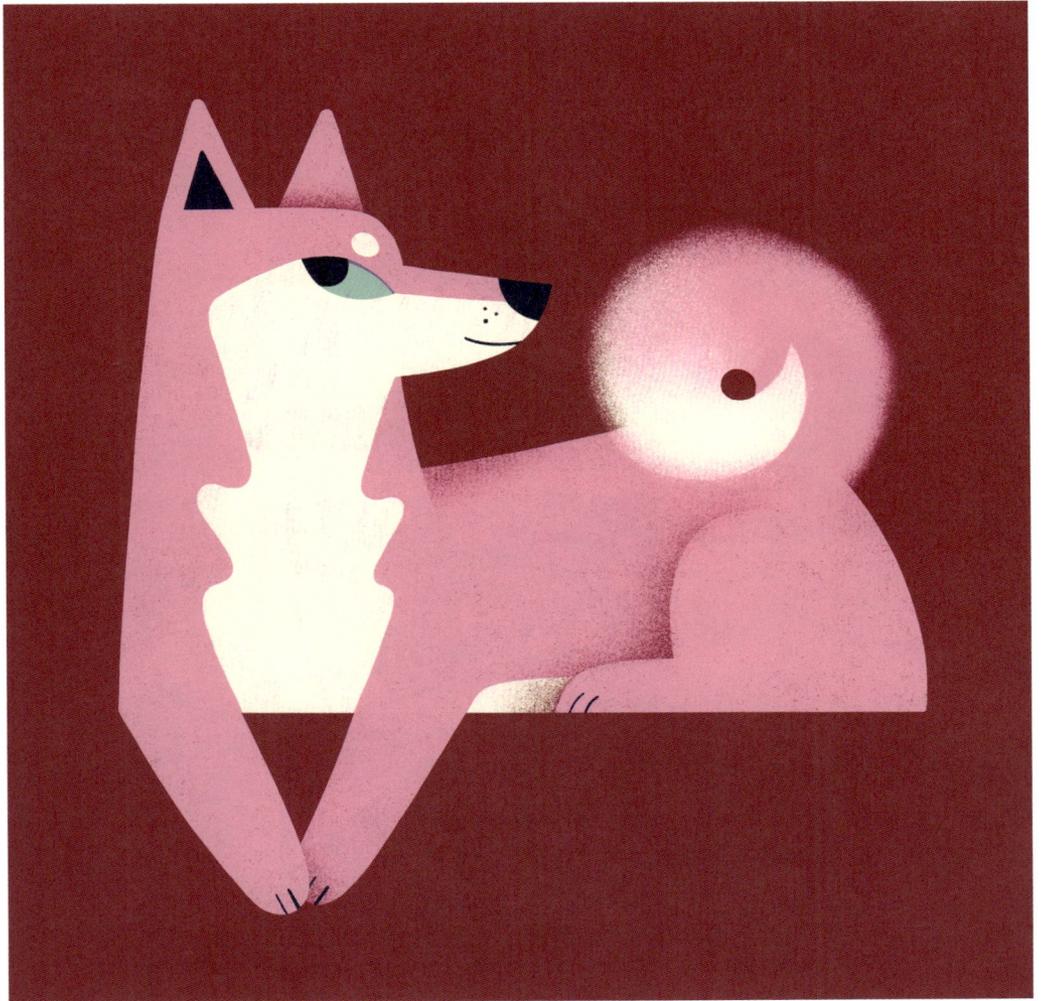

Shiba Inu
355 x 355 mm, Digital

Border Collie (←)
355 x 355 mm, Digital

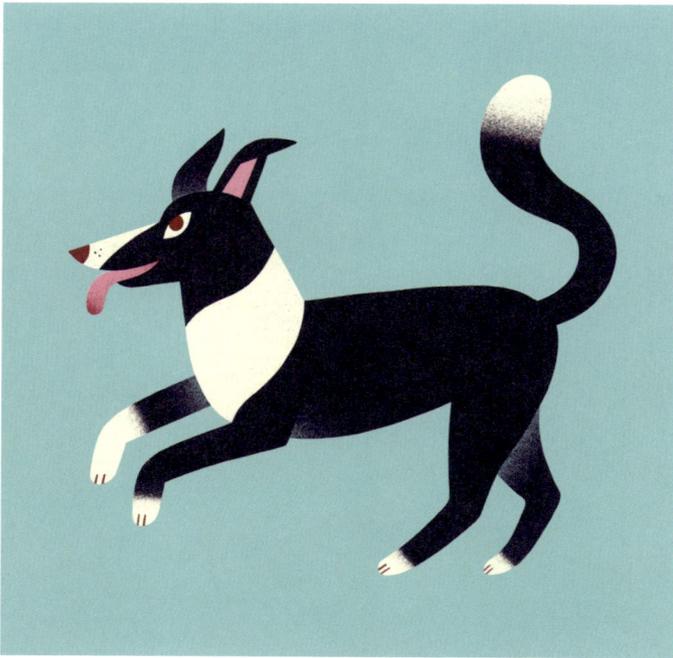

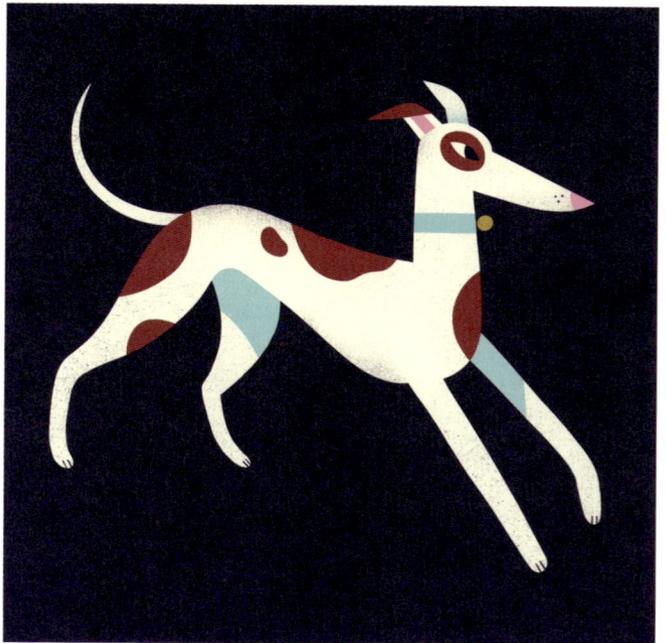

Greyhound (↑)
355 x 355 mm, Digital

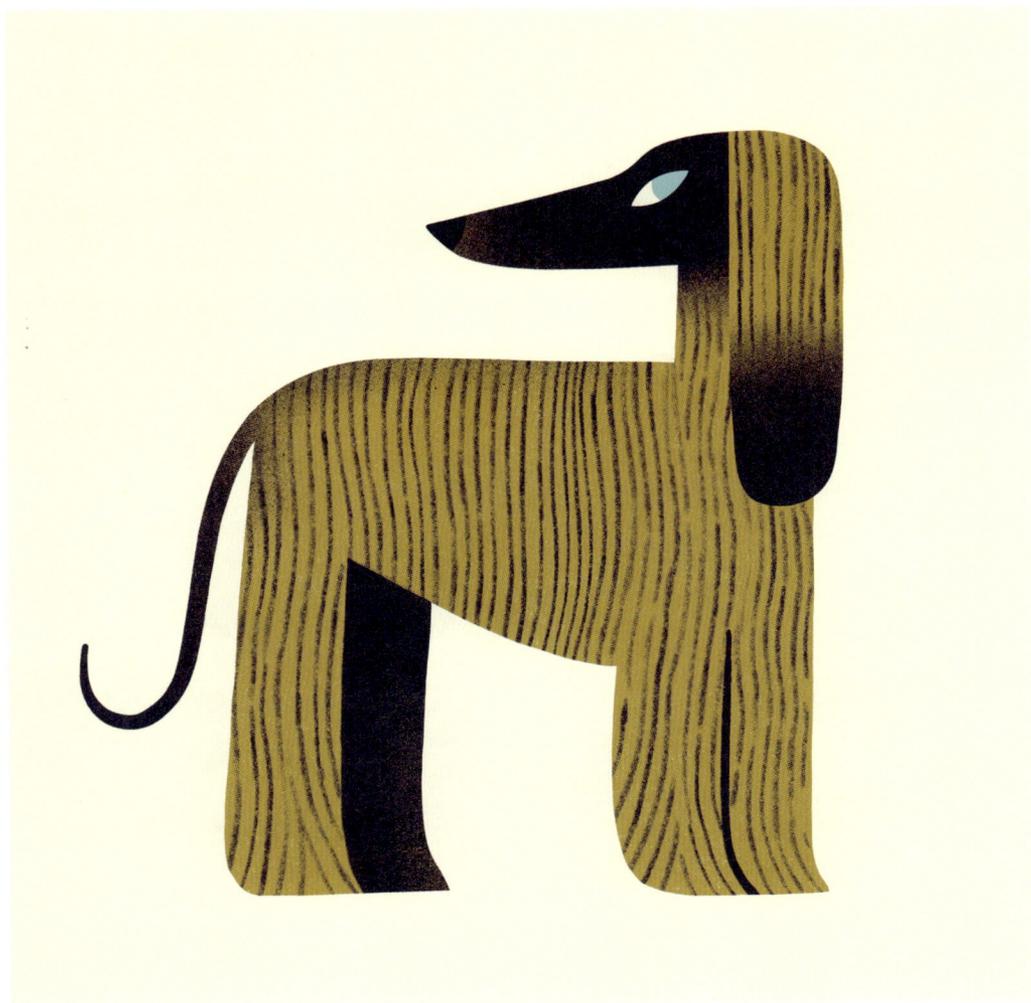

Afghan Hound
355 x 355 mm, Digital

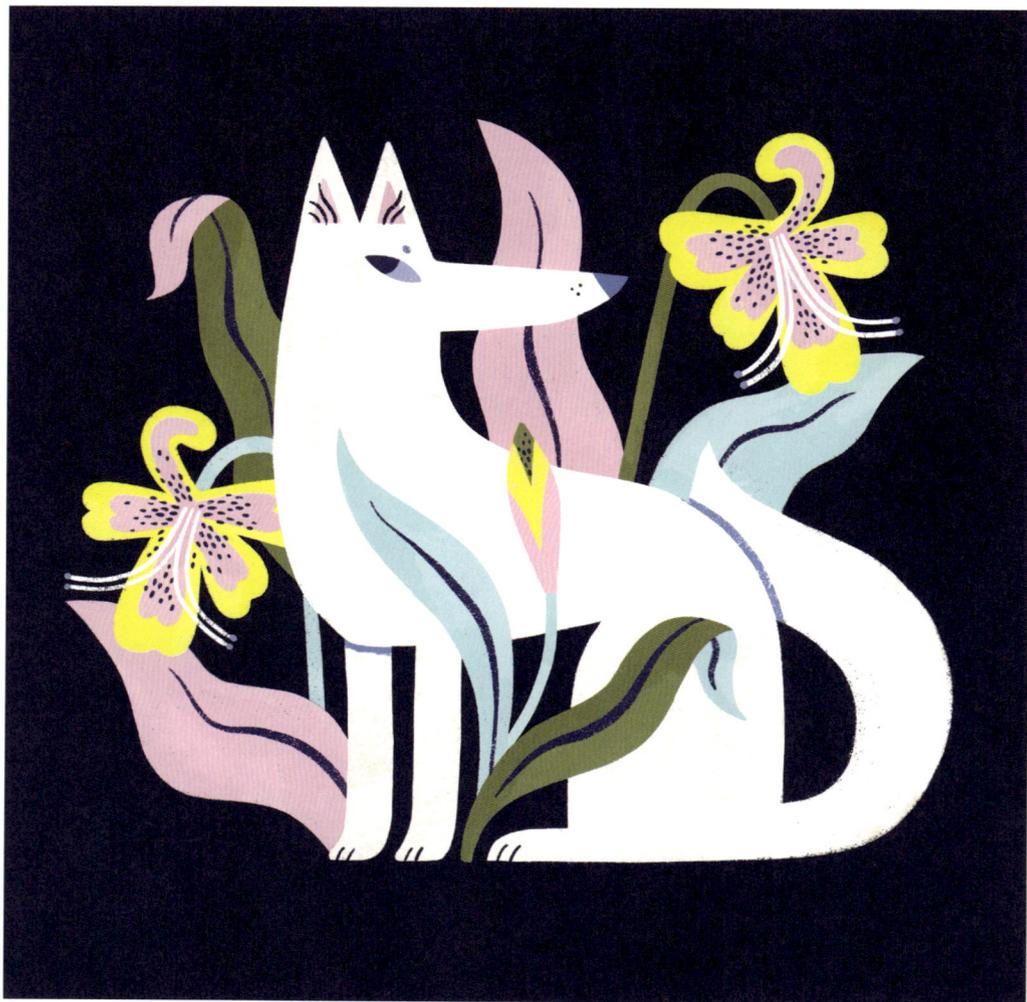

238

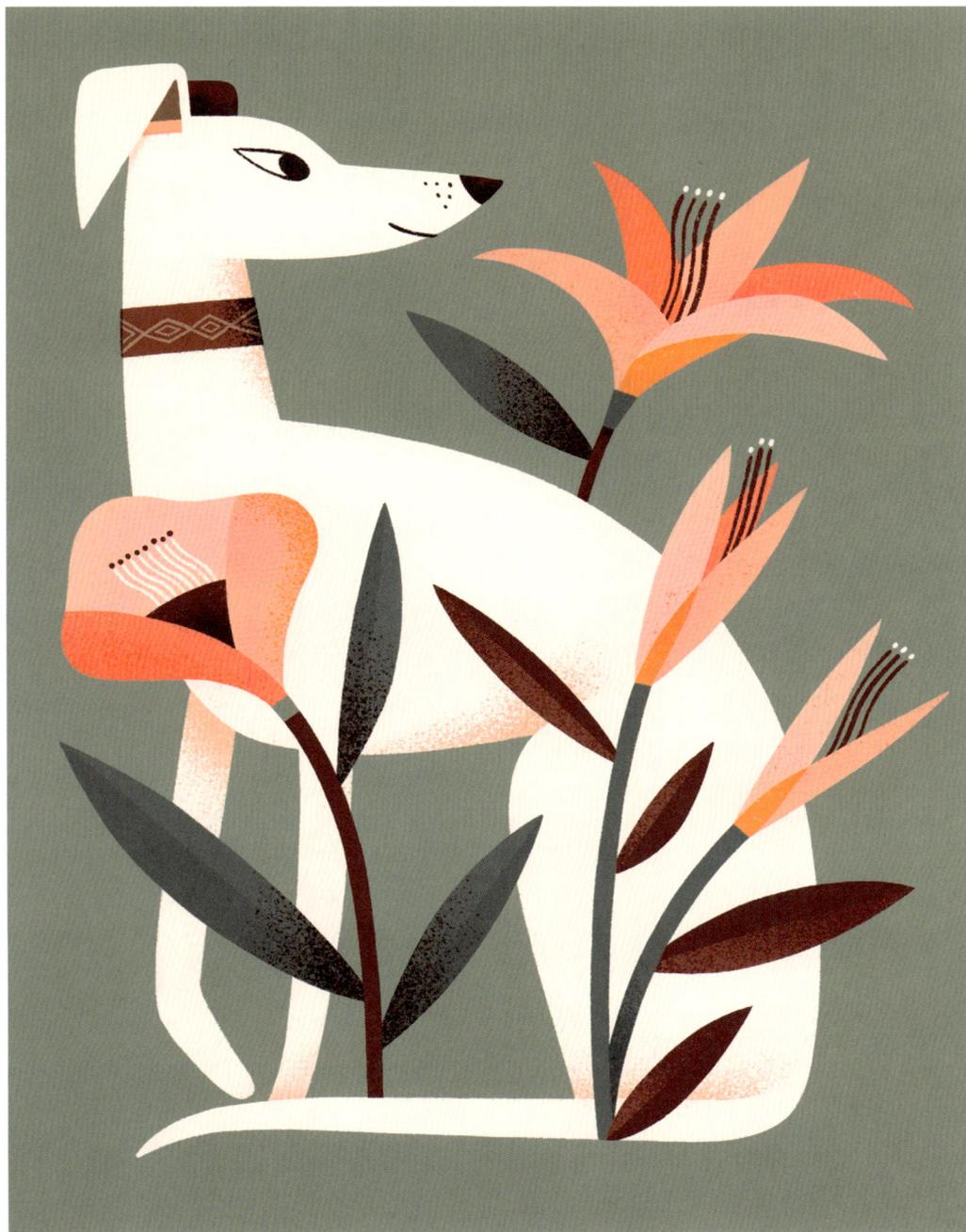

Hound and Flowers
209 x 279 mm, Digital

Russell Miyaki, a contemporary artist and creative director, has a studio in Bridgeport, CT. Born and raised in New Mexico, he graduated with honours in advertising design and illustration in Colorado. Russell's work spans oils, pigment sticks, and acrylics, drawing inspiration from the vibrant styles of Peter Max, Juan Gris, Lee Krasner, Franz Marc, and Jean-Michel Basquiat.

miyakigallery.com

Russell Miyaki

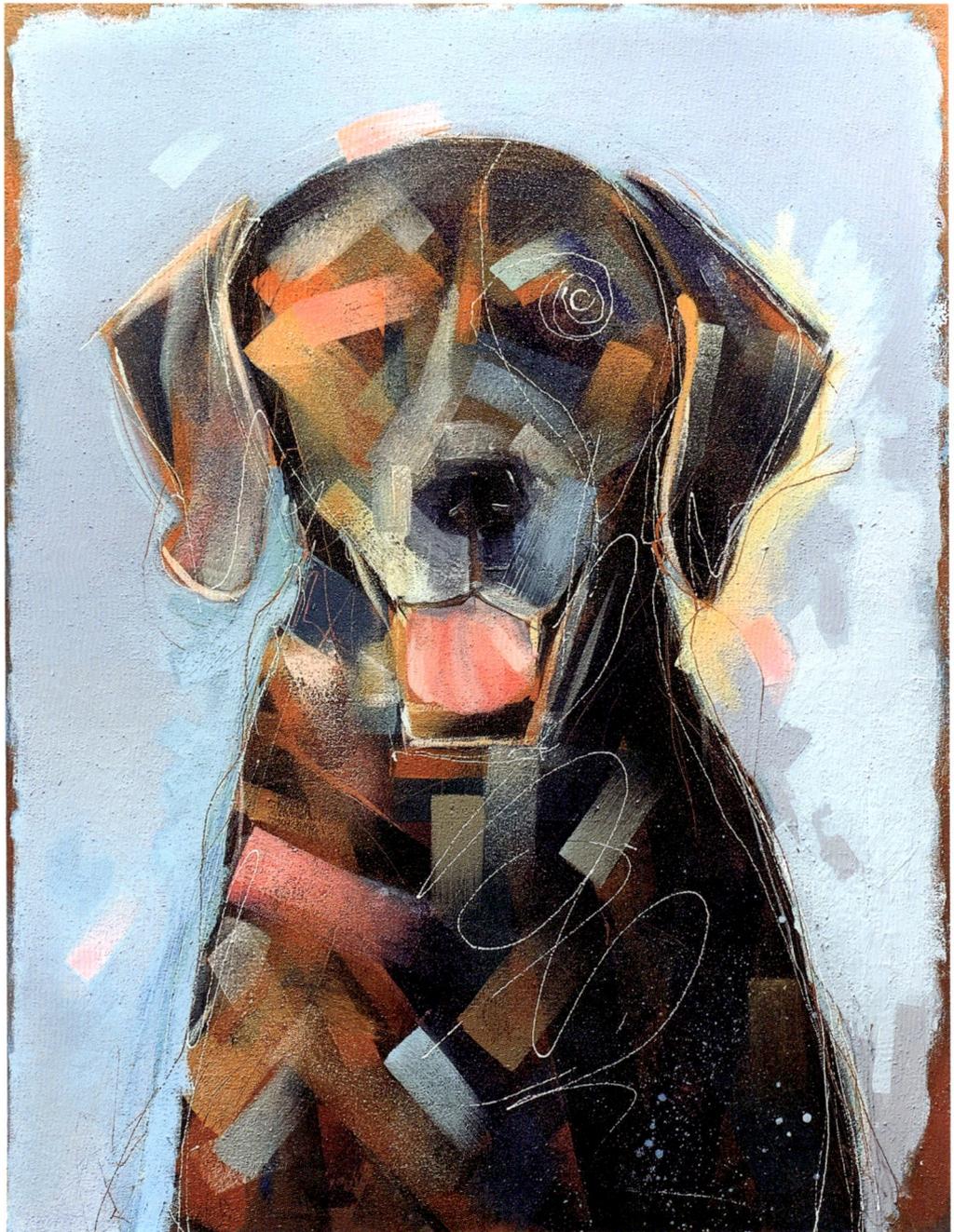

Private Commission
762 x 1016 mm, Acrylic, Canvas

241

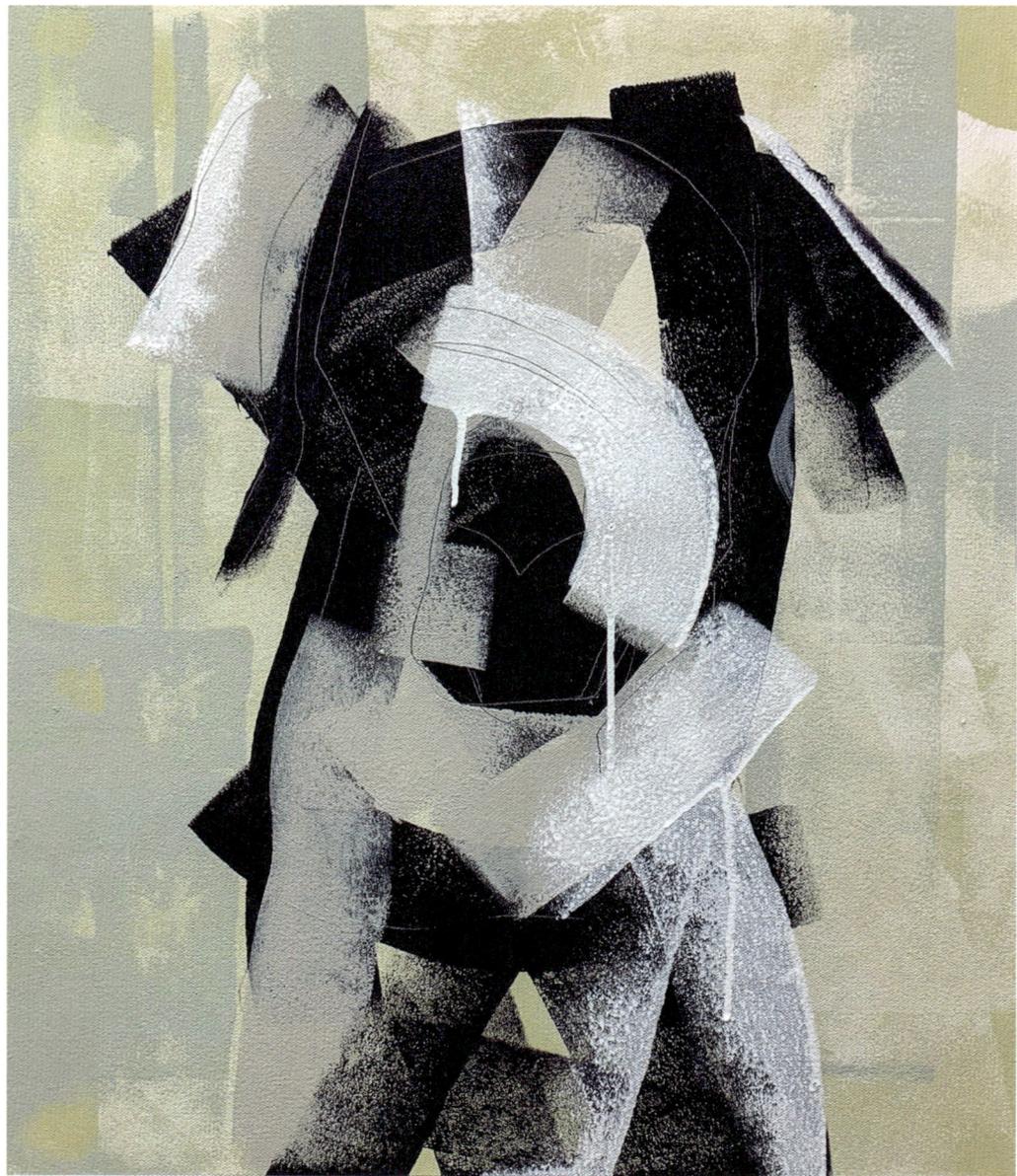

242

Beechnut
406 x 508 mm, Acrylic, Canvas

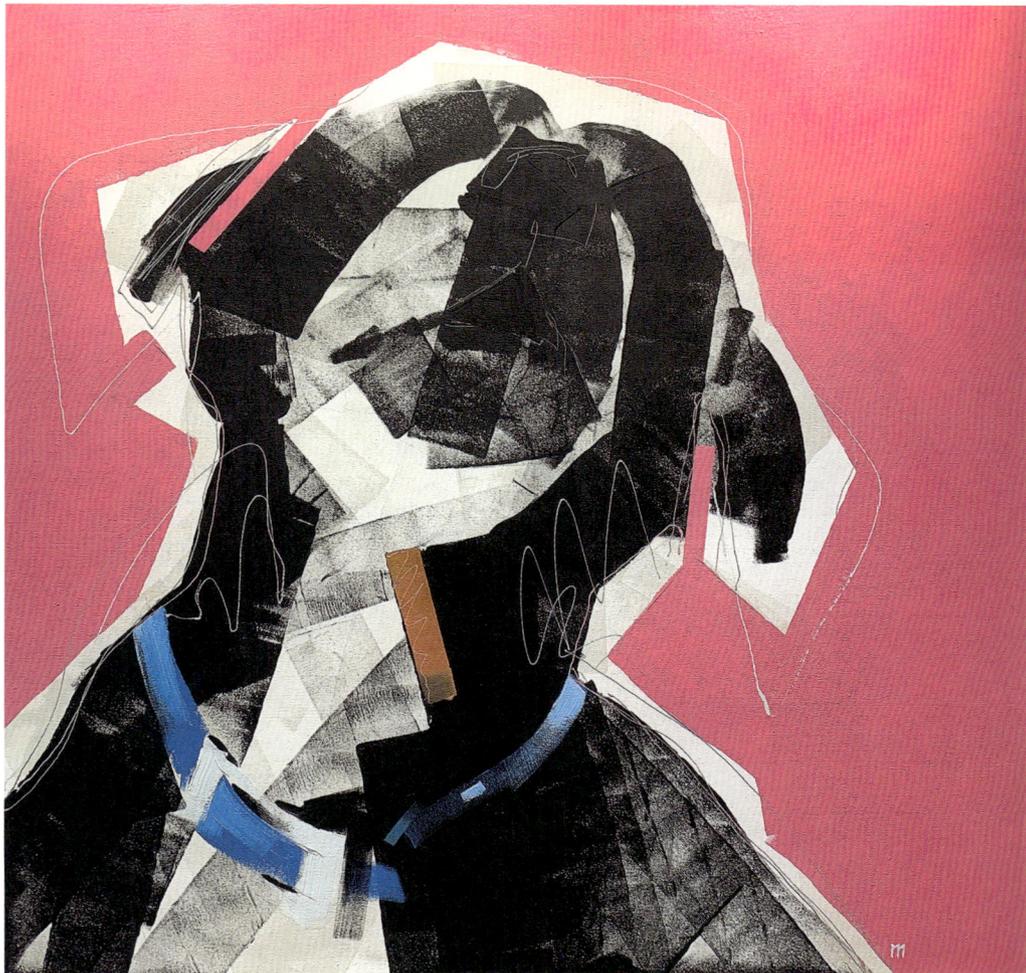

A Plea For Treats
1219 x 1219 mm, Acrylic, Canvas

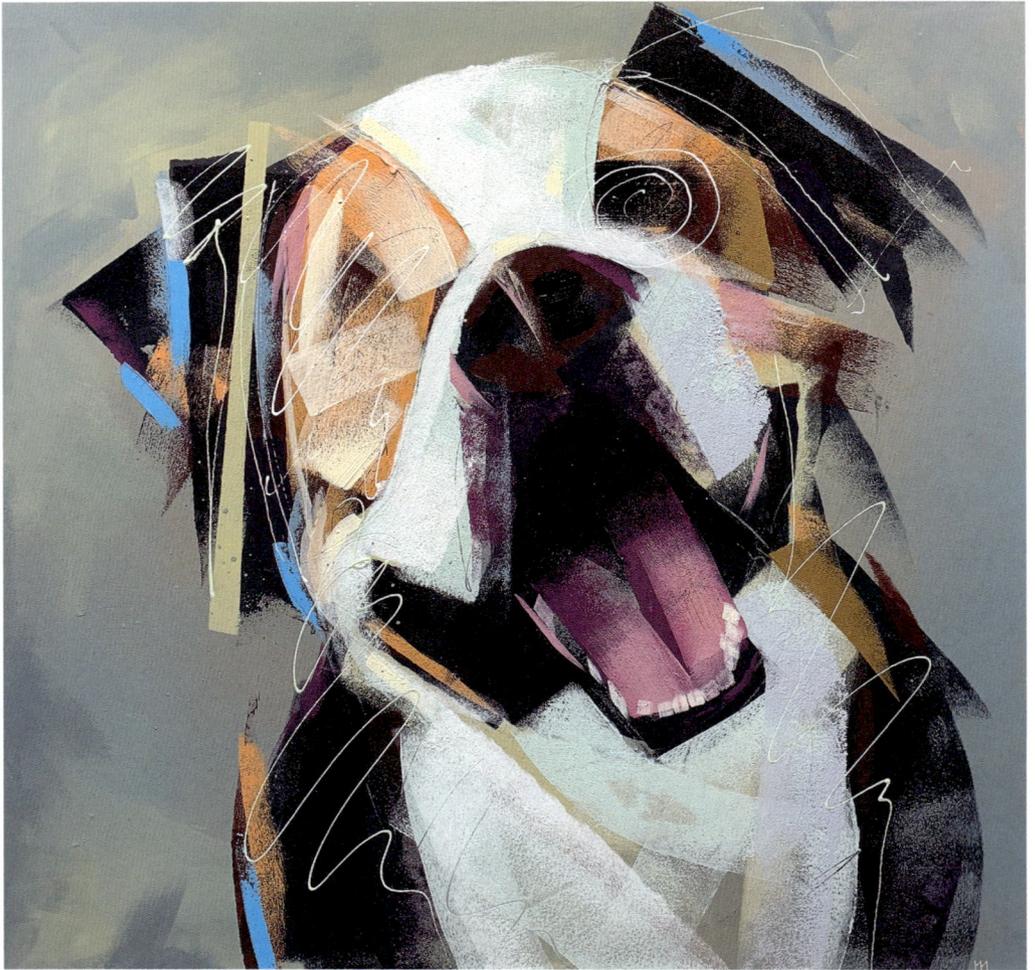

244

Bern Happy
762 x 762 mm, Acrylic, Canvas

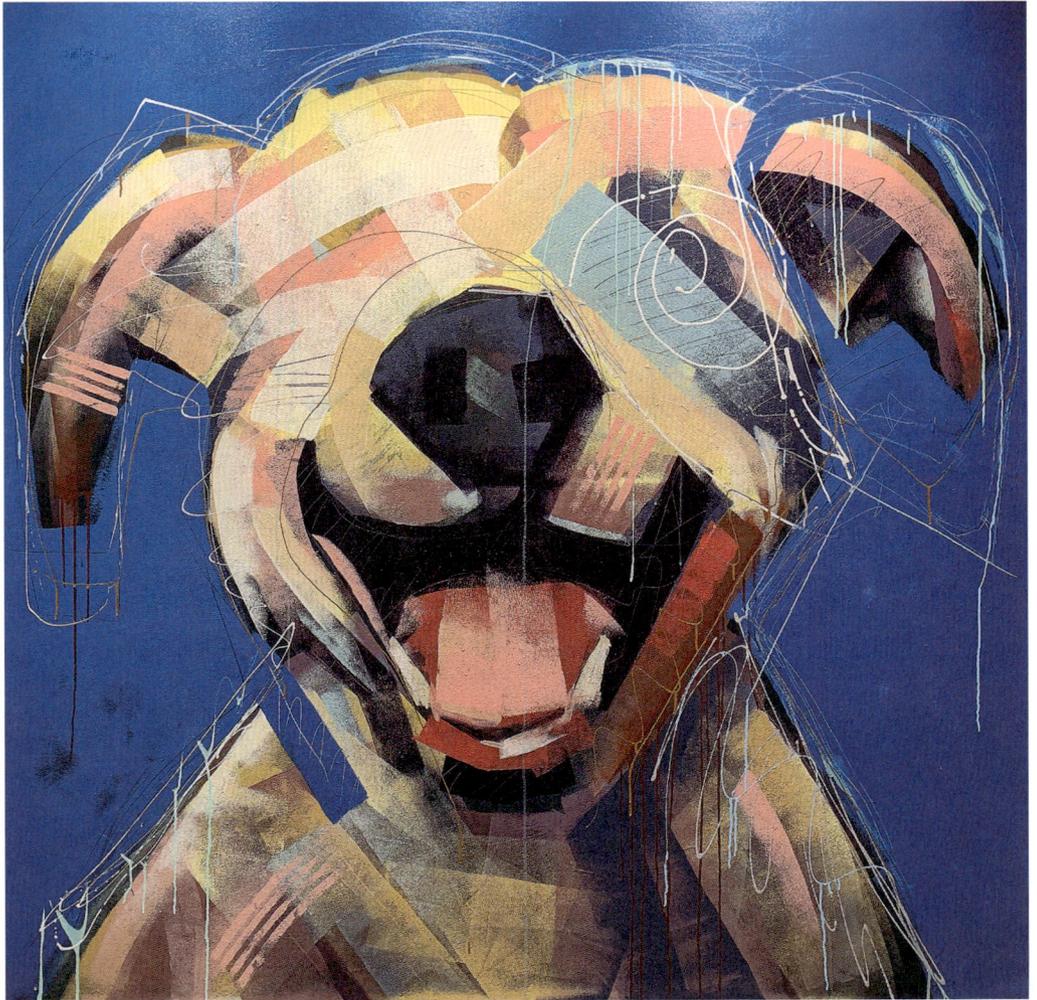

A Good Day
1574 x 1574 mm, Acrylic, Canvas

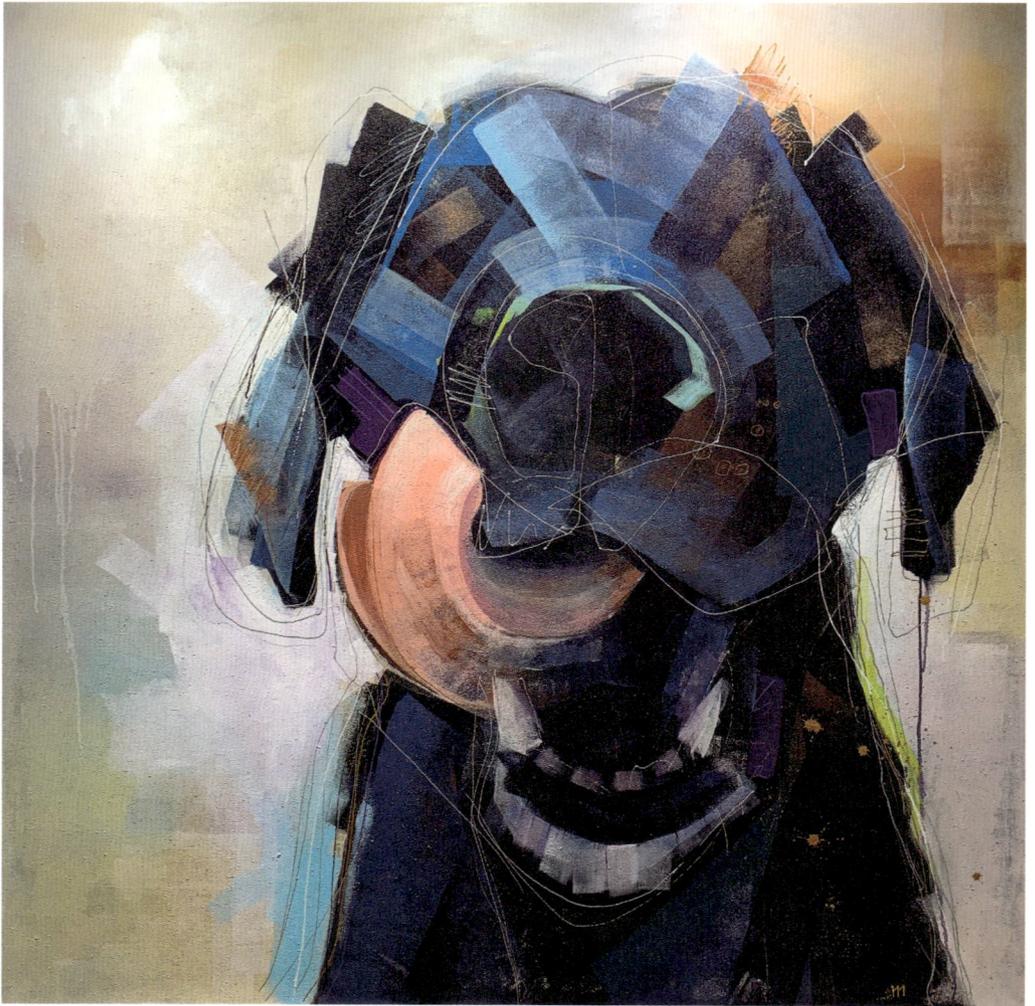

Lickin Chops
1549 x 1549 mm, Acrylic, Canvas

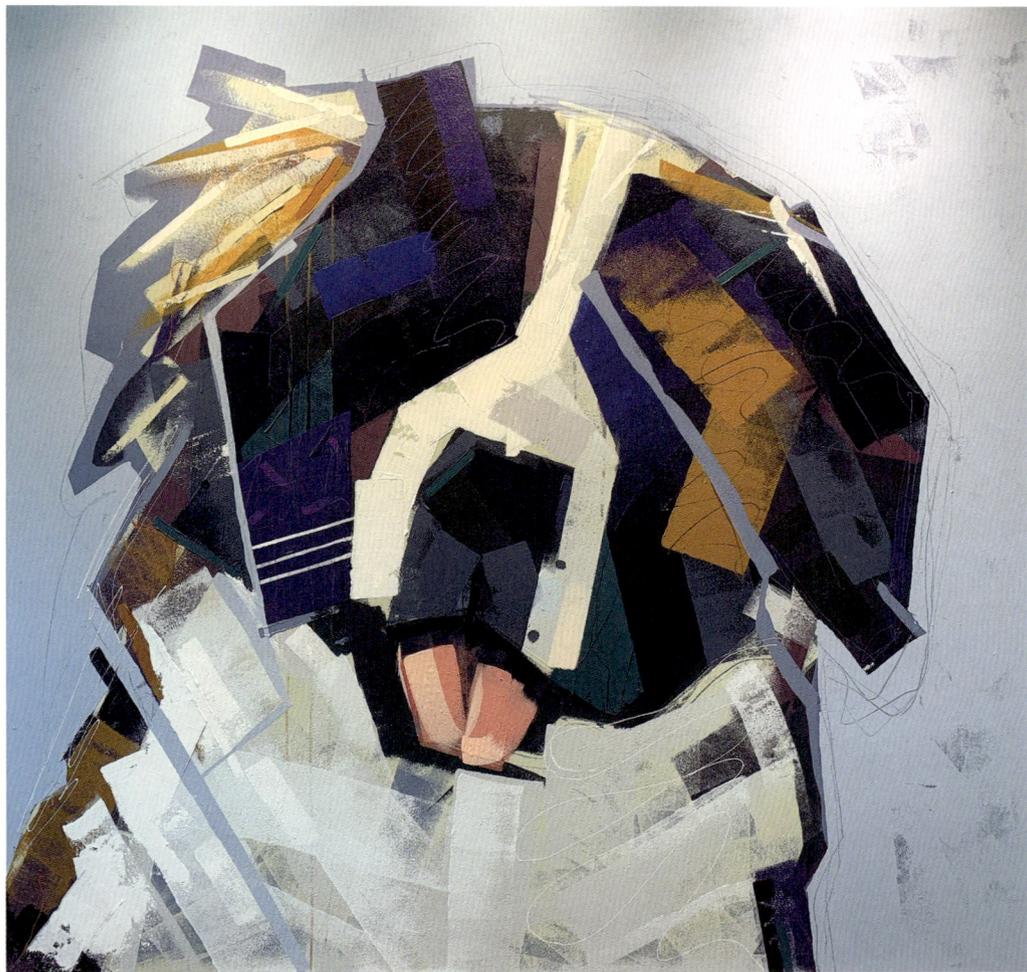

Private Commission
1574 x 1574 mm, Acrylic, Canvas

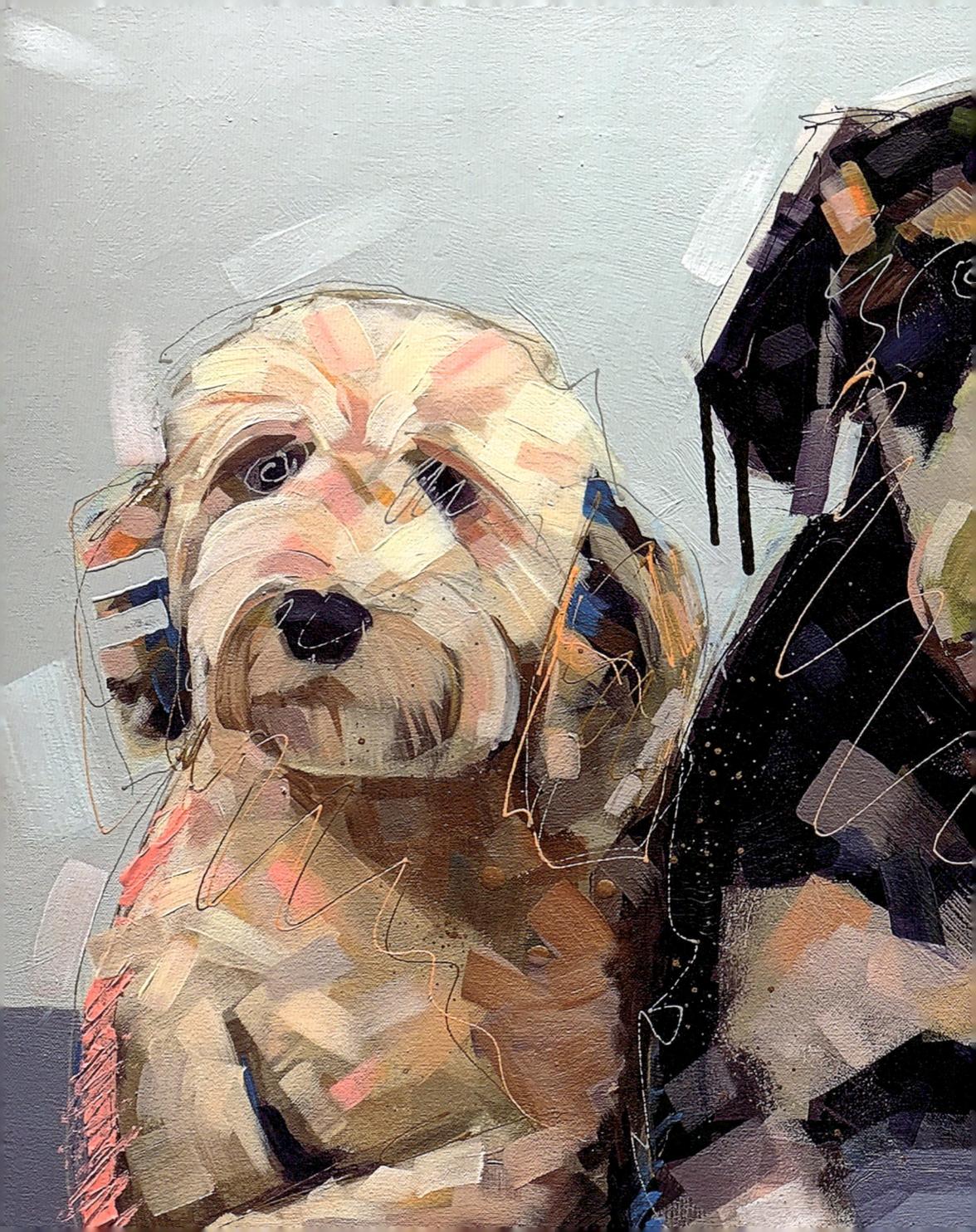

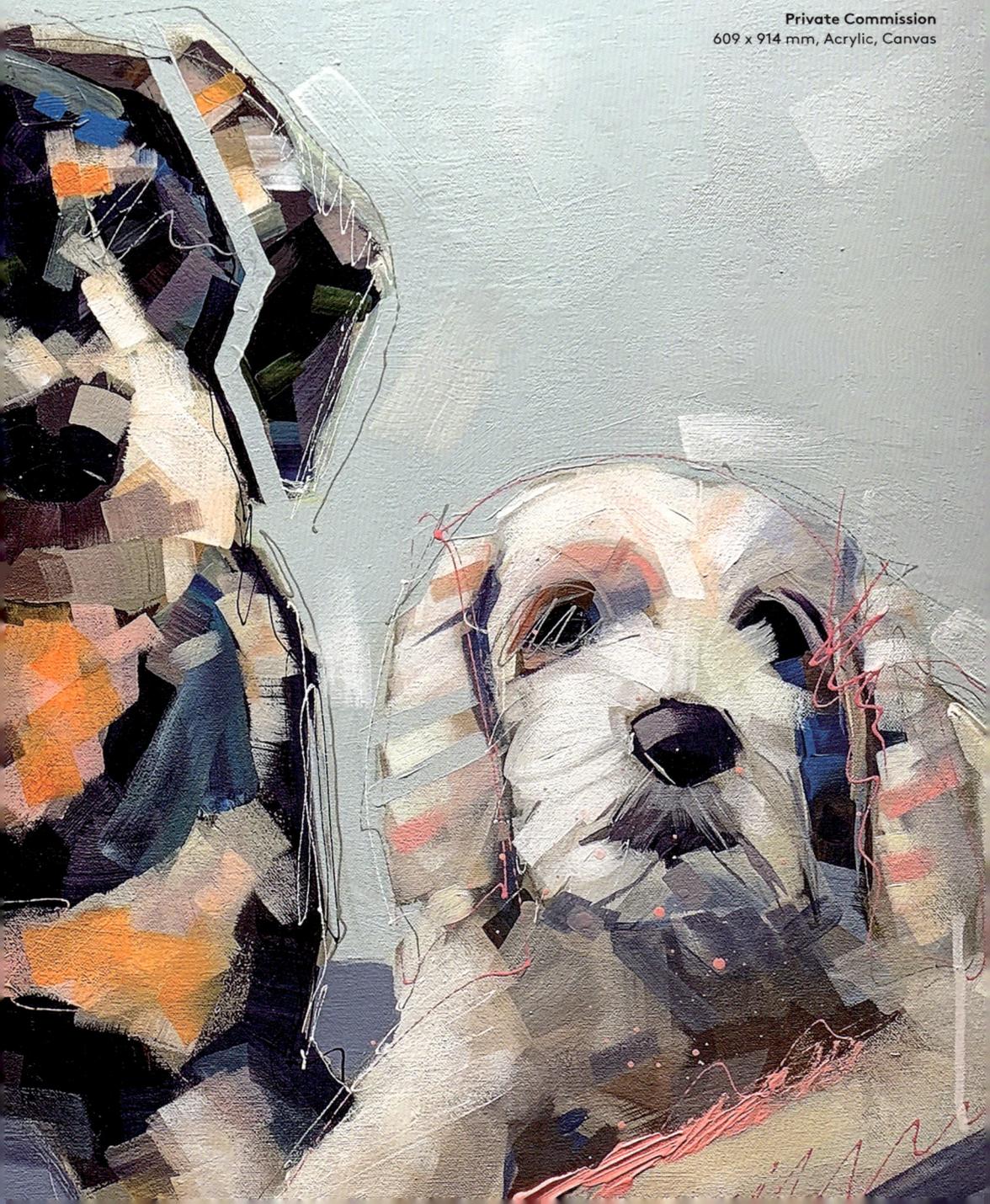

Private Commission
609 x 914 mm, Acrylic, Canvas

loladupre.com

Lola Dupre

Lola Dupre is a collage artist and illustrator based between Glasgow, Scotland and Seville, Spain. Her work, combining early 20th-century Dada influences with modern digital techniques, features projects such as cover art for TIME Magazine and Penguin Classics, and assignments with Nike Basketball and The Atlantic Magazine. She explores visual communication, animal portraiture, fashion, technology, and beauty.

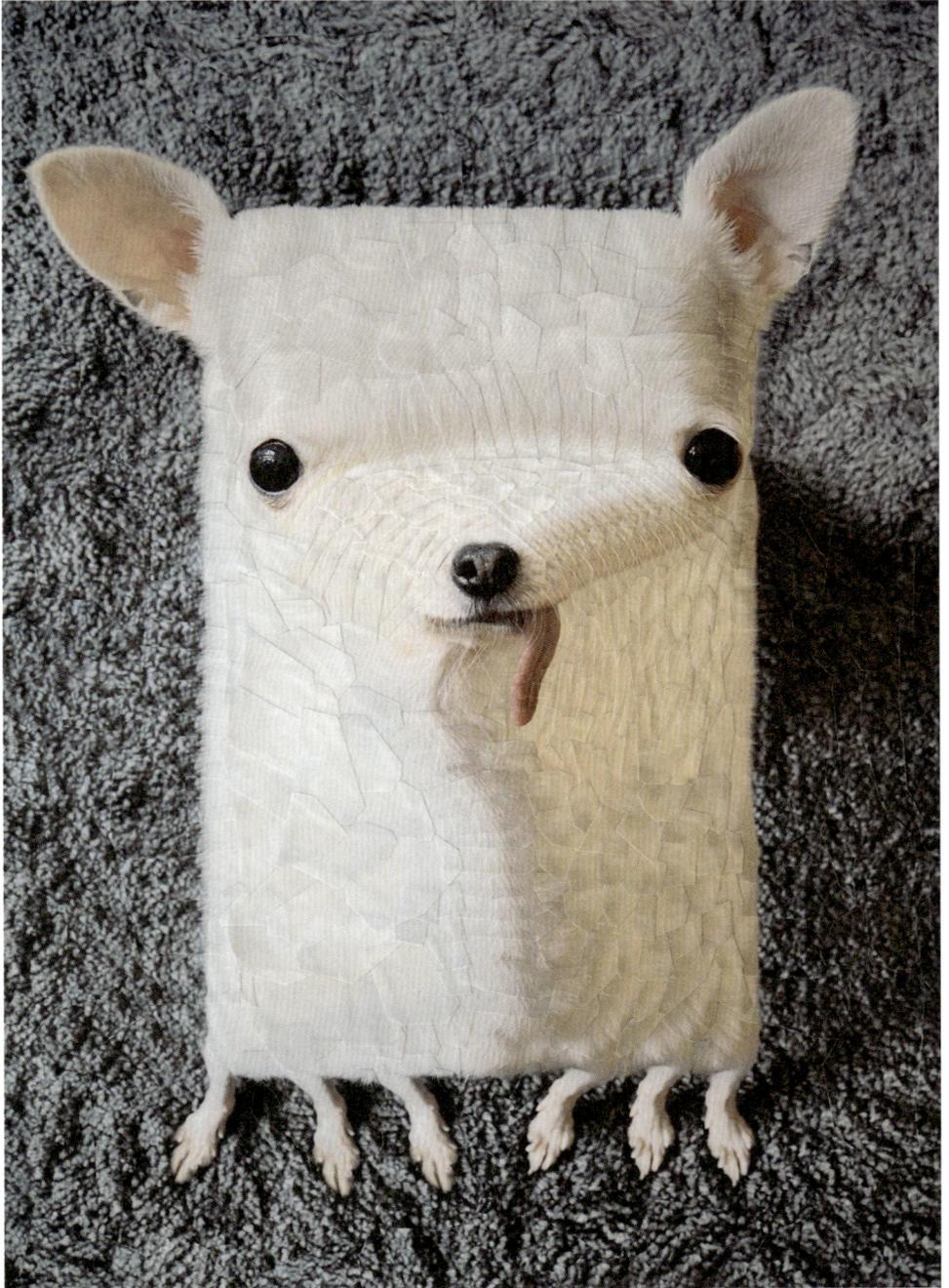

Dobby
208 x 195 mm, Paper Collage

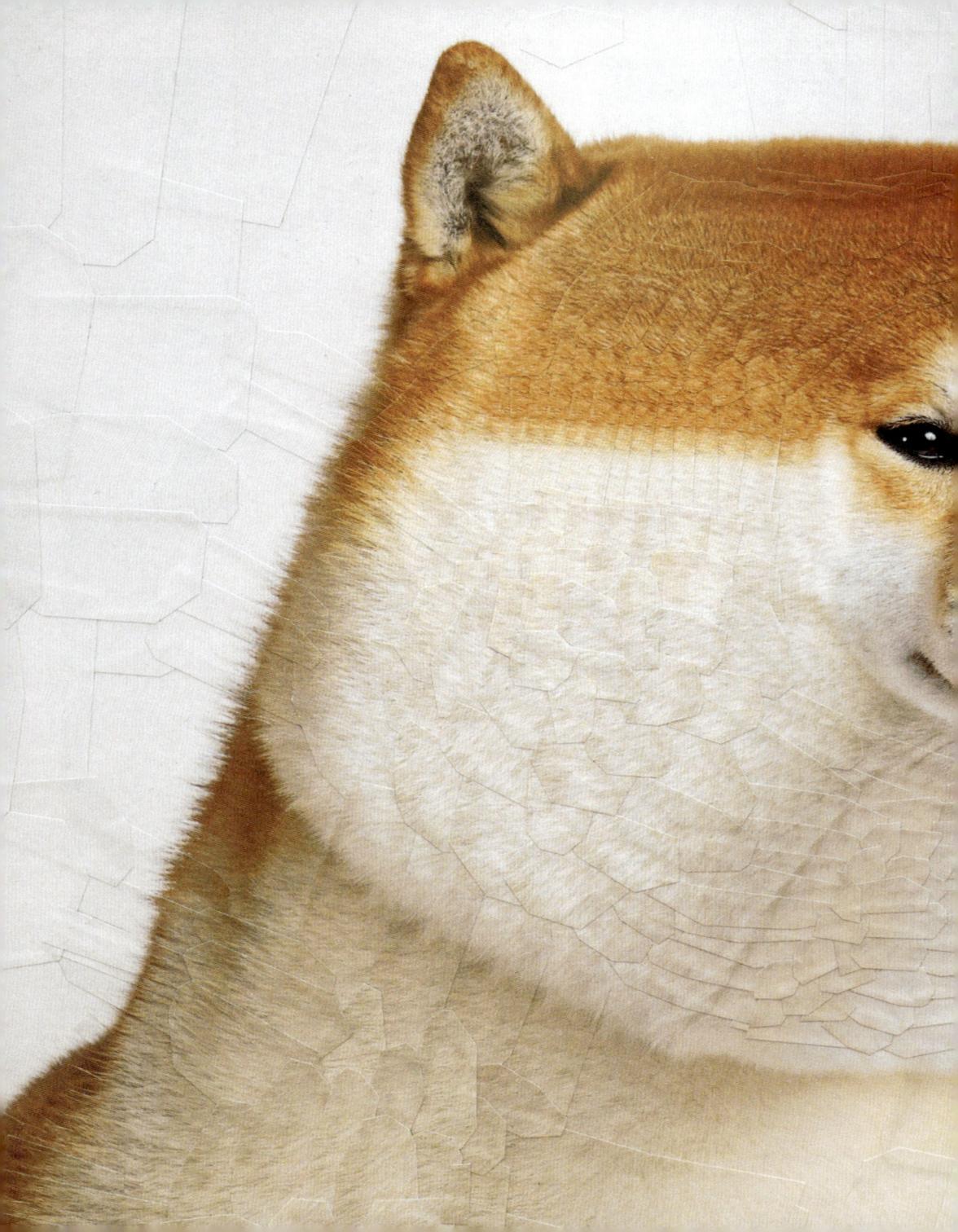

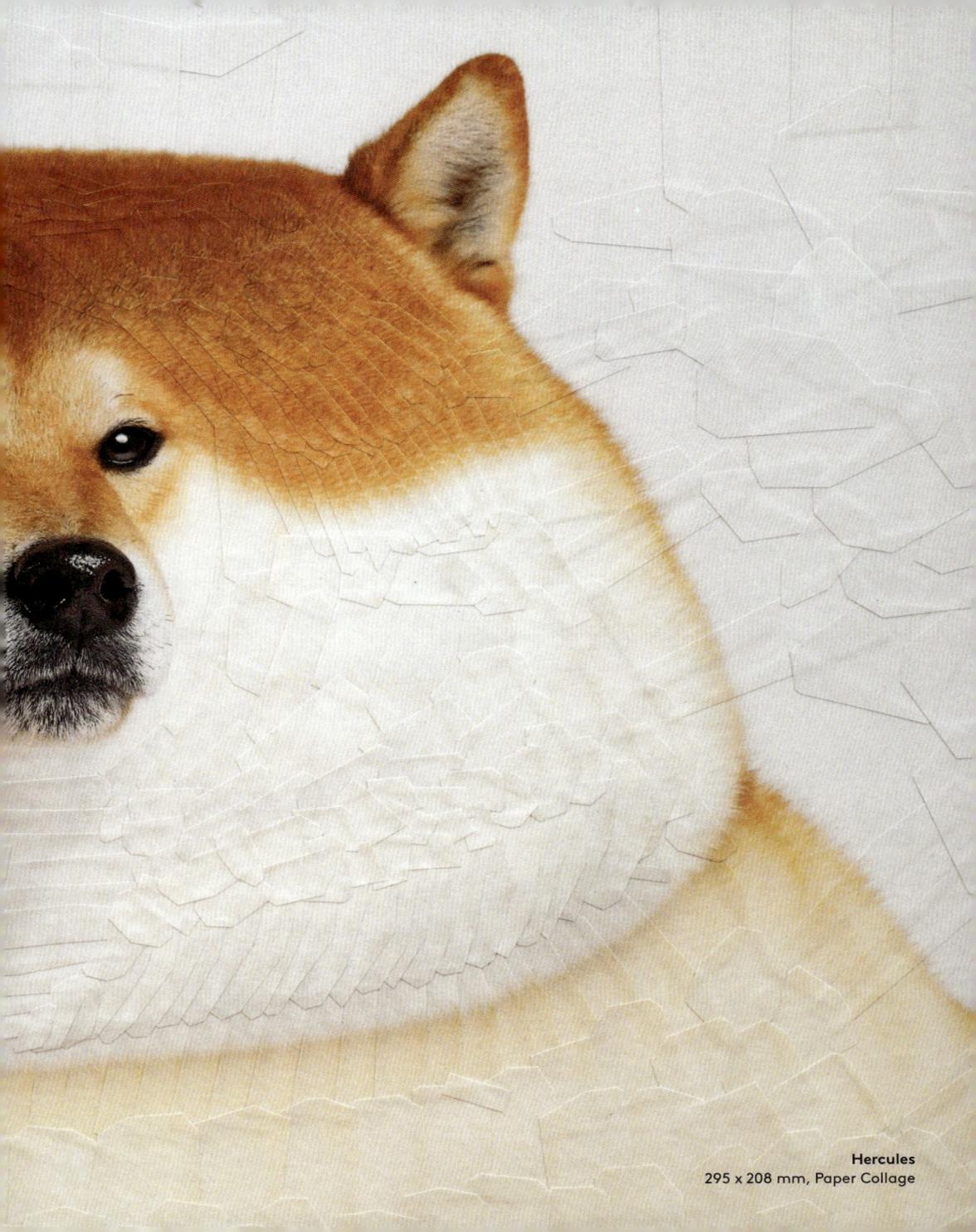

Hercules
295 x 208 mm, Paper Collage

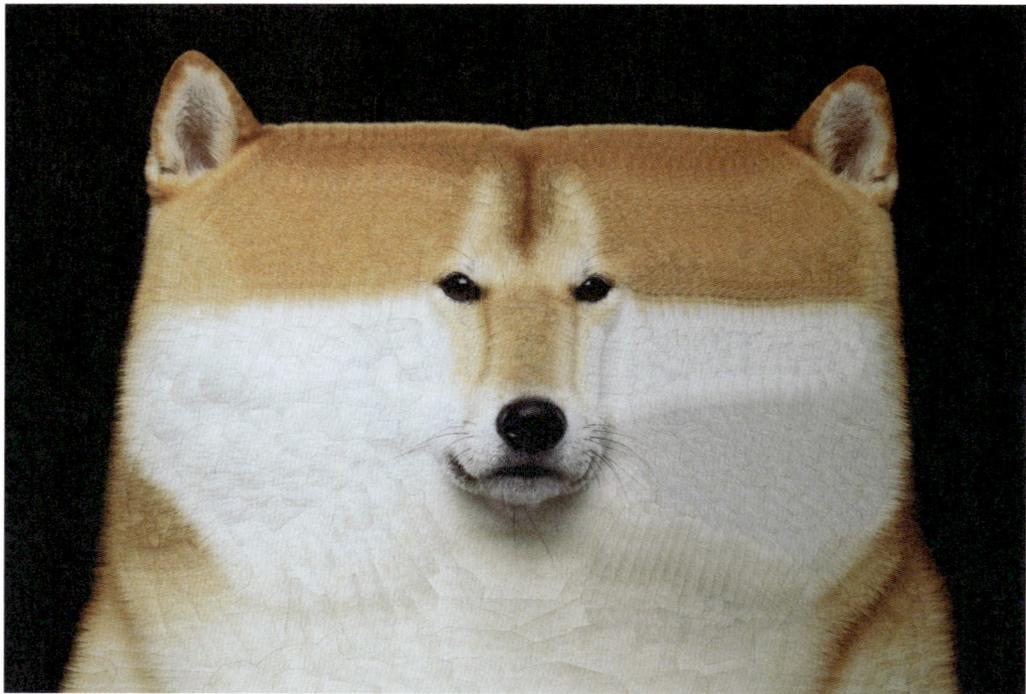

Randy 2
295 x 208 mm, Paper Collage

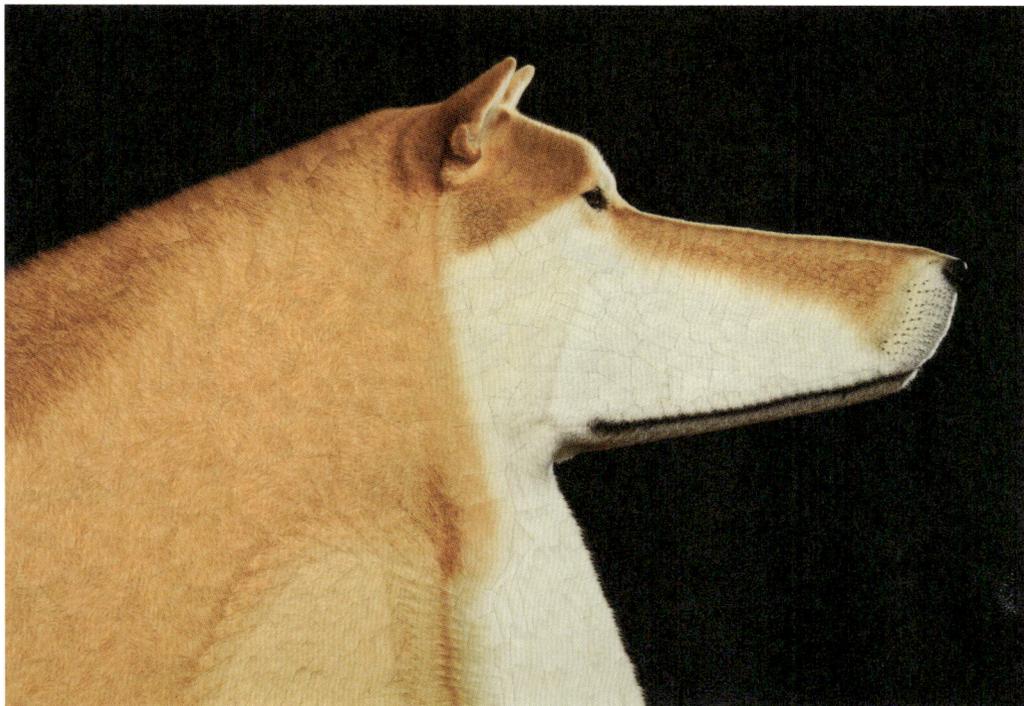

Randy
295 x 208 mm, Paper Collage

Randy 4
419 x 292 mm, Paper Collage

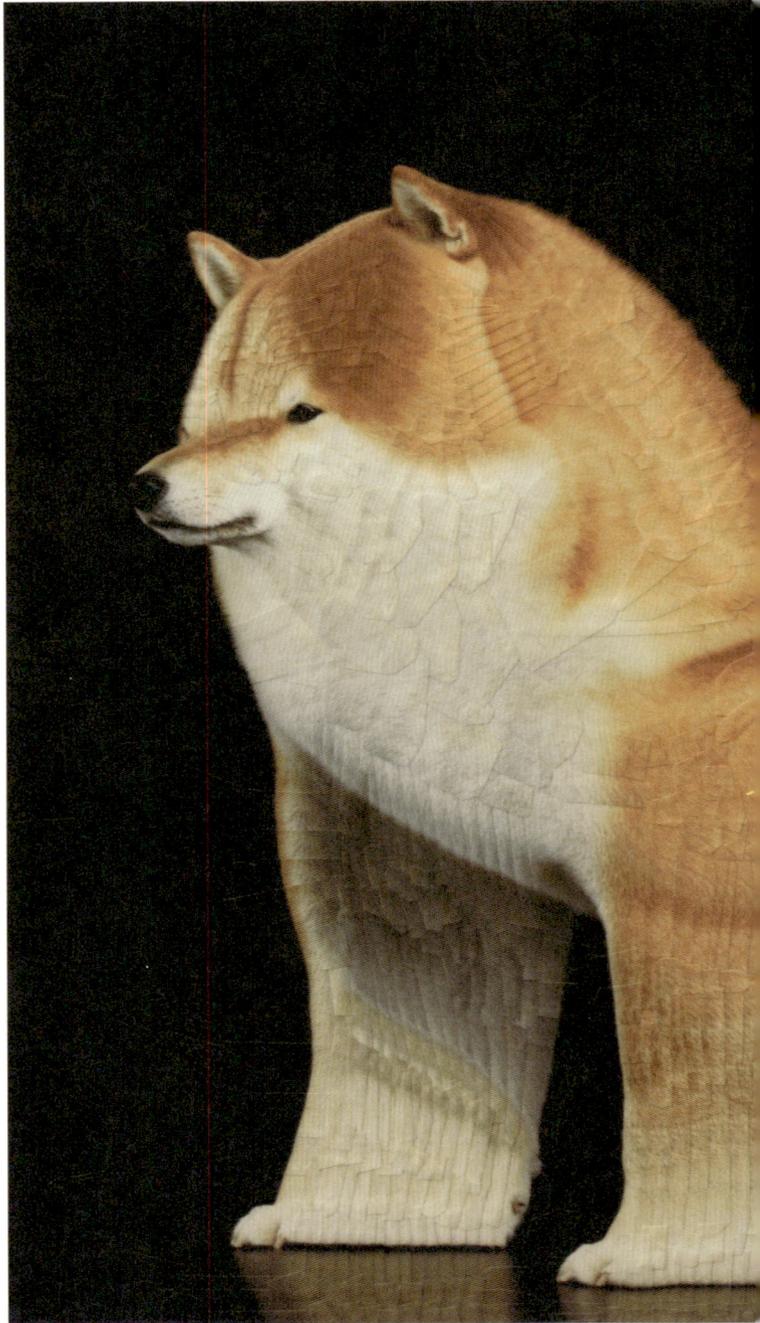

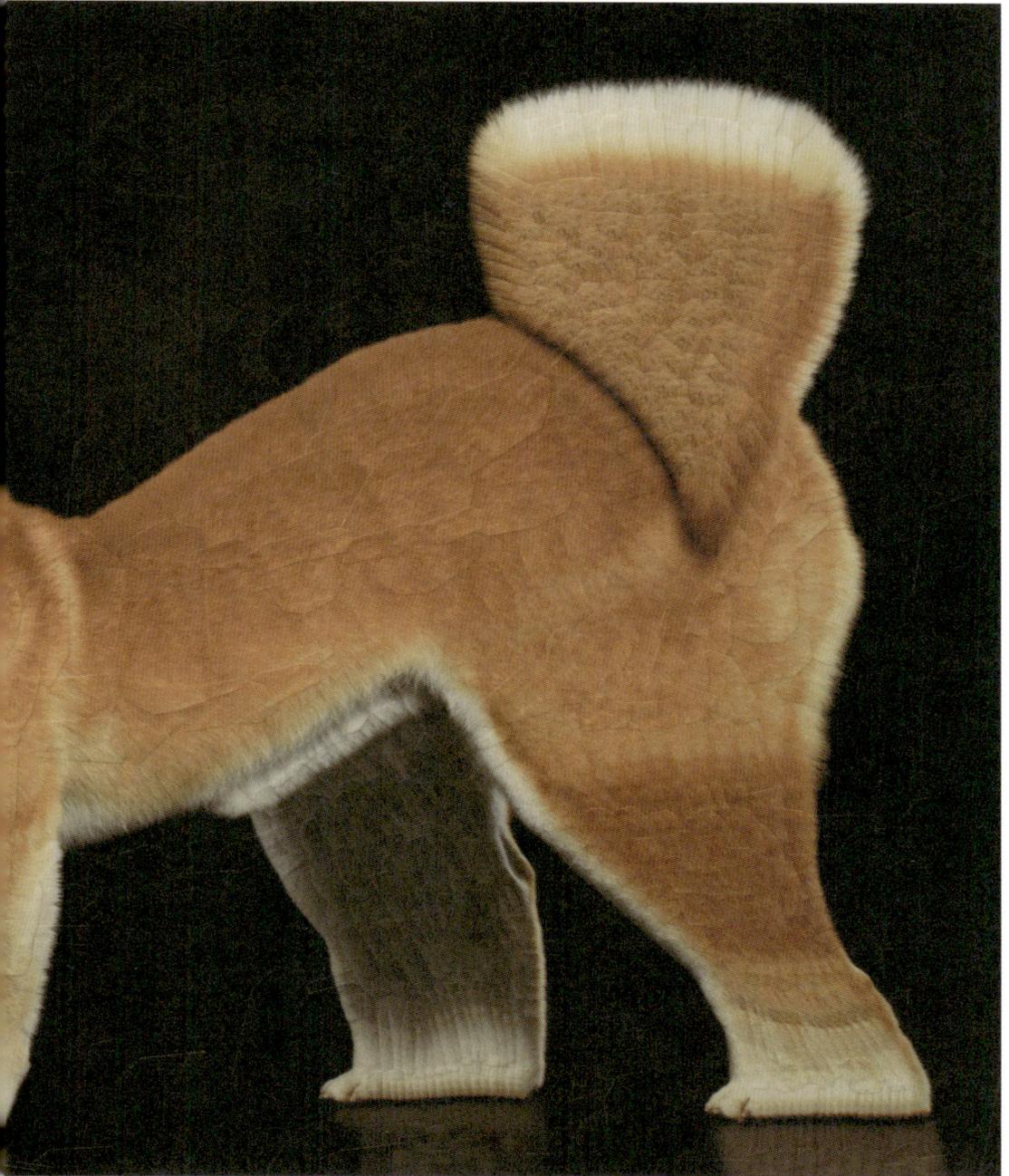

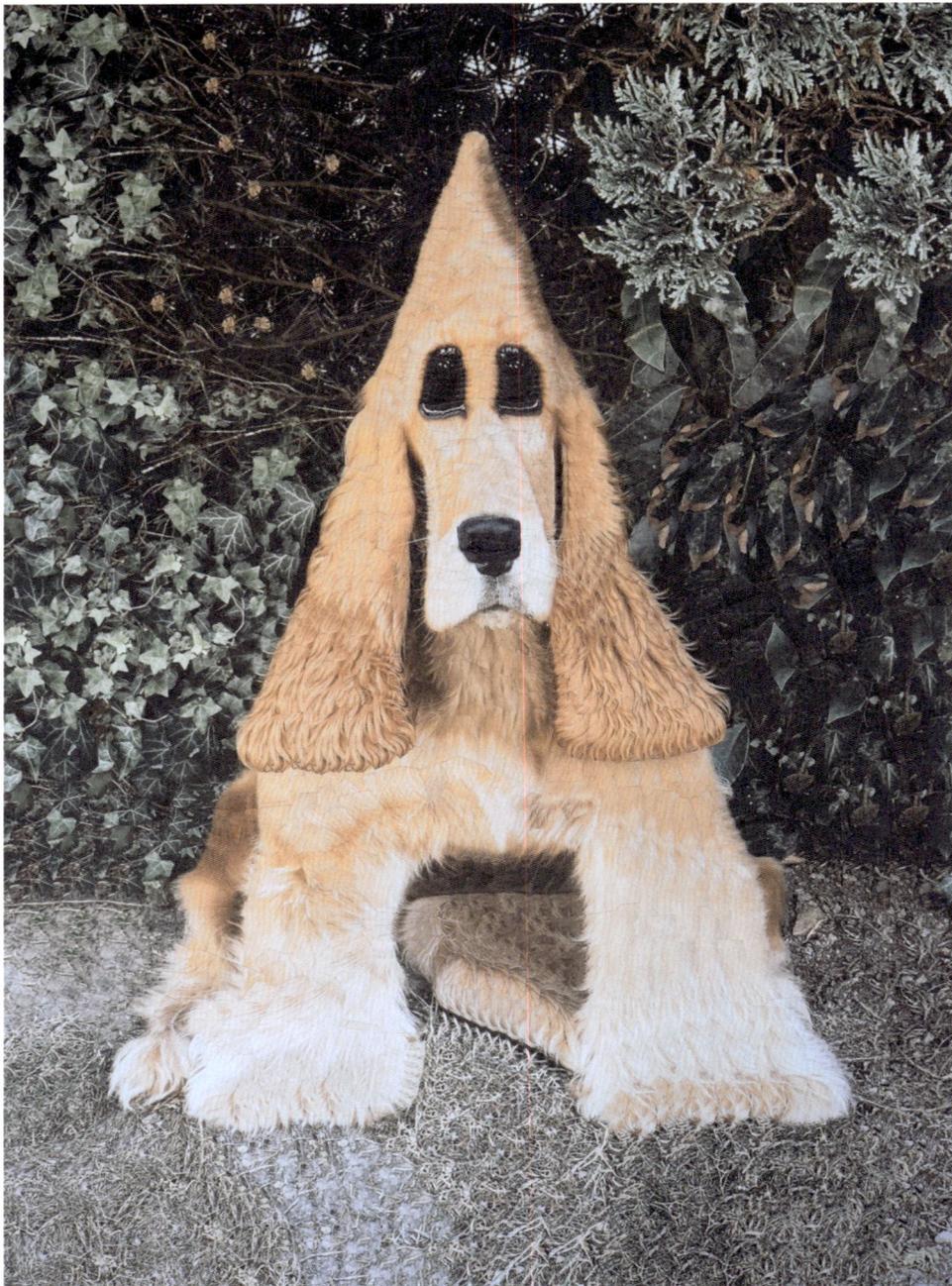

Tobby
208 x 295 mm, Paper Collage

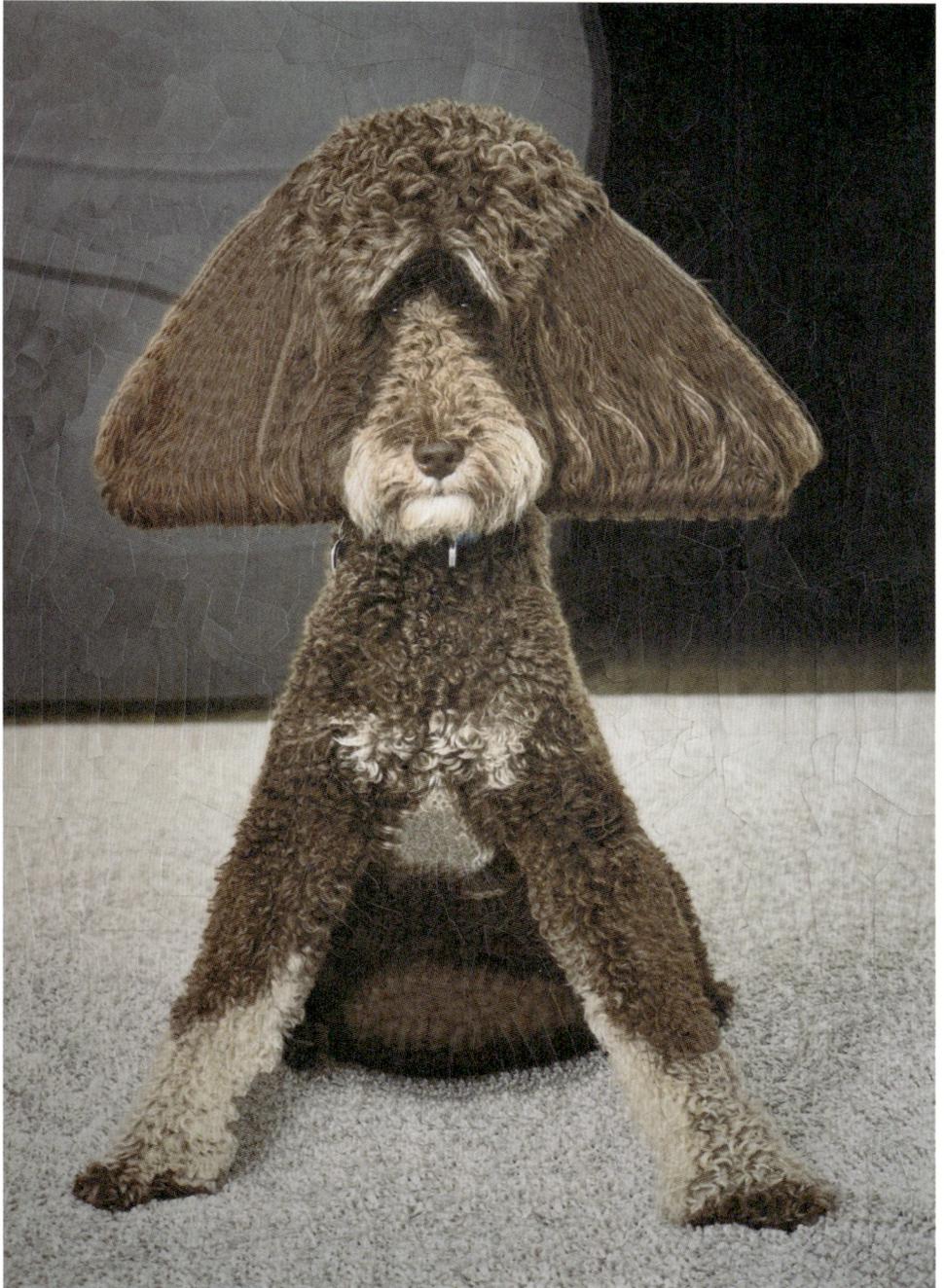

Baxter
208 x 295 mm, Paper Collage

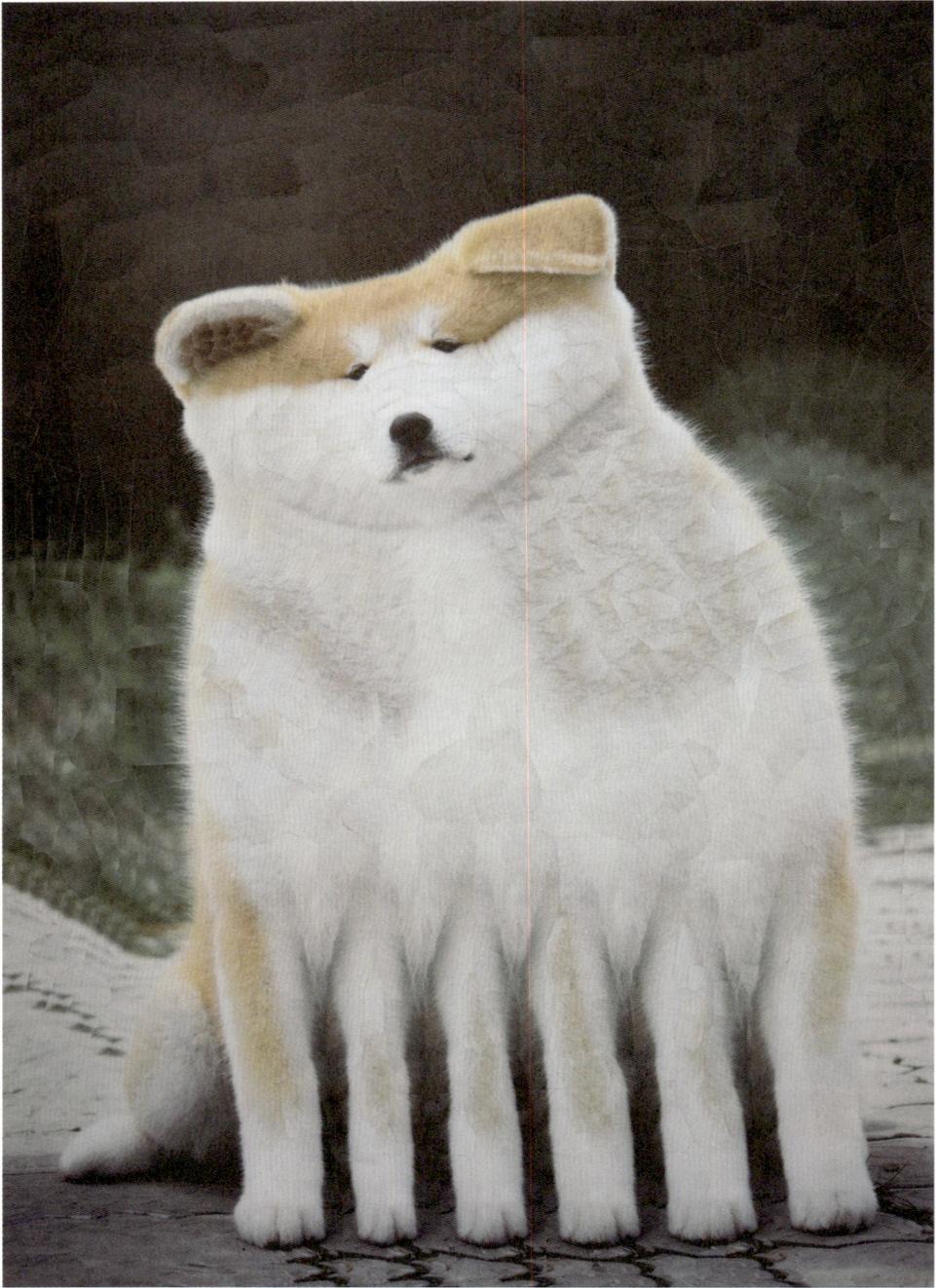

Thick Cheeks
208 x 295 mm, Paper Collage

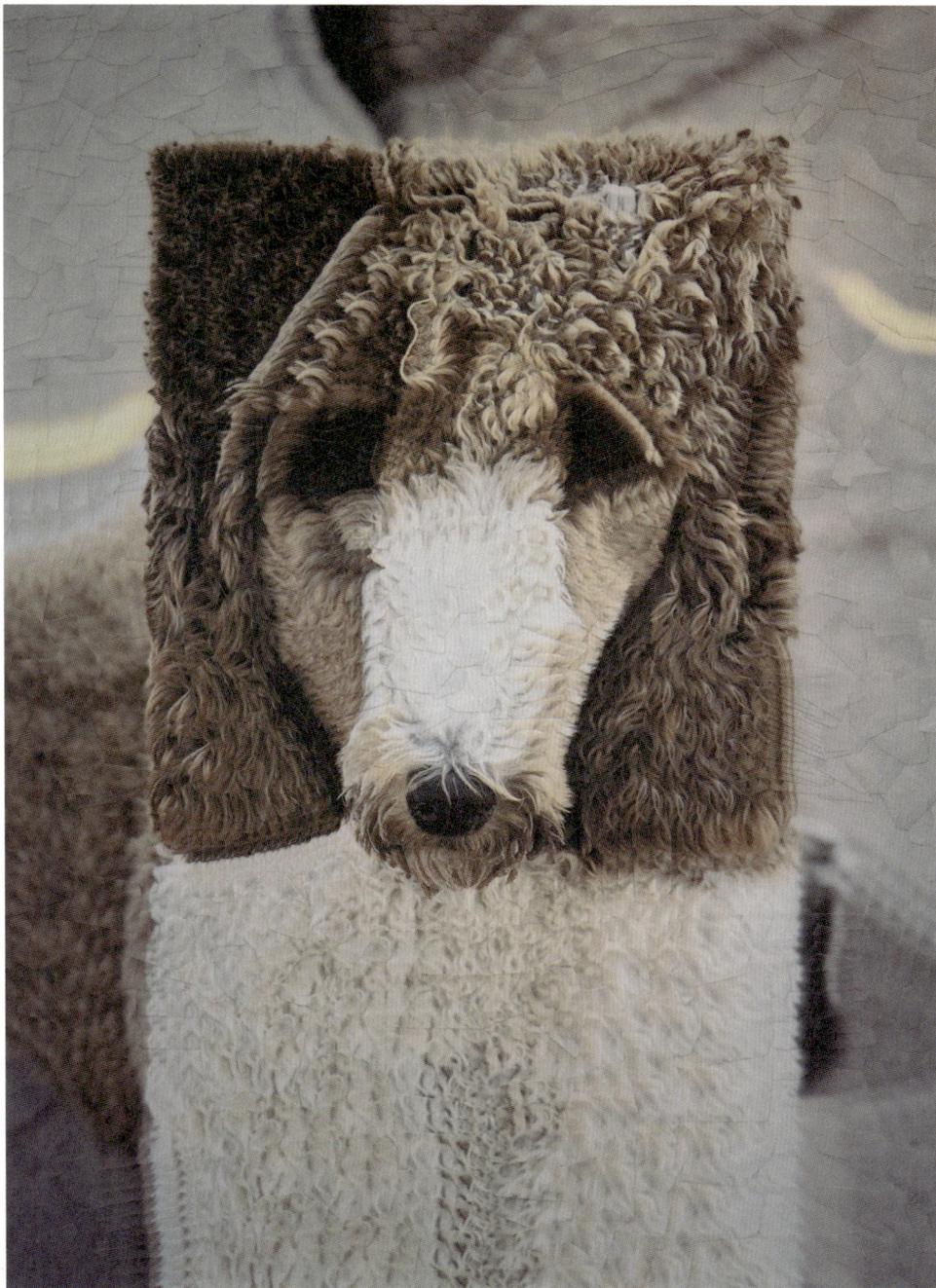

Nova
208 x 295 mm, Paper Collage

Tatsuro Kiuchi

tatsurokiuchi.com

Tatsuro Kiuchi, born in Tokyo in 1966, is a former biology major turned artist, and an ArtCenter College of Design graduate. He illustrates children's books, editorial work, and advertising; and has designed stamps for Royal Mail and holiday promotions for Starbucks. He owns PEN STILL WRITES studio, is a TOKYO ILLUSTRATORS SOCIETY member, and teaches at AOYAMAJUKU.

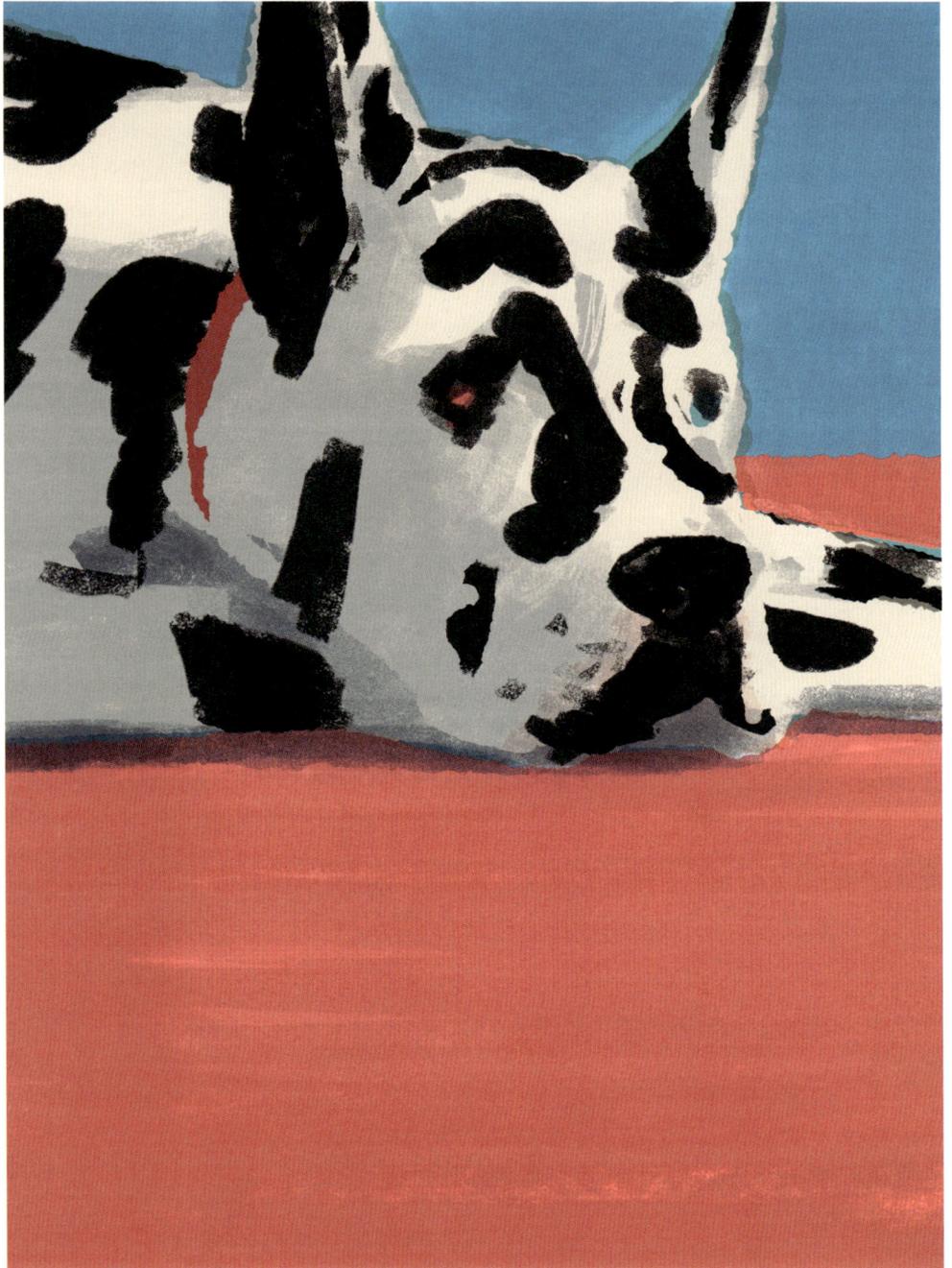

The Friend
4297 x 6156 px, Digital, Client: Shinchosha

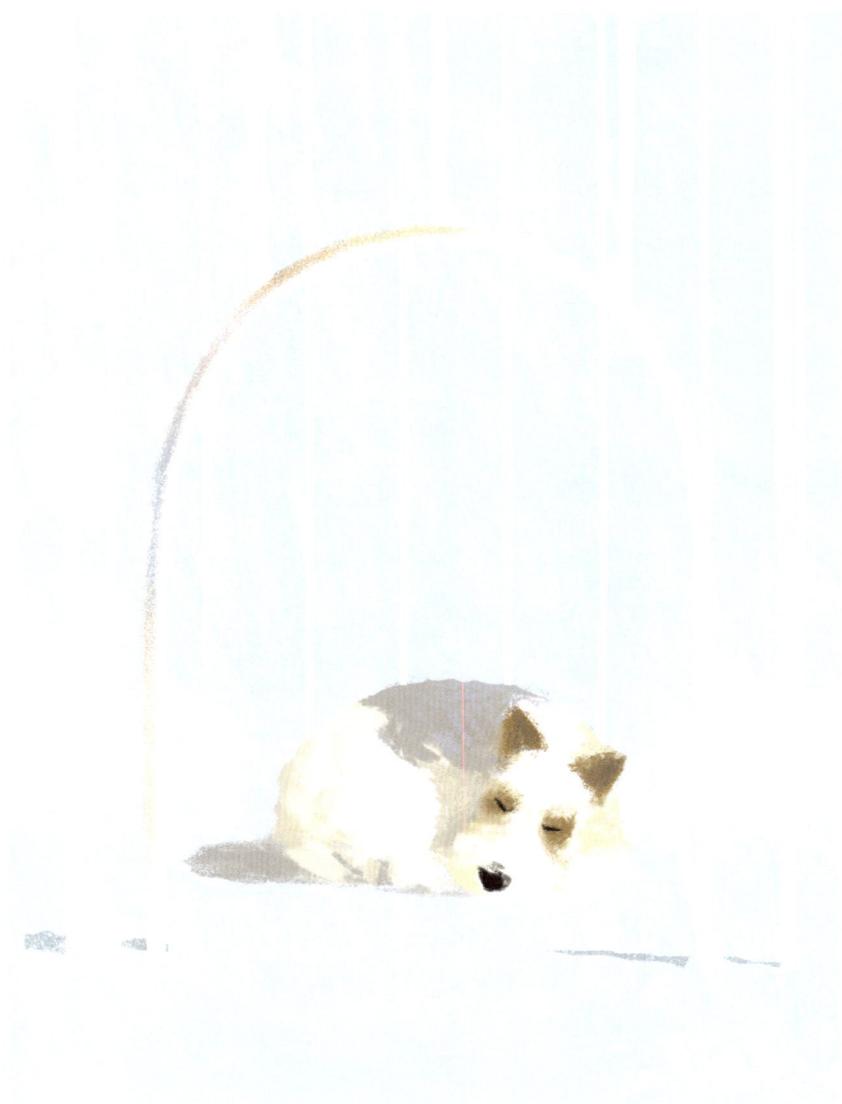

Happy Birthday Coco
1857 x 2512 px (↑), 2756 x 3698 px (→), Digital,
Client: POPLAR Publishing Co., Ltd

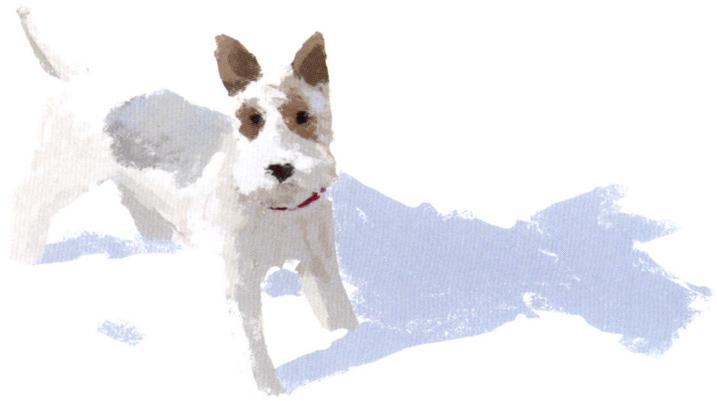

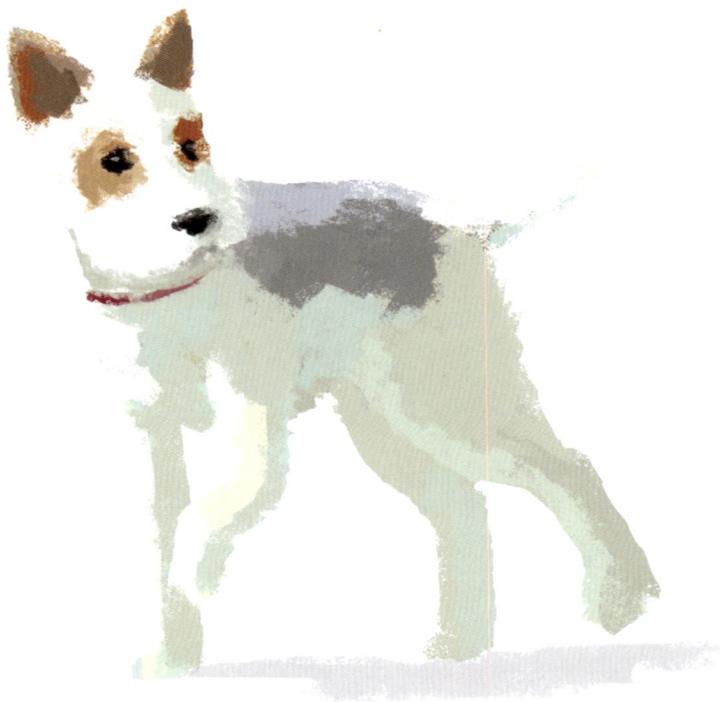

Happy Birthday Coco
1466 x 1301 px (↑), 1436 x 1779 px (→) Digital,
Client: POPLAR Publishing Co., Ltd

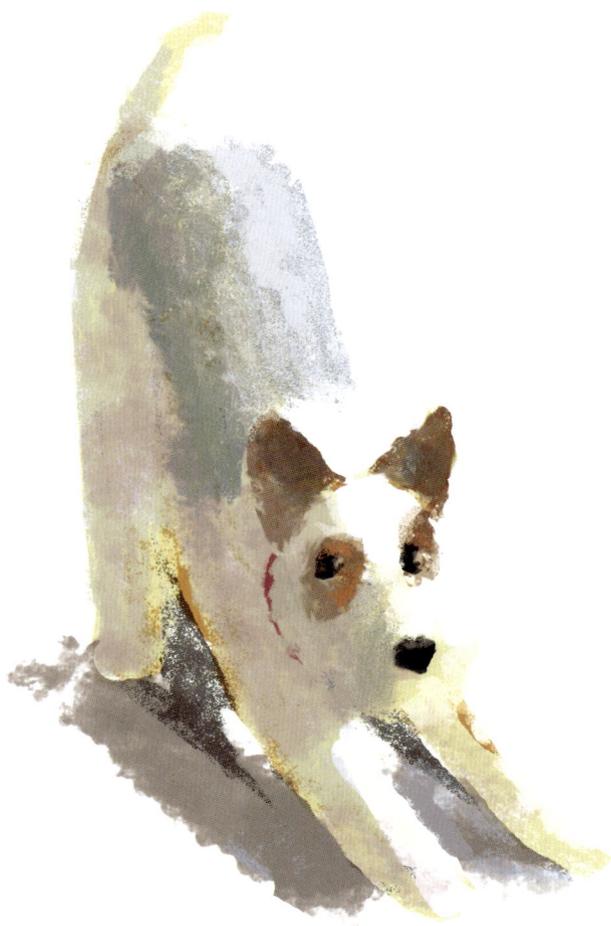

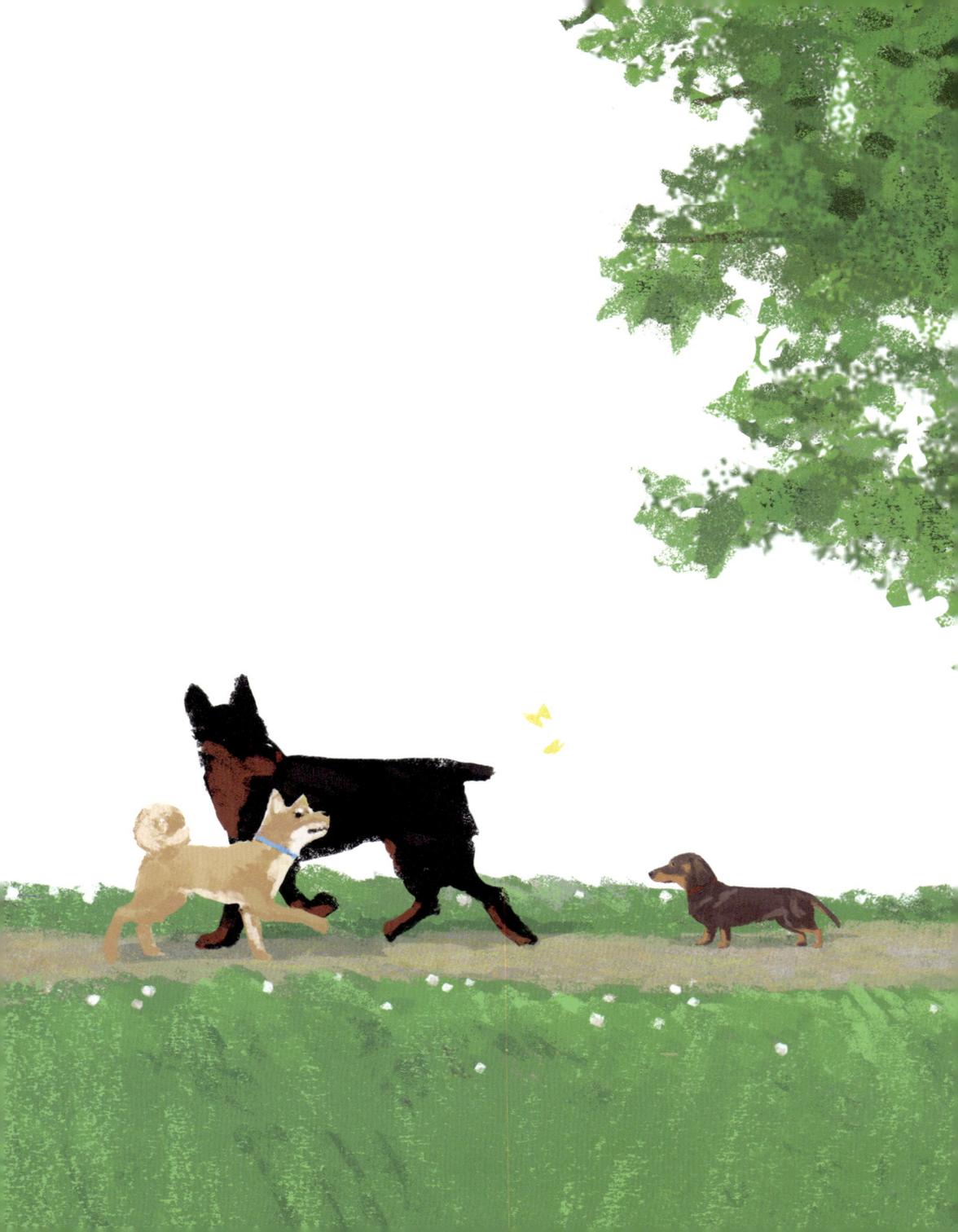

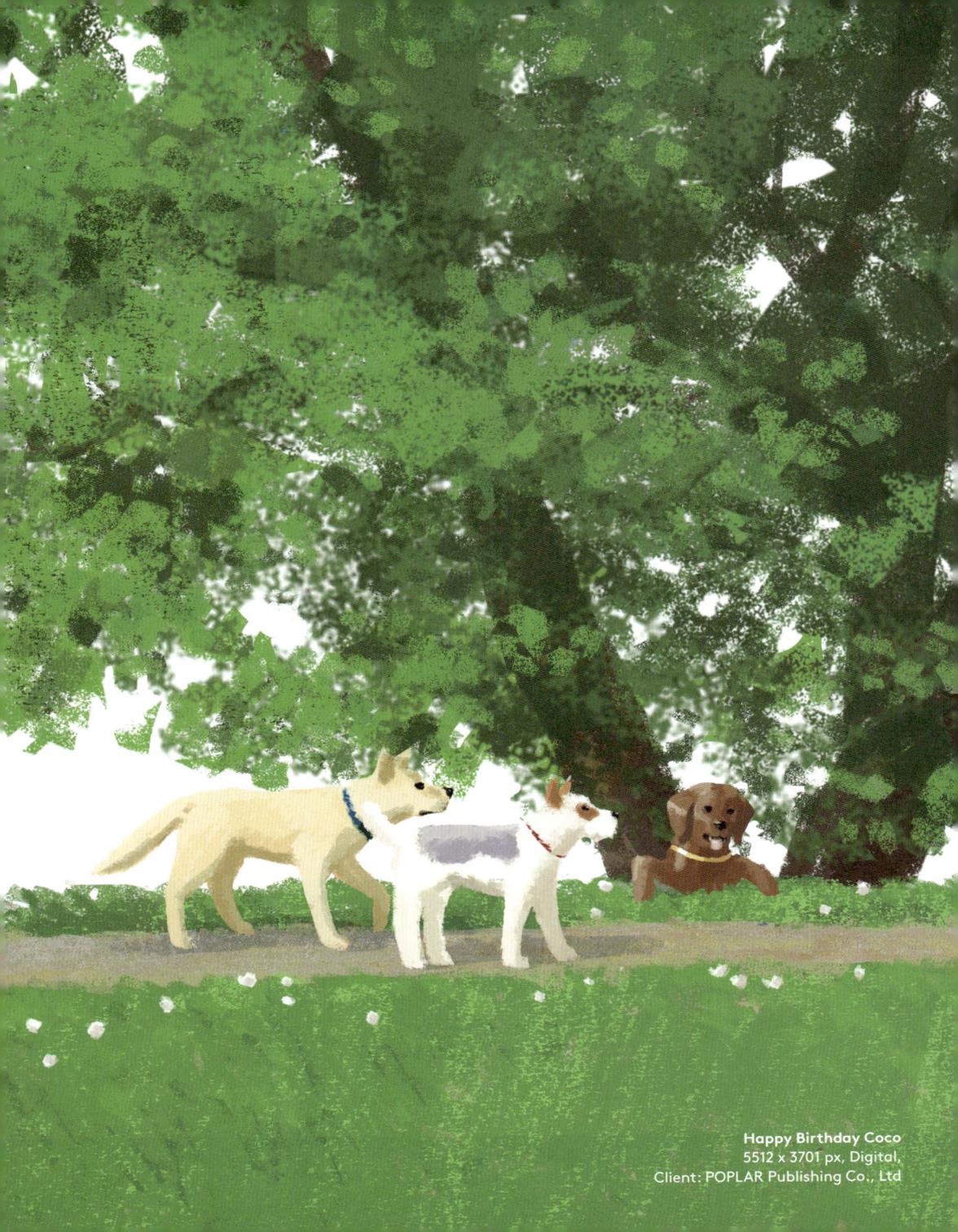

Happy Birthday Coco
5512 x 3701 px, Digital,
Client: POPLAR Publishing Co., Ltd

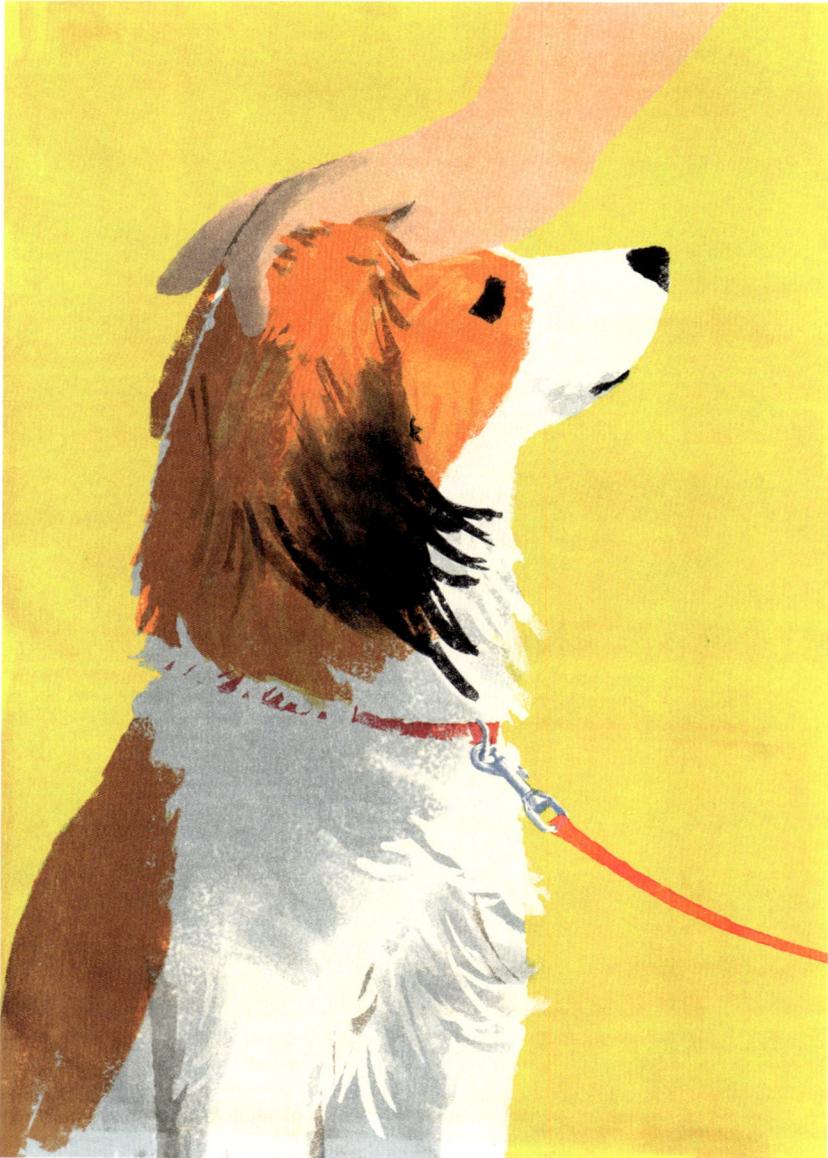

Uit Het Leven Van Een Hond (↑)
6980 x 10000 px, Digital, Client: Shinchosha

Taking Her A Walk (→)
6968 x 10000 px, Digital, Client: Globen

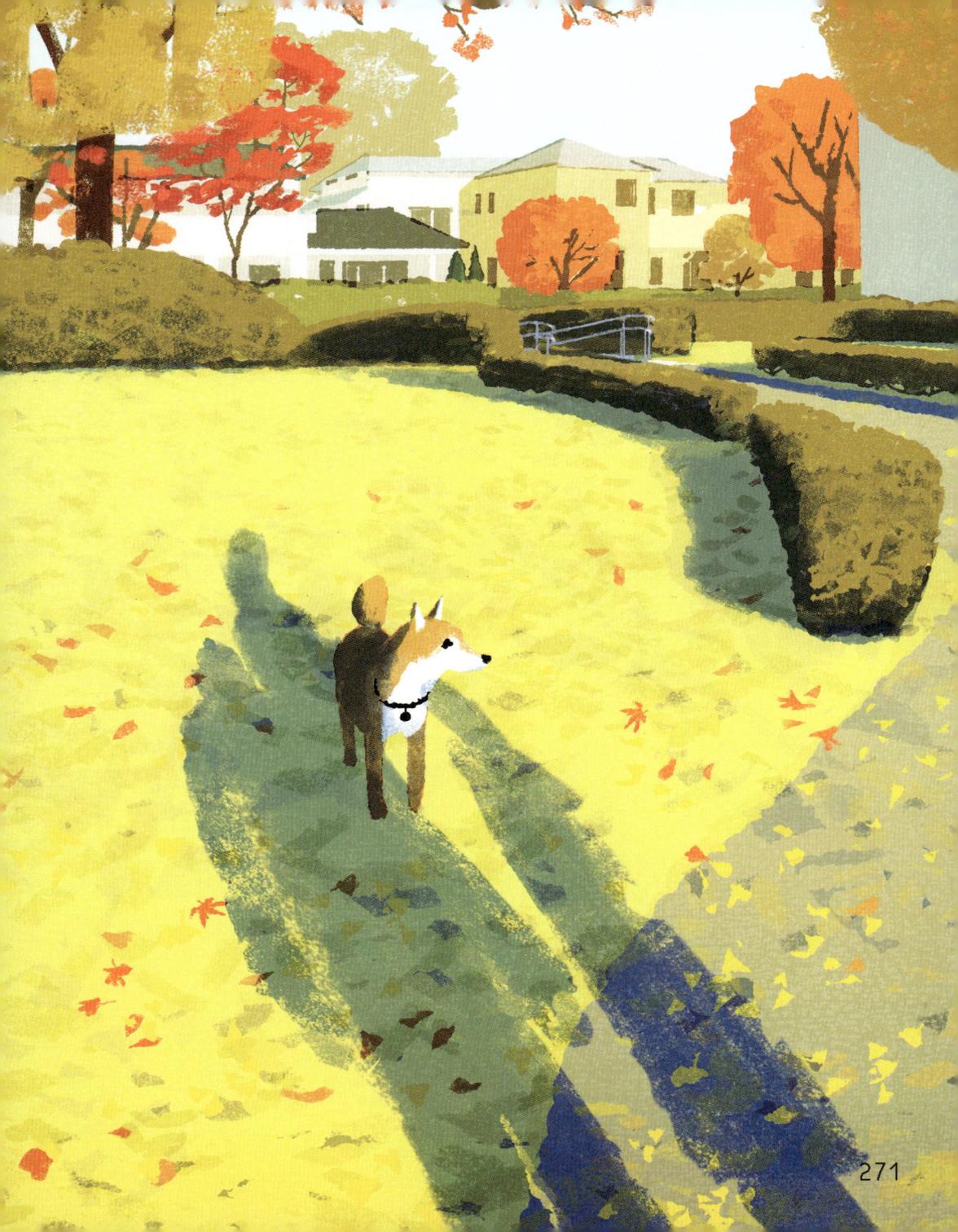

Enikő
Katalin
Eged

@nikoenikoeniko

Enikő Katalin Eged, a Budapest-based illustrator and pattern designer, creates dynamic narratives with familiar details. Her work focuses on animals, still lifes, emotions, and visual storytelling. She earned her master's degree from the Hungarian University of Fine Arts in 2022 and studied at Accademia Belle Arti di Roma for a semester.

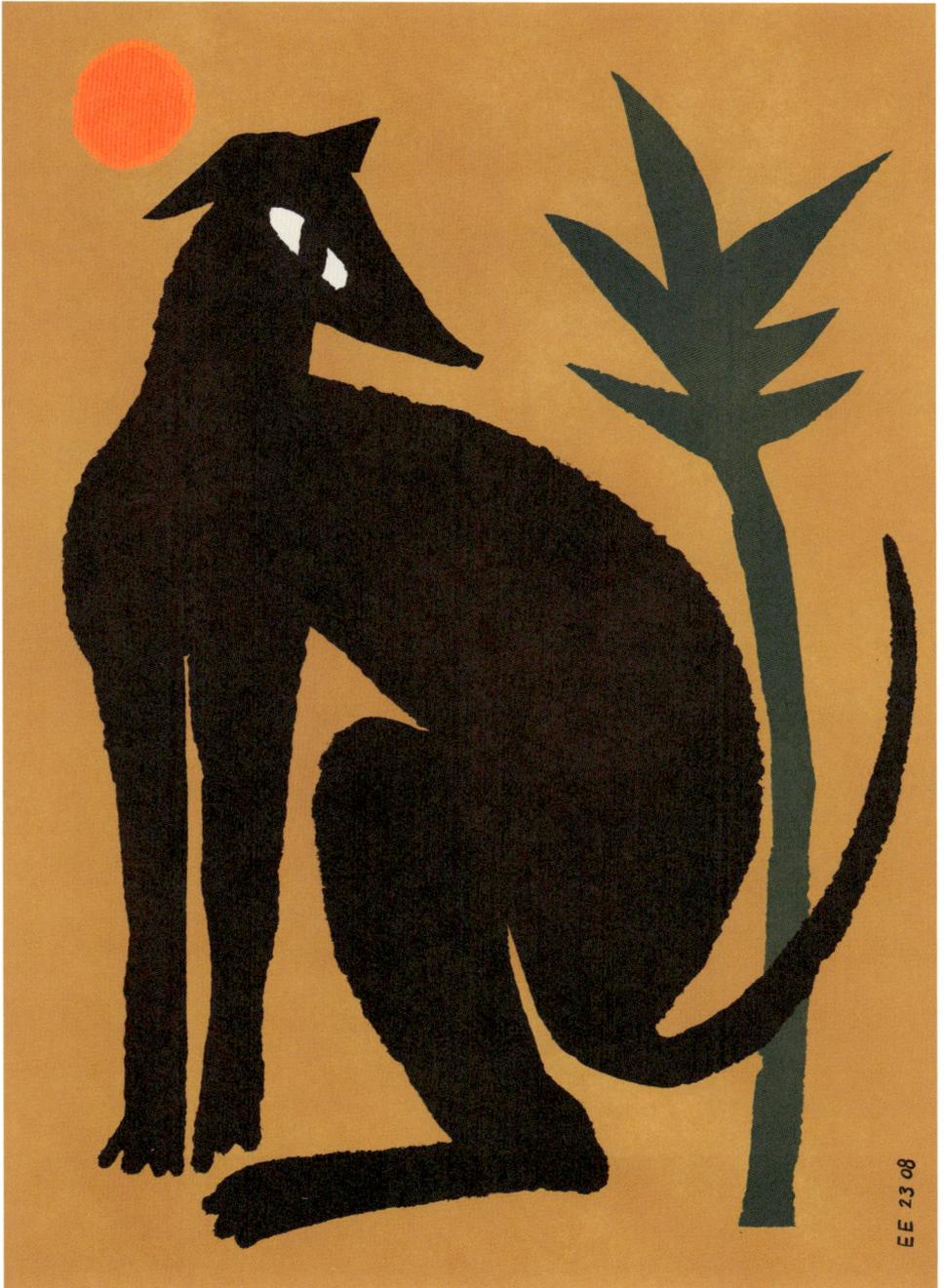

Peruvian Black Dog
297 x 420 mm, Digital

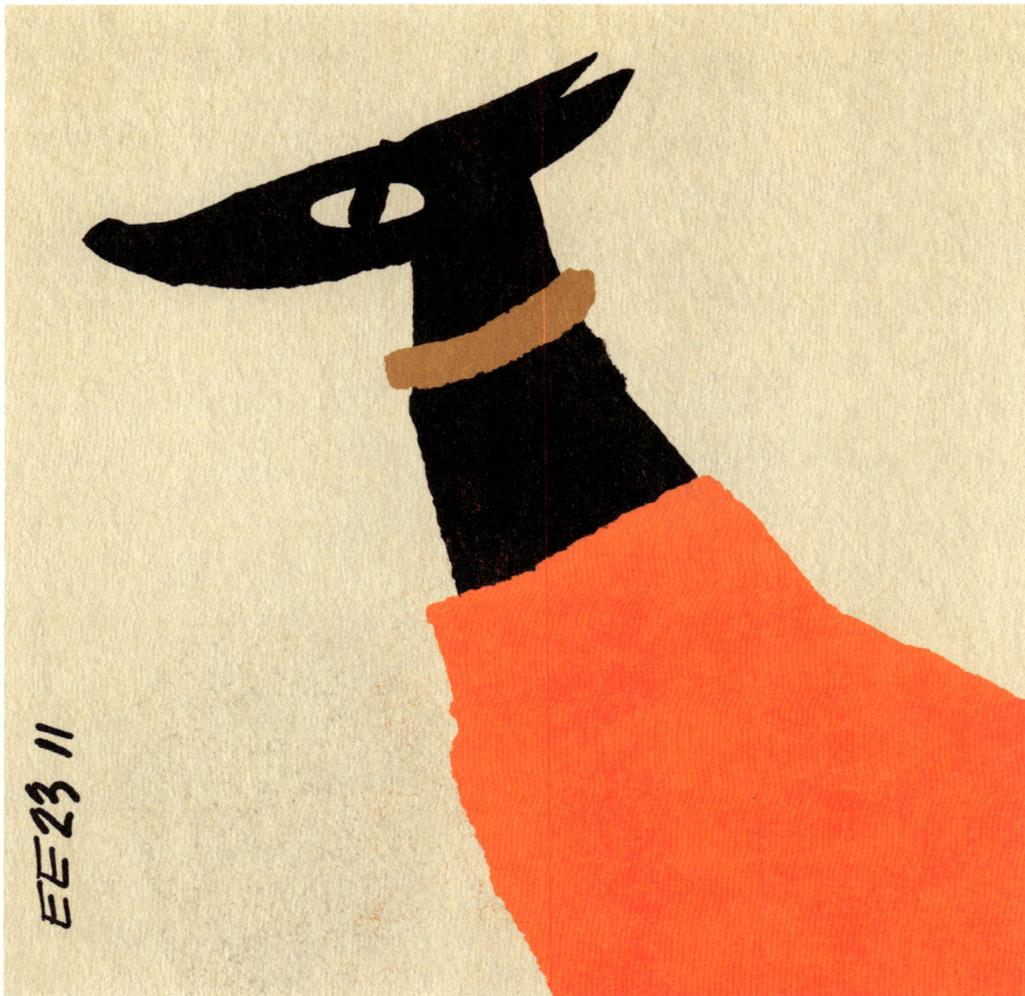

EE 23 II

274

Sonja in Red Jumper
711.2 x 711.2 mm, Digital

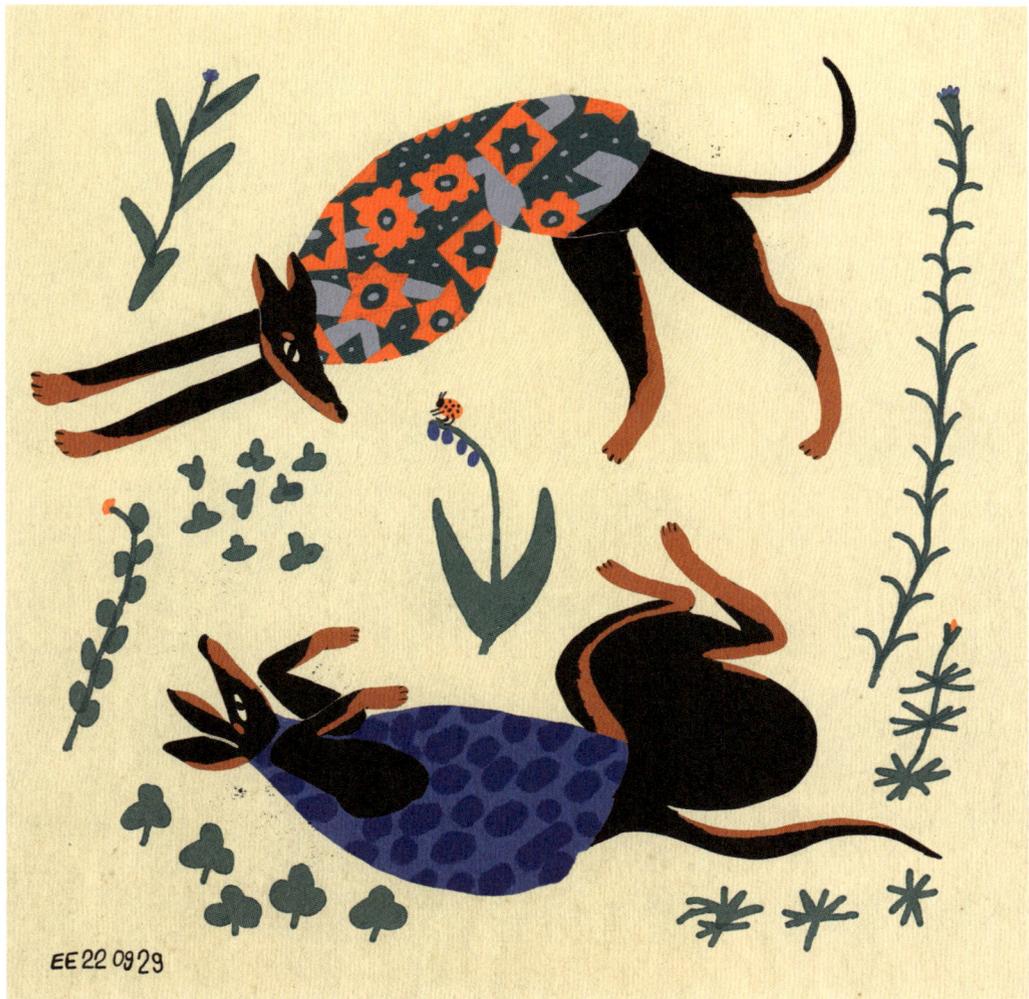

Playing Pinschers
592.67 x 592.67 mm, Digital

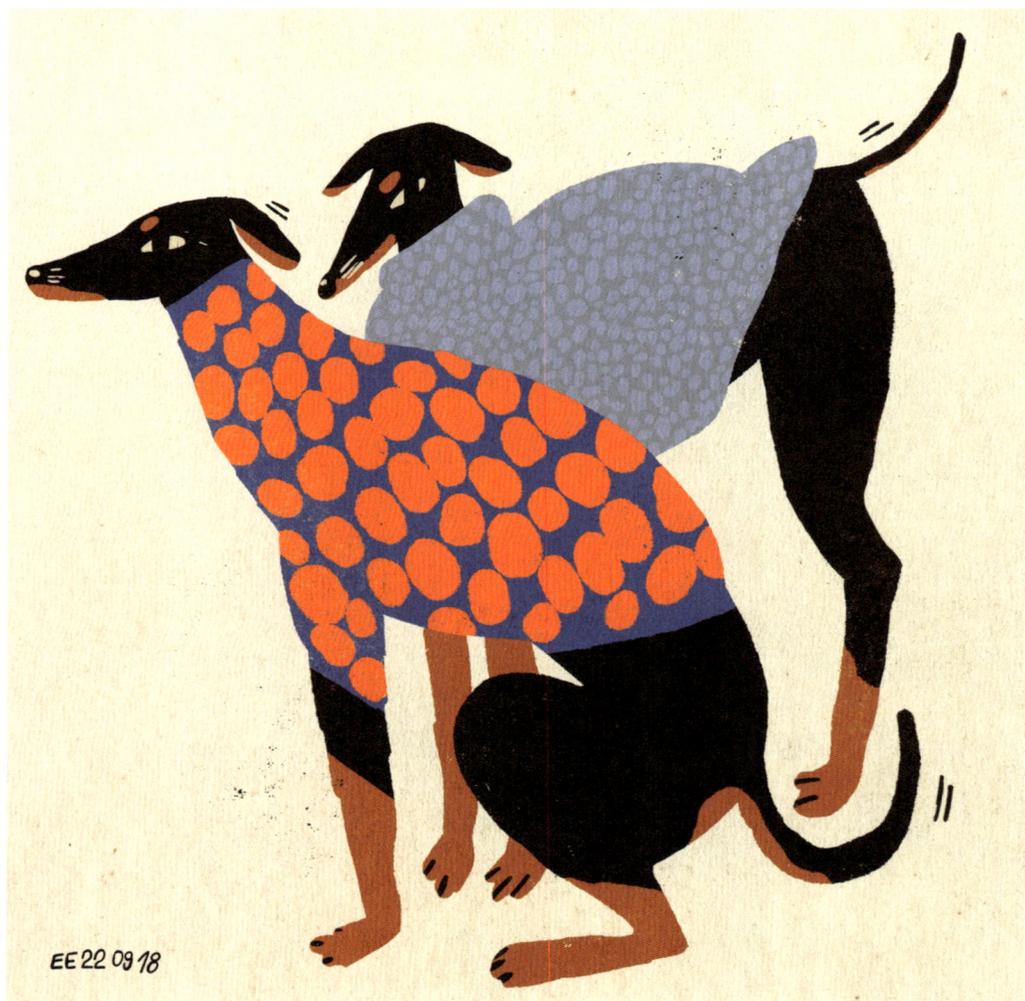

EE 22 09 18

Autumn Doggos
711.2 x 711.2 mm, Digital

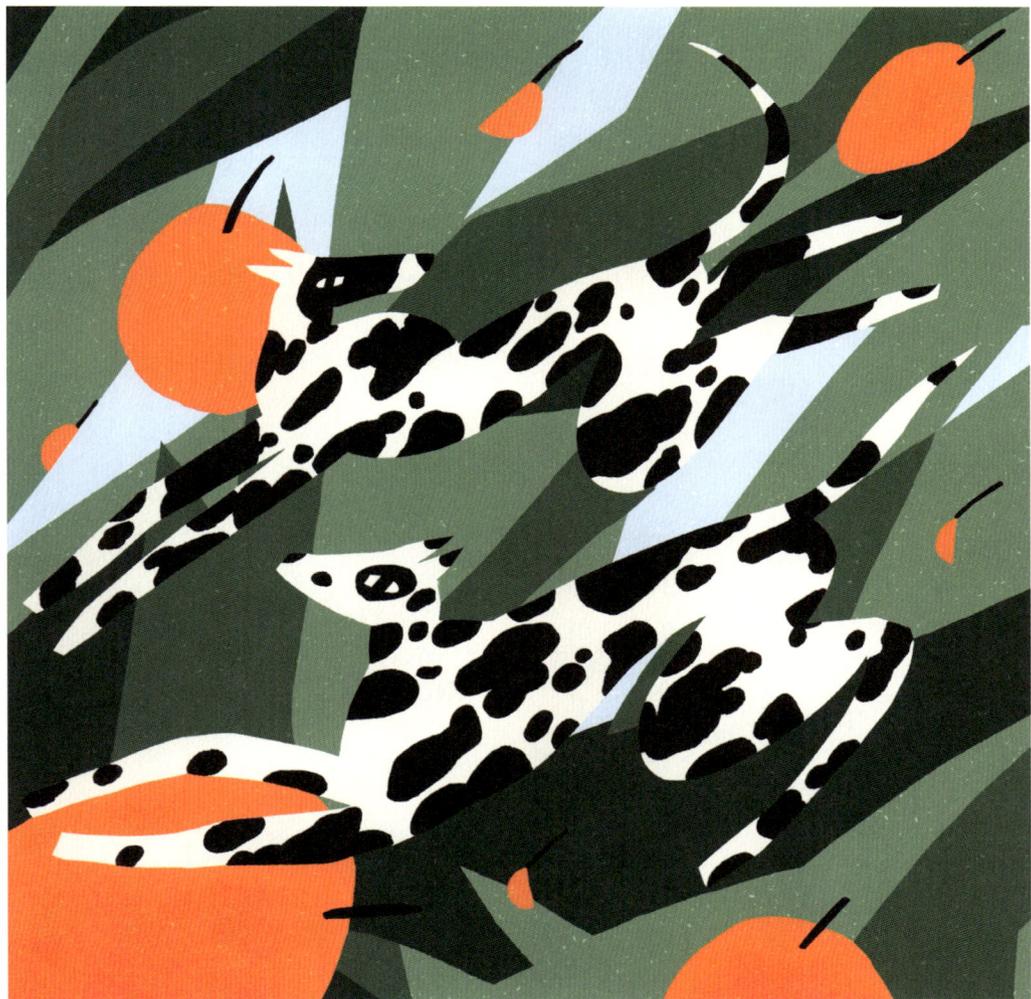

Cherry Garden
254 x 254 mm, Digital

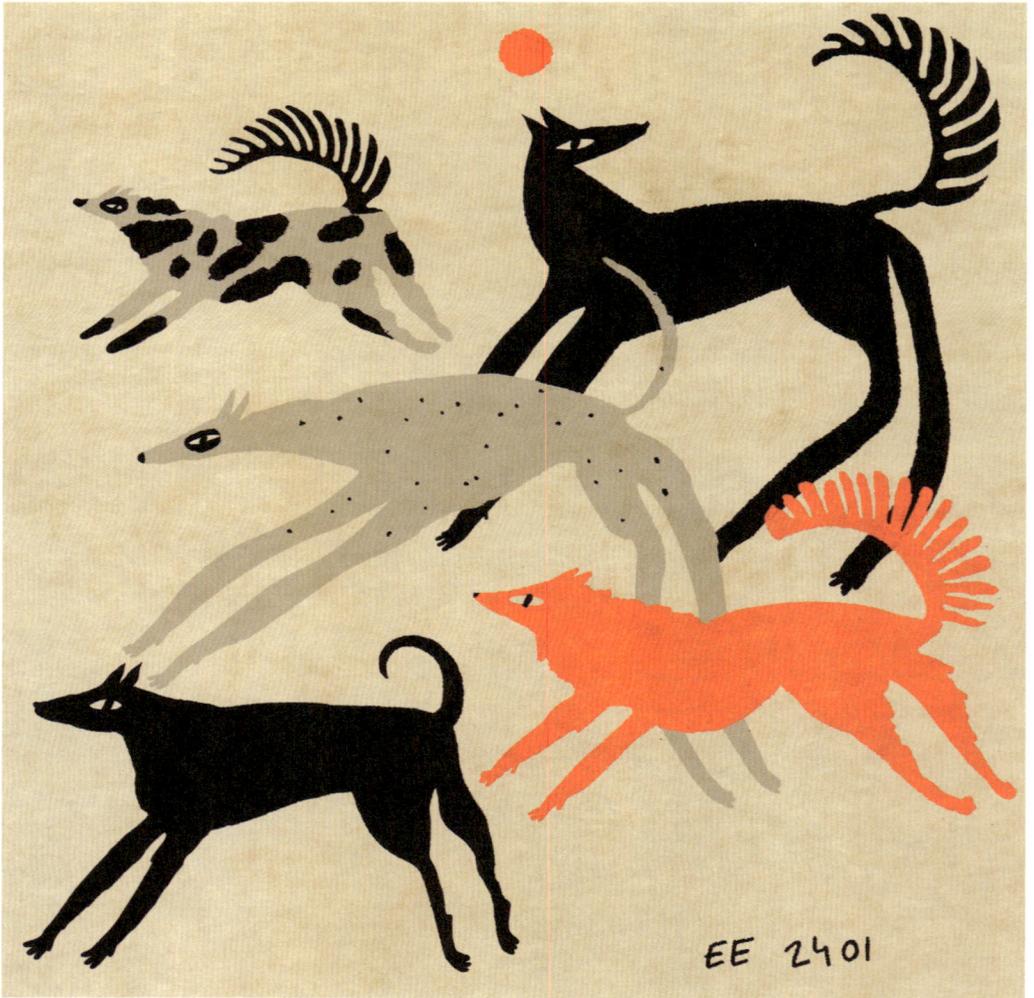

Afternoon Play
165.1 x 165.1 mm, Digital

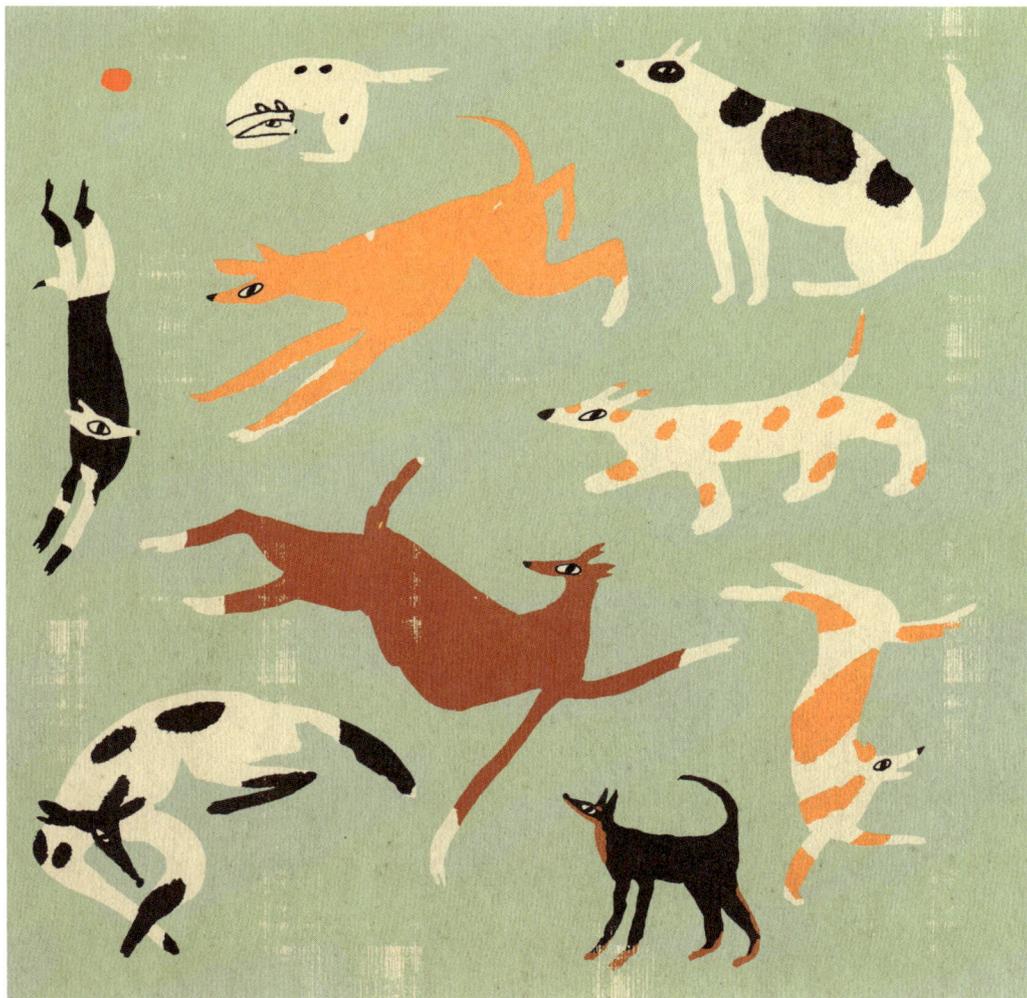

Playtime
168.02 x 168.02 mm, Digital

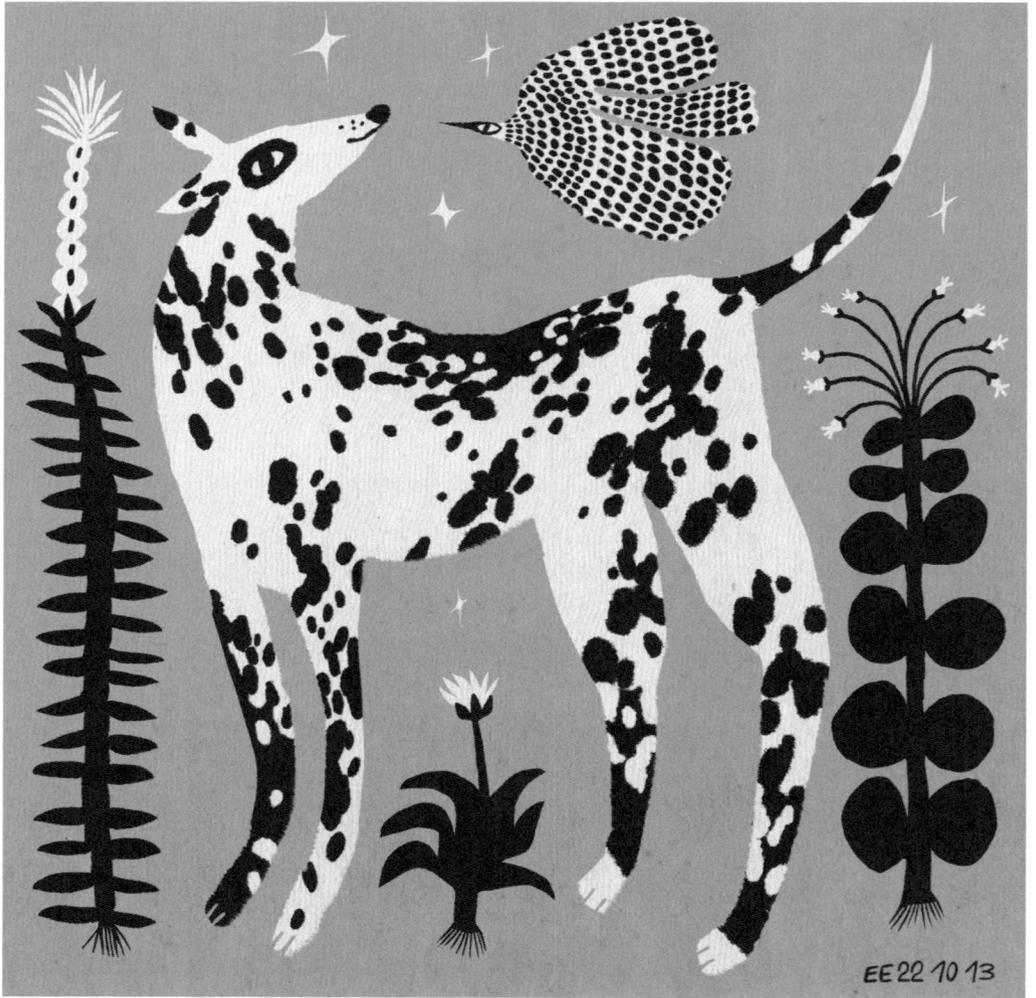

Spotted Dog in the Magic Garden
592.67 x 592.67 mm, Digital

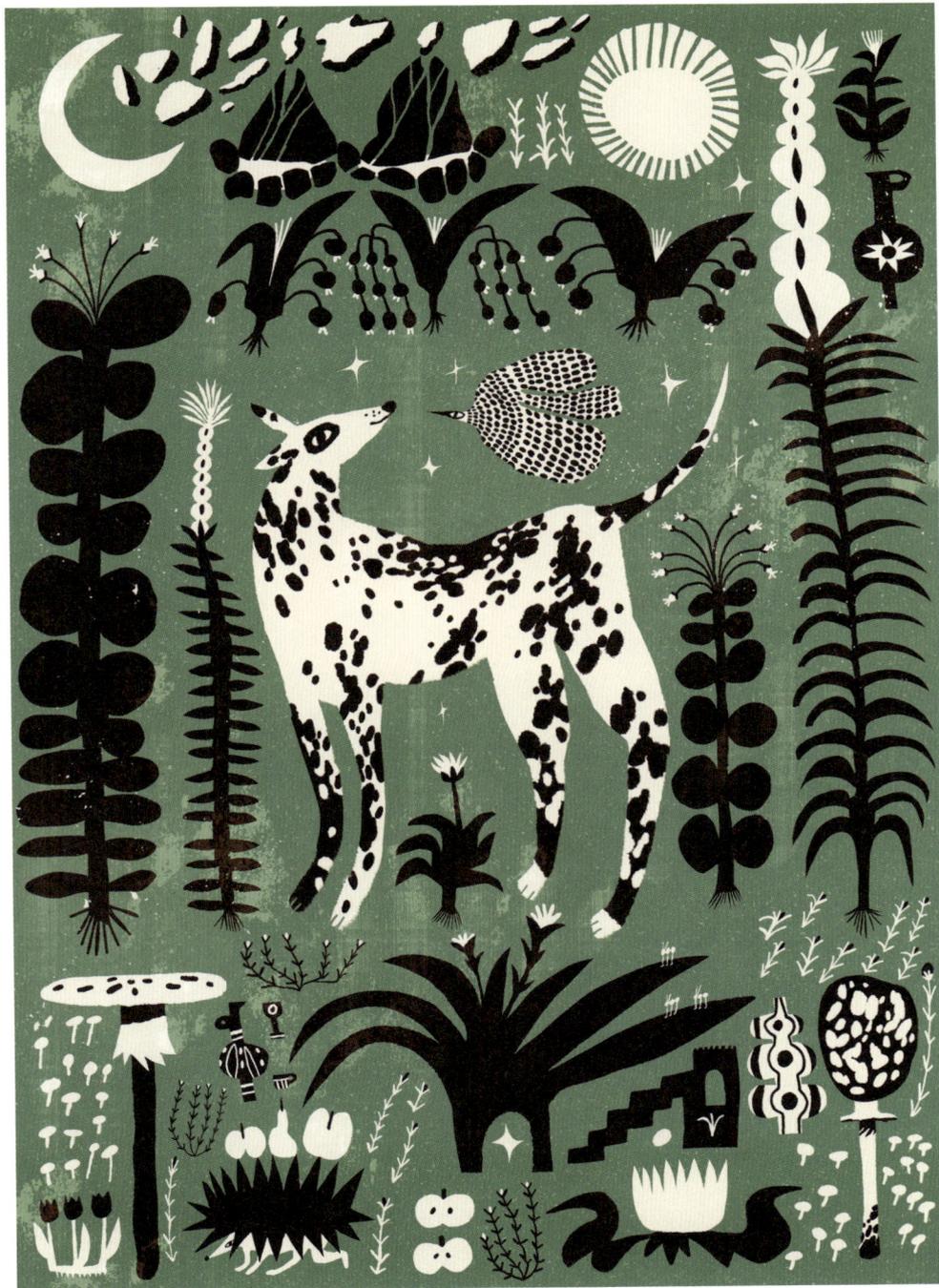

Spotted Dog in the Magic Garden
297 x 420 mm, Digital

Evgeniya Skubina

skubina.ru

Evgeniya Skubina is an artist and illustrator from Moscow. She has worked with various media, IT, and stationery companies, including Conde Nast Group and Moleskine. She is currently focused on her career as an artist.

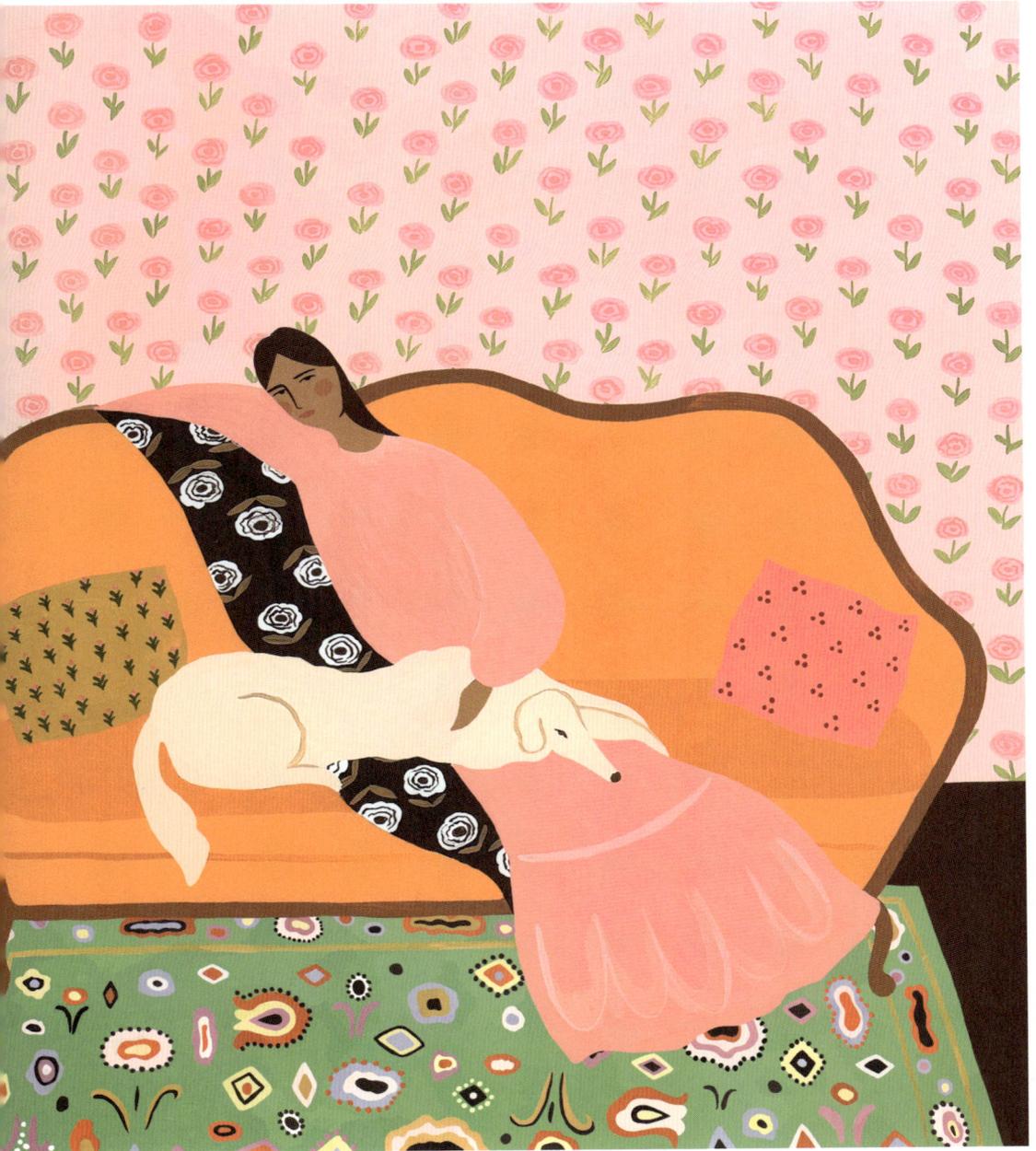

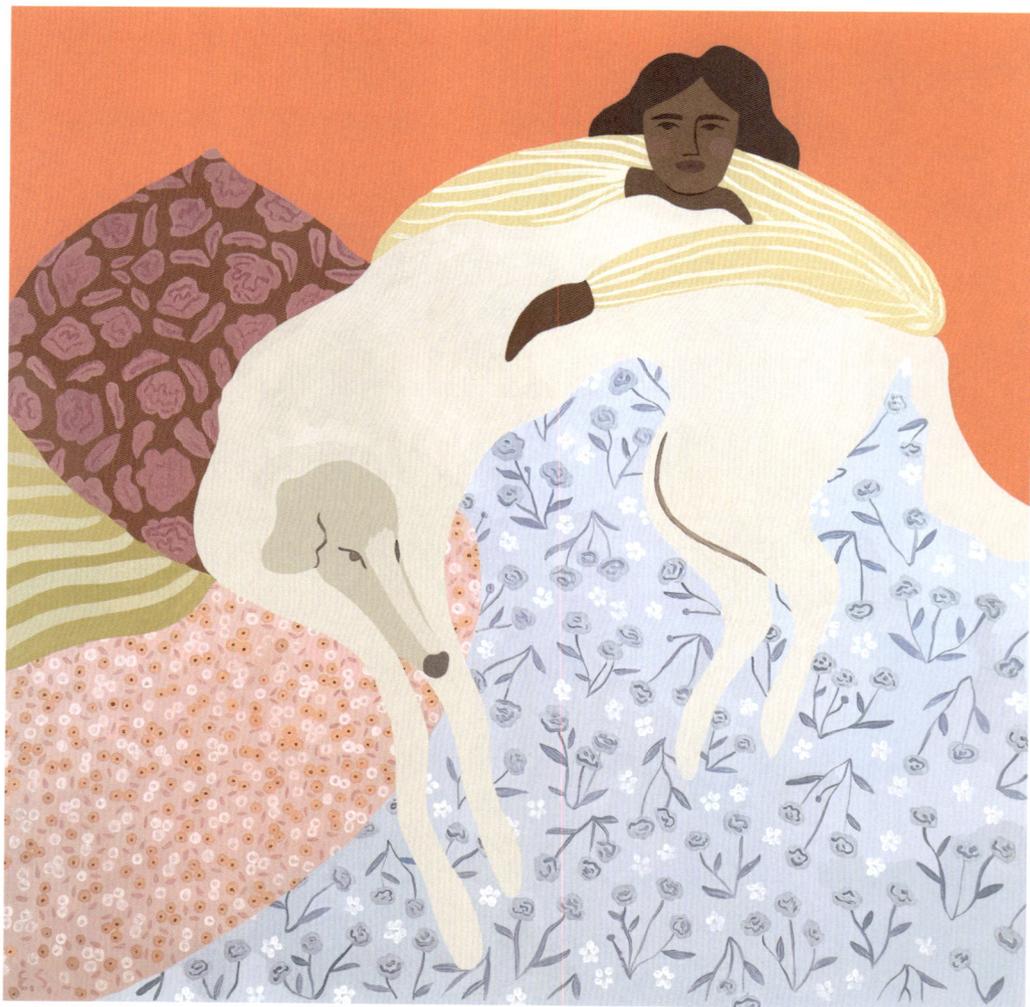

284

Girl Laying With Borzoi
700 x 700 mm, Acrylic, Canvas

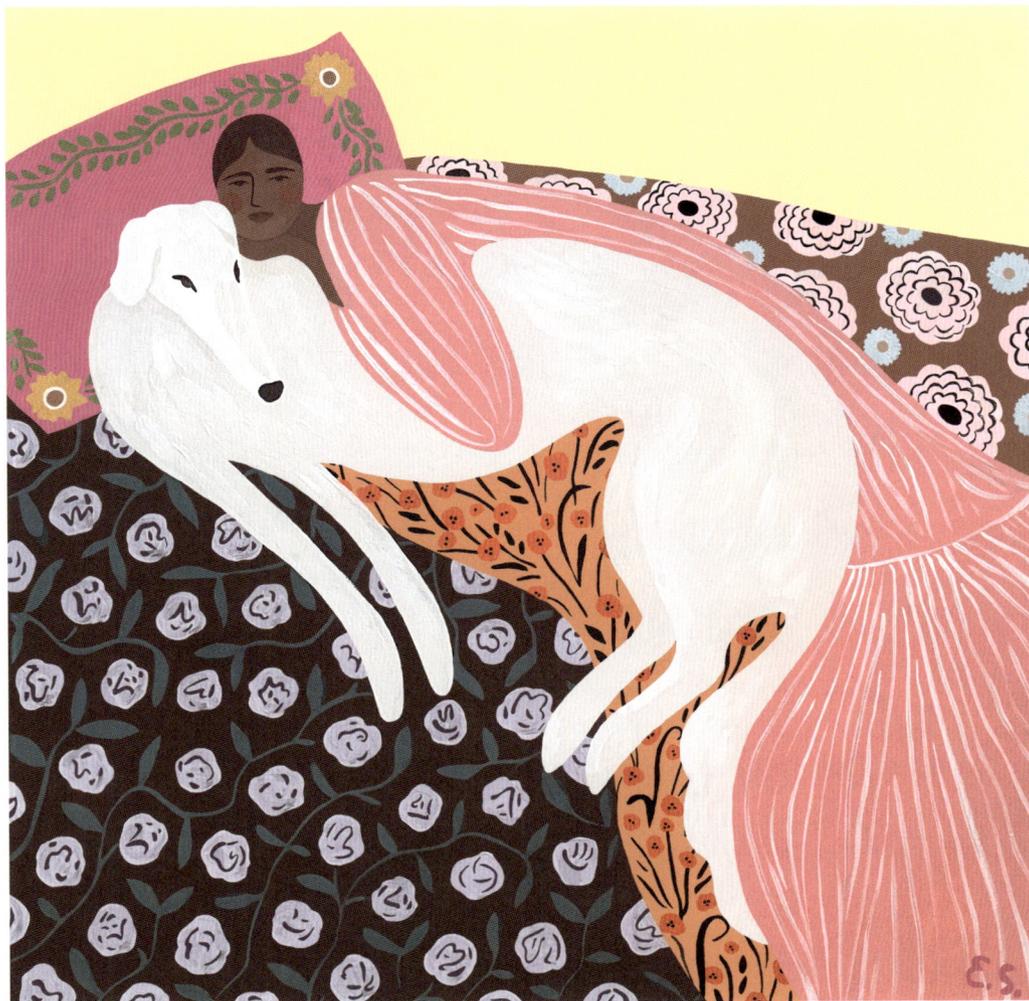

Girl In Pink Dress With Borzoi
600 x 600 mm, Acrylic, Canvas

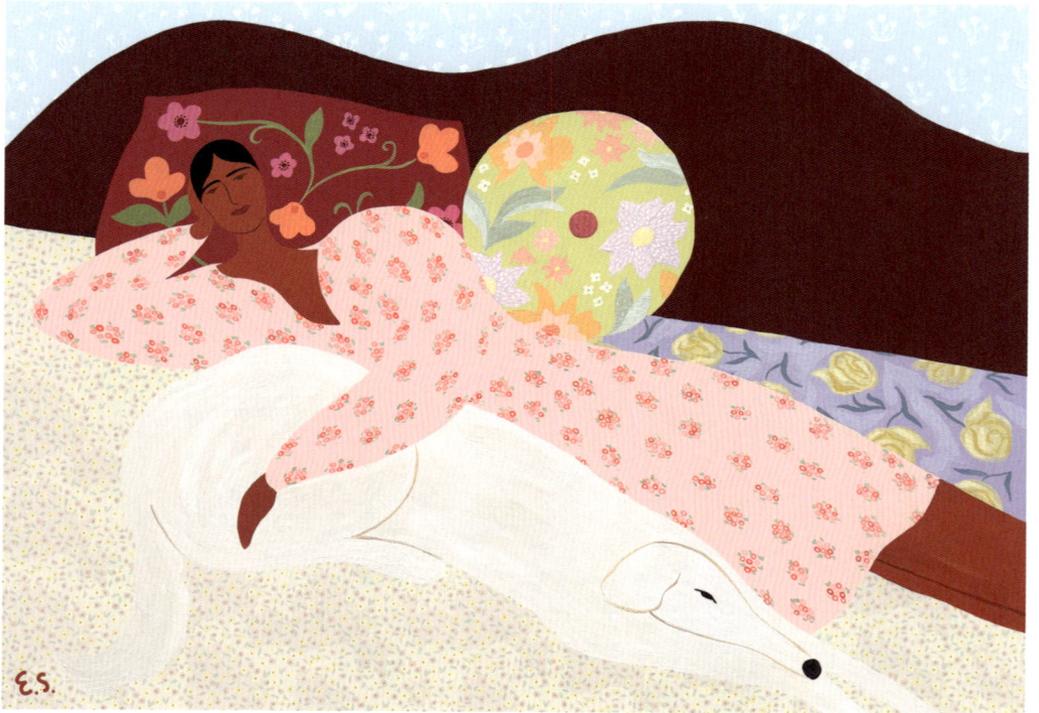

286

Girl With Borzoi
700 x 500 mm, Acrylic, Canvas

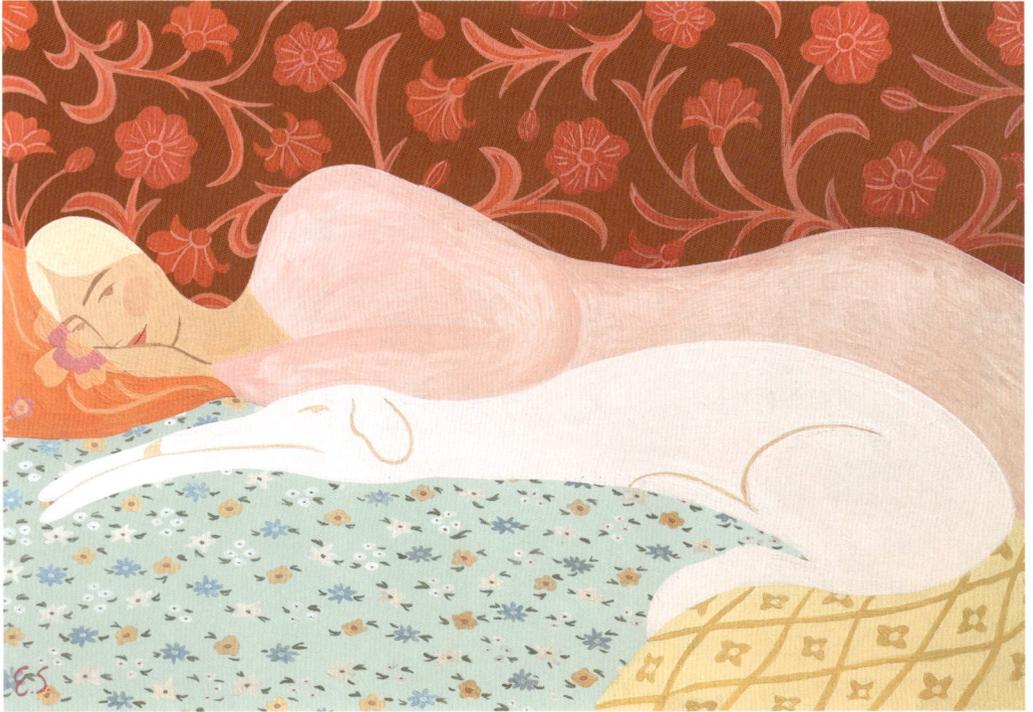

Pink Dreams
700 x 500 mm, Acrylic, Canvas

Miriam Martincic

Miriam Martincic is a fine artist, turned graphic designer, turned award-winning editorial illustrator. She draws, teaches, swims, and dances in Ames, Iowa under careful dachshund supervision.

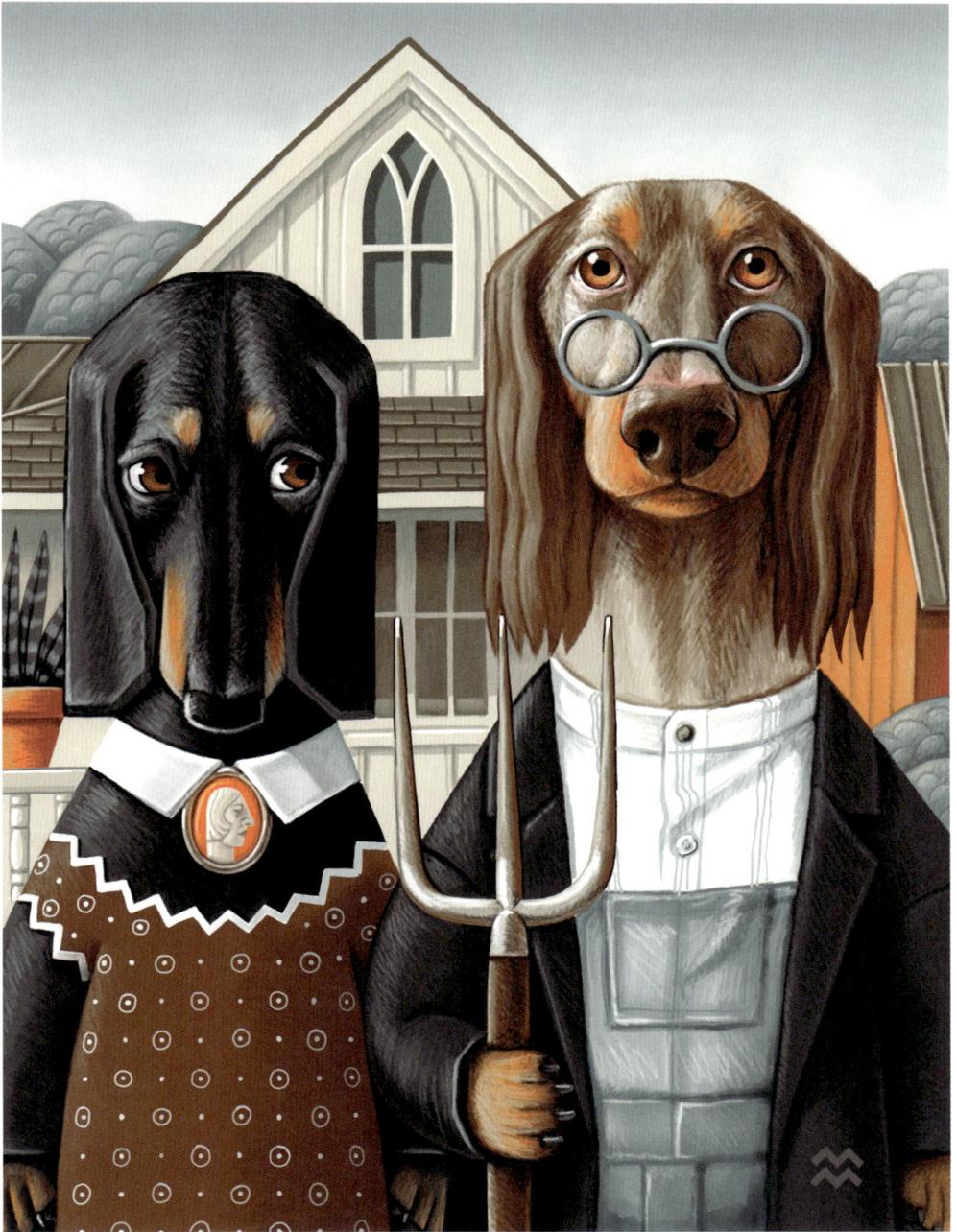

American Dachshund
2048 x 2732 px, Digital

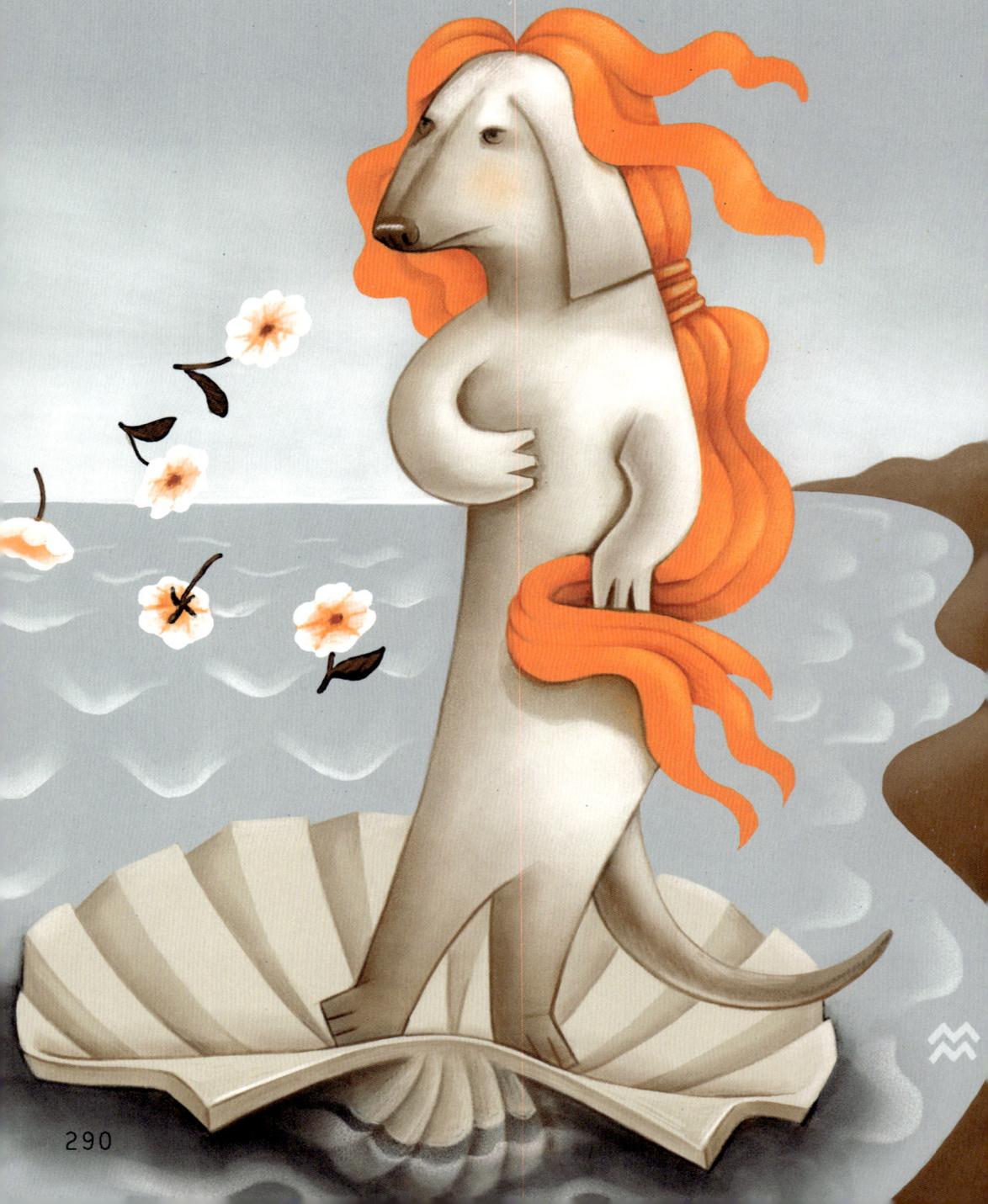

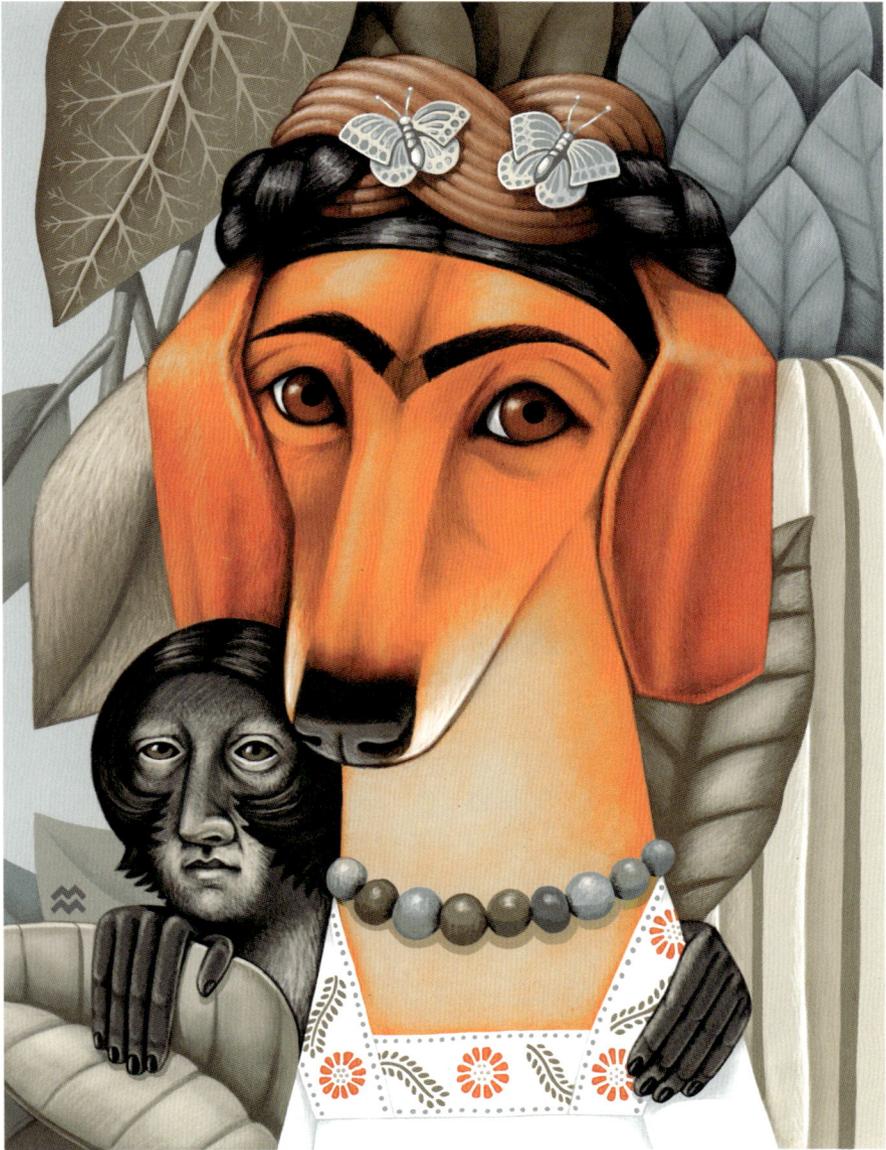

Birth Of Wienus (←)
2048 x 2732 px, Digital

Frida (↑)
2048 x 2732 px, Digital

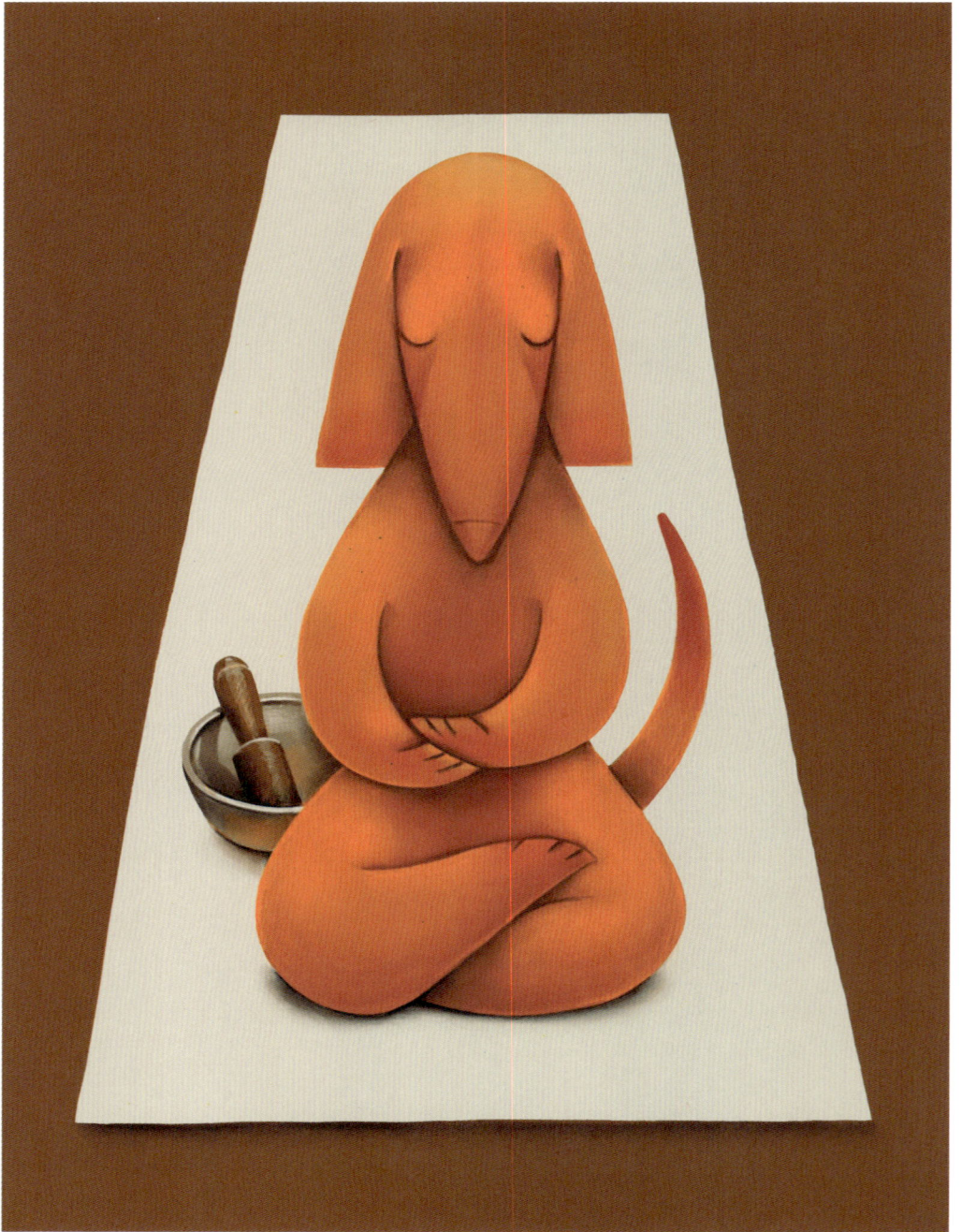

Sit
4498 x 6000 px, Digital

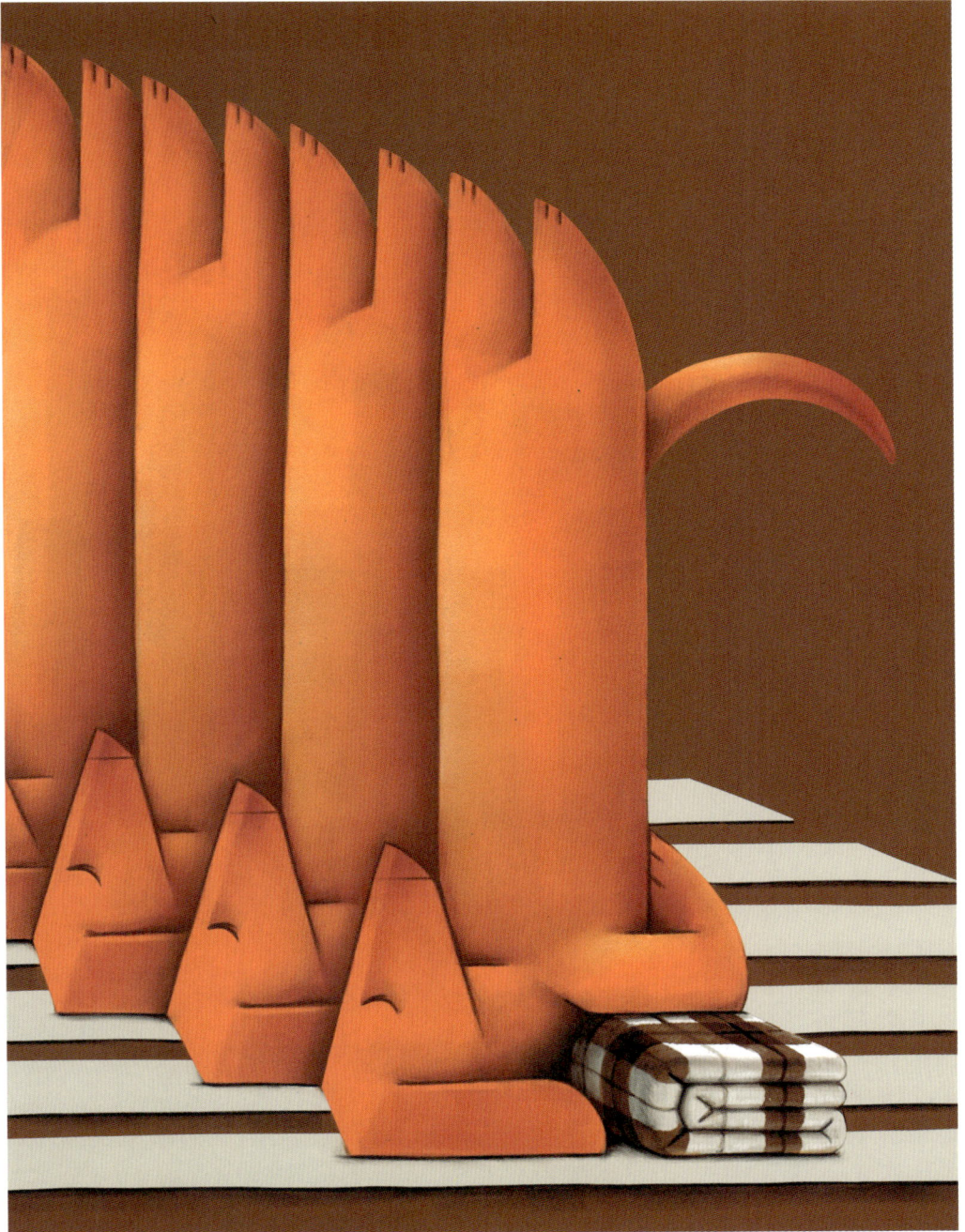

Shoulderstand
4498 x 6000 px, Digital

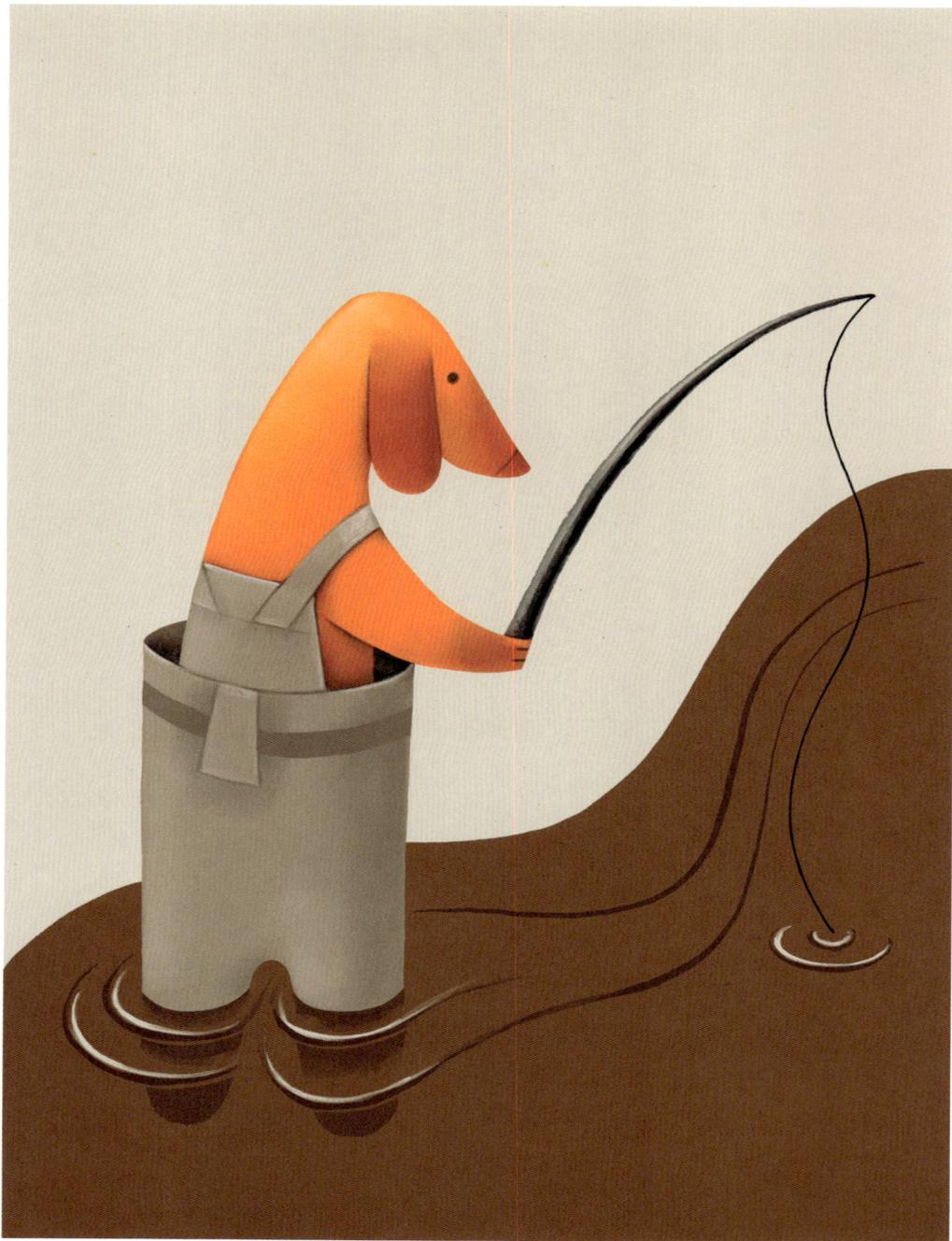

Fish
4498 x 6000 px, Digital

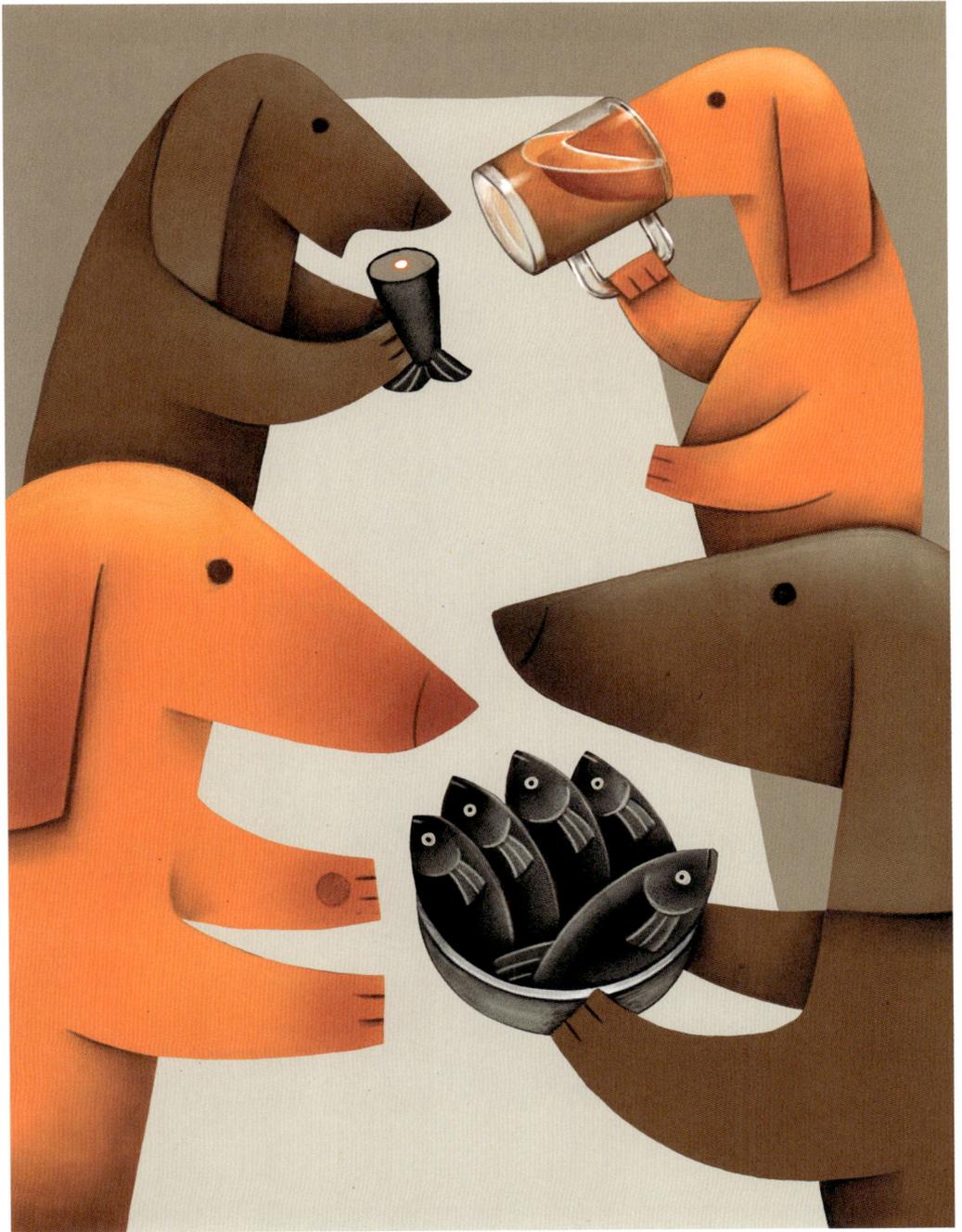

Share
4498 x 6000 px, Digital

Amelia H-Jastrzębska, known as inameliart, is an oil painter based in Poland. She hones her whimsical style with a bittersweet touch of sadness, drawing inspiration from the nature surrounding her studio.

@inameliart

Amelia H-Jastr zębska

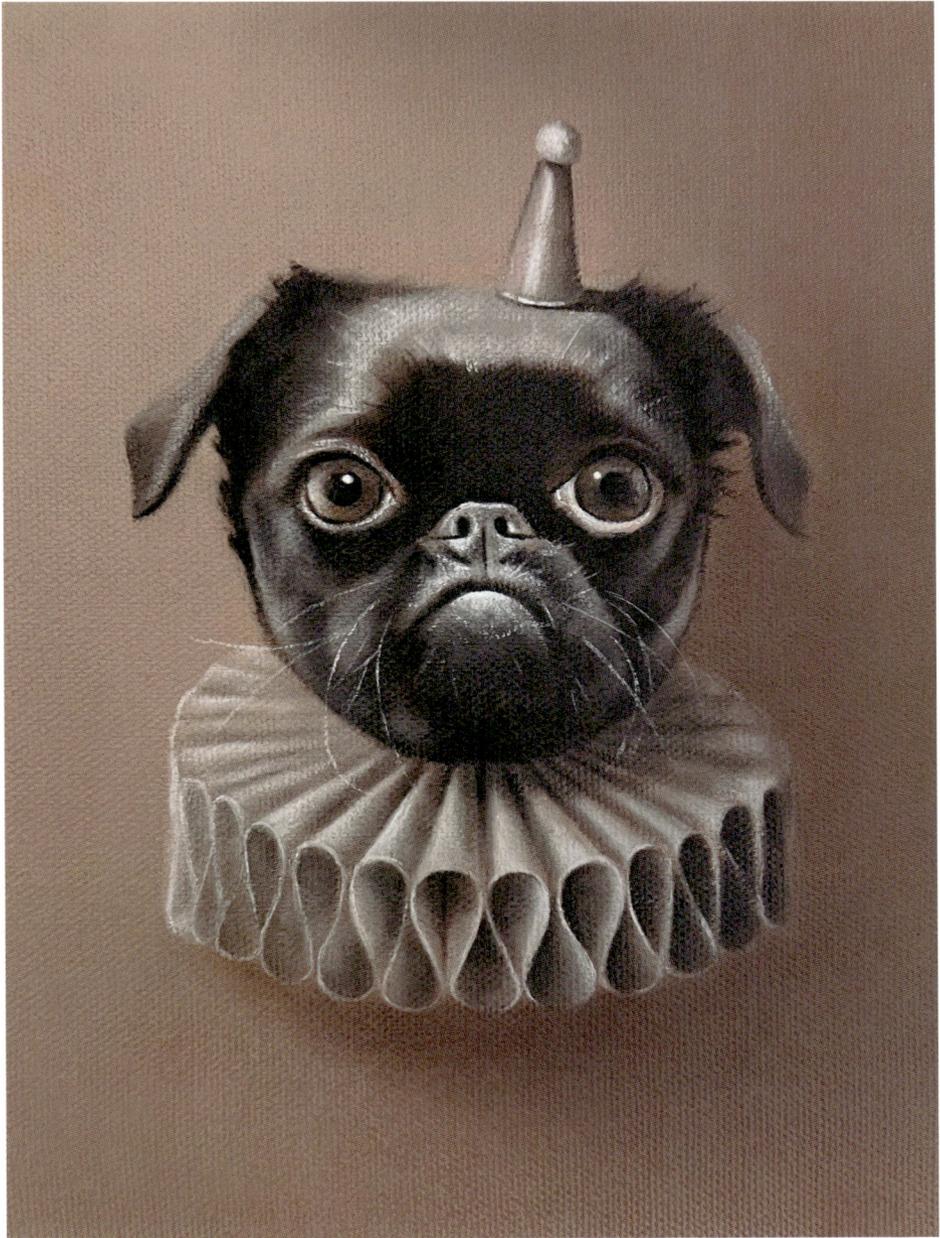

The Portrait with The Collar
240 x 180 mm, Oil, Canvas

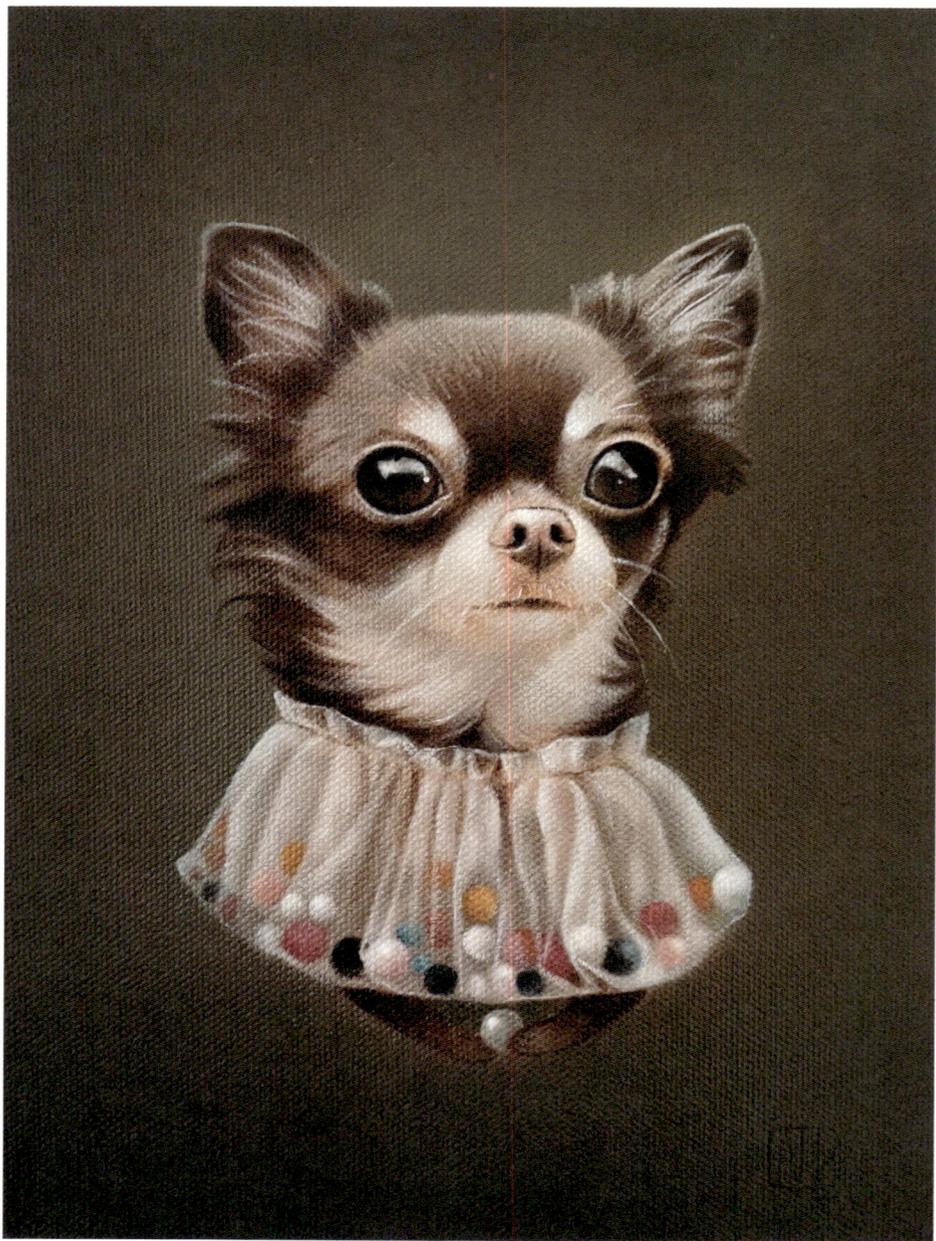

The White Little Ball
240 x 180 mm, Oil, Canvas

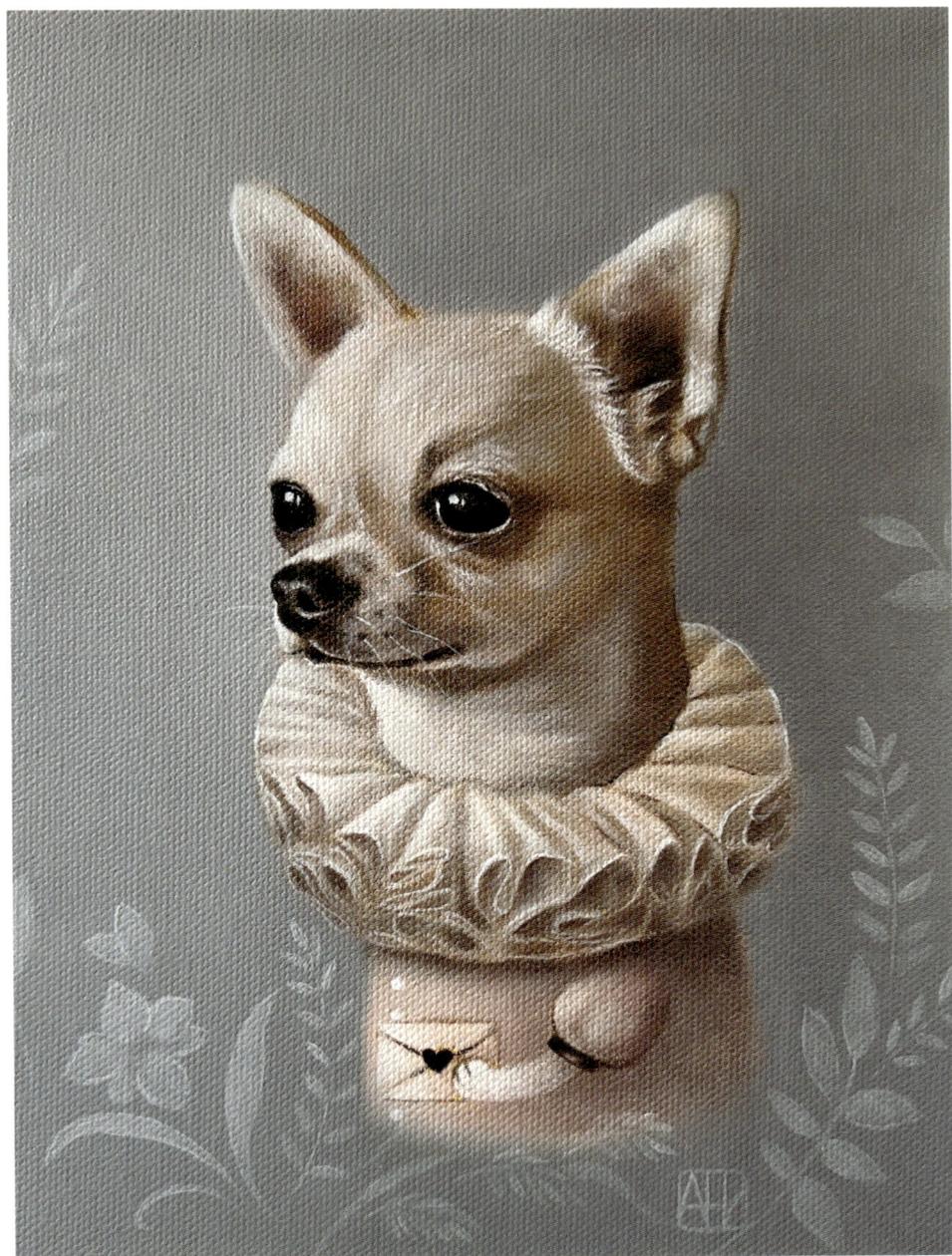

Love Letter
300 x 300 mm, Oil, Canvas

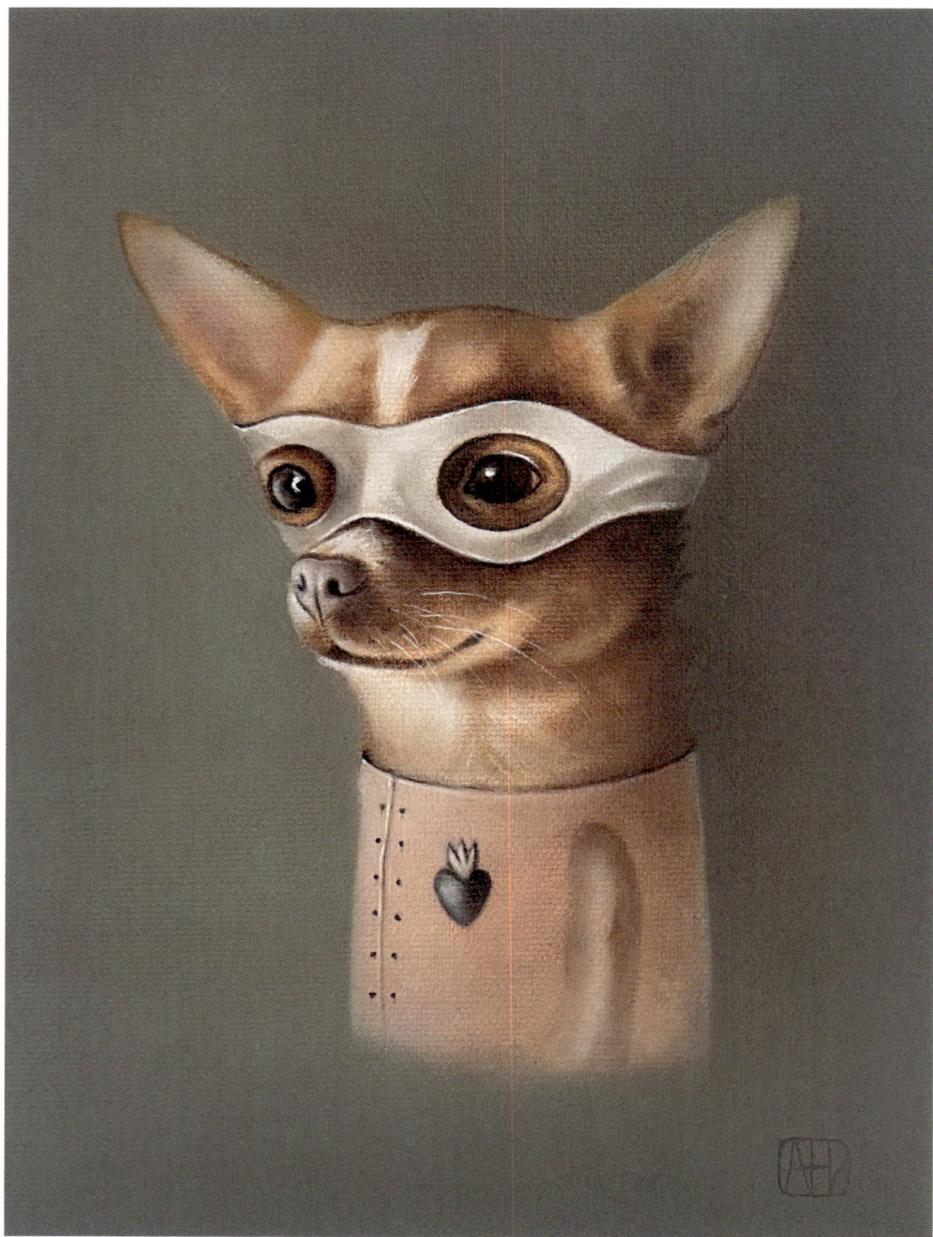

300

All In My Little Heart
240 x 180 mm, Oil, Canvas

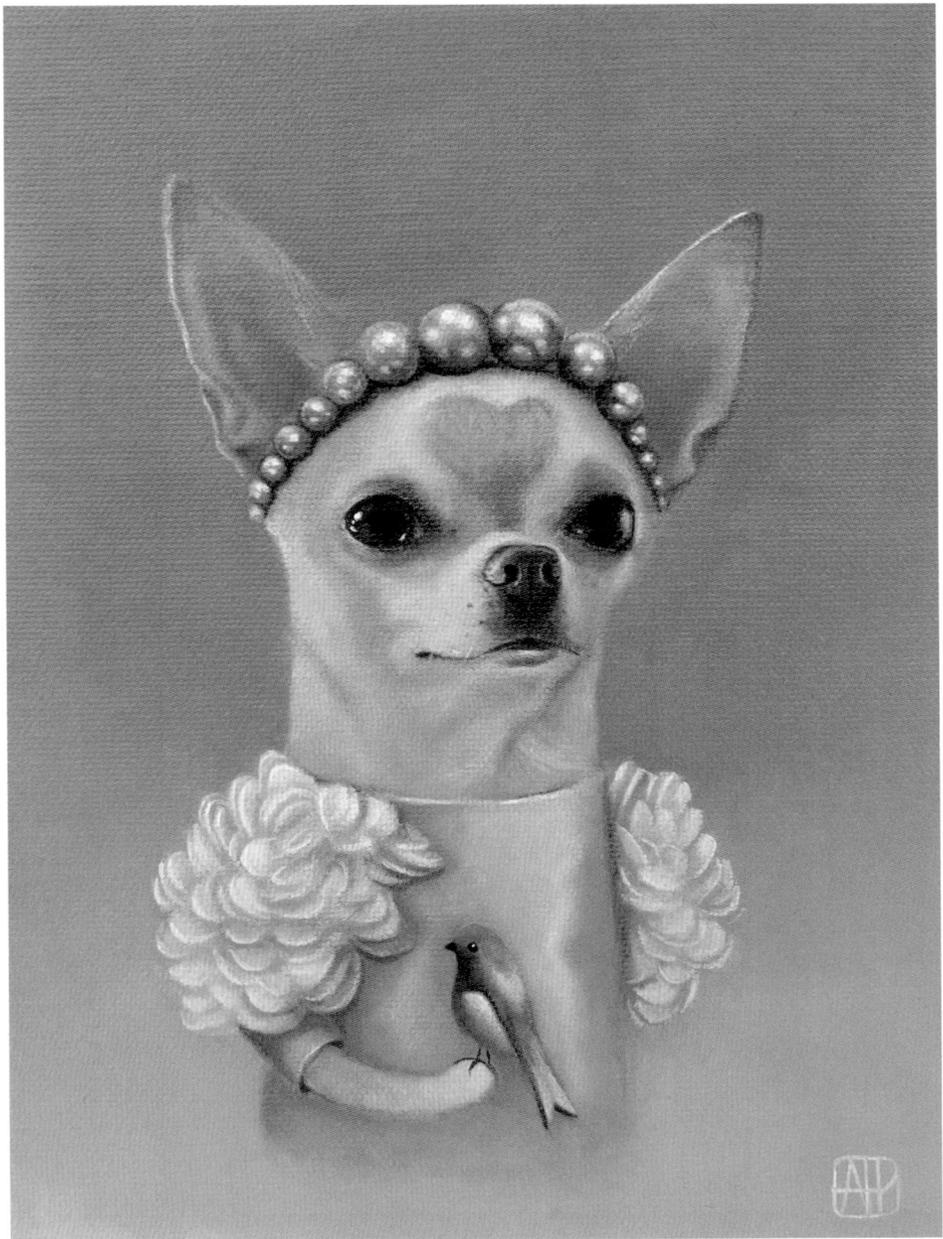

The Girl With The Bird
240 x 180 mm, Oil, Canvas

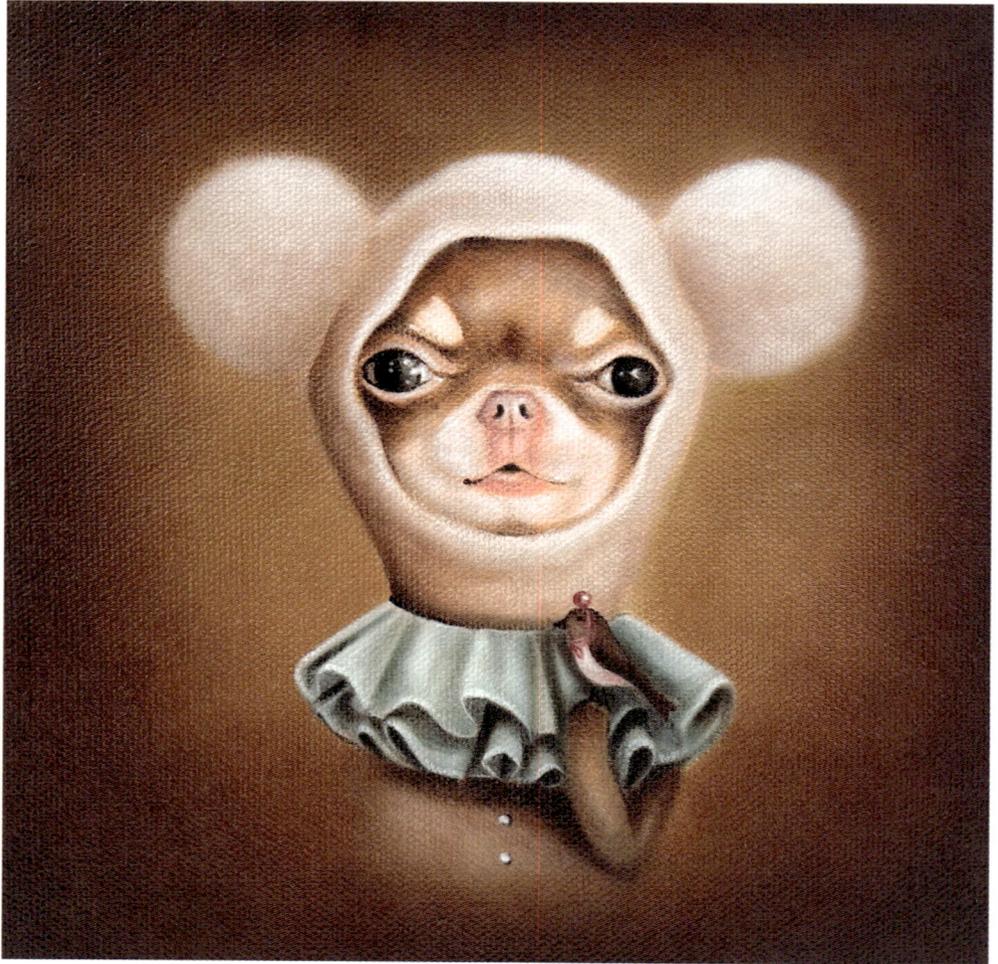

302

Friends
200 x 200 mm, Oil, Canvas

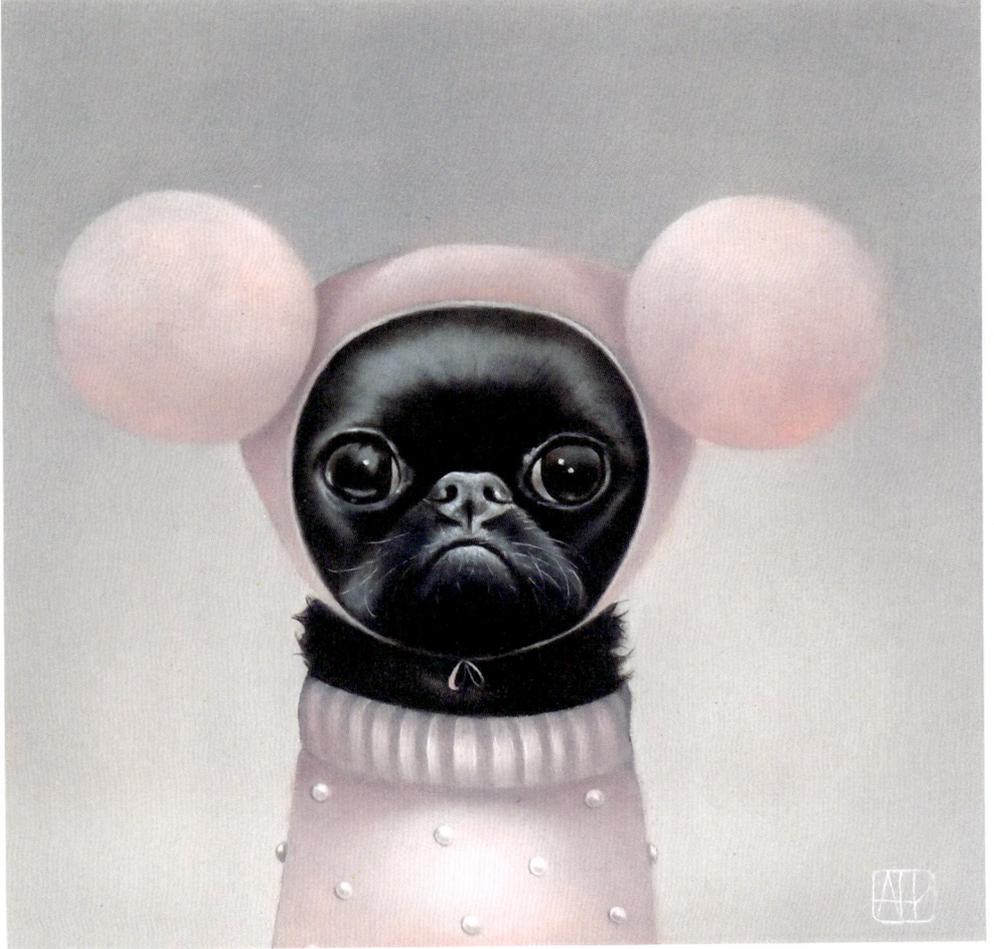

Two Pom Poms
300 x 300 mm, Oil, Canvas

FEATURED ARTISTS

ACKNOWLEDGEMENTS

We would like to thank all the designers and companies who were involved in the production of this book. This project would not have been accomplished without their significant contribution to its compilation. We would also like to express our gratitude to all the producers for their invaluable opinions and assistance throughout this entire project. Its successful completion also owes a great deal to many professionals in the creative industry who have given us precious insights and comments. And to the many others whose names are not credited but have made specific input in this book, we thank you for your continuous support the whole time.

FUTURE EDITIONS

If you wish to participate in viction:ary's future projects and publications, please send your website or portfolio to we@victionary.com.